Currier and Ives: America Imagined

Currier & Ives

America Imagined

Bryan F. Le Beau

Smithsonian Institution Press

Washington and London

Editor: Joanne Reams
Production editor: Ruth W. Spiegel
Designer: Chris L. Hotvedt

Library of Congress Cataloging-in-Publication Data

Le Beau, Bryan F.
 Currier and Ives: America Imagined / Bryan F. Le Beau
 p. cm.
 Includes bibliographical references and index.
 ISBN 1-56098-990-4 (alk. paper)
 1. Currier & Ives. 2. Lithography, American—19th century. 3. United
States—In art. I. Title
NE2312.C8 L43 2001
769.973'09'034—dc21 2001020472

British Library Cataloguing-in-Publication Data available

Manufactured in the United States of America
07 06 05 04 03 02 01 5 4 3 2 1

To

Nancy Le Beau

1919–2001

ᏩᎦ C O N T E N T S ᏫᏬ

ACKNOWLEDGMENTS ix

INTRODUCTION 1

ONE The "Best" Lithography Company 11

TWO Creating a Usable Past 31

THREE Responding to Civil War 69

FOUR Imagining the Frontier 109

FIVE Picturing Urban and Rural Life in America 149

SIX Views of the American Family 181

SEVEN Images of African Americans and

 Irish Americans 215

EIGHT Graphic Humor and Political Commentary 257

NINE American Pride and Play 292

EPILOGUE: DECLINE, DEMISE, AND REVIVAL 332

NOTES 339

INDEX 369

Ꮹ ACKNOWLEDGMENTS Ꮽ

Any project this size requires the involvement of many more people than can be thanked by name. I am indebted to all of them. I would like to acknowledge in particular the work of a few individuals who rendered extraordinary assistance.

Access to library resources, especially special collections, was essential to my research. So let me first thank the staff at the Museum of the City of New York. Eileen Morales, manager of collections access, and Marguerite Lavin, rights, reproductions, and licensing specialist, provided invaluable guidance in my work in their Currier and Ives collection. Also very helpful were the staffs at the Library of Congress, New York Public Library, and Creighton University's Reinert/Alumni Memorial Library.

The quality of any author's work benefits immensely from critical reading by others in the field. This book is no exception. The following scholars honored me with their reading of my manuscript at various stages and significantly improved the final product by their criticisms, comments, and suggestions: Joni Kinsey, Department of Art History, University of Iowa; Gary Kulik, deputy director for library and academic programs, Winterthur Museum; and Barry Shank, Division of Comparative Studies, Ohio State University.

My special thanks must be offered to the Smithsonian Institution Press. Mark Hirsch, senior acquisitions editor, not only welcomed the project but also worked closely with me to make it an even better product than originally envisioned. Joanne Reams, editor, did excellent work with the text, and Ruth Spiegel, administrative editor, saw this project through to completion in a highly professional manner. I could not have asked for a better team with whom to work.

And, finally, I would like to name those people who helped in other important ways: David Kosalka, whose research assistance was much appreciated; Ford Jacobsen, for his excellent photography; and Marlene Lenhardt, for her hard work in preparing the manuscript, as well as her patience and good humor in the process. My thanks to all of you.

Introduction

Most Americans recognize them as the creators of Christmas cards and calendar Americana. In the nineteenth century, Nathaniel Currier and James Merritt Ives called their company "the Grand Central Depot for Cheap and Popular Prints." They proudly advertised it as "the best, cheapest, and most popular firm in a democratic country," providing "colored engravings for the people." And indeed they created a legacy of more than seven thousand prints that sold in the uncounted millions of copies—at one point 95 percent of all lithographs in circulation in the United States.[1] Ironically, given the value now placed on their prints, Currier and Ives never intended to produce prints of great value. Rather than aspiring to have their work exhibited in the nation's fine-art museums and galleries, they sought to have them hung on the walls of America's homes, stores, barbershops, firehouses, barrooms, and barns. And in this they were wildly successful.

Nineteenth-century art critics belittled Currier and Ives's lithographs, often for their commercial success, though the critics' scorn was not always put quite that way. Guardians of fine art argued that Currier and Ives prints, like all commercial lithographs, simply cheapened art, deluding the people into thinking that they were real art. In 1857 English art critic John Ruskin warned: "Let no lithographic work come into your home."[2] Such criticism, however, was aimed as much at the larger growth of democracy as it was at popular art. As Ruskin's contemporary, Lawrence Godkin, editor of the *Nation,* put it in 1874, lithography was the quintessence of the democratization—and therefore the debasement—of high culture. It represented a pseudoculture, being one of a plethora of evil media (also illustrated magazines and lyceum lectures) that "diffused through the commu-

nity a kind of smattering of all sorts of knowledge, or taste for 'art'—that is, a desire to see and own pictures which pass with a large body of slenderly equipped persons as 'culture' and give them an unprecedented self-confidence in dealing with all the problems of life, and raise them in their own minds to a place on which they see nothing higher, greater, or better than themselves."[3]

The question of artistic merit must be settled elsewhere, if at all. Given the process by which it was produced, as well as its intent, the Currier and Ives print was a work of art secondarily; it was primarily a depiction of objects and scenes, a picture, a symbol, an event. It was "an aesthetic entity last; first it was a forum for discussion of national issues, a window on times past and times to come, a mirror of current anxieties and aspirations."[4]

The public taste for lithographs was a taste for information. And the principal function of Currier and Ives's prints, as was the case with lithographs generally in America, was to convey information in non-verbal form.[5] From that perspective, Currier and Ives created a panorama of life in nineteenth-century America, including its lifestyles, fashions, culture, and tastes. As Harry T. Peters, the most prominent collector of Currier and Ives prints and related materials, wrote, "Currier and Ives were businessmen and craftsmen . . . but primarily they [were] mirrors of the national taste, weather vanes of popular opinion, reflectors of American attitudes in the years from 1835 to 1907."[6]

Because of Currier and Ives, mid-nineteenth-century America was better pictured than any other time and place in history before the widespread use of photography. They created a historical record but not as conscious historians. They operated on terms the buying public—certainly a huge number—would accept, and of that they were quite conscious. They often avoided direct representations of conflicting reality and controversy, and where persuaded to take a stand on such subjects, during the Civil War for example, they chose "the side of the heaviest artillery." But their prints were not always entirely positive. Many conveyed critical, negative, or at least cautionary messages, in obvious as well as subtle ways, again reflecting the concerns or fears of their audience as well as their creators.

Many critics have suggested that Currier and Ives were America's preeminent romanticists, that they passed on "the romance of America to future generations." Others have argued that they "schooled our citizens in what it meant to be American," and a few have insisted that what they produced was "imperialism personified."[7]

All are correct, at least in part, but Currier and Ives's America was also the product of consensus involving the two principals, several artists or craftsmen, and the buying public. Currier and Ives's images resulted from their understanding of their clients' preferences, which in turn was based on the public's response to their previous pictures, measured through sales figures and direct communication. Such feedback, such access to the public pulse, led to prints being reproduced in varying numbers, reissued from new stones, modified to remove offending elements or to add more pleasing ones, or cancelled. Currier and Ives did not necessarily picture America as it existed, but rather as it was imagined—how their patrons imagined it to be or to have been, or wanted it to be, or in a few cases feared it might become. That, of course, is what makes the prints so valuable—they are texts from which we can learn even more about nineteenth-century America than if they were more literal snapshots of the past.

In the past few decades there has been an awakening to the importance of popular culture as a source by which we can better know the world around us. Cultural historians have found in the popular arts a valuable expression of the taste and understanding of the people, either in part or as a whole.[8] Decades ago John Dewey suggested that "the arts that have most validity for the greatest part of the population are not considered arts at all." He recognized that such forms of expression, rather than conveying the solitary artist's vision, confirm the experience of those who consume it. More recently, it has been argued that "popular art confirms the experience of the majority, in contrast to elite art, which tends to explore the new. For this reason, popular art has been an unusually sensitive reflector of the attitudes and concerns of the society for which it is produced." The popular artist corroborates "values and attitudes already familiar to his audience; his aim is less to provide a new experience than to validate an older one."[9]

Currier and Ives contributed to the break between high and popular culture in America. They were the leading source of popular art in the nineteenth century—thus the need to examine their work seriously, as more than just pretty pictures. The prints can be seen as historical documents, indispensable to an understanding of America in the making.[10] They need to be treated as a prism through which we may better examine the historical light of that time and place.

Popular culture is often seen as offering a set of simple answers but no hard questions, opinions but no arguments. It is described not as trying to tell us who we are, but rather as cajoling us with feel-good images of who we think we should want to be. "In the process," as

Holland Cotter has put it, "tragedy, contradiction, change—reality it-self—are discarded, like muddied boots outside the parlor door."[11] Critics have described Currier and Ives's lithographs as bland, moral-izing depictions of bourgeois family life and leisure. Cotter compared their work to the saccharine, unrealistic, family-oriented American television fare of the 1950s and found their work "as telling as Ozzie and Harriet."[12] Another noted that "they captured, in pictures as simple as parables, the charade that was going on about them."[13]

But are they that bland and simple? Currier and Ives certainly were not as overtly critical of society as Géricault or Daumier, but were they that confirming, that confident of the nineteenth-century American life they represented? I argue that, to a larger extent than previously acknowledged, they were not. They charted not only the dreams, en-thusiasms, and fantasies of nineteenth-century America, but also its biases, ambitions, and fears. To discover those traits, however, it is nec-essary to examine a much larger number and varied selection of prints than ever before, to place the prints in historical context, and then to venture beneath the surface of literalness—an approach to Currier and Ives that has not yet been taken in any consistent and substantial way.[14]

When we take this approach, we find in the works of Currier and Ives reflections of a turbulent time, a time when cities were boom-ing, industry was expanding at an unprecedented rate, immigrants were pouring into the country, and the nation was moving westward at breakneck speed. "The nation was fattening materially," one critic has written, "but was spiritually rudderless. . . . To compensate for their uncertainties, middle-class Americans sought answers in the here-and-now."[15]

The invention of lithography was a major breakthrough, not only in the art world but also in the ability to communicate, through a non-verbal, nonliterary medium, large numbers of exactly repeatable pic-tures to masses of people. Indeed, until the last quarter of the nine-teenth century, lithography was the only means of such large-scale visual communication. When Nathaniel Currier began his publish-ing business in 1834, there was no quick and inexpensive way to re-produce high-quality prints in large numbers, and thus illustrated newspapers, magazines, and books were few. Mass communication beyond the written word was all but unknown.[16]

Even the best-chosen words were hardly adequate to help readers visualize the fires and disasters, Native Americans, Mississippi steam-boats, and even presidential candidates they had never seen. Mass-produced, inexpensive lithographic prints provided those images.

"Ladies' 'drawing room' magazines and gentlemen's scholarly journals published in America before the Civil War exalted lithography as a new art for democracy. A cheap and durable printing process, it promised 'pictures for everyone.'"[17] The more the printers made, the more the people wanted, until "at the peak of America's Victorian age, the mass-produced color lithograph waved unchallenged as the flag of popular culture."[18]

The wealthy New York collector Harry T. Peters brought Currier and Ives back from oblivion years after their prints had been removed from the walls of America, discarded and forgotten. Peters's generation of the 1920s and 1930s, however, was in search of "a shared American heritage." As the prints' sole publisher and primary interpreter, Peters offered them as evidence of a romantic, heroic era. One *New York Times* reviewer of Peters's *Currier and Ives: Printmakers to the American People* wrote that the prints offer a view of "what the United States was like during the half century when our country was most 'American.'" It was a "100 percent American age," and there was "nothing foreign" to the Currier and Ives prints the age produced.[19] This book challenges that romantic image.

Genre painting is best studied "as a systematic cultural phenomenon that develops in certain economic and social circumstances and meets social needs peculiar to a specific audience."[20] Most of Currier and Ives's prints can be classified as genre prints. They reconstruct scenes of American life and provide commentary on commonplace activities of ordinary people. Therefore to understand what they are communicating—what they are saying and why—it is important not to rely exclusively on the content of the prints and the story ostensibly told therein. It is important to know: Whose story is being told? Whose everyday life is being depicted? Who are the actors? Why are the actors being portrayed as they are? How does that portrayal meet the needs of the viewers? What condition might have shaped that portrayal? In brief, what is the cultural construction in that story?[21]

It is also necessary to pay attention to the very function of their representation. Because of the commercial nature of popular genre lithography, especially Currier and Ives's genre lithography, the individual artist's voice is replaced by that of the consumer. "Genre prints were not conceived as objective records but instead self-consciously embodied the values and interests of their audience. They are an art form whose content was shaped as much by its audience as by its creators."[22] Such popular texts, by nature of the diverse audiences to which they appeal, are open to multiple, even oppositional, readings of the

same text. Audiences create meaning rather than passively absorbing it from the cultural products they consume.[23]

Accuracy of detail was a popular strain in nineteenth-century American popular taste, and Currier and Ives played to that strain by producing prints they claimed were "faithful" in likeness and in detail to the subject matter. When they were "rediscovered" in the 1920s, and for decades thereafter, they were touted as displaying literally the life, manners, and customs of nineteenth-century Americans.[24] And indeed Currier and Ives prints are deceivingly realistic; their messages are immediate and explicit.

One major effect of this perceived realism, however, is that the prints seem to be perfectly natural, even reportorial. Viewers were tempted, then as now, not only to assume the accuracy of the print but also to accept the ideological underpinnings of the print. To begin with, many Currier and Ives prints were not firsthand accounts but were taken from firsthand verbal accounts and graphically, often imaginatively, transposed. Nevertheless they documented life in nineteenth-century America reasonably well. The problem is that the documentation includes the morality and prejudices of the day, which were—and still are—often lost in the seeming realism of the pictures.[25]

Currier and Ives's success depended on their effective use of types; they did not create them, they merely employed them. Typing is part of the larger process by which human beings assert, parcel out, and both empower and deny power to members of their communities. It sets apart some as "others" in order to assert a genuine sense of community among the remaining members of society.[26] Currier and Ives's pictorial typing reflected the mental typing of that segment of the population to which it appealed—the white, middle-class majority of nineteenth-century America, more often than not from cities and larger towns, and women, to whom they were heavily marketed. The prints ridiculed blacks and suffragettes and, at the same time, held up as models those who embodied the commonly agreed upon, desirable qualities that middle-class America emulated. Such prints had to be morally sound and didactic, as well as decorative and inexpensive.

It might be said that Currier and Ives were not only the most successful printmakers of their time, but also among the most successful entrepreneurs of their viewers' ideologies. To what extent Currier and Ives shaped or influenced those ideologies, rather than corroborated or merely reflected them, is a difficult question. It is a problem with which students of other forms of popular culture and popular art have struggled. There is little evidence that Currier and Ives led public

opinion. Rather, as is true of the producers of other popular arts, they appear to have followed, reflected, corroborated, and influenced it. They gave concrete form to, or helped visualize, those opinions and quite likely assured individuals that they were not alone in their opinions. To that extent, they encouraged viewers to invest in ideologies and social hierarchies of which they might not have been previously certain, though disposed. It would be a stretch, however, to suggest that they changed anyone's mind.

One objection might be raised at this point: that this formulation suggests or even depends upon a homogeneous public with a consensual understanding of the meaning of these prints. In fact, no such public consensus existed. Members of different ethnic, racial, gender, and economic groups saw many things differently. Currier and Ives were mindful of that and to a remarkable extent marketed prints that appealed to a wide spectrum of individual groups, even to such disdained minorities as Irish Catholics. And the result was a series of contradictions or conflicting images.

Nevertheless, when taken as a whole, Currier and Ives's prints reflect substantial agreement among their patrons on certain prevalent representations, types, or even narratives. Individuals may have interpreted or responded to those representations, types, or narratives somewhat differently, but in large numbers they let their opinions be known in the marketplace and found their ideas, visions, hopes, and fears reflected in repeated representations in the majority of prints. Not all Victorian Americans—even middle-class, white Victorian women—shared the same intellectual resources for understanding the world and its events. Therefore Southerners and Northerners, urban dwellers and rural residents viewed prints somewhat differently. Still, the inventory of Currier and Ives's prints, controlled to a large extent by the taste of the marketplace, presents a common vocabulary and set of assumptions about life in nineteenth-century America.[27]

This discussion of the value of lithographic prints as cultural artifacts sets the stage for the first chapter, which presents a brief history of lithography and of its most commercially successful nineteenth-century purveyors, Currier and Ives. A substantive company history has never been written; most company files, including sales records, which would have been useful to this study, have been lost.[28] The absence of such useful materials is unfortunate but not fatal to the analysis that follows, which depends instead on a reading of the firm's prints as texts in historical context. Moreover we have at least some information as to which prints were most popular. Especially helpful in this

vein is the Harry T. Peters Collection, comprising company catalogs, advertisements, interviews with those who worked for the company, and other related materials, located at the Museum of the City of New York. Also useful are the Harriet Endicott Waite Papers, on deposit in the Archives of American Art at the Smithsonian Institution in Washington, D.C. Waite worked closely with Peters on his collection and publications on Currier and Ives and interviewed several of the firm's surviving associates during the 1920s. Also instructive are the letters of "Ned" (Edward W.) Currier to his father during the 1880s, when the son succeeded his father as partner.

In the story of the firm's founding and development in the context of a burgeoning young republic, two marketing breakthroughs determined not only the company's corporate future but also its impact on the nation. Nathaniel Currier first produced what most other lithographers were able to sell at the time, namely "practical lithography" such as sheet music, trade cards, handbills, and architectural plans. The first major change came in 1840, five years after the firm was established, when Currier and the editor of the *New York Sun* teamed up to offer for sale the first illustrated news extra. Its subject was the tragedy of the steamboat *Lexington,* which caught fire and sank in Long Island Sound on January 13, 1840, taking the lives of most of the ship's passengers and crew. Published just a few days after the event, the extra contained a finely drawn lithograph of the burning, sinking ship, as well as a news account. It created a sensation, and within weeks Currier's name was known nationwide. His disaster and news prints became a hot commodity.

The second breakthrough came in 1852, when James Merritt Ives joined Currier and persuaded him to expand his line of prints to include those scenes for which the firm is now best known—representations of the plain and simple experiences and pleasures of middle-class America. Those genre prints, which came to dominate the firm's inventory, are the main concern in this book.

Chapter 2 explores how Currier and Ives's popular prints contributed to the nation's task of creating a "usable past." The United States became a state before it became a nation, which is to say the United States, in contrast to European nations formed in the nineteenth century, had little history, tradition, or memory upon which to build a nation. With America taking its place among the nations of the world during the age of nationalism, political and cultural leaders found it necessary to create such a "usable past." Their tools in creating and disseminating that past consisted of history, literature, song,

art, patriotic symbols, and popular prints. Currier and Ives's contributions to American public memory are examined in their portraits of statesmen and leading public figures and in their selective picturing of the history of the colonial period, the American Revolution, the War of 1812, and the Mexican War. The chapter concludes with a brief discussion of what Currier and Ives chose to recall and reprint from that history during the nation's first centennial, in 1876.

Chapter 3 concerns the effects of the Civil War, the most devastating trauma in American history. The war not only tested whether the new nation, still less than a century old, would survive but also challenged Americans to examine their understanding of themselves as a people, their genesis myth, the forces that had nearly driven them into the abyss, and the means to recover. It forced them to confront the South's "peculiar institution" of slavery and the entire nation's attitude toward African Americans.

In creating a usable past, purveyors of American culture also created myths and ideology concerning the nation's past that were employed in developing their understanding of the frontier. Indeed, the images that nineteenth-century America created of the West served as metaphors of how the nation perceived itself as a whole. Chapter 4 examines Currier and Ives's response to the California gold rush, the westward movement, homesteading, the frontiersman or trapper, and Native Americans.

Chapter 5 considers Currier and Ives's response to American urbanization and shows how they reflected the massive changes that altered not only the course of the nation's development but also the personal lives of people in the cities and in the country. These changes were traumatic, both for those who left the countryside for the city and for those who stayed behind. The agrarian ideal, of which Thomas Jefferson had written in his *Notes on Virginia* (1785) and which remained dominant in American thinking, had to be reexamined. The first part of this chapter surveys Currier and Ives's portraits of the American city, which established the city as symbolic of America's growing technological and economic prowess. The remaining pages show how Currier and Ives nevertheless continued to picture rural America as the ideal America.

The American home was central to their nostalgic view of life in America, and central to the home was the American family. Not only was the Victorian home linked to a simpler past, it was also valued as a safe haven from a sometimes dangerous and morally destructive society, a refuge presided over by the Victorian woman. That home

began to transform, however, reflecting and underscoring society's changing attitudes toward women, men, and children. Chapter 6 deals with this changing concept of home and how Currier and Ives portrayed it.

Chapter 7 focuses on Currier and Ives's representation of African Americans and immigrants. Currier and Ives's picturing of African Americans changed over the course of the century, reflecting changing popular attitudes, which in turn were responses to contemporary events. By and large, however, they were negative and even vicious at times. In notable contrast, Currier and Ives seldom openly or blatantly criticized or caricatured immigrants. Ethnic stereotypes do find their way into the firm's prints, but such negative references are greatly outweighed by prints intended to appeal to those groups. Currier and Ives's prints about and for Irish Americans are explored as a significant case in point.

Currier and Ives's comics were among the most popular of the firm's prints. Other chapters allude to many of these cartoons, but Chapter 8 focuses exclusively on the political cartoons. Currier and Ives's political commentaries span the decades from the 1840s through the 1880s, but the most intensive period for such work, not surprisingly, was the era of the Civil War and Reconstruction, from the mid-1850s through the mid-1870s. That group of political cartoons is discussed in depth.

Some Currier and Ives prints were purchased by Americans because they depicted material success and also new leisure-time pursuits. In the nineteenth century, Americans were becoming increasingly materialistic; they took great pride in the finer or more impressive products of that materialism, including yachts, clipper ships, steamboats, and railroads. The urban middle class also found time to play and therefore sought leisure-time activities. New sports, like baseball, caught their fancy. Activities like hunting and fishing, which appeared as "sports" for the first time in nineteenth-century America, arose in response to the dramatically altered, more urban, commercial world, as well as in the new gender roles men were forced to assume. These new or transformed activities are considered in Chapter 9.

Finally, the epilogue recounts the decline of the firm, and the reasons for it, and addresses the limits of any single book on Currier and Ives.

❧ O N E ❧

The "Best" Lithography Company

Nathaniel Currier had been in business six years, employing a print medium invented nearly a half-century earlier and in ways that had already become commonplace, before he had his first major commercial success. That success came when he took lithography in a new direction and produced the first illustrated news extra. On the evening of January 13, 1840, the steamboat *Lexington*—built in 1835 by Cornelius Vanderbilt and the best-loved of all Long Island Sound steamboats on the New York–Boston route—caught fire. One large lifeboat was lowered but promptly smashed by a churning wheel. Panic-stricken passengers crowded into smaller boats, but many capsized

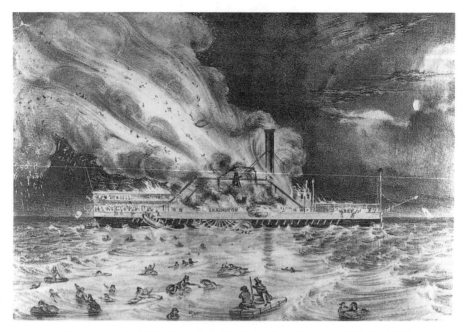

FIGURE 1. *Awful Conflagration of the Steam Boat "Lexington."* Nathaniel Currier (undated).

and only a handful of the crew of forty and the nearly one hundred passengers survived.[1]

When news of the *Lexington* disaster reached the *New York Sun*, Currier happened to be in the newspaper's office and had the brainstorm of illustrating the extra that editor Benjamin Day planned to issue. Currier immediately set William K. Hewitt and Napoleon Sarony to work on a lithograph of the event, supplying them with fresh details as they became available from eyewitnesses. Within three days, the illustrated news extra hit the streets. It was an unprecedented feat.[2]

"The Extra Sun," as it was titled, included not only a news account of the tragedy but also a finely drawn picture of the flaming vessel, captioned "Awful Conflagration of the Steam Boat 'Lexington' in Long Island Sound . . . by which melancholy occurrence over 100 persons perished." The print (Fig. 1) pictured the burning vessel, which the captain had tried to beach but failed when his rudder ropes burned through, causing him to lose control, and the engines failed. It included passengers lining the rails and leaping into the icy waters of Long Island Sound, while a badly launched lifeboat spilled its occupants into the sound. In the foreground terrified men and women took refuge on the cotton bales that were the ship's chief cargo and

clung desperately to bits of debris. Beneath the print appeared a map, showing the spot where the ship had sunk, and a seven-column news account.[3]

The separately issued *Lexington* print was a sensation as well. When orders continued to pile up from afar as well as locally, the print was reissued in a second state, from a second stone, minus the heading, "The Extra Sun," but with a new text—the firsthand report of one of the few survivors, Chester Hilliard. It was not only hawked in the streets of New York but also shipped to other cities. Presses ran night and day to keep up with demand, and nearly overnight "N. Currier, Lith. & Pub.," became known nationally.[4]

The highly successful partnership with the *New York Sun* was not continued.[5] Nevertheless the *Lexington* set Currier on a course that brought considerable success to the firm, publishing disaster prints and a much larger line of inexpensive lithographs illustrating the news ("rush stock") for which the American public had an unquenchable thirst. Over the course of the next half century, Currier—later Currier and Ives—added other successful lines to the business, producing millions of copies of more than seven thousand separate prints. The firm sold far more prints than any other lithographer or printseller in the nation, laying claim without rival to being "Printmakers to the American People."[6]

Writing on Stone

Lithography ("writing on stone") was invented in 1798 by a Bavarian named Alois (Aloys) Senefelder. As the story is often told, it all began in Munich with a laundry list. The son of an actor, Senefelder was determined to become a playwright. The expense of having his work typeset and commercially printed being prohibitive, he experimented with various cheaper methods of reproducing his dramas for public circulation. Then one day in 1798, while he was busy with yet more experiments, his mother asked him to help her write down a laundry list as she called out the articles of clothing. Not having a pencil and paper, he picked up a hardened piece of his homemade printing ink (a combination of wax, soap, and lampblack) and recorded each item on a handy block of limestone.[7]

Senefelder wondered whether a print could be made from the stone and its markings. He spread aqua fortis, or nitric acid, across the stone's surface, and, much as it did with metal, the acid ate away at the unwaxed areas, leaving his mother's laundry list in slight relief.

In washing off the acid, he noticed that although the water ran off the greasy letters, it soaked into the pores of the stone not sealed by the wax; the oily substance did not mix with the water. He inked the still-wet stone and saw the greasy ink build up on his lettering without sticking to the damp areas. After cleaning the excess ink away, he placed the inked stone in a copperplate printing press, laid a sheet of paper over it, cranked down the heavy platen to exert even pressure on the paper, and succeeded in producing the world's first lithograph—a mirror image of his mother's laundry list![8]

Although it did not benefit him in the way he hoped, Senefelder had invented a practical, inexpensive printing process. He soon found that by keeping the stone wet and repeatedly inking it, he could make as many impressions as he wished. He overcame the difficulty of preparing the text in reverse on the stone by drawing the image in greasy crayon on a sheet of paper dipped in a thin gum solution and then transferring it to the stone by laying the paper facedown on the stone. He invented a special press that exerted a moving, lateral force on the stone rather than a vertical one. In short order, Alois Senefelder provided the basic elements of the lithographic process necessary for its commercial success. The process changed little for the next century.[9]

The chief advantages of lithography over engraving, etching, and other previously existing methods of picture printing were the speed with which the printing matrix, in this case the stone, could be finished and in the greatly expanded number of impressions a single plate could yield. When it became clear that lithography was less costly than copperplate engraving, printing jobs began to come Senefelder's way. His first profitable commission in this new medium was to reproduce the compositions of court musician Franz Gleissner, for which he set up a lithographic workshop and trained craftsmen to carry out the process. Senefelder secured Austrian and British patents for the process, as well as a fifteen-year exclusive license from Maximilian Joseph, king of Bavaria. He failed, however, to publicly record his claims to lithography until 1818, and by then knowledge of Senefelder's printing process had spread to most parts of Europe and the United States.[10]

François Johannot, an Offenbach printer, is credited with being the first to use lithography for artistic purposes; by 1801 he was issuing lithographed prints by local artists. German lithographers like Wilhelm Reuter led the way in the development of lithography, but in 1802, Frederic André—Johannot's cousin—secured a French patent

for the lithographic process, and it was the French who made the best use of lithography for artistic purposes throughout the nineteenth century. Theodore Géricault influenced artistic lithography decisively. His first stone is dated 1817; by 1818 he had lithographed several of his masterpieces and set the stage for French dominance in the field. From Géricault the line of succession led to Eugene Delacroix, Honoré Daumier, Claude Monet, Edgar Degas, and Henri de Toulouse-Lautrec.[11]

The English showed little interest in lithography at first. In 1803, however, Philip André (Frederic's brother) published a series of lithographs in London called *Specimens of Polyautography*, as the process was first called in England. The series included *This Is My Beloved Son* (1802) by the expatriate American artist Benjamin West, president of the Royal Academy since 1792. The year before, West himself had made a small lithographic print, *Angel of the Resurrection* (1801), technically the first lithograph by an American. In 1806 G. J. Vollweiler published additional examples of the new process, but it was not until 1818 that Rudolf Ackermann and Charles Hullmandel converted other English artists to the cause.[12]

Benjamin West's London studio was the mecca for young American artists. Among them was Gilbert Stuart, who returned to the United States and in about 1794 settled in Philadelphia. It was Stuart's Philadelphia pupil, Bass Otis, who is credited with making the first lithographs in America. In 1818 Otis produced a portrait of the Reverend Abner Kneeland as a frontpiece to a collection of the clergyman's sermons, and for the July 1819 *Analectic Magazine* he made a lithographic view of a picturesque stone house alongside a stream. During the rest of the century, several American artists, like Rembrandt Peale, Thomas Cole, Thomas Doughty, Thomas Moran, and Winslow Homer, produced highly regarded lithographs, but as in most of Europe, lithography was hailed in America as a cheap means of reproduction; even more than in Europe it would become more a commercial than artistic success.[13]

The climate for art was not strong upon the arrival of lithography in the United States. For a time in the young country the practical necessities of staying alive took precedent, but there was also a cultural antipathy toward the arts. Art fostered class divisions, it was believed, something Americans rejected. "The fine arts," John Adams told Thomas Jefferson, "have been subservient to priests and kings. . . . [They] promote virtue when virtue is in fashion. After that, they promote luxury, effeminacy, corruption and prostitution."[14] When art was

produced, it bore the stamp of the national character. There was a demand for portraiture and a grudging respect for historical painting, but the flowering of other forms of American art was just beginning. The development of an art print tradition coincided with that flowering and the arrival of lithography.[15]

The first nonlithographic prints produced in America consisted of maps, bookplates, small decorative pieces, broadsides, and a few portraits. One of the earliest prints made in the British colonies of North America was John Foster's woodcut portrait, *Mr. Richard Mather* (ca. 1670). One of the best-known early prints, from an engraving, is Paul Revere's picture of the Boston Massacre. *The Bloody Massacre* (1770) became a major propaganda piece during the American Revolution, as did Amos Doolittle's *Lexington and Concord,* a series of four prints after paintings by Ralph Earl. John Trumbull offered several successful historical engravings after his paintings, including *The Death of General Warren at the Battle of Bunker's Hill* (1786), and Benjamin Franklin published what may be considered the first American cartoon in his *Pennsylvania Gazette* of May 9, 1754. *Join or Die,* a message to the American colonies facing war with France and France's Native American allies, but resisting any formal alliance among themselves, pictured a snake broken into several segments, each labeled by colonies' names.[16]

If the production of prints in America was limited, Americans' appetite for prints was not. Records suggest a considerable desire for the latest and best British engravings. William Hogarth's moral and biblical prints, as well as his satires, were popular in the mid–eighteenth century, as were scenes from Roman antiquity and various landscape and scenic engravings.[17] And that desire grew as the new century began.

By the mid–nineteenth century, the United States had developed from a simple nation, in which art played little part, into a culturally more complex and sophisticated state.[18] Industrialization, urbanization, commercialization, and the development of a taste-conscious middle class with discretionary income, as well as technological developments, created a heightened demand for commercial printing, as well as art. And that prepared the way for the wave of lithography that swept the nation. It has been called the "Golden Age of American Engraving," and Nathaniel Currier played a leading role in its development. By midcentury he could write confidently to distributors of his lithographic prints, "Pictures are now a necessity."[19]

Currier and Ives

The first commercial lithography house in America, Barnet and Doolittle, was established in New York City in 1822, but it lasted only one year. Other similarly short-lived ventures followed in New York and Washington before William S. and John Pendleton achieved the first American commercially successful lithographic shop in Boston. In 1824 William, then a wood engraver, bought an importer's lot of unclaimed lithography equipment and launched the firm. He notified his brother John, who was in Europe on business, and John brought back with him to Boston not only supplies but also an experienced French lithographer named Dubois to train the Pendletons in the art.[20]

By 1831 the Pendletons operated four lithographic and four copperplate presses. Like other American companies that were soon established, they subsisted on job work, which involved designing and printing on commission such commercial items as music sheets, certificates, trade cards, labels, and billheads. Some lithographers produced pictures of artistic quality. Childs and Inman of Philadelphia, for example, issued prints based on drawings by Thomas Sully, and Thomas Cole drew several works on stone for Anthony Imbert's press. But at least at the start, a firm's success depended on what was termed "practical lithography."[21]

In 1828, at the age of fifteen, Nathaniel Currier became an apprentice for the Pendletons. In 1833 he left Boston for Philadelphia, where he worked with master lithographer M. E. D. Brown. Within a year, however, Currier moved to New York, where he and his former employer, John Pendleton, intended to start another lithographic business. Before they could do that, Pendleton withdrew from the venture and sold his share in the proposed business to Currier, who in 1834 entered into a partnership with a man named Stodart, formerly of the New York music publishing business Dubois and Stodart.[22]

Currier and Stodart, located at 137 Broadway, were job printers, meaning they duplicated whatever a customer needed in as many copies as requested, be it labels, letterheads, handbills, architectural plans, portraits, or scenic views. Several music sheets bearing the Stodart and Currier imprint have survived, of which the earliest seems to be *The New York Light Guards Quickstep* (1834). So too does the scenic print *Dartmouth College* (1834). Nevertheless, by 1835 that partnership also dissolved, and Currier—only twenty-two years old—found himself the sole proprietor.[23]

"N. Currier" set up office at 1 Wall Street. In 1836 he moved his store to 148 Nassau Street and in 1838 to 152 Nassau, where it remained until 1872. It was near the center of America's largest and busiest city, a burgeoning metropolis with a population of more than half a million at midcentury, and New York's rise as the nation's business capital had much to do with its emergence as the leader in American lithography. To begin with, lithographers, unlike most fine artists, were at home in the world of commerce. Most of the stones and other supplies were imported through the New York harbor, and that attracted such nineteenth-century lithographic giants as Sarony, Major and Knapp, Julius Bien, and Currier and Ives. In turn they made the city the center of lithographic ideas, techniques, tools, production, and sales. Anthony Imbert, considered the pioneer of lithography in New York, established his press in 1825. By 1854 more than 60 New York City companies advertised themselves as lithographers; by 1880 the number reached 130.[24]

New York City's dominance in nineteenth-century lithography is important. As New Yorkers rose to positions of national influence in banking, politics, publishing, and commerce, they assumed as well a dominant role in the nation's cultural life. The lithographs they produced, even when they pictured the rest of the country, came from the minds of New Yorkers, most of whom had never seen the areas they drew. Although continually tested against the approval of their patrons in this most commercial of enterprises, the judgments they made and the values they incorporated were those of a segment of the population that considered itself the nation's cultural brokers, as well as the new urban sophisticates. The story of antebellum lithography has New York at its center.[25]

In 1838 Currier added a factory at 2 Spruce Street. At first, most of his work was a continuation of the commercial and contract work he did with Stodart. Currier continued to reproduce music sheets, creating appropriate and attractive scenes for the front covers. In 1837 he produced *The Crow Quadrilles*, a collection that included such tunes as "Jim Crow" and "Zip Coon," later known as "Turkey in the Straw." "Jim Crow"was written and made enormously popular by Thomas D. (Daddy) Rice, who created this first minstrel song (and character) as he sang it in blackface in Louisville, Kentucky, in 1828. Currier also reproduced the architectural plans of Alexander Jackson Davis.[26]

In 1835, still the first year of business for Currier, 13 acres (5 hectares) of New York City's business district were swept by fire. Four days later,

Currier offered for sale a lithograph titled *Ruins of the Merchants' Exchange N.Y. after the Destructive Conflagration of Decbr. 16 & 17, 1835* (1835). Although any major newspaper today could produce an image almost instantly, a hundred years ago the dazzling speed of Currier's presses created a sensation. Thousands of copies of the print were sold and Currier's local reputation was established.[27]

Although the exact order is not known, at about the same time Nathaniel Currier published another disaster print, *Ruins of the Planters Hotel, New Orleans* (1835), illustrating the hotel fire of May 15, 1835. The artist for both prints was J. H. Bufford. Both prints were uncolored; both indicate Currier's awareness of the commercial value of disaster or news prints five years before his famous *Lexington* print appeared; and both inaugurated the firm's venture into marketing prints of its own creation. The firm continued to engage in job printing, but to a lesser extent until after 1852, when the pictures we now associate with the firm became its stock and fare.[28]

Nathaniel Currier was born in Roxbury, Massachusetts, in 1813. Contemporaries recalled that he was "gentlemanly and liberal," that he was affable and had a good sense of humor, attracting to his office some of the most prominent men of the period, including Henry Ward Beecher, Horace Greeley, and P. T. Barnum. He was not a club, lodge, or society member, but he did entertain extensively in his home. He was described as "very philanthropic," but he is not remembered for having taken an active part in any charitable movement or civic reform. Although raised a Unitarian, when he moved to New York City he joined the Madison Avenue Presbyterian Church, but he was not particularly active. Although a Republican, he did not engage in party politics. In 1842 he became a member of the Governor's Guard, Company A, Second Regiment of New York State Artillery, but he never saw any action. And finally, he is said to have possessed "fine critical artistic judgment," but also, even more important for business purposes, a remarkable awareness of public taste. He had a shrewd business sense, and he conducted his business "with enterprise and vigor."[29]

Nathaniel Currier had one son, Edward West ("Ned") Currier, by his first wife, Eliza West of Boston. In 1847 he married a second time to Lura Ormsbee of Vermont, with whom he had a second son who died in infancy. Currier had a summer home in Amesbury, Massachusetts, where he was often visited by the poet John Greenleaf Whittier and where he kept a number of horses. The still-popular print *The Road—Winter* (1853), after a painting by R. A. Clarke, shows Currier

and his second wife driving in their sleigh in the Massachusetts countryside. *The Road—Summer* (1853) is a portrait of Nathaniel's brother, Charles Currier, driving one of his horses in Amesbury.[30]

Charles and Nathaniel Currier were associates at times and in part. Charles had a desk at the Currier factory. He took orders for the firm on commission, but he also operated a lithography business of his own, advertised in the New York City directory of 1862 as offering "portraits, views of cities, towns and buildings, book illustrations, maps and circulars, show cards . . . music titles, bill-heads, etc." His most valued product, however, was his lithographic crayons, which were considered—at least by American lithographers—superior to all others. As far as is known, once they adopted it, Currier and Ives used no other crayon.[31]

Nathaniel Currier's only true business partner was James Merritt Ives. Ives, who was born and raised in New York City, married Charles Currier's sister-in-law, Caroline. He maintained a home in Rye, New York, where, unlike Currier, he was active socially, politically, and religiously. He was involved in various organizations, such as the YMCA and a Rye literary club. He played a leading role in Rye politics, as "an ardent and consistent Republican," and he was a vestryman of that town's Christ Episcopal Church. When the Civil War broke out, he helped organize Company F of the Twenty-third Regiment of Brooklyn, New York State National Guards, with which, at the rank of captain, he saw active service during Lee's invasion of Pennsylvania in 1863.[32]

Ives has been described as a bookkeeper, art lover, and lithographer, and for those qualities Charles recommended Ives to his brother. Nathaniel Currier hired Ives as a bookkeeper in 1852, but the two hit it off so well—indeed their talents were so complementary—that after only five years Currier made Ives a partner. The business, which was already doing well, flourished under Ives's additional care. He assumed the position of general manager, but his contributions were even greater than that title would imply. He improved the firm's operations, systematized its stock of prints, and speeded up the production process.[33]

As a competent artist in his own right, Ives's conceptual advice was invaluable. Often commented upon were his constructive criticism of sketches before they were put on stone and his talent at combining features from various sketches into a well-designed composite. This synthesis was a frequent Currier and Ives device, many of their prints being the work of more than one artist. Ives has also been credited

with persuading Currier to add a new type of print to his inventory. For decades Currier had successfully marketed prints that recorded the newsworthy events of the day; Ives proposed creating a line of much simpler prints, presenting the plain daily experiences and pleasures of American life. Currier initially resisted such prints as "undramatic." But Ives persisted and proved that such pictures were attuned to harried city-dwellers' desire for depictions of a simpler, more fulfilling way of life. Together, and better than any of their competitors, Currier and Ives accommodated their subscribers' tastes and wishes.[34]

Producing Prints for the People

In order to meet the demand for the millions of prints they sold, Currier and Ives produced their prints in an assembly-line fashion at their factories at 2 and, later, 33 Spruce Street. The entire process took place there, from grinding the stones—which were imported from Solenhofen, Bavaria—to designing the print, printing on hand-powered presses based on the Senefelder prototype, and coloring. Grinding and regrinding the drawing surface of the stones, called "graining," by rubbing one stone against another with sand sprinkled between the two, was a full-time job for at least one person. The stones of the best-selling prints were often kept on hand; those of less-successful pictures were reground after only one printing. If there was an unexpected demand for a print, the regrounded stone would be relithographed, occasionally resulting in minor, sometimes unintentional, changes or variations in the print.[35] The result was less artistic, in the traditional sense, but more popular or responsive to its market.[36]

Currier and Ives seldom copied paintings by well-known artists. Staff artists, commonly called "delineators," who received fifteen to eighteen dollars a week in 1840, drew the pictures or copied the drawings of freelancers. Moreover, although many of the prints were made after the creations of artists who worked independently from the factory, most were subject to the review and quite often the reworking of a team of company artists and lithographers led by Currier and Ives. Copies of prints at various stages in the production schedule have been found, with notes penciled in the margins calling for changes in the original sketch, modifications of the first prints to be pulled from the stone, and reassessments of the colors originally agreed upon that did not meet someone's approval upon their application.[37]

In a few cases, where the response to a particular print was critical but not sufficiently negative to cause the entire print to be scrapped,

a lithograph was reworked and reissued. The print of George Washington's farewell to his army officers at the end of the Revolutionary War is a case in point. In 1848 Currier published *Washington Taking Leave of the Officers of His Army*, in which the general raises a wineglass to toast his men. Temperance groups objected to the image. When Currier and Ives issued the same print in 1876 for the nation's centennial, retitled *Washington's Farewell to the Officers of His Army*, the glass as well as a nearby decanter and glasses were deleted.[38]

The entire process quite likely worked something like this: Frances Palmer might bring in one of her rural landscapes, with a picturesque cottage in the background, and Nathaniel Currier might pass it on to Louis Maurer with instructions to add a few appropriate figures and some livestock. When the drawing reached the chief lithographer, John Cameron, he might find it necessary to rearrange certain elements to fit the picture onto his stone. And when it came to hand coloring the resulting lithograph, James Ives would exercise final approval of the palette. "No 'work of art' was sacred to Nat Currier"—he not only commercially reproduced the portrait of himself and his wife Lura, given him by his staff, as *The Road—Winter* (1853), but he also later reissued it as *The Sleigh Race* (1859), "with another fast cutter and pair of trotters cleverly drawn in behind his own equipage."[39]

The assembly-line approach was very effective, not only in providing a collective rather than solitary voice, but also in keeping costs down and increasing the speed with which the company could issue new designs. It has been estimated that over the course of the company's productive life span, it would have had to introduce a new lithograph every third day to total the number of separate prints it issued, now estimated to be in excess of seven thousand.[40] Some of the designs were only slight modifications of previous designs. *Winter Morning in the Country* (1873) is a modification of Palmer's *American Farm Scenes, No. 4* (1853), and others came out as nighttime versions of their originals; but the total remains impressive. It is not known which of the firm's prints was the biggest seller. One of the *Darktown* series comics sold seventy-three thousand copies, but many prints may have sold in lots of several hundred thousand copies.[41] Many of the Currier and Ives's prints reappeared as advertising posters or in reduced size as trade cards or cigar-box labels. *A Home on the Mississippi* (1871, Fig. 2) has been reproduced 3.5 billion times on the label of Southern Comfort liquor.[42]

Among the best-known artists linked to Currier and Ives were George Inness and Eastman Johnson, but they were responsible for

A HOME ON THE MISSISSIPPI.

FIGURE 2. *A Home on the Mississippi.* Currier and Ives (1871). Courtesy of the Museum of the City of New York.

only a handful of prints. George Catlin provided several more, but most of the prints were made from paintings or sketches sold by non-staff artists to Currier and Ives for about ten dollars a picture, with no royalties, or by artists the company employed. The rapid expansion of Currier and Ives was helped by the influx of young, well-trained graphic artists during the 1840s from England, France, and Germany.[43] English-born Frances Flora Bond Palmer was the most prolific of the lot. From Leicester, Fanny (as she was known) attended a private school in London, where she was instructed in the fine arts. She went to work for Currier and Ives at about the age of forty and remained with the firm for nearly thirty years. She was responsible for the design of scores of prints, including very popular prints of rural American scenery, railroads, and Mississippi River steamboats. She was also an accomplished lithographer, but her greatest contribution to the firm was in her designs.[44]

Fanny Palmer and her husband, Edward, owned and operated a lithography business in Leicester before leaving England in 1844. When they arrived in New York, they took up residence in Brooklyn

with their two children and Fanny's sister, Maria. They reestablished their business, but Edward, as Harry Peters noted, "pursued no other trade than that of being a 'gentleman.' He was fond of shooting, even fonder of drinking, and had no interest in any kind of work."[45] Perhaps that is why the business failed. About 1850 Frances went to work for Currier and Ives, for whom she had already provided some prints on a freelance basis. She worked for them until her death in 1876 at the age of sixty-four. She was certainly the most versatile of Currier and Ives's employees, as well as an excellent team member—an important attribute in the firm's production process.[46]

German-born Louis Maurer, lithographer as well as painter, is most closely associated with Currier and Ives's many fine horse prints and the *Life of a Fireman* series. Maurer emigrated to the United States in 1851, worked for the firm for eight years, moved on to Major and Knapp, and finally established his own firm, which he headed until he retired in 1884. Maurer was an accomplished artist in his own right. Ironically, given the nature of his work for Currier and Ives, Maurer's paintings reflect a reaction against the politeness therein, as well as the politeness of nineteenth-century American academic painting in general. Critics suggest that he anticipated the appearance much later of the celebrated Ash Can school of Robert Henri and John Sloan.[47]

Charles Parsons, English by birth, is best known for the famous print *Central Park, Winter: The Skating Pond* (1862). Only briefly employed by Currier and Ives, Parsons worked for thirty years for Endicott and Company, where he lithographed a number of clipper ships for Currier and Ives. From 1863 on, when Parsons became head of the art department at Harper and Brothers, he employed Thomas Worth, who was one of the largest single contributors to the Currier and Ives list and originated almost all of the *Darktown* series prints. Other artists associated with Currier and Ives included Englishman Arthur Fitzwilliam Tait, highly regarded for his hunting and fishing scenes as well as his pictures of the West; James E. Butterworth, also English, who specialized in marine and naval prints, especially clipper ships; and Connecticut-born George Henry Durrie, the source of some of the best designs of farm life in New England.[48]

To produce the small, lower-grade "stock prints," Currier and Ives no doubt employed many lithographers whose names have been lost to history. They made an estimated weekly average of six dollars in 1850 to ten dollars in 1880.[49] Among the lithographers known to have

worked with Currier and Ives were Franz Venino, John Cameron, C. Severin, J. Schutz, and Napoleon Sarony. Many, like Otto Knirsch, were independent lithographers who accepted assignments from the firm and prepared stones to sell to the company at forty to fifty dollars. John Cameron, a Scottish immigrant, served as chief lithographer for a time, but he also turned out some lithographs of his own design, especially of horses.[50]

Napoleon Sarony, one of Nathaniel Currier's earliest associates, was perhaps the period's best-known lithographer. Born in Quebec, of French-Austrian extraction, Sarony had few equals as a lithographer. He was also an accomplished artist, with a particular talent for historical pictures, and his work was exhibited at the National Academy in New York and in London galleries. He was on the cutting edge of new developments in his field, including photography.[51]

Sarony left Nathaniel Currier in 1846 to form his own company with H. B. Major, who also had worked for Currier for a time. The two firms competed in the same market, but they seem to have cooperated as well, helping each other out and even employing some of the same lithographers. Harry Peters has pointed out that if Sarony had not left Currier, the firm's print production might have changed significantly. Quite likely, he would have introduced to the firm the newer methods of lithography, which Currier and Ives resisted, especially the shift from the old single-stone, hand-colored process to color printing and chromolithography. Sarony, it will be recalled, lithographed the famous *Lexington* print.[52]

Some of Currier and Ives's prints were sold uncolored, often to schools, where they might be used for coloring lessons. The great majority were printed in black and white and passed along to colorists, who colored them by hand. In some cases a single color tint was added to the print directly from the stone—an expanse of sky or water, for example. Chromolithography, whereby pictures were reproduced in color directly from multiple stones, was introduced to the United States in the 1840s but not widely used until after 1860. During the 1860s Currier and Ives experimented with chromolithography, but they chose not to adopt the process. Probably their earliest chromo was *American Speckled Brook Trout* (1864), done by Charles Parsons after an oil painting by Arthur Tait. Most Currier and Ives chromos, however, were produced in the 1880s, including reproductions of Louis Maurer's, *The Futurity Race, Sheepshead Bay* (1889) and William Walker's *A Cotton Plantation on the Mississippi* (1884). Whether these

chromos were produced by Currier and Ives in their own shop or sent out is the subject of debate; that the firm did not make widespread use of the process is not.[53]

The vast majority of Currier and Ives prints were colored by a staff of about twelve young women, all trained colorists and many of German descent. They worked at long worktables from a model, a copy of the original provided by the artist or prepared from a black-and-white print by a supervisor, set up in the middle of the table. Each colorist applied only one color in all areas where that color was required and passed the print on to the next colorist until the coloring was complete. The print was then checked by the "finisher," who touched it up where necessary.[54]

When large numbers of rush stock prints were needed, extras were brought in and stencils cut for the various colors. The less-skilled extras washed in the colors over a broad area—all the Union soldiers' blue uniforms, for example—before passing the prints along to a regular colorist, who touched them up. The larger, more expensive folios were sent, with models, to colorists, often poor young artists who worked outside the shop. Currier and Ives paid the colorists a penny for each small print and a dollar per dozen prints for the large folios.[55] The process changed little over the several decades of the firm's existence.

Marketing and distribution of the uncounted millions of prints sold in the United States and abroad were central concerns for Currier and Ives. They were the first American lithographic firm to establish a national and international print market. The partners provided leadership in these areas, but they were capably assisted by Daniel W. Logan, their chief salesman and general sales manager for more than forty years. Logan worked with an average force of about five clerks, who waited on customers, packed and shipped prints, and performed other related tasks, at one point managing an inventory of nearly three thousand in-print lithographed subjects. Self-employed pushcart salesmen peddled the cheaper prints on consignment throughout the city and into nearby Brooklyn and communities in northern New Jersey. They arrived each morning, selected prints they thought would sell, left a deposit for the prints they chose, and returned at night to pay wholesale for the prints they had sold retail and to collect their deposits.[56]

Soon agents were hired for sales outside New York City, and in time distribution spread to Europe and even to Australia. Currier and

Ives maintained dealers in many large American cities, especially in the North, and they established a London sales office with agents in most of the countries of Western Europe. Currier and Ives comic and clipper-ship prints were particularly popular in France. In Germany and Great Britain, panoramic views and Western scenes were preferred.[57]

Currier and Ives advertised their prints as "suitable for framing or the ornamenting of walls . . . the backs of bird cages, clock fronts, or any other place where elegant tasteful decoration is required." Key to sales, however, was their cost. As their catalog stated, they sold "the best, cheapest and most popular pictures in the world."[58] At wholesale, small prints (8 by 12.5 inches/20 by 32 centimeters, printed on paper of 13.5 by 17.5 inches/34 by 44.5 centimeters) sold for 6¢ apiece, $6 a hundred, and $60 a thousand. The retail price was whatever the traffic would bear, of course, usually 15¢ to 25¢ each. Even as late as 1896, they advertised small prints at 20¢ each or six for $1. The larger lithographs, or "folios" as they were known (ranging from 20 by 26 inches/51 by 66 centimeters to 28 by 40 inches/71 by 101.5 centimeters), were colored by outside artists or colorists and sold by dealers, general stores, harness shops, or barrooms, depending on their content, at $1.50 to $3. But even these more expensive items were well within the reach of many Americans.[59]

To promote sales and to assist agents and other salespeople, Currier and Ives issued large catalogs of available prints. They also published special catalogs, promoting prints on a particular subject, such as the celebrated fire prints. When mailing catalogs to agents, Currier and Ives included sales letters, such as the one from the 1870s excerpted below and notable for the insights it provides into the business:

<div align="right">New York ——— 187——</div>

Dear Sir,

Herewith we enclose our new Catalogue of Popular Cheap Prints containing nearly Eleven hundred subjects, from which you can make your own selection of kinds wanted. You will notice that the Catalogue comprises Juvenile, Domestic, Love Scenes, Kittens and Puppies, Ladies Heads, Catholic Religious, Patriotic, Landscapes, Vessels, Comic, School Rewards and Drawing Studies, Flowers and Fruits, Motto Cards, Horses, Family Registers, Memory Pieces and Miscellaneous in great variety, and all elegant and salable pictures.

Our experience of over Thirty years in the Trade enables us to select
for Publication, subjects best adapted to suit the popular taste, and to
meet the wants of all sections, and our Prints have become a staple
article, which are in great demand in every part of the country.

To Peddlers or Travelling Agents, these Prints offer great induce-
ments, as they are easily handled and carried, do not require a large out-
lay of money to stock up with, and afford a handsomer profit than al-
most any article they can deal in, while at the same time Pictures have
now become a necessity, and the price at which they can be retailed is
so low, that everybody can afford to buy them. . . .

Our terms are strictly Cash with the order and on receipt of same we
carefully envelope and promptly forward prints the same day that the
order is received. . . .

Currier & Ives
123 & 125 Nassau St.
New York[60]

When Nathaniel Currier first entered the business, he faced a num-
ber of competitors, not only in the United States but in Europe. Gam-
bart, Delarue, and other French publishers provided for the inade-
quately served American market, and their influence can be seen even
in Currier's prints. During the 1840s and 1850s, Currier's prints often
reflected French romantic, even somewhat erotic, subjects. Currier's
Star of the North and *Star of the South*, both issued in 1847, for instance,
closely copied a recently issued French set of prints of prostitutes by
Eugene Guerard.[61] Currier and Ives found their American voice,
however, and then they outstripped all rivals.

The variety in subject matter of Currier and Ives's work distin-
guishes the firm from the many other commercial lithographers of the
time. The content of nineteenth-century commercial lithography in-
cluded views, the single largest group of prints; portraits, of nearly
all the celebrities of the day; historical subjects, which provide some
overlap with the preceding categories; transportation, including trains
and steamboats; horses, especially trotters but also thoroughbreds;
sports, including hunting, shooting, and fishing; elegant clipper ships;
temperance and morals; cartoons; sentimental and comic scenes; and
a large collection of miscellaneous lithographs. What set Currier and
Ives even further apart from the other lithographic firms was their
success at gauging their market and the sheer volume of their sales.

Once established, Currier and Ives, "the Grand Central Depot for

Cheap and Popular Prints," as they styled themselves, had few seri-
ous rivals. Dozens of other firms engaged in the same business. They
marketed their wares in much the same way, and some did quite well,
but none of them had a list that could be compared either in variety
of subject or market appeal to that of Currier and Ives. The genius
of Currier and Ives was in their marketing an eclectic collection of
imagery.[62]

The half century during which Currier and Ives prospered coin-
cided with, and was nurtured by, a period of explosive development in
the United States. In 1834, when Nathaniel Currier formed his first
partnership, Andrew Jackson was president; the nation was divided
between slaveholding and nonslaveholding populations; and the
United States was expanding westward, although the entirety of what
was to become the American Southwest still belonged to Mexico. The
way was being prepared for the Industrial Revolution, and a few major
cities had developed, but the nation was still overwhelmingly agrar-
ian and rural. By the time Currier died in 1888, the United States
spanned the continent, crossed by mighty railroads; a devastating civil
war had purged the nation of slavery and preserved its unity, though
deep sectional wounds remained to be healed; and the great age of in-
dustrial, commercial, and urban expansion was well under way, draw-
ing thousands of immigrants to the United States. The size of the
nation had doubled, and its population had grown from 13 to 62
million.[63]

Lithography in the antebellum period developed in a complex re-
lation to all of these economic, geographic, and cultural factors, as well
as to the real and perceived advances in democratic government with
which the Age of Jackson became associated. In a half century, the
United States had grown from a small, young republic to an increas-
ingly democratic nation that rivaled in size and wealth and power any
country in the world. Currier and Ives documented these changes—
as well as the nation's sense of pride and optimism, its misgivings and
fears, its smugness and anxiety—if not absolutely accurately, then in
a way that mirrored what middle-class Americans understood, be-
lieved, or at least liked to think was happening.

Currier and Ives helped middle-class Americans weather this pe-
riod of traumatic transition by providing them with a "usable past,
when it was most needed." Mid-nineteenth-century Americans—
their moorings having been shaken by the rush of events—needed to
know what kind of firm ground previous generations had stood on

and to believe that perhaps it had not yet entirely disappeared. That ground could only be reclaimed through an inexpensive, visual means of communication. In 1835 there was no such thing as illustrated news, no quick and inexpensive way for most Americans to grasp what was happening to the nation. Currier and Ives helped change all that.[64]

⟨ T W O ⟩

Creating a
Usable Past

It has been said that the United States was the first of the "new" nations. The American Revolution may have inaugurated modern nationalism elsewhere, but in the case of the United States, unlike other new nations formed in the following century—Italy and Germany, for example—the state came before the nation.[1] In Europe, new states were built on a solid foundation of history and traditions, but in the United States that foundation was still to be laid, the traditions still to be formed. If European nations that arose in the nineteenth century were already amply equipped with a "usable past," quite the reverse was true of the United States, where public memory became the

"created history" of the nation. Currier and Ives made a substantial contribution to that story.

It is hardly necessary to belabor the point that history, tradition, and memory are essential to modern nationalism. Friedrich von Schlegel, trying to quicken a sense of nationalism in the Germans, argued that "nothing is so important as that the Germans . . . return to the course of their own language and poetry, and liberate from the old documents of their ancestral past that power of old, that noble spirit which . . . is sleeping in them." Giuseppe Mazzini, in his struggle for the unification of Italy, was ever conscious that "the most important inspiration for nationalism is the awareness of past glories and past sufferings."[2]

Finding inspiration for nationalism was not a problem in nineteenth-century America, where an aggressive national pride drove the new nation's successful experiment in republican government and the rising power of the common people. But where was the nation to find the ancestral past, the glories of which von Schlegel and Mazzini spoke? Where could such a new nation find the substance for patriotism, for sentiment, for pride, for memory, for collective character? In his reflections on the historical and intellectual environment in which the young Nathaniel Hawthorne found himself in 1840, Henry James perhaps described the new nation best. He asked how Hawthorne could possibly create literature when there were "no palaces, no castle, nor manor, nor old country houses, nor parsonages, nor thatched cottages, nor ivied ruins; no cathedrals, nor abbeys, nor little Norman churches; no great universities, nor public schools, no Oxford nor Eton nor Harrow; no literature, no novels, no museums, no pictures, no political society, no sporting class—no Epsom nor Ascot!"[3]

Like many other Americans, Hawthorne viewed his surroundings differently, however. He was delighted to be in a land that had "no shadow, no antiquity, no mystery, no picturesque and gloomy wrong, nor anything but a commonplace prosperity, in broad and simple daylight."[4] Clearly, Americans were not of one mind on this matter of history.

Citizens of the new republic found they had three options in addressing their lack of history. First, they could simply declare that they had no need of a past, because they were so sure of a future. Goethe, no less, congratulated them on their good fortune in his famous poem, "Amerika, du hast es besser": "No ruined castles, no venerable stones, no useless memories, no vain feuds. . . . May a kind providence preserve you from tales of knights and robber barons and ghosts." French visitor Alexis de Tocqueville also expected this to be the case when he

wrote in 1840, "Among a democratic people, poetry will not be fed with legends or the memorials of old traditions."[5]

Closer to home, the romantic artist Thomas Cole observed that although American scenery was "destitute of the vestiges of antiquity," it had other features that were reassuring, because "American associations are not so much with the past as of the present and the future, and in looking over the uncultivated scene, the mind may travel into futurity." James Paulding entertained the same sentiment when he wrote, "It is for the other nations to boast of what they have been, and, like garrulous age, muse over the history of their youthful exploits that only renders decrepitude more conspicuous. Ours is the more animating sentiment of hope, looking forward with prophetic eye."[6]

This theme was advanced by Michel Guillaume Jean de Crèvecoeur, who, at the time of American independence, predicted that "instead of submitting to the painful and useless retrospective of revolutions, desolations, and plagues, [Americans] would, on the contrary, wisely spring forward to the anticipated fields of future cultivation and improvement, to the future extent of those generations which are to replenish and embellish this boundless continent." It was continued by John Louis O'Sullivan, who, in his formulation of Manifest Destiny, dismissed the past in favor of the future: "We have no interest in scenes of antiquity, only as lessons of avoidance of nearly all their examples. The expansive future is our arena. We are entering on its untrodden space with the truth of God in our minds, beneficent objects in our hearts, and with a clear conscience unsullied by the past. We are the nation of human progress, and who will, what can, set limits on our onward march? . . . The far reaching, the boundless future will be the era of American greatness."[7]

"This was all very well, this confidence in the future," observed Henry Steele Commager. "But it was, after all, pretty thin fare for nationalism to feed on at a time when other self-conscious nations were rejoicing in an ancient and romantic past."[8] Thus, as a second option, Americans could claim that they had, in fact, the most impressive of all pasts: the entirety of European history, which would be given a progressive orientation so as to establish the United States as the latest and greatest manifestation of God's historical plan. This option was tempting to some, but ultimately it seemed risky business to a people who had already declared that they wanted nothing to do with Old World corruption.

Even the most cosmopolitan of early Americans—those who actually lived abroad and gave proper credit for the cultural, techno-

logical, and other advancements of the Old World— shunned any association such a historical perspective might suggest. When, in the heat of political battle between the mother country and its colonies, talk of political reconciliation surfaced, Benjamin Franklin warned members of Congress that when he contemplated "the extreme corruption prevalent among all orders of men in this old rotten state, and the glorious public virtue so predominant in our rising country, I cannot but apprehend more mischief than benefit from a closer union."[9] When John Banister wrote to Thomas Jefferson, inquiring as to the advantages of educating his son in Europe, Jefferson responded

> Why send an American youth to Europe for education? . . . Let us view the disadvantages. . . . To enumerate them all, would require a volume. I will select a few. . . . He acquires a fondness of European luxury and dissipation, and a contempt for the simplicity of his own country; he is fascinated with the privileges of the European aristocrats and sees, with abhorrence, the lovely equality which the poor enjoy with the rich, in his own country. . . . He is led, by the strongest of all the human passions, into a spirit for female intrigue, destructive of his own and others' happiness, or a passion for whores, destructive of his health, and, in both cases, learns to consider fidelity to the marriage bed as an ungentlemanly practice.[10]

This perception of European corruption not only reinforced Americans' sense of moral superiority but also necessitated a third option: to create a usable past from what little history it had already. Americans would cultivate the art of memory in order to ensure a sense of legitimacy, to prove that history was on their side. Some have argued that by the second quarter of the nineteenth century this position was given greater urgency by a growing sense of sectionalism. Whether because of insecurity or pride, however, this was ultimately the option that nineteenth-century America took, and as Commager concluded, "Nothing in the history of American nationalism is more impressive than the speed and lavishness with which Americans provided themselves with a usable past: history, legends, symbols, paintings, sculpture, monuments, shrines, holy days, ballads, patriotic songs, heroes, and . . . [even] villains."[11]

Most observers share the view that creation of a usable past is "a familiar attribute of the human condition." In the United States, however, in a democratic culture committed to a democratic ethos, manipulation of collective memory and the invention of tradition are cultural manifestations that date to the late eighteenth century but

that have flourished only since the second quarter of the nineteenth century. The result was the ostentatious manifestation of the possession of a historical past, as Americans sought to fill their historical canvas with elements of their past, from Plymouth Rock to the continuing unfolding of the nineteenth century. Nowhere was that usable past more openly manifested—nor were "the mystic chords of memory" more poignantly invoked—than in the historical prints of Currier and Ives.[12]

America's evolving usable past would be effectively disseminated in multiple texts: in the written word; in the new nation's poetry and popular histories; in its children's books, like McGuffey's readers and the historical morality tales of Parson Mason Weems; in its songs, holidays, and monuments; and in its popular art. Indeed the "rising glory of America," with all its symbols and icons, was perhaps best presented in pictorial form. Portraitists, such as John Singleton Copley, Charles Willson Peale, and Gilbert Stuart, and historical painters, like John Trumbull, paved the way, but access to their work was limited. The solution was a means by which large numbers of inexpensive prints, both of portraits and of historical events, could be run off and distributed to the nation's growing middle class, that was provided by lithography.

America's usable—and largely fictional—past flourished in the nineteenth century despite the widespread availability of factual information that contradicted it. It is often dismissed as myth, but that is to deny its real value. Bronislaw Malinowski once described *myth* as a story about the past that has the function of justifying the present and thereby contributing to social stability. Even in a democratic society, myths are often activated or reactivated in order to legitimize a version of history that is useful or attractive. A myth may be mobilized to bolster a traditional order, or to achieve social control, on the basis of a distant past, but it can also provide the basis for change.[13] In short, myth—or public or collective memory—can serve conservative as well as innovative ends.

Public memory has been defined as "a body of beliefs and ideas about the past that help a public or society understand its past, present, and, by implication, its future." To that extent societies reconstruct, rather than faithfully record, their pasts. They do so with the needs of contemporary culture in mind, manipulating the past in order to mold the future.[14] The shaping of public memory or a commonly agreed-upon past can be contested, however, and involve a struggle for supremacy between advocates of various political ideas and sentiments.

Although in no way as visible as it is today, public memory was contested even in the early nineteenth century. Patriotism and national unity, at high tide in 1825, began to decline in the late 1820s because of increasing regional and class divisions.[15] In the case of Currier and Ives, however, the challenge was to assemble from those various, often- conflicting images a representation of the past that would appeal to as large and inclusive an audience as possible.

Such a construction of the past can create an illusion of social consensus and legitimacy to buttress presentist assumptions and the authority of the cultural and social elite. But public memory can also serve to mediate the competing societal interests, whose differences lie in the specifics. "Because it takes the form of an ideological system with special language, beliefs, symbols, and stories, people can use it as a cognitive device to mediate competing interpretations and privilege some explanations over others."[16]

In their agreed-upon view of the past, Americans chose a stable, immutable image of home, insulated by time from the accidents of the present. Historical themes were the popular alternatives, or at least a much-needed balance, to their restless, uncertain future. Americans' choice of history bespoke their commitment to their supposed roots as a means of dealing with their unsettling present and uncertain future. Viewed individually, Currier and Ives's hundreds of historical prints might be seen as nostalgic Americana. Viewed as a whole, however, they encapsulate the usable past created in the nineteenth century—the "American Genesis" myth that embodied and defended a system of values, an image of the ideal America for most Americans.

Portraits

Americans "prefer plasticized apotheosis to historicized memory developed in judicious doses."[17] Nowhere was the apotheosis of our American heroes more apparent than in the portraits of the Founding Fathers and of later figures, who may not quite qualify as "founding" but nonetheless were held up as examples of American virtue for the new republic. John Quincy Adams wrote, "Democracy has no monuments. It strikes no medals. It bears the head of no man on a coin."[18] Indeed, monuments in pre–Civil War America were few and simple, but plenty of portraits were reproduced for democratic Americans.

Portraits constitute one of the largest classifications of Currier and Ives prints, reflecting an appetite among their buying public for pictures of prominent persons. Among the more than six hundred like-

nesses are all of the American presidents through the end of the nineteenth century, as well as military officers, statesmen, religious leaders, sports figures, and visiting royalty and other foreign dignitaries. Just about anyone in the news might find his or her way into print at least once, but those represented in the largest numbers were American statesmen. George Washington and Abraham Lincoln, the men who, in the minds of most Americans, had founded and saved the nation, were most common.[19]

Though Benjamin Franklin was the subject of only six prints, his inclusion in the Currier and Ives gallery is instructive of nineteenth-century values. Probably because he was the first of his generation of potential demigods to die (in 1790), he was the first to be apotheosized. Franklin was the Leonardo da Vinci of early America. His accomplishments were many—statesman, diplomat, philosopher, publisher, author, signer of the Declaration of Independence, and inventor—so it is useful to note which of those accomplishments Currier and Ives and the American public chose to honor.

More than a half century after his death, Franklin continued to be remembered as a statesman, as in Currier's *Benjamin Franklin. The Statesman and Philosopher* (1847). But he was increasingly represented in popular culture as the common people's philosopher and as an inventor. The pithy wisdom that he put into the mouth of "Poor Richard," Richard Saunders, and the useful information he published in his renowned *Almanac,* so captivated Americans that Franklin was never again clearly distinguished from the cheeky fictional character. The nineteenth century saw Franklin in this light and reverenced him as the epitome of the native spirit; he became the national philosopher. Scores of Franklin's homilies gathered dust on parlor and bedroom walls and could be recited by many Americans. Men and women of all degrees of sophistication chuckled and sighed over his trenchant wisdom, delivered with disarming humor:

> If you know how to spend less than you get, you have the philosopher's stone.

> Three things are men most likely to be cheated in, a horse, a wig and a wife.

> After three days men grow weary of a wench, a guest and weather rainy.

> Keep your eyes wide open before marriage; half shut afterwards.[20]

Currier and Ives capitalized on this association. A favorite form of entertainment in the nineteenth century was the rebus, a graphic

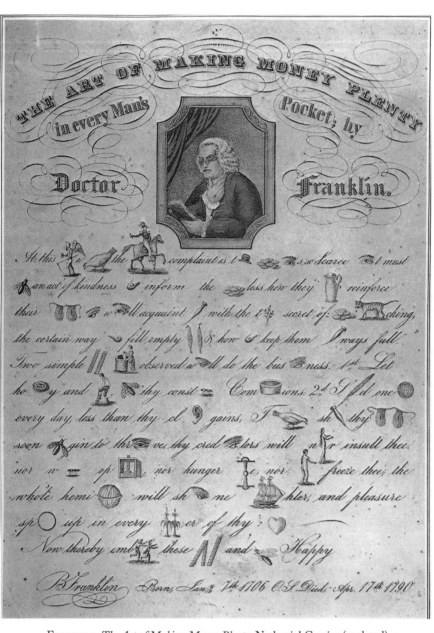

FIGURE 3. *The Art of Making Money Plenty*. Nathaniel Currier (undated).

puzzle of objects, signs, and letters, and Currier and Ives used it to illustrate Franklin's homilies. *The Art of Making Money Plenty* (undated, Fig. 3) flooded into American homes by the thousands. A thirteen-line rebus bearing a portrait of "Dr. Franklin" quoted him thus:

> At this time when the general complaint is that money is so scarce it must be an act of kindness to inform the moneyless how they can reinforce their purses. I will acquaint all with the true secret of money catching, the certain way to fill empty purses and how to keep them always full. Two simple rules well observed will do the business. 1st Let honesty and labor be thy constant companions: 2d Spend one penny every day less than thy clear gains. Then shall thy purses soon begin to thrive, thy creditors will never insult thee nor want oppress nor hunger bite, nor naked freeze thee, the whole hemisphere will shine brighter, and pleasure spring up in every corner of thy heart. Now thereby embrace these rules and be happy.[21]

To the nineteenth-century Currier and Ives consumer, Franklin was the worldly-wise American, speaking a universal tongue, and his other accomplishments complemented this image. Franklin wandering the streets with a loaf of bread under his arm, ushering in a new era of comfort by inventing the Franklin stove, or clarifying the theories of electricity with his kite and key, were merely Poor Richard in other guises. Nevertheless, the inventive side of Franklin did not come to the fore until the final quarter of the nineteenth century, when the United States underwent its industrial revolution and began to celebrated its inventors. In a sense, Franklin became the founding father of American invention.

On the nation's centennial, Currier and Ives pictured Franklin, the man of Yankee common sense, as the practical man of science and invention. Having established such things as a printing shop, a circulating library, and a fire company in Philadelphia, Franklin was portrayed carrying out his famous kite-flying experiment in 1752. As in so many Currier and Ives prints, the seeming realism of *Franklin's Experiment, June 1752* (1876) masks many errors: Franklin's son, William, was by 1752 a handsome, husky lad, more than six feet tall, not the youngster pictured in this print; Franklin let his son sail the kite, while he stayed for the most part in the doorway of a shed, not wishing to attract too much attention from neighbors. The Franklin home was of brick and, situated at the corner of Race and Second Streets in Philadelphia, not nearly as isolated as it is depicted. The kite was ac-

tually square, and Franklin would not have touched the string above the key, as this would have shorted out the current that he hoped to draw from the cloud to the brass key and thence to the collecting Leyden jar, which should be shown as glass rather than metal.[22]

Such license with the facts did not detract from the scene's appeal, however. Intended to be historical, it was to be timeless as well. Currier and Ives described the picture in just a few words: "Demonstrating the Identity of Lightning and Electricity, from which he invented the Lightning Rod." The simplicity of the scene and printed words, however, belie the print's impact. Franklin was an inventive genius, a virtue Americans had come to link with the American character and to honor above all others that he might have represented. He revealed, much as industrial America was revealing, the mysteries of experimental science to an admiring and somewhat incredulous Old World.[23]

Currier and Ives appear to have produced only one portrait of John Adams and three of Thomas Jefferson, although these figures also appear in other group pictures. Both were suddenly elevated to heroic status by their dramatic, nearly simultaneous deaths on July 4, 1826, fifty years to the day after they had signed the Declaration of Independence. In *John Adams: Second President of the United States* (undated), Adams is represented in scholarly pose, seated at a table covered with books and papers, holding a book in his right hand. Jefferson appears in the same fashion in *Thomas Jefferson: Third President of the United States* (undated), of which there are two versions. None of the three—Franklin, Adams, or Jefferson—attracted anything like the attention focused on George Washington.

The idea that God had ordained the founding of this country lent a sanctity to the stirring events of its early history and led to near deification of the great general.[24] One year after his death in 1799, Parson Weems, rector of the nonexistent Mt. Vernon parish, published the immensely popular *Life of George Washington* and launched the mythologizing of the first president as a man of unparalleled honesty and wisdom. It was not until the fifth augmented edition (1806), however, that young George took full responsibility for felling (barking, actually) the legendary cherry tree by declaring, "Father, I cannot tell a lie." The title page of the "Ninth Edition . . . Greatly Improved" suggests the following lessons to its reader:

A Life how useful to his country led!
How loved! while living! how revered! now dead!

Lisp! Lisp! his name, ye children yet unborn!
And with like deeds your own great names adorn.[25]

On February 7, 1832, the U.S. Senate and House of Representatives established a joint committee to arrange celebrations for the one-hundredth anniversary of George Washington's birth. Most committee members were pleased with their assignment, but Sen. Littleton Tazewell of Virginia (of all places) resigned to show his opposition to any form of "man worship, how great soever the man."[26]

"Man worship" was precisely what the centennial committee had in mind. On February 13 it proposed that Congress canonize Washington by removing his body from Mount Vernon and placing it in a tomb below the center of the Rotunda in the U.S. Capitol: "The man and the nation would, thus, become one." At the time Edward Everett of Massachusetts supported the move, noting: "The sacred remains are . . . a treasure beyond all price, but it is a treasure of which every part of this blood-cemented Union has a right to claim its share."[27] By 1832 the "blood-cemented Union" of which Everett spoke was already feeling the strains of disunion, making his words and the act he described even more poignant.

Thus the image of the beatified George Washington was irrevocably set in the American mind. By the time Washington Irving issued his five-volume biography, from 1855 to 1859, Currier and Ives already had begun reverently commemorating the man and the events in his life, which if not precisely historical were at least well known to all Americans. With Currier and Ives's help, the cultivation of beliefs and the observance of rites entered directly into the adoration of George Washington, whereby he became the object of a kind of secular religion.[28]

In the 1840s the firm issued a series of prints on the military and political triumphs of Washington's career, largely based on the imperial imagery found in European and American historical painting. In time they produced more than a hundred prints, on subjects ranging from Washington's birthplace (1876) to the imagined scene of his deathbed (1846) and including the Gilbert Stuart portrait that came to grace the one-dollar bill (undated). The largest groups of prints dealt with Washington as Revolutionary leader and as president, the former outnumbering the latter. The themes that united them were Washington as the father of his country and as Cincinnatus.[29]

Nothing better highlights the symbolism of the soldier-statesman than the pictures of General Washington during the Revolutionary War, from assuming command of the army in 1775 to taking leave of

his officers at the end of the war. In *Washington, Appointed Comman-der in Chief* (1876), Washington stands amidst the members of the Continental Congress on June 15, 1775, to receive his commission. The inscription reads in part that when John Hancock, president of the Congress, offered him the appointment, Washington "modestly and with great dignity signified his acceptance of the important trust."

Currier and Ives added to *Washington, Appointed Commander in Chief* the romantic touch of women standing in the gallery waving their handkerchiefs. Their presence suggests Washington's role as de-fender or protector of the fair and weaker sex, a theme that had al-ready become central to representations of America at war. It con-tinued in other Washington prints, including *Washington's Reception by the Ladies* (1845), for example, redone in at least nine separate prints, wherein Washington is greeted by a group of women and little girls as he passes a bridge at Trenton, New Jersey (the scene of one of his best-known victories as general), on his way to be inaugurated in New York as the first president of the United States in April 1789. Riding a horse whose head is bowed to the crowd, Washington emerges from a covered bridge and tips his hat to some young women, who throw flowers in his path.

Washington taking command of his army in Cambridge, Massa-chusetts, in July 1775 is dutifully reported by Currier and Ives in mul-tiple prints with that title. The most notable artistic liberty taken therein is the transformation of the largely rag-tag troops into long, straight lines with immaculate uniforms. More interesting is *Wash-ington's Dream* (1857, Fig. 4), which shows Washington willing to fight for his country but also dreaming of peace. He is asleep at a table, his battle plans before him, his sword by his side. Three allegorical women in flowing robes appear in a dream scene above him, with army tents visible through a door in the background.

Currier and Ives continued the theme of Washington as reluctant warrior, but they added divine favor in *Washington at Prayer* (undated). In that print the general, pictured in his tent with his field glass and sword beside him, prays on one knee, placing his hand on a Bible that lies on a table in front of him. In a poignant scene at Fraunces Tav-ern in New York City, the war won and his charge and duty suc-cessfully executed, Washington takes leave of his officers. They can-not bear even to look him in the eye but instead look dejectedly at the floor before them. The inscription for *Washington's Farewell to the Officers of His Army* (1876, Fig. 5) is from John Marshall's *Life of*

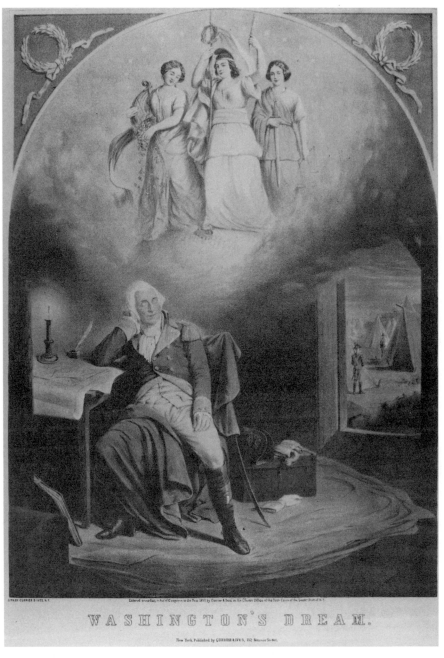

FIGURE 4. *Washington's Dream.* Currier and Ives (1857).

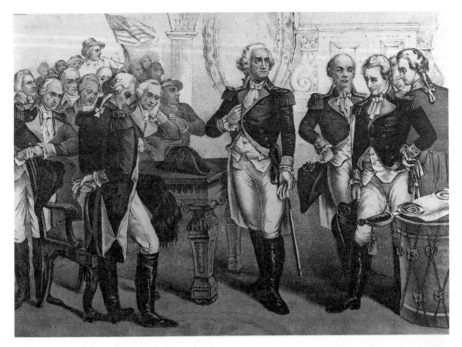

FIGURE 5. *Washington's Farewell to the Officers of His Army.* Currier and Ives (1876).

Washington (1804–1807): "Entering the room where they were await-
ing him, Washington said: 'With a heart full of love and gratitude I
now take leave of you.' [Henry] Knox turned and grasped his hand,
and while tears flowed from the eyes of both, the Commander-in-
Chief teased him; this he did to each of his officers; the scene was one
of great tenderness."

Complementing these dramatic scenes are dozens of prints show-
ing General Washington in much the same pose that Currier and Ives
would employ for later military heroes, many of whom—Andrew
Jackson, William Henry Harrison, and Zachary Taylor—were nomi-
nated for and, in some cases, elected president. They were impressively
uniformed, mounted on white horses, and present at major military
victories and events. The multiple images of *Washington, Crossing the
Delaware* (1876, for example) and *Surrender of Cornwallis: At York-
Town VA. Oct. 1781* (1845 and 1846), set the tone. *Washington at Prince-
ton* (1846) reports, in its inscription, that "at this important crisis, the
soul of Washington rose superior to danger; seizing a standard he ad-
vanced uncovered before the column and reining his steed towards the
enemy with his sword flashing in the rays of the rising sun [symbolic

of the new nation], he waved on the troops behind him to the charge. Inspired by his example the militia sprang forward and delivered an effective fire which stopped the progress of the enemy." In *Washington at Valley Forge* (undated), a pensive Washington, a cloak around his shoulders and one hand resting on a cannon, stands both amidst his troops, enduring the same ordeal, and aloof from them as they huddle around a campfire behind him.

Like Cincinnatus, a much-revered Roman figure who provided the model for the citizen-soldier, Washington would return. He, the citizen who became general, might have become king; instead, out of loyalty to the republic that he had helped found and for which he had fought, he resisted the entreaties of those around him and opted instead to lay down his sword and return to his farm. The second group of portraits pictures Washington's return as Cincinnatus, from private to public life, upon his unanimous election to the nation's presidency in 1789. Perhaps most symbolic in this group is *Washington: The Cincinnatus of the West* (undated), a straightforward portrait of the general who became president. No descriptive commentary is either offered or necessary; the meaning and intent is clear.[30]

Equally suggestive, however, is a series of at least seven separate prints, none of which is distinguished by its content. They simply offer poses of the military figure returned to civilian life, but they are made interesting by Gen. Henry Lee's descriptor: *Washington: First in War, First in Peace, and First in the Hearts of His Countrymen* (1846, for example). Lee's words were replaced in two prints by the title *Washington: First in Valor, Wisdom and Virtue* (undated), perhaps to spell out more clearly the values that Washington came to represent to the American people. In a series of four prints titled *George Washington: First President of the United States* (undated), Washington is seated with a piece of paper in his hands and a sword cradled in his left arm. In the single print of his inauguration, *The Inauguration of Washington* (1876), he takes the oath of office with his right hand on the Bible, his left hand holding a sword.

Family portraits abound, adding the dimension of Washington as devoted husband and stepfather (the children are Martha Custis's grandchildren through her previous marriage). So too are scenes of Washington's birthplace, his home at Mt. Vernon, and his deathbed and tomb. Currier and Ives pictured Washington's death in at least seven prints, all of which present the dying demigod in bed surrounded by family, friends, and domestics. Common to nearly all of these prints—*Death of Washington* (1846), for example—is the figure

of Martha Washington comforting her weeping grandson; his grand-daughter, standing behind and holding a handkerchief; a physician taking Washington's pulse; and two or three weeping black servants, kneeling or standing. A plumed military hat and sword lie on the floor, nearby. After decades of neglect of the various sites associated with the men and events of the nation's founding, Americans chose those associated with Washington to be among the first to be preserved and hallowed.

Some of the tomb prints feature visiting dignitaries paying homage to the Founding Father. One of the most notable was the Marquis de Lafayette, French general and statesman. Excited by the ideals of the American Revolution, he joined Washington's army in 1777, and the event was the subject of the print *The First Meeting of Washington and Lafayette* (1876). Lafayette returned to France in 1781 and became active in the French Revolution. The capture of the Bastille in July 1789 symbolized the beginning of that movement, and thus it was a great honor when Lafayette sent the prison's key to Washington. Although Americans would eventually shun that revolution's violence, they saw in its ideals an extension of those born in America. Lafayette's moderate position, though rejected by the revolution's more radical leaders, was a product of those American ideals—suggesting the new nation's influential role in the course of world history. When Lafayette visited the United States in 1824–1825, he was given an unprecedented welcome and made an honorary citizen. He paid homage to the general who had become a father figure to him as well as the nation by a much-publicized visit to the tomb, which Nathaniel Currier recorded in *Lafayette at the Tomb of Washington* (1845). Washington's burial place became an important stop on the itinerary of dozens of other foreign visitors, most of whom had never met him but had come to recognize his importance, including dignitaries from the country against whom he had fought. One of these was *The Prince of Wales at the Tomb of Washington: Oct. 1860* (undated).

In 1860, on the eve of the American Civil War, Currier and Ives brought forth the spirit of the nation's father in an appeal for union. *The Spirit of the Union* (1860) provides a full-length portrait of Washington in military uniform, framed by clouds and suspended between renderings of the Capitol, Washington's tomb, and Mount Vernon. In the face of Southern secession, the inscription pleads:

Lo! On High the glorious form,
Of Washington Lights all the gloom;

And words of warning seem to come,
From out the portal of his tomb;
"Americans your fathers shed
Their blood to rear the Union's fare,
Then let your blood as free be given,
The bond of union to maintain."

Thematically, this print was followed in 1865 by *Washington and Lincoln in the Father and the Saviour of Our Country*, wherein Washington and Lincoln, holding a scroll (the Constitution), shake hands in front of the eternal flame of liberty, which rises from a stone base decorated with an eagle and a shield. A variation on this theme is *Washington, McClellan, and Scott* (undated), wherein Washington, the general, is grouped with Union generals George McClellan and Winfield Scott. Such symbols of might and divine mission also were attributed to the president who saved the Union and, as one might expect, portraits of Lincoln—more than seventy—exceeded all others except those of Washington.

The Pageant of American History

Currier and Ives produced more than 250 prints depicting high points of American history. To judge by their coverage, the nation's story begins in earnest in 1776. Only about fifteen prints deal with the colonial period, and they focus on only five different figures, groups, or scenes. Nevertheless, they are important. Currier and Ives and other purveyors of American culture sought to create a usable past by reinterpreting these early historical events to support the ideology of the New Republic:

> The historical recovery of the colonial past involved a parallel attempt to reassert the moral and social values of the founding (the Puritan seventeenth century), the making of the republic (the Revolutionary era), and the fulfillment of the ideal through the preservation of the Union and the freeing of the slaves (the Civil War). This was New England's claim to moral predominance and national leadership, and it reinforced the searching for historical roots, back to a British and, for some, an Anglo-Saxon racial heritage.[31]

The rediscovery in 1855 in London of William Bradford's lyrical account of the landing of the Pilgrims at Plymouth in 1620 and their

struggle to survive their first years in the wilderness encouraged this historical focus. Although it would not be brought back to Massachusetts until the end of the century, *Of Plimoth Plantation* was immediately copied and published by the Massachusetts Historical Society in 1856. It became a part of the historical record that helped nineteenth-century Americans define the meaning of their past, especially after the Civil War.[32] In the wake of the South's defeat, which had cultural as well as military repercussions, an increased number of popular prints of colonial New England flowed from the nation's presses.

Artists portrayed the Pilgrims in a number of representative settings, such as George Henry Boughton's *Pilgrims Going to Church* (1867) and *Landing of the Pilgrim Fathers* (1869). John Ehninger's *A Thanksgiving Dinner among the Puritans* (1867) was paired in the November 30, 1867, issue of *Harper's Weekly* with W. S. L. Jewett's *A Thanksgiving Dinner among Their Descendants*. The first emphasized the praying father looking up to God for deliverance; the second, set in the nineteenth century, reflected the prosperity with which God had responded.[33]

Currier and Ives's colonial American history was heroic and, perhaps more important, foreordained. Because nineteenth-century Americans were often baffled and even disturbed by the social, economic, and political changes of their time, they looked to the colonial period for reassurance that the nation had been founded on a solid foundation of virtue. What they found in historic scenes like Columbus's discovery of America, the baptism of Pocahontas, and the Pilgrims' landing on the coast of Massachusetts and signing the Mayflower Compact, was the development of the nation from its earliest years as the slow unfolding of a predestined and natural greatness. Lyman Beecher reflected this idea in *The Memory of Our Fathers*, published in 1826 on the fiftieth anniversary of Independence: "If it had been the design of Heaven to establish a powerful nation in the full enjoyment of civil and religious liberty, where all the energies of man might find full scope and excitement on purpose to show the world by one great experiment of what man is capable . . . where could such an experiment have been made but in this country!"[34]

It is no accident that, of all the colonial events they could have chosen, Currier and Ives saw fit to reproduce scenes that would embed in the consciousness of Americans the courage, ingenuity, and genius of their forefathers. Christopher Columbus, the Pilgrims, and William Penn personified those ancestors who journeyed from the Old to the New World to bring order, religion, peace, and law to a virgin land

and to its savage people. The colonization of America promised a glorious future, and in Columbus's standard, the Pilgrim's piety and republicanism, and Penn's signature one finds the symbols of progress and achievement.[35]

Those pictorial symbols complemented nicely the more formal symbols included in the nation's Great Seal, voted on by Congress on June 20, 1782. On its face the Great Seal displays a distinctly American bald eagle. Its wings are outspread, and a floating streamer that bears the motto *E Pluribus Unum* ("from many one") is caught in its beak. The other side of the seal features a more mysterious symbol: a truncated pyramid capped with a single eye set in a nimbused triangle. Above this is the motto *Annuit Coeptis* ("He [God] has smiled on our undertaking"). Below the pyramid is another motto, *Novus Ordo Seclorum* ("a new order of the ages"), by which Congress proclaimed the beginning of a glorious era for humankind.[36]

These themes—even the symbols and mottoes themselves—pervade Currier and Ives's historical pageant. The heroic individual stands forth, but the ideal of community is represented as well. Individualism was already perceived as central to the American character, but among people already diverse and alarmingly regionalized, shared experience was equally important. Printmakers reflected the latter concern by introducing into these historical prints the balancing motif of an envisioning community, of the larger society that sustained and gave meaning to the heroic individual. Neither Columbus nor the Pilgrims, for example, act alone. Even the explorer, who appears as the fearless and triumphant individual, is involved in a joint enterprise within an association of intrepid men. Americans have always vaunted their self-reliance, but Currier and Ives suggest that they were also no less concerned with the common good.[37]

That Currier and Ives chose Columbus and the Pilgrims to represent the founding of America is a distinctly nineteenth-century point of view. Columbus was virtually ignored in British America and the United States until the end of the eighteenth century and really did not attract significant attention until the time of Currier and Ives's founding. He was, after all, an Italian sailor, who had acted on Spain's behalf to discover and colonize America. With independence, however, and soon after that the three-hundredth anniversary of his landing, cultural leaders began to reconstruct Columbus's story. It was a story about which little was known and was therefore sufficiently malleable that he could be adopted into the American pantheon of demigods. The process began in the 1790s, when the first Columbus

Day would be celebrated and the newly constructed nation's capital named for both of the nation's founders: the city of Washington in the District of Columbia. It would be greatly advanced by publication of the wildly successful Columbus biography by Washington Irving in 1828, but it would not peak until the World's Columbian Exposition in 1893.[38]

Such was the case with the Pilgrims as well. That their 1620 landing site would be hailed as the birthplace of British-American civilization—as opposed to the first permanent British settlement in America, Jamestown (1607)—could only have resulted from the cultural dominance of New England in the nineteenth century, enhanced by the out-migration of New Englanders, creating, for example, the New England Society of New York (City). That was matched by the suppression of Southern history begun in the first half century but made complete by that section's secession from the Union and defeat in the Civil War. Forefathers' Day, which as late as the early nineteenth century remained a local New England commemoration, became the nation's Thanksgiving Day, proclaimed by Lincoln in 1863. The Pilgrims had become the rootstock of all Americans.[39]

What is perhaps most interesting about Currier and Ives's scenes of colonial America is their typical, subtle combination of romanticism and realism, making them more credible and effective purveyors of imagery as well as content. Such is the case with *The Landing of the Pilgrims at Plymouth* (1846, Fig. 6) showing the Pilgrims coming ashore on December 22, 1620, after "a boisterous passage of sixty-three days"—a trying voyage filled with hardship and division. The men, women, and children appear weary; one man carries his weakened wife. Their faces bear no smiles, their gaze reflecting the concern they must have felt at the prospect of having to remain in so forsaken a land on which they accidentally stumbled. One Pilgrim kneels in prayer. Another carries a pick and shovel. A third holds a rifle but does not notice the Indian to the left, observing the landing.

The Mayflower Compact was largely ignored by orators at events commemorating the Pilgrims' landing until the late eighteenth and early nineteenth centuries. At that point New Englanders seized upon the compact, as well as Plymouth Rock, as evidence and symbol of the independent and democratic spirit of the Pilgrim fathers. They made the Pilgrims the most appropriate founders of the new nation. That the Mayflower Compact was executed in order to bring under control a group of near-mutinous passengers and crew is not noted. Instead, as the caption added to the 1876 edition makes clear, the

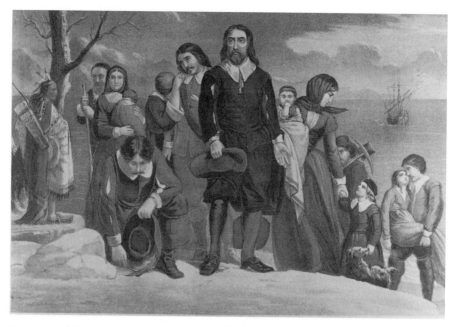

FIGURE 6. *The Landing of the Pilgrims at Plymouth*. Nathaniel Currier (1846).

Mayflower Compact is representative of the Pilgrims' capacity and determination for self-government: "In [the Mayflower's] cabin the first republican government in America was solemnly inaugurated. That vessel thus became truly the 'cradle of liberty' rocked on the free waves of the ocean."[40]

Columbus's landing is presented in a similar manner. Plymouth Rock is missing, but the Niña, Pinta, and Santa María replace the Mayflower in the background. On shore Columbus falls to one knee, bearing Spain's colors in his hand and laying claim to the land for his patrons. A priest holds a crucifix on high, blessing the land, while others of the crew scramble ashore, one prostrate in the sand, giving thanks for his safe arrival. Three Indians stand in the shadows, much like their counterpart at Plymouth, warily eyeing the new arrivals.

Currier and Ives published *First Landing of Columbus on the Shores of the New World* (1892) on the four-hundredth anniversary of that landing, when national homage to the explorer peaked. They had produced three earlier prints, one undated, another in 1845, and a third on the nation's centennial. The most notable difference in these prints is that in the 1845 version Columbus neither kneels nor bears the flag of Spain. Instead, he holds his sword aloft in such manner as to re-

semble a cross. In the age of Manifest Destiny, the preferred image of conquest was by the sword in the name of God, and the role of Catholic Spain in the discovery of the New World was played down on the eve of war with Mexico.

The same combination of realistic portrayal and romantic and symbolic interpretation permeates Currier and Ives's treatment of Native Americans in the colonial period. *William Penn's Treaty with the Indians* (undated), for example, suggests fair treatment of Native Americans by Pennsylvania Quakers, whose holy experiment in Penn's Woods was supposed to represent Christian brotherly love at its finest. Penn, who had received his charter from Charles II in 1681, did negotiate such a land-purchase treaty with the Indians who occupied the land. The historical record surrounding the treaty stands in stark contrast, however, to the course of events described by the print's caption, which no doubt represents how Americans had come to "remember" the event. Currier and Ives tell us that it was "a treaty with the Delaware Chiefs that should continue 'as long as the sun and moon shall endure,'" when, in fact, it was broken by none other than Penn's son, who obtained more land for the proprietorship from the Indians by fraud and chicanery.

The Quakers hoped to bring the Indians out of "heathenism" and into a saving awareness of the divine principle within them. Given their belief in the spiritual equality of all humanity, the Pennsylvania Quakers had the best chance among all the colonial people of bringing the Indian to God, to civilization, and to living in peace. Yet they too failed; the treaty enshrined in this lithograph was perhaps the high point in Indian–Quaker relations. Indian converts were few, and under William Penn's son, colonial mercantile interests came to dominate colonial politics and Indian relations. In Pennsylvania, as elsewhere in colonial America, "savages" stood in the way of empire.

By the 1730s Pennsylvania administrators were forced to take sides in intertribal relations, which in turn were exacerbated by the English-French wars for empire. As one historian has put it, "In 1756 there was war, and Pennsylvania, having secured Iroquois friendship, was offering large bounties for Delaware scalps. A principle of survival had overridden a principle of divinity." No prints memorialize this aspect of the historical record; thus in William Penn's treaty, the dominant note is critical as well as inspirational, if not factual: Penn is the benevolent fair dealer and man of law and justice, an image that Americans fostered of themselves. Offsetting this motif, however, is

the implicit critique in the subtitle of three other undated versions of this print: *The Only Treaty That Never Was Broken.*[41]

If the Indians in the Columbus and Pilgrim prints are shadowy and foreboding, Currier and Ives waxed romantic in their treatment of Pocahontas. *Pocahontas Saving the Life of Captain John Smith* (undated) was based on the quite likely apocryphal story made popular by Smith only after Pocahontas had become well known and died. It pictures the Indian maiden throwing herself over Smith, protecting him from the executioner's blow, and pleading with her father, Chief Powhatan, for Smith's life. The details of the account are subject to dispute, but not so the facts that later, in 1613, the approximately eighteen-year-old princess was captured, taken to Jamestown, and held hostage for English prisoners detained by her father. At Jamestown, she was converted, apparently willingly, to Christianity and baptized as "Rebecca."

In *The Baptism of Pocahontas* (undated) Pocahontas kneels with eyes lowered and hands folded in prayer. A soldier, wearing a breastplate and holding a sword, stands nearby, and an Indian woman is seated on the floor at right holding a baby in her lap. The message of impending warfare commingles with hope through conversion of the heathen Indian to Christianity. Viewers knew the rest of the story: that Pocahontas married the English settler, John Rolfe, bringing a temporary peace to the colony; that she adopted the white man's ways, went to England with her husband in 1616, and was presented at court; and that although she died the next year, her son, Thomas Rolfe, later returned to Virginia and gained considerable wealth and prominence. The story of Pocahontas provided solace for the nineteenth-century American conscience, perhaps a wistful solace for what might have been.

The American Revolution

Independence precipitated a crisis of historical identity for Americans. In repudiating their British past, they sought a new historical foundation for the nation and found it in the American Revolution.[42] To judge by Currier and Ives's representation, American history began with the American Revolution. For artists like John Trumbull, Charles Willson Peale, and Emanuel Leutze, as well as Currier and Ives, it proved to be a cornucopia of heroic episodes and images for the creation of a usable past: from the Boston Tea Party and Bunker

Hill to Saratoga and the British surrender at Yorktown. To Currier and Ives's generation, increasingly burdened with their own concerns for the union and the preservation of the republic, no event proved more inspirational. It not only represented the origins of the nation-state but also produced leaders, documents, and events that served as important objects of commemoration.[43]

Symbols had to serve political needs in the material world, and no greater political need existed at the time than to ensure survival of the new nation. Consequently, anything that might remind Americans of the "other" reality—of the hesitant steps toward independence, the tattered forces put together by sometimes less-than-competent officers; losses at Brooklyn Heights and Fort Washington; fiscal mismanagement and profiteering; families (even Benjamin Franklin's) divided in their loyalties; and the disunity of the new nation after peace—were shunned. What Americans wished to remember were the "truths" of another kind: the heroism of the day, the unifying events, the successes of war, and the arts of self-government. Symbols that generated loyalty and respect for the new structure of political power became widely honored, from George Washington to the Declaration of Independence. One major theme tied all related representations together: "Nation and Union, North and South, inseparable and indivisible."[44]

The significance of the American Revolution in public memory was given a boost by the fiftieth anniversary of independence on July 4, 1826, and the nation's centennial celebration of 1876. The images those events emphasized included patriotism and loyalty, the material progress of the nation, a unified society, as well as the nation's incomparable civil and religious liberty. The story of the American Revolution both extended and confirmed the larger narrative of America's foreordained presence in the world.[45]

Prints of George Washington, the unimpeachable champion and symbol of independence and union, dominated Currier and Ives's historical prints of the era of the American Revolution. But Currier and Ives told the rest of the story as well, in a pictorial panorama that included at least sixty separate prints—more prints than on any historical subject except the Civil War. Several of those historical prints were based on paintings by artists such as Benjamin West, John Trumbull, and Emanuel Leutze, but others originated in the Currier and Ives shop.[46]

All of the significant battles of the American Revolution were included, often in multiple prints. Five representations of the Battle at

Bunker Hill were published, all after the work of John Trumbull with the highly romanticized death of Gen. Joseph Warren as its center-piece. All focused on the theme of that battle as the first real stand-up fight between untried colonial troops and British regulars. One print is specifically titled *Death of Warren at the Battle of Bunker Hill* (undated). The others, though similarly constructed, are titled *Battle at Bunker's Hill* (all undated), and, in two cases, bear the inscription: "The path to liberty is bloody."

That the British technically won that battle is of so little impor-tance as to be lost in the larger message that the victory was gained only at the expense of great loss of life on the part of the British: 1,054 British killed and wounded, as opposed to 441 casualties on the rebels' side. "A dear bought victory," British Gen. Henry Clinton would write of the battle. "Another such would have ruined us."[47] Even more in-spiring were the words of British Gen. Thomas Gage, who offered the following assessment to his superiors of a people wondering whether they could withstand the greatest army on earth: "These people show a spirit and conduct against us they never showed against the French. . . . They are now spirited up by a rage and enthusiasm as great as ever people were possessed of, and you must proceed in earnest or give the business up. . . . The loss we have sustained is greater than we can bear."[48]

In *Surrender of General Burgoyne at Saratoga* (1852), also based on a Trumbull painting, "Gentleman" Johnny Burgoyne, as he was known because of his always-fashionable, even swashbuckling, apparel and comparatively luxurious surroundings, is defeated, thereby blocking British plans to divide and conquer the thirteen rebellious colonies. More symbolically than historically accurate, Burgoyne, richly and dashingly attired, surrenders to Gen. Horatio Gates, who is dressed, out of character for Gates, unlike any other person on either side in the picture. He wears the homespun clothing often represented in portrayals of the minuteman and "the spirit of '76."[49]

Similarly interesting for its presentation is General Cornwallis's surrender at Yorktown, Virginia, in 1781, the final major battle of the war, of which Currier and Ives produced at least five prints. The first two, titled *Surrender of Cornwallis*, were published in 1845 and 1846. In the first Cornwallis is flanked by Banastre Tarleton, Charles O'Hara, and General Chewton. He surrenders his sword to Washington, who stands amidst Benjamin Lincoln, Alexander Hamilton, and the Mar-quis de Lafayette. All are standing before a large tent, likely Wash-ington's, with troops off in the distance celebrating the occasion. In

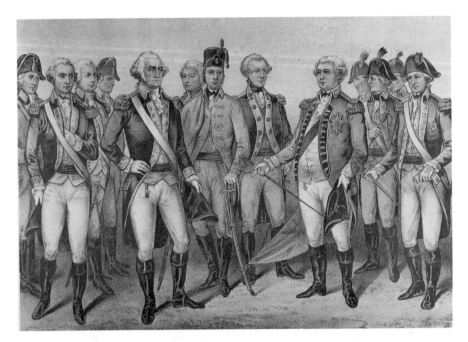

FIGURE 7. *Surrender of Lord Cornwallis.* Currier and Ives (1876).

the second print the same principal figures are represented, but Washington, Lincoln, and other American officers are mounted on horseback, whileand British soldiers and officers are on foot. Cornwallis hands his sword to Benjamin Lincoln.

The 1846 composition is repeated in two prints titled *Surrender of Lord Cornwallis,* one of which is dated 1852, the other undated. In 1876, however, Currier and Ives returned to their earliest image of Cornwallis handing his sword to Washington (Fig. 7), to which they added the following inscription: "By this event, the clouds of war were broken, and the dawn of peace burst forth like the light of a clear morning after a night of tempest and woe."

None of these scenes are historically correct, but then they may not have been intended to be. Historically, to the strains of *The World Turned Upside Down* played by British troops, Brigadier General O'Hara headed up a column of British officers. When he came before Washington and French Admiral Comte de Rochambeau (who was not included in any of the pictures despite his importance to the victory), O'Hara first offered to surrender to Rochambeau—interpreted by some as one way to save face, by surrendering to a French professional rather than to a colonial amateur. The French com-

mander refused the gesture, however, and pointed to Washington. O'Hara then addressed himself to Washington and explained that he was representing Cornwallis, who was indisposed. Rather than accept surrender from the hands of a second in command, Washington referred O'Hara to General Lincoln, his second, who accepted O'Hara's sword in token surrender before returning it with instructions on where his men were to lay down their arms.[50] Clearly the surrender involving subordinates would not have made as inspiring a picture.

Special note might be made of *Destruction of Tea at Boston Harbor* (1846), "*Give Me Liberty or Give Me Death*" (1876), and the five prints on the Declaration of Independence. The first conveys with high drama, if not exceptional precision, the spirit and significance of this important event of the Revolutionary era. Although the destruction of the tea took place under cover of night, here we see the Sons of Liberty, disguised as Mohawk Indians, boarding one of the three ships laden with tea during the day and dumping the 342 chests valued at eighteen thousand pounds into the harbor. Moreover, whereas the original event was observed by only a few bystanders, according to this rendering these republican labors occur in full view of a well-dressed male throng, which rends the air with loud huzzahs. The print captures the elation of a respectable citizenry, united in its actions, as opposed to the "rabble" of the Sons of Liberty often associated with an act of vandalism. In fact, British authorities never found a witness to testify to the deed, providing one of the high points in the movement toward what John Adams later called "a Revolution the Most Complete and Remarkable in History."[51]

"*Give Me Liberty, or Give Me Death*" pictures Patrick Henry delivering his speech on the rights of the colonists before the Virginia Assembly on March 23, 1775. The orator stands with his left fist pressed to his chest and his right arm raised above his head. The room is filled to capacity, all hanging on his every word, some raising their arms in a similar gesture of defiance. At Henry's feet lies a volume labeled *Proceedings of the Virginia Assembly*, and the title of the print reminds viewers that Henry's now immortal words became "the war cry of the Revolution."

Four of the five prints Currier and Ives published on the Declaration of Independence are after the well-known painting by John Trumbull. All are undated, but at least one was reproduced in 1876. In these largely fictional prints the signers of the declaration, most of whom sit at tables along three walls, fill the room. The Declaration Committee—Thomas Jefferson, John Adams, Benjamin Franklin,

Roger Sherman, and Robert R. Livingston—stand in front of the table. John Hancock sits behind the table, the declaration lying between him and its authors.

The Declaration Committee (1876) focuses exclusively on the previously noted five authors. An inscription provides a brief history of the declaration's genesis, from appointment of the committee on June 11 to its adoption on July 4. Jefferson is credited with principal authorship. The point that Currier and Ives chose to emphasize was that "the thirteen colonies were declared free and independent states, under the name of the United States of America."

Trumbull's Declaration of Independence (1787), popularized by Currier and Ives (undated), is the most enduring image of the American Revolution, because of its association with American independence and the document proclaiming to the world that the new nation would be dedicated to the proposition that "all men are created equal." Currier and Ives provided other popular representations, however—fictionalized illustrations, really—with other appealing images. The following four examples, arguably the best known, all appeared in 1876, during the centennial celebration of American Independence.

In Heroes of "76," Marching to the Fight (1876), a company of American soldiers marches toward the front, led by the proverbial fife player and drummer. An image of the minuteman is introduced in The "Minute-Men" of the Revolution (1876). A man on horseback gestures to two men, possibly father and son, standing in front of a house, summoning them to battle. One carries a musket on his shoulder; the other is handed a musket by an older woman standing on the stoop, probably the mother. A young woman, likely the younger man's wife, stands in the doorway of the house, crying but comforted by her small child.

A Patriot of 1776 Defending His Homestead (1876, Fig. 8) brings the fighting closer to home and to the ultimate purpose of defending one's home from invasion. In the foreground a neat but plainly dressed patriot is about to strike a mounted British dragoon, decorously attired with epaulets and plumed helmet, with his sword. Another British soldier lies dead or wounded in front of the patriot's home; three other enemy soldiers appear in the background. During the American Revolution, stories of atrocities carried out by the British, including the infamous Hessian soldiers and their Indian allies against American property and civilians, helped turn the tide of public opinion against the mother country. Many of those stories became legends, including the murder and scalping of Jane McCrea by several Indians

FIGURE 8. *A Patriot of 1776 Defending His Homestead.* Currier and Ives (1876).

in the New York frontier, also the subject of a Currier print, *Murder of Miss Jane McCrea A.D. 1777* (1846).[52]

And, finally, most closely related to Trumbull's *Declaration of Independence* was "the tocsin of liberty"—the Liberty Bell—rendered by Currier and Ives in a print of the same title in 1876. Consistent with legend, a man pulls a rope to ring the bell in the tower above the Pennsylvania State House (subsequently renamed the Liberty Bell and Independence Hall), announcing the declaration of American independence. People wave from the windows of surrounding buildings, and a crowd cheers from below.

One of Currier and Ives's final prints on the American Revolution—also issued during the centennial—suggests the purpose of all previous scenes. *The Story of the Revolution* (1876) conveys nothing in particular on the historical event but instead reminds us of the process of historical public memory and the place of Currier and Ives in that process. A grandfather, dressed in Revolutionary garb and pointing to his musket and powder horn over the mantle, tells his grandson about the country's heroic beginnings.[53]

The War of 1812

Compared with the American Revolution, the War of 1812 was a grim and largely disappointing, even sectionally divisive, affair. Opposition by the New England states to "Mr. Madison's War," expressed at the Hartford Convention of 1814, threatened the federal union. For its participants and later historians, the War of 1812 was a much-contested event, and awarding victory to either side was problematic. Purveyors of the nation's usable past, however, turned it into a successful and even glorious second war for American independence and, in the process, added to the list of national heroes.[54]

Among their twenty or so prints on the war, all battle prints, Currier and Ives highlighted the nation's victories, despite several notable defeats, such as the burning of Washington, which sent President James Madison fleeing into the countryside on horseback. Britannia ruled the waves throughout the war, but nevertheless, some of the more celebratory prints highlighted American naval victories on inland waterways. *The Constitutiton and Guerriere* (1846) showed the sea fight of those two ships, reporting the disproportionate loss of British lives and showing the victorious *Constitution* flying three American flags; McDonough's *Victory on Lake Champlain* (1846) took the same approach. The caption of *Perry's Victory on Lake Erie* (undated) includes Oliver Perry's famous brief report, "We have met the enemy and they are ours." The Perry print proudly shows the British fleet surrendering "to the American flag" that is being hoisted on board the *Niagara*, a representation perhaps more meaningful for Currier and Ives's nineteenth-century audience than the specifics of the actual battle. It was the War of 1812, after all, and the print reminds the viewers of the bombardment of Fort McHenry in 1814, which inspired Francis Scott Key to compose the words to "The Star Spangled Banner," paying tribute to survival in battle of the nation's preeminent symbol.[55]

There were several versions of Gen. Andrew Jackson's victory at the Battle of New Orleans in January 1815. It was the most important victory of the war, fought after a settlement had been reached but before news of the cease-fire reached New Orleans. It came when American morale was particularly low. Given the superior British naval power, the attack on New Orleans was expected and feared. Nevertheless the main thrust of British troops stalled within range of American lines, and U.S. artillery inflicted disastrously heavy casualties on them until they retreated.[56]

Given the course of the war to that point, and despite the fact that

the battle did not affect its outcome, Americans needed to memorialize the Battle of New Orleans. Because Currier and Ives prints of the battle were all produced after General Jackson became President Jackson, hero of the American people and "symbol for an age," Andrew Jackson became the focus of those memorializations. When Jackson lay dying at the Hermitage in 1845, a naval captain who had just returned from the Mediterranean with the sarcophagus of a Roman emperor suggested to Jackson that he place his remains therein. Jackson, once derisively called "King Andrew" by his political enemies, declined: "I do not think the sarcophagus of a Roman emperor a fit receptacle for the remains of an American Democrat." As Washington McCartney wrote in his eulogy to Jackson, Jackson had become "the embodiment of the true spirit of the nation in which he lived. . . . He put himself at the head of the great movement of the age in which he lived." Because of that, he "received the admiration of his contemporaries." They saw in him "their own image," because in him was "concentrated the spirit that . . . burned in their own bosom."[57]

Earlier prints tended to be more matter-of-fact and to take a reportorial approach—to sketch out troop positions and battle lines for a visually starved, news-hungry population. By the 1840s, in the Age of Jackson, Nathaniel Currier assisted that same public in elevating the Battle of New Orleans to its "usable past" and Andrew Jackson to its pantheon of demigods. The battle took on spiritual significance as it was increasingly seen not only as a military victory but also as a triumph that restored the nation's honor. Once again God had intervened on the side of his chosen people.[58]

One of the more interesting prints, *General Andrew Jackson: The Hero of New Orleans* (undated), shows a uniformed Jackson mounted on his horse and tipping his cockaded hat to his troops, with the caption: "The Union It Must and Shall Be Preserved." The statement may have been appropriate for the battle or war, but it was taken almost directly from Jackson's toast at the Jefferson Day dinner of the Democratic Party in 1830. In the heat of his quarrel as president with his vice president, John C. Calhoun, and with South Carolina over the tariff and the issue of nullification, which in turn thinly masked the issues of state's rights and possible secession, Jackson proclaimed: "Our Federal Union, it must and shall be preserved." Calhoun responded, "The Federal Union—next to our liberty the most dear."[59]

In 1842 Nathaniel Currier published three other prints on the Battle of New Orleans, all with the same title and all similar conceptually to each other and to the portrait noted above. In all four prints

Gen. Andrew Jackson is highlighted riding a white horse and leading his troops into battle. In one print Jackson is flanked by an aide and an officer. He holds a baton in his right hand and the reins in his left. Two men are pushing protective bales of hay into place, while another soldier leans over a wounded comrade. In another Jackson holds a sword in the air. A demolished cannon lies nearby. A British soldier attempts to climb over the American breastwork but is about to be struck down by a sword-wielding American. In the third print Jackson's right hand cannot be seen, and there are two dead soldiers on the ground.[60]

Two other notable prints on the War of 1812 are *Death of Tecumseh, Battle of the Thames, October 18, 1813* (1846, Fig. 9) and *General William H. Harrison at the Battle of Tippecanoe* (undated). Both involve Native Americans, foreshadowing their representation in Currier and Ives's prints on the frontier. Tecumseh was the Shawnee leader of an Indian confederacy formed to oppose the white man's depredations on Indian tribal lands supposedly reserved to them by sacred treaty. In the War of 1812, the Indians, having allied with British forces based in Canada, retreated with them after Oliver Hazard Perry's victory on Lake Erie. Pursued by Col. Richard M. Johnson's cavalry troop of Kentucky volunteers, the Indians decided to make a stand on the banks of the Thames River. In the battle that ensued, Colonel Johnson, a former "war hawk" congressman from Kentucky, struck the fatal blow against Tecumseh that was to ensure Johnson's subsequent political success in a country that rewards its military heroes with high office. By the time the print was issued in 1846, Colonel Johnson had become senator and ultimately vice president under Martin Van Buren, having waged the close-fought political campaign of 1836 under this stirring battle cry:

> Rumpsey dumpsey, rumpsey dumpsey,
> Colonel Johnson killed Tecumseh![61]

Similarly, William Henry Harrison, then-governor of the Indiana Territory, led the attack in the Black Hawk War at the Battle of Tippecanoe in 1811. Neither side won a decisive victory, but tales of Harrison's bravery spread throughout the country and helped in his election to the presidency in 1840 with the campaign slogan, "Tippecanoe and [John] Tyler, too." The second print shows Harrison on his white horse, his troops trying to restrain him from attacking the enemy lines. Harrison nonetheless pushes on, the caption reads, forcing the enemy back, one Indian lying trampled underneath his horse's hooves.

FIGURE 9. *Death of Tecumseh, Battle of the Thames, October 18, 1813.* Nathaniel Currier (1846).

The Mexican War

The market for American battle scenes blossomed during the Mexican War of 1846. The American people sought news, including pictures, of their soldiers in battle, which led Nathaniel Currier not only to offer a number of Mexican War scenes for sale but also to go back in history to provide most of the already-mentioned heroic war scenes from the American Revolution and War of 1812. The 1840s, then, were a period of considerable activity in such prints, second only to the peak period of the American Civil War.[62] What is most interesting to us, however, is how Currier sought not only to picture those battles but also to interpret them in a manner consistent with public expectations, so that they could become part of the nation's usable past.

To satisfy the thirst of a nation, lithographers produced hundreds of prints on the Mexican War, with at least seventy coming from Nathaniel Currier. Currier occasionally acquired a sketch from the front, but more often his shop artists worked from newspaper accounts and modeled their portrayals after European battle prints. Few were accurate in their details; most were of such a general nature, focusing on common aspects of battle, that only their titles and inscriptions allow the viewer to identify them in time and place. But accuracy was not their purpose.[63]

The Mexican War produced the first contemporary Currier and Ives war prints. Unlike the War of 1812, this war provided a preponderance of victories. As one contemporary source wrote, "The recent contest between the United States and Mexico has called forth the military energies of this country, and has led to displays of valour and military science which had astonished the whole civilized world." The war was not without its opponents and critics. Charges made earlier in the war that the conflict was really only about "despoiling a friendly nation . . . of a considerable portion of her territory" for the expansion of slavery were drowned out, however, by the hurrahs of victory and seeming vindication of Manifest Destiny and the annexation of nearly the entirety of what was to become the American Southwest.[64] And once again, military heroes were made—such as Zachary Taylor and Winfield Scott, the first of whom would eventually find his way to the White House, the second a candidate for that office.

Currier's war prints could not compare in either detail or artistic merit to those of James Walker, an army interpreter in the Mexican War, or of Carl Nebel, who bore witness to the various battles he pictured. But that did not inhibit their sales. Regardless of their lack of

accuracy, the prints first and foremost brought home the immediacy of the war in a way never experienced by Americans. Moreover, as one historian has remarked, although artists such as Nebel insisted on painting what he saw, others, like Nathaniel Currier, operated under no such limitation; they printed what the people wanted to see.[65]

Currier's prints emphasized and glorified, and did not simply report, victory and acts of heroism. They provided a series of heady triumphs over a foreign power for a nation increasingly worried about, and insecure in, its growing sectionalism. As in prints of wars past, the enemy is not taken lightly but indeed is shown, and often described in captions, as fighting valiantly, which only made American victory all the sweeter.[66]

The battle that attracted Currier's greatest attention, as measured by the several prints produced of it, was that of Veracruz. Fought in March 1847, it began the final campaign of the war and involved both a land and a sea assault. As one historian put it, after examining Nathaniel Currier's two prints of the bombardment of Veracruz, "All the troops are soldiers, instead of sailors. General Winifield Scott [mounted on a white horse] is too prominent, no sandbags are in view, and the perspective seems too low. The troops were on a slight hill."[67] The print chose to report in its inscription only the enemy's capitulation, the American loss of life, and the names of the principal American officers, Gen. Winfield Scott and Comdr. Matthew Perry. *Siege of Vera Cruz* (1847), by John Cameron, is a straightforward and largely generic land battle scene, in which, at center, an American soldier holds aloft the American flag. He stands next to a cannon, which fires at enemy targets across the water. In *Capitulation of Vera Cruz* (1847), mounted Mexican officers surrender to General Scott.

Much the same is true of Currier's *Battle of Cerro Gordo April 18th 1847* (1847), depicting the battle in which the Mexican general Santa Anna was defeated. When compared with Nebel's print of the same battle, it is statistically deficient. But the print "depicts what could have been true," as well as what people wanted to be true, namely the close-in fighting showing the personal heroism of the soldiers.[68] American troops surge toward the Mexican lines at the top of the hill. Dramatic clouds frame the scene, and the inscription reports that American troops ascended the hill "without shelter; and under the tremendous fire of artillery and musketry." "With the utmost steadiness," it continued, they drove the enemy from the field.

The titles of most of the remaining prints speak for themselves: *The Brilliant Charge of Capt. May* (1846), in the Battle of Reseca de la

Palma; *Storming of the Heights at Monterey* (1846); *The Gallant Charge of the Kentuckians at the Battle of Buena Vista (1847); Flight of the Mexican Army* (1847), at that same battle; and *General Scott's Victorious Entry into the City of Mexico Sept. 14th 1847 (1847)*. Heroic portraits round out the list, including Winfield Scott and Zachary Taylor.

The firm held Zachary Taylor up for special applause in a series of nine prints that bear his name and focus especially on his victories at Palo Alto, Reseca de la Palma, Monterey, and Buena Vista. *General Taylor at the Battle of Palo Alto* (1846) is typical of this group. On horseback, Old "Rough and Ready," as he came to be known, reins in his mount with his left hand and with the other points forward with his sword, leading his troops into battle. Somewhat more dramatic, however, is *"General Taylor Never Surrenders"* (1847), in which three Mexican officers, messengers of Santa Anna, offer to accept Taylor's surrender before the American victory at Buena Vista. Again Taylor is depicted on horseback, reining in his prancing horse with his left hand and holding a sword in his right. The inscription provides the text of his response to Santa Anna: "Sir: In reply to your note of this date, summoning me to surrender my forces at discretion, I beg leave to say that I decline acceding to your request. With high respect, I am, sir, your obedient serv't; Z. Taylor." The undated versions of these prints may well have been issued in 1848, the year the Mexican War ended, when Taylor became a successful candidate for the presidency.

Until midcentury, painters and commercial illustrators monopolized battle art, and their romantic impressions shaped the thinking of the young men who volunteered for the Union and Confederate armies. Little wonder, then, that so many who volunteered to fight in the Civil War came to think such pictures were inadequate, misleading, or even lies.

The Nation's Centennial

The year 1876 marked the centennial of American Independence, the first in a series of centennial celebrations with which the century ended: 1887, 1891, and 1892. Each should have called forth the productive efforts of Currier and Ives for historic prints of Columbus's landing in the Americas, the American Revolution, the Constitution, and the Bill of Rights. Production remained strong throughout the period, but not the firm's focus on history. In 1876 Currier and Ives did issue more than forty prints dealing with aspects of the American Revolution, nearly all reproductions of earlier prints, but 1887 and 1891

passed without any recognition and 1892 with only one tribute to America's discoverer.

History, collective memory, or the nation's usable past remained popular, but compared with the second quarter of the nineteenth century, the fourth quarter was animated by a spirit of a sense of progress and technological innovation and industrialization.[69] Not surprisingly the theme of the centennial of American Independence was progress, but progress that tied material gain to republicanism and liberalism, which in turn was reflected in the nation's history, now more than ever proclaimed to have begun in 1776. Thus the great Centennial Exposition held at Philadelphia in 1876, complete with historical exhibits, orations, and publications, intended to recall the moment of origin in terms by then well established in the public memory. President of Harvard Charles W. Eliot set the tone for the centennial year when he observed, "I think we Americans particularly need to cultivate our historical sense, lest we lose the lessons of the past in this incessant whirl of the present."[70]

Currier and Ives responded to Eliot's call with dozens of prints of the American Revolution, nearly all reissued from previous decades. Not surprisingly the only variations on the theme were republication of a handful of prints on George Washington and Abraham Lincoln, continuing the "Peter and Paul" image of the celebrated figures.[71] Appropriate for this final year of Reconstruction and Northern military occupation of the South, the firm reissued *The Spirit of the Union,* first published in 1860 on the eve of the Civil War, reminding Americans of the blood their fathers had shed "to rear the Union's fame." Because the centennial's celebratory spirit was somewhat diminished by the death in battle of George Armstrong Custer at the Little Bighorn on June 25, it might also have been appropriate to issue prints memorializing the ill-fated general and tying his death to the spirit of the centennial. Currier and Ives accomplished the first in *Custer's Last Charge* (1876), a heroic military equestrian portrait, and the second in *1876— On Guard: "Unceasing Vigilance Is the Price of Liberty"* (1876). In *On Guard,* a young soldier stands guard on the wall of a frontier fort, while three Indians appear ready to attack from the darkness.[72]

Currier and Ives supported the theme of progress with prints such as *The Progress of the Century* (1876), a collage of four important nineteenth-century inventions, American by implication: the "lightning" steam press, the electric telegraph, the locomotive, and the steamboat. In the center of the picture sits a man tapping out the following message on the telegraph: "Liberty and Union now and forever

one and inseparable. Glory to God in the highest. On earth peace, good will toward men." The words are those of Daniel Webster, senator from Massachusetts, in the Webster-Hayne debates of 1830 over South Carolina's claim of its state's right to nullify federal law. The matter was not settled, only postponed, until the Civil War. The lessons, or hopes, of the Civil War were still very much present.

Currier and Ives reassured Americans that freedom had been guaranteed by that war in *Grand Centennial Wedding: Of Uncle Sam and Liberty* (1876), a cartoon that features a female figure, garbed as Liberty, and Uncle Sam. Uncle Sam has built a model building and has removed the roof to reveal a treasure trove of jewelry. Hovering above the legend, "Bless You My Children," George Washington raises his hands in benediction of their union. Two torches stand at opposite sides, one marked 1776, the other 1876.

Finally, Currier and Ives celebrated the country's anniversary by comparing its self-image with its perception of other nations. In the political cartoon *Grand Centennial Smoke: History in Vapor* (1876), eight figures in different costumes personify Turkey, Germany, Russia, England, France, Italy, Spain, and the United States. Each puffs on a pipe or cigar, the smoke from which forms an image above his head that contains a symbol of that nation taken from the American popular imagery: a turkey; a skeleton, holding a bomb; a bear; a figure with a crown nearly falling from its head; a cavalryman peering into a keyhole; a fleeing pope; and a woman, labeled "Cuba," burning at a stake. Uncle Sam, at the center, is associated with images of George Washington with hatchet and cherry tree.

The historical content of commemorative exhibitions not only remained steady but even increased through the end of the century, as did the nation's celebrations of those events. Historical perspectives, if only to attest to the nation's progress and promise for the future, were important to each centennial celebration. But Currier and Ives no longer played a part. Production remained strong until 1893, but even during centennial years the firm chose not to invest in history again, save one reprint of *The Landing of Columbus* in 1892. That would become the final chapter in Currier and Ives's pictorial narrative of American history. Their final prints, *The U.S. Battleship Maine* (1898), *Our Victorious Fleets in Cuban Waters* (1898), and *Col. Theodore Roosevelt, U.S.V. Commander of the Famous Rough Riders* (1898), much like their pictures of the Mexican War and Civil War, merely celebrated the victorious news of the day.

THREE

Responding to Civil War

Shelby Foote has called the American Civil War "the crossroads of our being." He made the comment on the public television series *The Civil War*, first broadcast in 1990. It was certainly the most traumatic event in American history, an event that challenged the usable past that was being assembled in the nineteenth century. Another historian has said, "Nothing in the national history compares in drama and tragedy.... None has aroused the passions nor bequeathed a more enduring legacy of suspicion and bitterness."[1] Just how would the war that divided God's chosen nation, that pitted the people of one section against another, be incorporated into the national public, or col-

lective, memory so as to retain the ideological basis for Americans' faith in progress?

The word *trauma* is used to describe extraordinary experiences in the personal lives of individuals. So too it may be applied to extraordinary events in the collective lives of a nation. In such a situation previous feelings of safety and security are replaced by perceptions of danger, chaos, and a crisis of meaning. Initial responses to a traumatic event are those of shock, disbelief, and incredulity. The life of the nation loses its predictability. Chaos prevails, and people become uncertain about what they ought to believe.[2]

The problems that led to the Civil War were long-term, even chronic. Nevertheless, when it began—when Confederate forces fired on Fort Sumter and President Abraham Lincoln declared the Southern states in rebellion—the war seemed sudden, unexpected, and shocking. Most people, north and south of the Mason–Dixon line, thought the war would end quickly in victory for their side.[3]

Northern abolitionists challenged the morality of the South's "peculiar institution," as well as its appropriateness in a nation dedicated to the proposition that all men are created equal. Southerners responded by defending slavery, arguing that their treatment of the slaves was better than the conditions for immigrant labor in the North, that slavery was recognized by law and the constitution, and that the constitution guaranteed state's rights and protected personal property, meaning slaves. And just to complicate matters even more, Southerners had allies in the North, especially in cities like New York, where Currier and Ives were located.

As cultural and political historians have long noted, a Democratic Party alliance between Southern planters and the white Northern working class in the 1830s, 1840s, and 1850s checked the rising power of industrialists and abolitionists who increasingly turned to the Whig, Free Soil, and Republican parties as vehicles for their programs. For all their considerable differences, some agrarian and urban workers believed they shared an interest in white supremacy: the planters to secure their labor system and the workers to foreclose competition in their own sphere.[4]

Nevertheless, whether playing on white fears of massive black migration into nonslaveholding areas, persuading Northerners that the slave system impeded economic development, or simply arguing for abolitionism on moral grounds, the Republican Party was able to win enough support to take on the Southern system directly. By the time Abraham Lincoln was elected to the presidency in 1860, the still-new

usable past could no longer mediate to contain sectional difference, which, at least temporarily, eclipsed all others.[5]

When the war came, so did even more insistent declarations of war aims in political and popular culture. Depending on who was speaking, the Civil War was presented as a necessary astringent for Anglo-Saxon stock or as a quest for freedom. The war began as an attempt on the part of the North to save the Union; in time Lincoln made it a war for emancipation. Many in the North as well as the South were unsure as to the wisdom of Lincoln's decision; some argued that it totally changed the nature of the war, making it something to which they had not been, and were not, committed. But that divisiveness was overcome by the feelings of victory that followed and the sense of loss from Lincoln's assassination.[6]

Officially the Civil War ended in 1865, but culturally it did not. At stake was the war's meaning and how that meaning would be applied to the nation's understanding of its past, present, and future—its public memory. Southerners, defiant as ever, sought to secure ideologically what they could not achieve militarily, establishing the legend of a land of cavaliers and fair ladies and of a genteel culture that would be perpetuated in the writing of Thomas Dixon, among others, perhaps reaching its apogee in 1936 with publication of Margaret Mitchell's *Gone with the Wind*.[7]

The North's preoccupations after the war were to punish the South and to reconstruct it in the image of Northern Radical Republicans. But that gave way to a greater desire to heal the wounds that divided the nation and to go about the business of America, even at the expense of leaving the newly freed slaves, or freedmen, on their own.[8]

The Pictorial Record

The pictorial record of the Civil War was greater than that of any previous American war. The new art of photography, most notably at the hands of Mathew Brady, made a significant contribution to this record. But photography was still comparatively rudimentary, and because of the shutter's slow speed, the photographer was limited in his subject to whatever would stand still. The artist's sketch pad, woodcuts, and lithography, therefore, continued to rule the market.[9] Never had there been such a demand for news, and the "press" responded accordingly. The still-new illustrated weeklies—*Frank Leslie's Illustrated Newspaper* (1855), *Harper's Weekly* (1857), and the *New York Illustrated News* (1859), for example—capitalized on public demand and flour-

ished. Within a year they had as many as fifty corresponding artists at the front. They could provide illustrations of events within ten to fourteen days of their occurrence—a remarkable advance in print technology.[10]

In 1996 a *New York Times* art critic observed that the Civil War "was never one of Currier and Ives's great subjects." He based his observation on the supposed dominance of photography in print journalism during the war, as well as the unnerving effect the war had on the firm's buying public.[11] The use of photography in journalism was still limited, however, and the trauma of the Civil War seems only to have stimulated the public's interest in mass-produced illustrations of various scenes related to the war. Lithographers and engravers sold thousands of pictures of army camps, military installations, and ships of war. "For the picture industry, the war was a blessing," and the Civil War became a "great subject" for Currier and Ives.[12]

Currier and Ives published more than two hundred lithographs of the Civil War, not counting a large number of related prints of President Lincoln. The majority of the prints were battle scenes, purporting to illustrate the great battles of the war. Others included cartoons, or graphic satires, of the war; those that might be labeled patriotic prints; and those related to secession, politics, and Lincoln's assassination. Arranged chronologically, Currier and Ives's prints provide a veritable narrative of the war.

James Merritt Ives served during the war as a captain in the Twenty-third Regiment of Brooklyn, New York State National Guards, and saw action briefly when Lee invaded Pennsylvania. He also served on the Union Defense Committee, which promoted the enlistment of Union soldiers and took care of the enlistees' families while they were at the front.[13] None of the other principals in the firm could claim such first-hand experience. Designed largely by Louis Maurer, who did not witness any of the scenes he depicted, the firm's Civil War prints depended on firsthand reports from the front received by the several newspapers housed near Currier and Ives's offices in Printing House Square.

More than most newsprints, Currier and Ives's Civil War prints reflect the emotional impact of the war, if not the specifics of battle.[14] During the early years of the war, both in the work of Currier and Ives and in the illustrated weeklies, prints continued the tradition of portraying warfare in the romantic tradition of hand-to-hand combat by heroic soldiers and the occasional magnificent death of a general on the battlefield in the arms of his grief-stricken aides. As artists began

to witness the reality, rigors, and agonies of war for the first time, however, their sketches for the illustrated weeklies began to diverge from that tradition. By 1863 the differences were quite striking, but through the efforts of Currier and Ives and other sources of popular culture—in print, song, and art—the romantic ideal survived.[15]

The savagery and soaring number of battle-related as well as disease-induced deaths of what is often seen as the first "modern" war became readily apparent to the war's participants and correspondents. And inevitably there were stories of atrocities, exaggerated or not. A few newspaper publishers agreed with the editor of *Leslie's* that such "wanton and fearful atrocities are too shocking and revolting to place before our readers," but others did not hold back, especially *Harper's Weekly*.[16]

For *Harper's* and those that followed that Northern weekly's lead, hatred and unwavering loyalty became the themes of the war—hatred of the Confederate enemy as the source of all the nation's troubles, and total, unquestioning loyalty to the Union. It followed from *Harper's* political cartoons that there existed "a vast conspiracy of slaveholders and political and military leaders dedicated not only to treason and the destruction of the Union, but also to the commitment of degenerate atrocities against the true, the faithful, and the innocent." Editorial cartoonists pictured "drunken and ignorant hordes" of Confederate soldiers looting the homes of loyal Americans, burning and destroying nonbelligerent property, bayoneting wounded men in the field, desecrating the dead after a battle by stripping them of their belongings, massacring Union black troops, and, of course, desecrating the American flag.[17]

Other publishers, like Currier and Ives, though generally supportive of the Union, took a more moderate stance. They avoided the sordid realities of battle in their prints, retaining the romance and glory of war, and they were comparatively more tempered in their criticism of the South. Where *Harper's* provoked outrage at the South's secession and conduct of the war, Currier and Ives provided comfort and reassurance that Union sacrifices were for a righteous cause without demonizing the enemy. Ironically, Fletcher Harper was a Democrat; Currier and Ives were Republicans. Both had enjoyed significant sales in the South in the antebellum period but lost them once the war began.[18]

The ideological use of such images was consistent with the fact that the Civil War was both a military conflict and a complex political and social upheaval. Certainly for editorial artists, but even for the creators

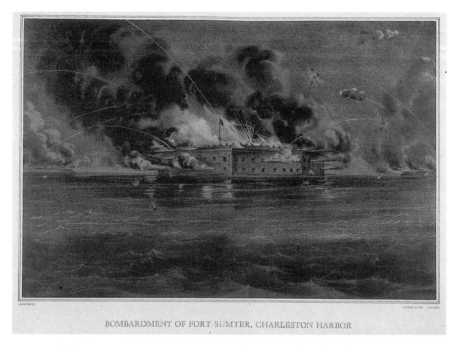

BOMBARDMENT OF FORT SUMTER, CHARLESTON HARBOR

FIGURE 10. *Bombardment of Fort Sumter, Charleston Harbor.* Currier and Ives (undated).

of separately published popular prints, the objective was to create disciplined mass support of the war. They knew that the success of the war effort depended on sentiment on the home front.[19] *Harper's* and Currier and Ives differed not in principle on the war and its related issues, but rather in degree; Currier and Ives avoided the weekly's extreme position and remained closer to the more complex public response that dominated areas like New York City.

Currier and Ives established the flag as the symbol of the Union in its earliest Civil War prints. In *Bombardment of Fort Sumter, Charleston Harbor: From Fort Moultrie* and *Bombardment of Fort Sumter, Charleston Harbor* (undated, Fig. 10), both of which were rushed out soon after the battle of April 12, 1861, Confederate soldiers, from behind a battlement, fire cannons across the water on Fort Sumter. Smoke rises from the fort, but the U.S. flag flies high above the fort in an illuminated section of the otherwise darkened sky, recalling the scene in 1814 at Fort McHenry described in "The Star Spangled Banner."

The four thousand shells that rained on Fort Sumter claimed not a single human life. The only Union martyr was the American flag, at one point shot down only to be rehoisted on a "jury mast extem-

porized on the parapet." Maj. Robert Anderson described his depar-
ture from Fort Sumter as occurring "with colors flying and drums
beating . . . and saluting my flag with fifty guns." Commenting on the
attack, Abraham Lincoln wrote, "The Constitution, the Union, and
the Flag" have been "assailed by paracidal rebellion."[20]

Thus the grand Union symbol of the Civil War was born. A New
York journalist dubbed it "flagmania," to which Currier and Ives con-
tinued to contribute in its many battle prints, as well as in a series of
prints that focused exclusively on the flag. Five weeks after the fall of
Fort Sumter, Currier and Ives used the symbol to recruit Union sol-
diers in *The Union Volunteer*.[21] It featured a young recruit, one hand
raising his sword, the other clutching the flag, and the following verse:

> O'er Sumters wall our flag again we'll wave,
> And give to traiters all a bloody grave.
> Our Union and our laws maintain we must;
> And treason's banner trample in the dust.

Three weeks later, in *The Flag of Our Union* (1861), Currier and Ives re-
placed the young recruit's image with that of a Union officer that bore
a resemblance to Col. Ephraim Elmer Ellsworth, the first Union offi-
cer killed in the war. Ellsworth was shot to death by a Confederate sym-
pathizer in Alexandria, Virginia, on May 24, 1861, after cutting down a
Confederate flag flying atop the Marshall House, which was visible
from the White House across the Potomac River. He too clutches the
flag in one hand as it unfurls over his shoulder, while he raises his
saber as if to rally the troops in the other.[22] The inscription reads:

> Strike—till the last armed foe expires,
> Strike—for your altars and your fires!
> Strike—for the green graves of your sires,
> God—and your native land!

The third print in Currier and Ives's early flag-waving trilogy was *The
Spirit of 61/God, Our Country and Liberty* (1861). The linking of the
Union cause and God's will was completed with the replacement of
the soldier-officer once again, this time with the symbol of the nation
itself. Columbia now hoists sword and flag above the inscription:

> Up with the Standard and bear it on,
> Let its folds to the wind expand.

Remember the deeds of Washington,
And the flag of our native land.

Currier and Ives continued the flag theme to the very end, in 1865 publishing *The Old Flag Again, Waves over Sumter*, wherein an exultant staff officer, Henry Bragg, realizes the young recruit's earlier pledge by planting the standard into the debris-littered ground where Fort Sumter once stood.[23]

With *The Flag of Our Union*, Currier and Ives also initiated its series of Civil War heroes, pictured at the moment of their heroism or martyrdom and also in portrait. *Death of Col. Ellsworth* (1861) is typical. It dramatically shows Ellsworth's gaping and bleeding wound, which resulted from the blast of Marshall House innkeeper James Jackson's double-barreled shotgun, and a Union soldier (Cpl. Francis Brownell) preparing to fire on Jackson, killing him. The colonel's wound was actually over his heart, rather than in the stomach, as pictured. Moreover, although the unknown artist shows Jackson firing point-blank at Ellsworth, the Union soldier had actually batted away Jackson's shotgun before he fired, thereby diverting the shot in the more deadly direction. But such discrepancies were of little consequence. The scene had such impact on Northern emotions that it became known as the "shot heard 'round the North."[24]

Pictures of War

Another of Currier and Ives's early pictorial renderings of Civil War battles featured the contest between the *Monitor* and the *Merrimac*. Once again Currier and Ives made the case for a Union victory, but they also played on the popular response to this unique confrontation between two hitherto-unknown types of battleships, the Civil War ironclads. Historically, the *Monitor* met the *Merrimac* on March 9, 1862. The Confederate *Merrimac*, which had been guarding the water route to Richmond up the James River, sailed out to challenge the Union blockade at Hampton Roads. On March 8 it destroyed two Union ships and ran three aground; the next day it encountered the *Monitor*. A five-hour battle ensued in close quarters, during which each vessel sustained more than two dozen direct hits without suffering crippling damage. The exhausted crews broke off the duel and both ships withdrew, the battle judged by most, then and now, as a draw.[25]

In *The Great Fight between the "Merrimac" and "Monitor" March 9th, 1862: The First Battle between Iron-Clad Ships of War* (1862), Currier

and Ives present the battle as an event to behold. The two ironclads exchange fire at point-blank range. Both ships are accurately rendered and fly the flags of their countries. In the background, providing heightened contrast for the viewer, Currier and Ives placed four three-masted steamer-sailers and two steamboats. Perhaps because their clientele preferred to have an evaluative message, Currier and Ives also issued three more prints on the battle, in which the *Monitor* was declared the victor. In *Terrific Combat between the "Monitor" 2 Guns and "Merrimac" 10 Guns: The First Fight between Iron Clad Ships of War* (1862), Frances Palmer simply added to the print's inscription that "the little 'Monitor' whipped the 'Merrimac' and the whole 'school' of rebel steamers." In a later group of prints the inscription varies, reading that "the Merrimac was crippled, and the whole rebel fleet driven back to Norfolk."[26]

As the war progressed, Currier and Ives's Civil War prints became increasingly patriotic. The firm clearly set its sites on capturing the Northern, pro-Union market. Most of the battle prints were of Union victories and were so labeled with little concern for the facts of the matters pictured. No one who has ever studied the firm's surviving records, including this author, has ever found evidence that any of Currier and Ives's Civil War prints were commissioned or otherwise influenced by anyone other than their buying public.[27] But the message they sent was clear. It was the message of victory and glory.

Four of the more interesting examples of this approach are *Battle of Bull Run, Col. Michael Corcoran at the Battle of Bull Run, The Second Battle of Bull Run*, and *The Battle of Antietam*, wherein we find creatively selective views of those battles that were either Union defeats or, in the case of Antietam, hardly a victory. The First Battle of Bull Run, on July 21, 1861, was the Union's single greatest moral defeat, and possibly the biggest fiasco, of the entire war. Second Bull Run, August 29–30, 1862, resulted in another Union defeat, though not so ignominious.[28]

Although Antietam, fought on September 17, 1862, might best be described as a draw, Lincoln and his cabinet declared it a victory, pointing out that after the battle Lee pulled back to Virginia.[29] The withdrawal had repercussions both at home and abroad; at home, the "victory" enabled Lincoln to issue his Preliminary Emancipation Proclamation. Lincoln had submitted the first draft of the proclamation to his cabinet on July 22, but he was persuaded to withhold it because of military reverses. Abroad, the British and French governments, which had been considering recognizing the Confederacy and even intervening to force mediation, now held back.

Rather than labeling the first two engagements Confederate victories, Currier and Ives pictured elements of the battles that reflected Union success or courage. The inscription on *Battle of Bull Run* (undated but, like nearly all the battle scenes, almost certainly done soon after reports of the battle filtered back to New York) reads "Gallant Charge of the Zouaves and Defeat of the Rebel Horse Cavalry," and the print pictures one of few positive moments in an otherwise disappointing battle. The only hint of pending defeat is the Zoave soldier lying on the ground at the left of the picture with his arm extended over his head. *Col. Michael Corcoran at the Battle of Bull Run* (undated), which pictures Corcoran leading his troops into Confederate lines while a soldier at the center of the picture holds the American flag aloft, is subtitled *The desperate and bloody charge of the "Gallant Sixty Ninth" on the Rebel Batteries.*

Currier and Ives found glory in Second Bull Run by focusing only on the first day of that battle, August 29. The inscription for both prints of *The Second Battle of Bull Run, Fought Augt. 29th 1862* (undated) simply states, "Between the 'Army of Virginia' under Major General John Pope, and the combined forces of the Rebel army under Lee, Jackson, and others. This terrific battle was fought on the identical battle field of Bull Run, and lasted with great fury from daylight until after dark, when the rebels were driven back and the Union Army rested in triumph on the field." In the picture, Union troops charge the Confederate line, which is breaking and beginning to flee.

Like Lincoln, Currier and Ives seized upon even the technical nature of the victory at Antietam to proclaim a glorious victory. In two prints titled *The Battle of Antietam* (undated), the firm proclaimed the "splendid victory . . . achieved by the Army of the Potomac, commanded by their great General George B. McClellan, over the rebel army under Lee, Jackson, and a host of others, utterly routing, and compelling them to a precipitate retreat across the Potomac to save themselves from capture or annihilation." Union troops are shown charging on white horses under a Union flag. Confederate troops, on foot and accompanied by their flag, break ranks and begin to flee. At the center of the print, reminding viewers of the dear price to be paid for such "victories," a Confederate soldier bayonets a Union soldier, who topples from his rearing horse.

It should be noted that in their determination to exalt Union courage in battle, Currier and Ives did not denigrate Confederate valor. Perhaps to underscore the difficulty of Union victory against a worthy foe, Currier and Ives often gave the enemy his due. In *The*

Battle of Sharpsburg (1862), for example, Gen. George McClellan, atop a white horse and brandishing a pistol, gallantly leads Union troops in a charge into Confederate lines that have broken and are in retreat. The caption reads, "In this battle the Federal troops under General McClellan, contended with the great Rebel army commanded by General[s] Lee, 'Stonewall' Jackson, Hill and Longstreet, for three days. The Rebels fought with desperate determination and courage, but the indomitable valor and heroism of the gallant Union soldiers finally prevailed and defeated the enemy with great slaughter."

The Battle of Gettysburg was the most decisive battle of the war. Partly in the hope of winning foreign recognition, partly to encourage dissension and appeasement in the North, Lee decided to carry the war to the enemy. His Army of Northern Virginia met the Union Army of the Potomac on June 30, 1863. On July 1 the Confederates drove the Union forces back through Gettysburg to strong defensive positions on Cemetery Hill and Culp's Hill; the Confederates occupied Seminary Ridge. Lee attacked Gen. George Meade on July 2 and 3 without success. He was repulsed again the next day, whereupon he ordered the now-legendary Pickett's Charge, a direct attack on the strongest part of the Union center on Cemetery Ridge. More than half of the attacking Confederates were mowed down by artillery fire and volleys of musketry before they reached the crest of the ridge. The Union casualties were 3,155 soldiers killed and about 20,000 wounded or missing; 3,903 Confederates were killed and approximately 24,000 wounded or missing. Lee retreated to Virginia. On November 19 the cemetery at the Gettysburg battlefield was dedicated. The principal oration was delivered by Edward Everett, but President Lincoln's brief remarks, in the course of which he referred to "a new birth of freedom," constituted the most memorable of all American addresses.

Currier and Ives pictured the battle at Gettysburg in three undated prints by that title. None represents any particular part of the battle realistically, but instead they simply capture the theme of immense conflict and glorious victory. All three bear the same inscription, which reads in part, "This terrific and bloody conflict between the gallant Army of the Potomac . . . and the hosts of the rebel army of the east . . . end[ed] in the complete rout and dispersion of the rebel army. A nation's thanks and undying fame ever crown the arms of the heroic soldiers who fought with such unflinching bravery this long and desperate fight." Currier and Ives did not picture the dedication of the Gettysburg battlefield or Lincoln's now-enshrined Gettysburg Address.[30]

Although not as well known today as it was at the time, the Union victory at Vicksburg was one of the most significant battles of the Civil War, and Currier and Ives dutifully represented it in two prints, one of which paid tribute to a future president. Following two assaults and a six-week bombardment by Union forces, Vicksburg fell on the same day Lee retreated from Gettysburg, July 4, thereafter altering the nature of the Independence Day celebration in the South. By taking Vicksburg the Union seized control of the entire Mississippi River and successfully split the Confederacy. *Siege and Capture of Vicksburg* (undated) pictures Union troops advancing on Vicksburg. A Confederate flag flies over the ramparts in the distance, below which cannons can be seen pointing toward the Union troops. The inscription reads in part: "Blowing up of one of the enemy's forts and desperate charge of the Union volunteers through the breach . . . after which time the rebels were vigorously pressed on every side by our army and navy, when finding further resistance hopeless, they surrendered on the 'glorious anniversary' July 4th to our victorious arms." The second print interjects Lt. Gen. Ulysses S. Grant into the scene and bears the new title *Lieutenant General Ulysses S. Grant at the Siege of Vicksburg*. It is undated but may well have been published five years or more later, when Grant successfully ran for the presidency and occupied the White House.

Currier and Ives published several prints of Civil War naval engagements. Besides the pictures of battles of the ironclads, some of the firm's best work focused on confrontations on inland waterways. Among the most interesting of those prints are the companion pieces *The Mississippi in Time of Peace* (1865) and *The Mississippi in Time of War* (1865, Fig. 11), both copyrighted just about a month before Lee's surrender at Appomattox. They were drawn by Frances Palmer with considerable unacknowledged debt to George Caleb Bingham.[31]

Palmer produced a substantial number of Currier and Ives's naval war prints. Several of those prints had less to do with specific scenes or battles than with capturing the essence of the war, thereby producing prints symbolic of the war, even warfare in general. *The Mississippi in Time of Peace* is simply a steamboating picture, one of the thirty or more such prints produced by Currier and Ives. Perhaps because Palmer had never seen the Mississippi River, she employed major elements of Bingham's *Jolly Flatboatmen* (1846), notably the figures atop the flatboat at the lower right. In contrast to what Bingham accomplished, the result is a celebration of the burgeoning life, enterprise, and freewheeling activity on the river before the war began.

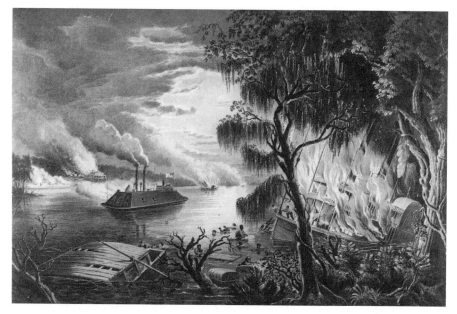

FIGURE 11. *The Mississippi in Time of War.* Currier and Ives (1865).

The companion print symbolizes the nightmare of war. Without reference to any particular battle, Palmer presents the destruction of the previous idyllic scene with the fiery destruction of a paddle-wheel steamer, a half-sunken flatboat, and the dark hull of a Union gunboat bringing retributive destruction to the ultimate symbol of the Confederacy, the plantation house. The river is filled with men swimming for their lives. Unlike most Currier and Ives Civil War prints, *The Mississippi in Time of War* is not about victory but about loss, about "an ugly ironclad Union machine, the product of an advanced industrial economy, destroying the Southern plantation society." Together the two prints convey a moral neither unionists nor secessionists were likely to miss or soon forget. In fact the message increased in popularity after the war ended.[32]

The American Civil War ended unofficially when General Lee surrendered to General Grant at Appomattox Court House on April 9, 1865. His forces having shrunk to fewer than ten thousand soldiers and surrounded by Union troops, Lee accepted Grant's offer to meet with him at Appomattox Courthouse and agreed to terms of surrender. Lee's soldiers were paroled to return home, officers were permitted to retain side arms, and all soldiers were allowed to retain private horses and mules. All other equipment was surrendered to the Union army.

Currier and Ives pictured Lee's surrender in three prints titled *Surrender of General Lee at Appomattox C. H.* The first, dated 1865, is a simple portrait of Grant and Lee sitting across a table from one another, while the latter signs the articles of surrender. Essentially the same print was reissued in 1868 and 1873, during Grant's first campaign for election to the presidency and his reelection to that office, with only minor changes. The men look somewhat different, and an open door has been added through which we can see troops in a nearby field.

When Lee surrendered to Grant, Confederate President Jefferson Davis fled Richmond heading south, continuing to urge his people to fight on. But on May 10, 1865, he was captured by federal cavalry near Irwinsville, Georgia. Purportedly Davis was wearing women's clothes. According to the story that circulated, in an effort to escape capture, he put on his wife's coat, supposedly by mistake, but then his wife put a shawl over his head. Cartoonists had a field day, and some, like Currier and Ives, chose to picture the capture not in serious but in comic form, poking fun and belittling Davis in the process.[33]

In *The Last Ditch of the Chivalry, or a President in Petticoats* (1865) an unknown artist shows Davis fleeing Union soldiers dressed as a woman. Davis is being taunted by the soldiers but verbally defended by a female bystander, presumably his wife. The soldiers variously shout: "Give in Old Chap, we have got a $100,000 [reward] on you!" "It's no use trying that shift [dress] Jeff, we see your boots!" and, from one pointing a pistol at Davis, "Surrender Old Fellow, or we will let daylight into you; you have reached your last ditch!" Davis, who clutches to himself a bag of Confederate gold, replies: "Let me alone you bloodthirsty villains. I thought your government more magnanimous than to hunt down women and children." The woman warns, prompting further humor: "Look out you vile Yankees, if you make him mad he will hurt some of you."

In *The Capture of an Unprotected Female, or The Close of the Rebellion* (1865, Fig. 12), by John Cameron, the Union soldiers continue their taunting of the female-clad Davis, while one woman begs that he be left alone. One soldier exclaims: "You run well old Gal, but your wind gin out, didn't it?" Davis responds: "I plainly perceive that this is another blessing in disguise!! And the greatest of them all!" In *Jeff's Last Shift*, repeating the same scenario, Cameron added a well-dressed Southern male civilian in a top hat, who says to one soldier: "Ain't you ashamed to treat the President so?" The Union soldier quips in return:

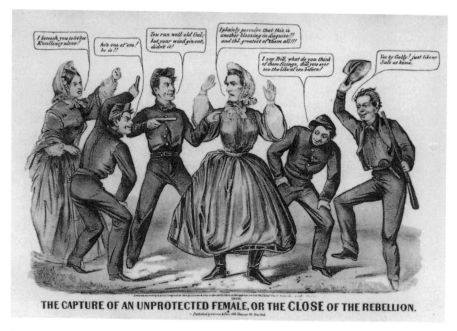

THE CAPTURE OF AN UNPROTECTED FEMALE, OR THE CLOSE OF THE REBELLION.

FIGURE 12. *The Capture of an Unprotected Female, or The Close of the Rebellion.* Currier and Ives (1865).

"President!! Who is he President of?" underscoring the point that the Confederate States of America no longer existed.

Davis has been described as a "leader without legend." The South made him a scapegoat for its defeat, and the North vilified him as a latter-day Benedict Arnold.[34] Currier and Ives's several caricatures of Jefferson Davis are consistent with that public scorn and stand in stark contrast to their respectful portrayal of Robert E. Lee. In the above-mentioned print of his surrender, Lee, the vanquished leader of the lost cause, sits with dignity and composure before a gracious Grant at Appomattox. Davis was confined to Fortress Monroe for two years and then released on bail pending a federal trial that never occurred but left him stigmatized for the rest of his life—he lived until 1889—and beyond. The public quickly forgave Lee and even honored him for his faithful devotion to his beloved state of Virginia, leaving it unclear, even doubtful, that he ever supported secession or slavery. President Andrew Johnson never granted Lee the official amnesty for which he applied, but he nevertheless urged Southerners to work for the restoration of peace and harmony in a united country. Though the

military leader of one section of the nation was pitted against the
other, in the country's bloodiest and most traumatic war, Lee became
an American hero, and Currier and Ives captured that heroic image
in at least ten prints.

Currier and Ives provided portraits of Lee at the grave of
"Stonewall" Jackson, another Civil War hero; at his death; lying in
state; and as entombed. Lee died in 1870, and Currier and Ives
promptly offered its standard deathbed scene. In *Death of General
Robert E. Lee* (1870), Lee lies in bed with his right hand over his heart.
He is surrounded by an entourage of mourners including a physician,
a clergyman, and his family, the women weeping. The inscription
reads: "His deeds belong to history, while his life of devoted, unos-
tentatious piety and firm and living trust in Jesus as his personal re-
deemer, gives assurance that he has received the Christians crown of
glory, and entered into that 'rest that remaineth for the people of
God.'" *The Decoration of the Casket of General Lee* (undated) shows a
young woman placing a wreath on Lee's casket, which bears several
other wreaths and is draped in black.

Commentaries on the War Effort

Although the vast majority of political cartoons published in the
North supported the nation's leaders during the Civil War, some were
critical. Most of the critical cartoons found fault with individuals and
not with any of the war's overall objectives. Cartoonists associated
Lincoln's first secretary of war, Simon Cameron, with wartime profi-
teering. Secretary of State William Seward came under attack for his
handling of the Trent Affair, when the seizure of two Confederate
agents from a British ship brought the United States and Great
Britain close to war. And Gideon Welles, secretary of the navy, was
skewered for his failure to adequately enforce the Union's naval block-
ade of the Confederacy.[35]

Currier and Ives contributed to those barbed and often humorous
criticisms of Union leadership. When the war began, Gen. Winfield
Scott—veteran of the War of 1812 and hero of the Mexican War—
took charge of the Union army. His Anaconda Plan called for divid-
ing the Confederacy along the Mississippi River and blockading the
South, strangling it into submission. Currier and Ives pictured Scott
in *The Old General Ready for a "Movement"* (1861); the uniformed gen-
eral sits on a foxhole labeled "Richmond" and waits for the head of
Confederate President Jefferson Davis to emerge into the noose he

dangles before him. Also pictured are foxes with the heads of Confederate Generals P. T. Beauregard and Gideon Pillow, who attempt to flee to the left and right, but Scott is standing on their tails. The scatological double entendre in the title was no doubt intended, but it was somewhat unusual in its tastelessness for Currier and Ives. It may have been intended to mock "Old Fuss and Feathers" by depicting him squatting, "implying in the caption that he was more constipated than aggressive."[36]

The hope of the North is similarly pictured in *The Hercules of the Union, Slaying the Great Dragon of Secession*, anonymous and undated though almost certainly done in 1861. Scott swings a club labeled "Liberty and Union" at a serpent with seven heads, each with faces of Confederate military and political leaders and the crime against the Union for which he was responsible. Davis is blamed for "piracy," Beauregard for "perjury," and Confederate Vice President Alexander Stephens for "lying."

The disastrous First Battle of Bull Run forced the elderly and ailing Scott to retire. The war continued, however, and Currier and Ives shifted their caricatured praise to later, more successful military leaders. In an undated print, likely done in 1861, an unknown artist for Currier and Ives pictured Gen. Nathaniel Lyon's Union victory over Missouri secessionist forces under Gen. Sterling Price. Like Jefferson Davis, Missouri governor Claiborne Jackson was pictured in defeat as a woman in *The Battle of Booneville, or the Great Missouri "Lyon" Hunt*. Lyon, as a lion, chases Jackson and Price from the field.

Late in 1862 Benjamin Day drew *Breaking That Bone* (Fig. 13) for Currier and Ives. The cartoon addresses the North's search for a way to end the war, including Lincoln's pending Emancipation Proclamation. Jefferson Davis displays the "Great southern Gyascutis," a saber-toothed creature named "Rebellion" advertised as having an unbreakable backbone. Union Generals Henry Halleck and George McClellan wield sledgehammers labeled "Skill" and "Strategy," neither of which had found much success thus far. At the right, Secretary of War Edwin Stanton holds a hammer labeled "Draft," a reference to the draft law of 1862. Lincoln holds an axe labeled "Emancipation Proclamation," which he had issued on September 22, 1862, to become effective January 1, 1863. Stanton says to Lincoln, "Halleck may use his skill and Mac his strategy, but this draft will do the business." Lincoln disagrees, insisting that emancipation is the only approach likely to work. By it he hoped to renew the North's will to win, discourage the South, and make it politically less likely that En-

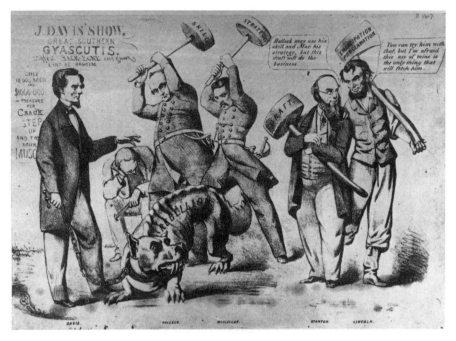

FIGURE 13. *Breaking That Bone.* Currier and Ives (1862).

gland would intervene on the part of the Confederacy. In the background an unnamed man sits, head in hand, despondently holding a small hammer labeled "Compromise."[37]

In 1864 Ulysses Grant took command of the Union forces, and Currier and Ives gave him comic praise in *Why Don't You Take It?*—undated and anonymous but attributed to Frank Beard and quite likely dating to 1864 or 1865.[38] The cartoon pits a ferocious-looking, well-fed, muscular dog, wearing a collar labeled "Old General U.S.," against a thin whippet with "Jeff" on its collar. The dog-general, in plumed hat and epaulets, guards a side of beef labeled "Washington Prize Beef," and taunts Jeff—who wears a broad-brimmed hat and Confederate flag vest—to take it. Behind Grant are barrels of corn, beef, and flour, as well as a cannon; behind Davis is a bale of cotton.

Given the respect the Union held for Robert E. Lee, it is not surprising that in their caricatures Currier and Ives chose Jefferson Davis to represent the South. To show their respect for Lincoln, they often pictured him as representing the Union. In *Caving in, or a Rebel "Deeply Humiliated,"* undated but distributed as early as June 1861, Benjamin Day shows Lincoln and Davis boxing. Lincoln, who has the

better of it, calls Davis a "scoundrel" and explains that he now has his "muscles up" and intends to finish him. Davis, flinching, responds, "Oh! Mr. Lincoln I abandon the 'Defensive policy.' I see that I have undertaken more than I can accomplish." Various European dignitaries watch the contest unfold.[39] The King of Prussia offers, "Go it, Lincoln, I knew he'd be obliged 'to cotton.'" Napoleon III notes, "I will say nothing just yet," and John Bull exclaims, "Ho my! I begin to feel queer. H'im afraid when he has finished Jeff he'll pitch into me." The prize fight, with Lincoln and Davis as contenders, was a device commonly employed during the first year or so of the war; Lincoln is always the victor, or clearly likely to be. At least in part, the motif dates to a story of sixteen-year-old Lincoln in Indiana and his fight with William Grigsby. "The fight," contemporary Dennis Hanks later recalled, "arose over a pup which Abe and Bill each claimed Dave Turnham had promised them." Lincoln won quite easily.[40]

When Currier and Ives were critical of the Union war effort, their criticism was usually aimed at the failure of individuals. *The Blockade on the "Connecticut Plan"* (1862) serves as a case in point. The tongue-in-cheek print is "respectfully dedicated to the Secretary of the Navy," Gideon Welles of Connecticut. Welles was charged with failing to build a navy sufficiently powerful to implement effectively Winfield Scott's blockade of the Confederacy. Though ultimately successful, Welles's progress was too slow for some. In 1862 Currier and Ives pictured two large wooden tubs, flying U.S. flags and armed with tiny cannons, attempting to stop a much larger Confederate steamship, the *Nashville*. The Union captains order the Confederate crew to surrender to their "magnificent" vessels. Failing that, they explain that they will write to the secretary of the navy for further orders. The Confederate officers not only refuse but also taunt the Union sailors, asking them to give the secretary their compliments and to tell him that he would hear from them "by every Northern vessel that we meet." One Union sailor comments wryly, "The only way to capture that ship is to get [J. P.] Morgan to buy her."

In February 1862 the Confederate steamer *Nashville* was able to run the Union blockade. On March 31, 1863, however, it was sunk by a Union ironclad in waters of the Savannah River. The Confederacy had access to more such superior ships—such as the *Florida* and *Alabama*— because they were built under contract with England. After nearly two years of considering whether to ally itself with the Confederacy, or at least offer it official diplomatic recognition as a sovereign nation, Britain opted to remain officially neutral. It adopted the

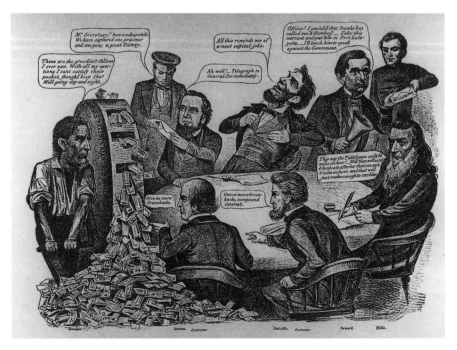

FIGURE 14. *Running the Machine*. Currier and Ives (1864).

Foreign Enlistment Act, which made it a crime for its citizens to en-
list on either side in the Civil War. Much like British willingness to
build ships for the South, however, the policy was ultimately intended
to hinder the Union war effort by discouraging the North's more ef-
fective recruiting efforts in Britain and, especially, in Ireland.[41]

Running the Machine (1864, Fig. 14) is an attack on members of the
Lincoln administration. The title comes from a letter written by
Edwin Stanton, former legal adviser to Lincoln's secretary of war,
Simon Cameron, to former president James Buchanan on July 26,
1861, just after the First Battle of Bull Run. Speaking of the disastrous
Union defeat, he raged: "The imbecility of this Administration cul-
minated in that catastrophe; an irretrievable misfortune and national
disgrace never to be forgotten are to be added to the ruin of all peace-
ful pursuits and national bankruptcy, as the result of Lincoln's 'run-
ning the machine' for five months."[42]

Running the Machine shows Secretary of the Treasury William Fes-
senden directing the manufacture of a flood of greenback money on
"Chase's Patent Greenback Mill" (Secretary of the Treasury Chase
had recently resigned), exclaiming: "These are the greediest fellows I

ever saw. With all my exertions I can't satisfy their pocket, though I keep the mill going day and night," a reference to contractors, munitions makers, and other profiteers who supplied the army with shoddy goods and equipment while reaping a substantial profit. Contractors are shown eagerly demanding more funds. Seward's alleged arbitrary arrests also are not overlooked. Habeas corpus has been suspended, and the secretary of state issues a warrant for the arrest of "Snooks," who has called him a "Humbug." Seward explains, "I'll teach him to speak against the government." Secretary of the Navy Gideon Welles is shown dispatching gunboats to maintain the Union's blockade of the Confederacy that can sail six miles (ten kilometers) an hour to catch a Confederate ship that sails twenty-four miles (thirty-eight kilometers) an hour, and Secretary of War Edwin Stanton appears pleased with the slightest success.

Lincoln was well known for his affection for humor. This may have endeared him to many, but it was also used against him in political cartoons, suggesting that he was unfit for the presidency. In one particularly vicious pro-McClellan cartoon, for example, published in the *New York World*, Lincoln is shown requesting a comic song while visiting the Antietam battlefield still littered with dead and wounded bodies. (He had actually requested a sad song on his way home.)[43] In *Running the Machine* Lincoln, in the midst of the serious business of running the war, is "reminded" inappropriately of "a most capital joke."

For the first year of the war, McClellan, who commanded the Army of the Potomac, was the most visible personality of the Union effort. To many Northerners he was America's Napoleon, an association McClellan welcomed and even cultivated in numerous photographic and lithographic poses that poured from American presses.[44] By November 1862, however, when his campaign against Richmond faltered, McClellan's image tarnished, and he became the subject of taunts and ridicule.

Printmakers satirized McClellan's lack of aggressiveness in a series of prints dealing with the Seven Days battles of 1862, in which he failed to take Richmond. In *Head Quarters at Harrison's Landing* (undated), subtitled "*See Evidence before Committee on Conduct of the War*," an anonymous artist shows McClellan lounging on the deck of a gunboat. Armed only with a glass of champagne, his sword lying at his side, he appears indifferent to the battle raging on shore. Currier and Ives made a similar point in *The Gunboat Candidate at the Battle of Malvern Hill* (1864), probably drawn by Louis Maurer and published during McClellan's presidential bid of 1864. McClellan observes his

troops from a saddle placed over the boom of the ship *Galena*, his highly symbolic saber having been replaced by a field glass. Though actually the name of the vessel, the reference to that Illinois city's native son, Ulysses Grant, then-commander of Union forces, no doubt added to the insult. From that safe distance, peering through his field glass, McClellan speaks: "Fight on my brave soldiers and push the enemy to the wall, from this spanker boom your beloved general looks down upon you."

The common assertion was that McClellan remained aboard the gunboat *Galena* while his army fought the Battle of Malvern Hill. In fact McClellan had set out on the *Galena* before the battle began, to inspect a possible fallback position for his army, which he thought exhausted. The seeming defeatism of the gunboat trip, combined with the risk he took in leaving his troops exposed to attack in his absence, led many journalists and cartoonists to criticize him. In *The Gunboat Candidate* Currier and Ives transformed that criticism into a charge of cowardice.[45]

In the same election year, 1864, Currier and Ives further drove home the point on McClellan by offering a denigrating comparison to his military successor in *The Old Bull Dog on the Right Track*. A diminutive McClellan tries to persuade "Uncle Abraham" not to allow the "old bulldog," Grant, to attack Richmond, pictured as a doghouse at the end of the Weldon Railroad, the Confederate supply route. The doghouse contains Confederate military leaders Lee, Pierre Beauregard, and Jefferson Davis. "I am afraid he will hurt those other dogs if he catches hold of them," McClellan explains, to which Lincoln responds that the Confederates constituted "the same pack of curs" that had chased McClellan aboard the *Galena* in 1862, but that they were by then "pretty nearly used up." The time had come to finish them off. The three Confederate leaders tell Grant, "You ain't got this Kennel yet, old fellow!" but Grant responds confidently, "I am bound to take it."

Views of Secession, Conscription, and Proponents of Peace

Though battle prints constituted the largest number of Currier and Ives Civil War lithographs, other aspects of the war were represented as well, again telling the story from the Northern or Union perspective. The firm addressed secession in a series of political cartoons. Upon receipt of the news that Lincoln had been elected president, the South Carolina legislature called for a state convention, which on December 20, 1860, unanimously passed an ordinance declaring that "the

union now subsisting between South Carolina and the other states, under the name of the 'United States of America,' is hereby dissolved." By January 26, 1861, five other states from the Deep South followed South Carolina's lead; Texas seceded on February 1. Because Texas is absent from the print, Currier and Ives probably produced *The "Secession Movement"* (1861) after January 26 but before word reached them of Texas's action.

The "Secession Movement" includes five figures, representing Louisiana, Mississippi, Alabama, Florida, and South Carolina, riding a pig and donkeys to the edge of a precipice overlooking a body of water labeled "breakers." They are chasing a butterfly labeled "Secession Humbug" and are unaware of the imminent danger. A sixth figure, Georgia—where a large minority opposed secession from the Union—takes a fork in the road and says, "We have some doubts about the end of that road and think it expedient to deviate a little," and although not over the cliff, it nevertheless heads down a slope to the water. The other figures make enthusiastic comments about the prospect of leaving the Union. South Carolina leads the charge, proclaiming, "We go whole hog. Old Hickory is dead and now we'll have it," a reference to the nullification crisis during the presidency of Andrew Jackson, wherein South Carolina threatened secession and was in turn threatened with coercion by Old Hickory. Florida follows, calling ahead, "Go it Carolina! We are the boys to wreck the Union." Alabama calls out, "We go it blind, 'Cotton is King.'" Mississippi cries, "Down with the Union! Mississippi repudiates her bonds," while Louisiana brings up the rear, shouting, "Go it boys! We'll soon taste the sweets of secession."

Currier and Ives published *The Folly of Secession* in 1861 as well. In that cartoon, Gov. Francis Pickens of South Carolina, President James Buchanan—on whose watch secession actually began—and a third man labeled "Georgia" are gathered around a cow, on which is written, "The Union. I have a good Constitution and can stand a pretty strong pull." Pickens pulls the cow's tail, exclaiming, "We intend to smash the Union up!" Buchanan grabs the cow by the horns and responds, "Not if I can prevent it, governor," while "Georgia"—seen by some as hoping to gain from its position on secession—milks the Union cow into a bucket labeled "Savannah," which may allude to that state's seizure of federal Fort Pulaski at Savannah on January 3. He explains to the viewer, "Pull away boys!! Georgia will get the cream of this joke!" The cow warns Pickens that if he pulls too hard on his tail, he'll kick him into the Atlantic Ocean.

Four undated prints on secession, probably done at about the same time, are *South Carolina's "Ultimatum"; The Fox without a Tail; The Dis-United States or The Southern Confederacy;* and *Jeff Davis, On His Own Platform or The Last "Act of Secession."* *South Carolina's "Ultimatum"* was likely produced after January 5, 1861, when President Buchanan ordered reinforcements for Fort Sumter—perhaps after January 9, when his federal supply ship was repulsed as it entered Charleston Harbor—but before March 4, when Abraham Lincoln assumed the presidency. The unknown artist shows Gov. Francis Pickens of South Carolina standing in front of the muzzle of a cannon he is threatening to fire. If Buchanan does not surrender the fort, he warns, "I'll be blowed if I don't fire." The muzzle of the cannon is labeled "Peace Maker." Despite the apparent threat of self-destruction, Buchanan, standing on the other end of the canon, raises his arms and implores Pickens not to fire until he leaves office. Fort Sumter stands in the background.

In *The Fox without a Tail* an unknown artist includes representatives from all of the Southern states, portrayed as foxes below the waist. They meet around an ornate table, on which are a chopping block and ax. An inscription explains the title: "A cunning fox [Governor Pickens of South Carolina] having lost his tale in a trap to save himself from ridicule called a convention of the other foxes and stated to them that having found his tail a great encumbrance he had cut it off, and advised them all to do the same." While members alternately voice approval and concern or reluctance, Pickens, holding a motion for secession, rushes through a vote in favor of their "losing their tails."

In *The Dis-United States*, Currier and Ives comment on the problem the Confederacy faced immediately upon its secession from the Union with dissent within its own ranks. Six men, representing six Southern states, claim supremacy for the interests of their own states, as opposed to seeking the good of the whole. In *Jeff Davis*, the Confederate president stands on a gallows ready to be hanged. He cries, "O dear! O dear! I don't want to secede this way—I want to be let alone." Confederate leaders stand to his right awaiting their similar fate; Union men exclaim, "So perish all traitors to the Union," and "Amen!" Davis was never hanged, but Currier and Ives returned to the image in 1867 with *Jeff. D—Hung on a "Sour Apple Tree," or Treason Made Odious*, wherein Horace Greeley holds open Davis's prison door. Davis, who sees the "sour apple tree" behind Greeley, clings—feet in the air—to Greeley's hair in fright.

Although the much-vaunted early American militia dwindled away in the decades before the Civil War, the call to arms in both North and South that followed secession was met initially with enthusiasm. Volunteers with romantic images of war and personal glory rushed to enlist, expecting to return home in ninety days. The rush slowed, however, as the reality of war and the realization of its likely duration set in, and both sides were forced to resort to a draft or mandatory military service. The Northern illustrated weeklies and Currier and Ives rushed to support voluntary enlistment. Once again *Harper's* took the lead early in the war, when, just after the Union defeat at Bull Run in July 1861, it launched a campaign to boost enlistments. It published cartoons suggesting that men who had enlisted for three months' service at the beginning of the war—the standard, and all that was expected to be needed at that time—but who failed to re-enlist when it became apparent that their continued service was necessary, had not earned the heroes' homecoming they imagined and expected.[46]

In a typical cartoon a properly patriotic wife repels the embrace of her husband with the remonstrance, "Get away! No husband of mine would be here while the country needs his help!" Another implied that men who stayed at home instead of enlisting were not manly. It shows a woman holding her husband on her lap and consoling him, "He shouldn't go to the horrid war, away from his 'wifey, tifey,' and spoil his pretty mustache . . . sweet little boy. He shall have a petticoat and a broom, and stay at home." In view of the widespread opposition of the New York City Irish to conscription, *Vanity Fair* published a cartoon in 1861 showing an Irish parlor maid repelling the advances of an amorous cook: "Don't bother me! Why ain't you away soldering with the rest, you great hulking fellow? Kisses is for them that come back!"[47]

When the Conscription Acts of 1862 and 1863 allowed draftees to hire a substitute or pay a sum of money to secure exemption, *Harper's* cartoonists attacked men who took advantage of those provisions, accusing them by implication of being cowardly or effeminate and suggesting that female acquaintances of such slackers bestow favors only on men enlisted in the service of their country. Nevertheless, for that and other reasons, conscription remained unpopular in certain quarters. Some were even hostile, especially when they concluded that emancipation would produce a flood of Southern freedmen to threaten the jobs of the laboring poor, the most dramatic response being the New York City riot of July 1863.[48]

Instead of bringing pressure directly to bear upon potential Northern enlistments, and perhaps because of their New York City location, Currier and Ives poked fun at the lack of volunteers in the South. In *Southern "Volunteers"* (undated), three well-dressed men are dragged by ropes and prodded by bayonets to "fight for our King Cotton." One of the men protests, to no avail, "Let me go, I tell you. I'm a Union man and don't believe in your Southern Confederacy." In *The Voluntary Manner in Which Some of the Southern Volunteers Enlist* (undated), attributed to Thomas Worth and the year 1861, a shabbily dressed man is forced into a recruiting office by bayonet.[49] Another "volunteer" is propped against the wall in an alcoholic stupor, perhaps having imbibed from the whiskey barrel upon which a recruiter does the paper work. A small dog urinates on him. Signs describing exaggerated, even mythical, Confederate glories hang on the walls. One announces that Lincoln has committed suicide and that Washington is about to be taken. Another announces the South's "glorious victory" at the Battle of Booneville, and the third reports that the property of J. C. Smith is to be confiscated and sold, the proceeds going to the Confederate cause, because Smith has been suspected of "favoring the unholy and wicked designs of the North."[50]

Northern war weariness revived talk of negotiations for peace during the presidential election of 1864. The majority of the firm's prints supported Lincoln although acknowledging the opposition's appeal to a war-weary Union. *The True Peace Commissioners* (undated), attributed to John Cameron, shows Jefferson Davis and Robert E. Lee, back to back, surrounded by Union Generals Philip Sheridan, Ulysses Grant, and William Tecumseh Sherman and Adm. David Farragut.[51] They demand Southern surrender, in response to which Lee continues to brandish his sword and Davis, unarmed, raises his arms in self-protection. Sheridan explains to Davis and Lee, "You commenced the war by taking up arms against the government and you can have peace only on the condition of your laying them down again." Grant and Farragut demand unconditional surrender, to which Sherman adds, reflecting continued concern in the North as well as the South over Lincoln's Emancipation Proclamation, "We don't want your negroes or anything you have; but we do want and will have a just obedience to the laws of the United States."

Lee responds to the demand for his surrender by proclaiming that he will not surrender but that he is willing to consider an armistice and suspension of hostilities "through the Chicago platform." The reference is to that plank in the Democratic platform for 1864, agreed

to at the party's Chicago convention, which declared that "after four years of failure to restore the Union by the experiment of war" immediate efforts should be taken to reach "a cessation of hostilities" through negotiations.[52] Davis agrees, adding that if they could "get out of this tight place by an armistice, it will enable us to recruit up and get supplies to carry on the war four years longer"—the same position taken by many Northern opponents to the Democrats' call for negotiations with Confederate leaders.

The True Issue or "That's What's the Matter," the title likely taken from Stephen Foster's popular anti-Southern song, "That's What's the Matter" (1862), distributed in August 1864 following the Democratic Party's national convention, represents Currier and Ives's "minority opinion." Abraham Lincoln and Jefferson Davis are having a tug-of-war over a map of the United States, which has begun to tear apart. Lincoln proclaims, "No peace without Abolition"; Davis responds, "No peace without separation." A uniformed Gen. George McClellan, Democratic Party candidate for president, stands heroically between them, holding each by the lapel and preventing their further tearing the map. He proclaims, "The Union must be preserved at all hazards."[53]

Even Lincoln understood the support for this position. On August 23, 1864, on the eve of the Democratic convention, Lincoln wrote, "This morning, as for some days past, it seems exceedingly probable that this Administration will not be re-elected. Then it will be my duty to so cooperate with the President-elect as to save the Union between the election and the inauguration; as he will have secured his election on such grounds that he cannot save it afterward." John Hay, Lincoln's secretary, recorded that "he then folded and pasted the sheet in such manner that its contents could not be read. As the Cabinet came together he handed this paper to each member successively, requesting them to write their names across the back of it." On November 11, 1864, having been reelected, Hay continued, Lincoln took the piece of paper from his desk and said to his cabinet, "Gentlemen, do you remember last summer I asked you all to sign your names to the back of a paper of which I did not show you the inside? This is it." He then read the memorandum and explained both his fears of losing the election and his intention of cooperating with McClellan. Everyone present was no doubt relieved to realize Lincoln would not have to follow through on his pledge but would continue to pursue his plan to end the war.[54]

Slavery and Politics

As one might expect, slavery was the subject of hundreds of popular prints during the Civil War. From the 1850s through the 1870s, the dominant image of slavery was as the catalyst of disunion. Throughout this period Currier and Ives produced a series of political cartoons that were critical of, and even held up to ridicule, the influence of blacks on national politics. As early as 1856, in *The Great Republican Reform Party*, they pictured a caricature of an ostentatiously dressed African American standing at the head of a line of "types," "calling on their candidate," John C. Freemont. The others advocate prohibition of tobacco, meat, and alcohol; the right of women to vote; equal distribution of property; free love; and the power of the pope. The black man adds, "De poppglation ob color comes in first—arter dat, you may do wot you please." Fremont, the Republican Party candidate, promises to satisfy them all if elected.

Currier and Ives sent a similar message in *The Democratic Platform*, also produced for the 1856 campaign. Three men in dark suits kneel, supporting a similarly dressed James Buchanan (the party's candidate) lying across their backs. A white Southerner, pistol in hand, and his slave sit facing each other on the "platform" created by the group of four. The Southerner proclaims, "I don't care anything about the supporters of the platform as long as the platform supports me and my niggers." Buchanan complains that he is "no longer James Buchanan but the platform" of his party. Uncle Sam, standing off to the left of the group, warns the Southerner, whom he refers to as "Mister Fire Eater," that he shouldn't "rely too much on the supporters of that platform, they are liable to give way at any moment."

Currier and Ives's criticism of the influence of slavery on politics escalated in 1860 and, despite their growing support for Lincoln, continued prominently in their work through the era of Reconstruction. In *The "Irrepressible Conflict" or the Republican Party in Danger* (1860), for example, Currier and Ives pictured the major Republican figures of the day and a black man trying to keep their boat from capsizing by tossing the Radical William Seward overboard and giving the more moderate Abraham Lincoln the helm. Standing on the bank, Uncle Sam recommends that they "heave that Tarnal nigger out" instead. In an undated print likely produced in 1868, titled *Fate of the Radical Party*, a train engineered by Thaddeus Stevens and Ulysses Grant, but powered by a black man whose head sticks out of the engine's smoke stack, speeds toward its destruction.

At the Front and on the Homefront

Although it is impossible to measure precisely the effectiveness of Northern pictorial coverage of the Civil War, the evidence suggests that it was more effective among civilians at home than among soldiers at the front.[55] Hardened soldiers may have sneered at romanticized pictures of war, but civilians had no such experience. What mattered most to them were the conditions in which their loved ones lived while at the front. Dozens of Currier and Ives prints were intended to satisfy that need.[56]

Life in the army camps was often difficult, at times depressing. Accustoming the green, amateur soldiers of the Union and Confederate armies to the age-old procedures of army life was not easy. Discipline and respect for authority were often wanting; idleness and boredom, constant features of life between battles. Matters grew worse when the call for volunteers gave way to conscription, when those anxious to fight were replaced by those who could not avoid it, and when enthusiasm for the war gave way to resistance or resignation.[57]

In the late summer of 1863 Maj. James H. Connolly wrote to his wife of his life in the Union army, "If you could see me in my rags and dirt . . . you would laugh immensely, and if my dear mother could see me she would laugh and then cry to see me looking so much like a beggar man." Only two years before, Connolly had left his wife and son and a comfortable law practice to fight for the Union. Since then he had been at Chattanooga, Chickamauga, and Missionary Ridge, and he had lived in the mud and rain and dirt of a hundred different camps and bivouacs. His once-fine uniform was in rags. His coat was torn at the elbows and the lining was missing. The soles of his boots were "gone up," and his hat was "the very picture of misery and dilapidation." This was not what he had expected. He remembered that as a young boy "I used to read stories about the Mexican War, and earnestly wished I was a man, so that I could go to war like the men in the pictures, wearing a nice blue coat and red pants, flourishing a great yellow sword over my head, and dashing into the thickest of the fight on a furious, coal black horse."[58]

For Connolly the pictures had been misleading; reality had not matched fantasy. Nevertheless, perhaps to Connolly's relief, Currier and Ives avoided that reality, giving their audience a more sanitized and upbeat picture of their loved ones at the front. Though the paintings and prints of other artists showed men wounded and maimed, the awful conditions in prisons such as Andersonville, or even soldiers

living in inclement weather or engaging in the several vices endemic to camps of men at war, no Currier and Ives prints provide any glimpse of these horrors.[59] Currier and Ives thought of themselves as intermediaries between the men in the service and their families and friends at home. They portrayed the camps as pleasant sanctuaries where men relaxed from the tensions of war.

Typical of Currier and Ives's portraits of Union camps is Thomas Nast's *Life in the Camp: "Preparing for Supper"* (1863). In this print a group of well-dressed and clearly quite healthy and content, if serious, Union soldiers gather around a campfire on which a cook is roasting two pigs. Other soldiers work or talk nearby. Rows of neat and orderly tents can be seen in the distance. More suggestive are Currier and Ives's companion prints, *The Soldier Boy: "Off Duty"* (1864) and *The Soldier Boy: "On Duty"* (1864). In the first a solitary young soldier, hands in his pockets, leans against a tree near a campfire. Three soldiers sit talking in an encampment in the background. In the second, the young soldier stands in front of a cannon on guard duty, resting his arms on the muzzle of a rifle. The American flag flies from a nearby tent.

What is striking about *The Soldier Boy* prints is the youth of the soldier. Available statistics, which if anything overestimated the age of Northern soldiers (many having lied about their ages in order to enlist), show that over 225,000 teenagers served in the war.[60] In comparison with prints of children playing at war, "these were not portraits of children imitating adults in homemade uniforms; these showed children brought too early to maturity, . . . compelled by 'war spirit' and other exigencies into premature adulthood, not to mention grave danger." But that was as far as Currier and Ives would go. Nowhere did they provide the more realistic scenes of these teenaged soldiers exposed to the bloodshed and horrors of war, or even the vices of their more senior comrades in arms.[61]

Currier and Ives emphasized the emotional attachment between the soldier, young or old, and his home and family for whom he fought. In *The Soldier's Dream of Home* (undated), in an appropriately oval sentimental scene appropriate for the soldier's wife, a Union soldier lies asleep next to a campfire and dreams of being reunited with his wife and small son. A companion piece to this print in a matching oval shape is *The Soldier's Home, the Vision* (1862), in which a woman sleeps on a divan dreaming of her husband, who carries a flag as he leads the Union army in battle. The inscription for this print reads,

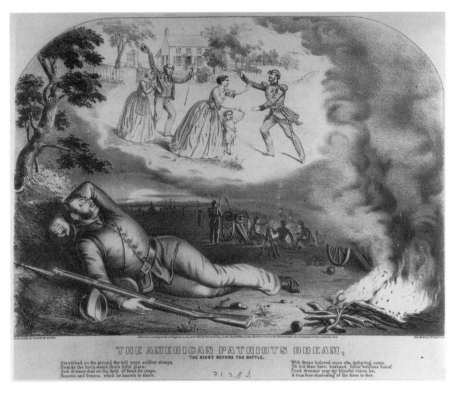

FIGURE 15. *The American Patriots Dream/The Night before the Battle*. Currier and Ives (1861).

Ever of him who at his country's call,
Went forth to war in freedom's sacred name;
She thinks in waking hours: and dreams are all,
Filled with his image,
On the field of fame.
She sees her hero foremost in the fight,
Bearing the glorious banner of the free;
Triumphing o'er the traitors boasted might,
Then home returning crowned with victory.

In *The American Patriot's Dream / The Night before the Battle* (1861, Fig. 15), a soldier will soon be entering battle—no doubt his wife's, if not his own, greatest fear. Nevertheless, while his comrades huddle sleeplessly around a campfire, he dreams of his triumphant return home and the welcome of his wife, child, and aging parents:

Stretched on the ground the toil worn soldier sleeps,
Beside the lurid watch fire's fitful glare;
And dreams that on the field of fame he reaps,
Renown and honors, which he haste's to share.
With those beloved ones who gathering come,
To bid their hero, husband, father "welcome home,"
Fond dreamer may this blissful vision be;
A true foreshadowing of the fates to thee.

Such scenes no doubt reassured many families that their men in arms remained inspired, even protected and blessed, by thoughts of home and hearth.

Currier and Ives's prints that focused on the homefront were equally positive and often sentimental. *The Brave Wife* (undated) and *Off for the War: The Soldier's Adieu* (1861) repeat the theme of the soldier departing home that we saw in prints of the American Revolution. In *The Brave Wife* a Union soldier stands between his small son, who rubs a tear from his eye and holds on to his father's sleeve, and his wife, who fastens her husband's scabbard. A toy drum lies on the floor; a framed portrait of a soldier on a rearing horse is on the wall. The inscription celebrates the bravery of volunteers, the nobility of their spouses, and the unspoken understanding that each farewell might be the last:

The wife who girds her husband's sword,
Mid little ones who weep or wonder,
And bravely speaks the cheering word,
What tho her heart be rent asunder. . . .

Doomed nightly in her dreams to hear,
The bolts of war around him rattle,
Hath shed as sacred blood as e're,
Was poured upon the plain of battle!

In the three prints titled *Off for the War*, a Union soldier and his wife and son embrace at the gate to their yard. In one version the volunteer appears quite young, in a private's simple uniform. In another, perhaps designed for members of the officer class, the soldier, fully bearded, sports emblems of rank on his uniform and wears a saber and sash. In one version of the second scene, a formation of soldiers stands nearby, carrying guns with bayonets straight up and a Union flag. In

another the other soldiers are missing; the picture focuses on the family. All three picture a family and home, flowers blooming behind a picket fence in front of a substantial two-story house, amidst acres of lush property—all worth fighting for.[62]

Currier and Ives also pictured the soldier's return. In *Home from the War / The Soldier's Return* (1861) the Union volunteer of the previous print returns from his tour of duty. He has grown a beard, evidence of his hard living and maturing during the campaign. His wife wears the same black dress with white lace collar that she wore when he departed, attesting perhaps to the sacrifices she made to maintain their home while he was away. The flowers in the yard are in bloom, once again. It has been suggested that the flowers reflect expectations early in the war that the campaign would be brief—even within one season—and victorious.[63]

In 1863 Currier and Ives returned to the same theme in *The Union Volunteer / Home from the War*. In this more elaborate print, as if to compensate for the intervening years and the prospect of more to come, a veteran, sporting a colorful sash and a saber denoting his rank, returns to "the cathedral of American life," the parlor, to his wife's embrace and to his mother's and two children's warm welcome. The Victorian parlor—typically ornate, cluttered, but still inviting and comforting—promises the well-earned peace and quiet the soldier so richly deserves.

As in any war, wounded soldiers returned from the front to their homes, as well. That is the subject of Currier and Ives's *The Story of the Fight* (1863), wherein a solider, sitting with his bandaged leg propped on a stool and a crutch beside him, relates his war experiences to another man, two women, and two children at a table that is being set for tea. A dog lies at his feet. Currier and Ives recorded his story in verse:

T'was there amid the storm of fire,
Of shot and bursting shell,
Upon the ramparts bloody slope, our standard bearer fell,
But as in death his eye grew dim, one look on me he cast,
Which nerved my arm and thrilled my heart as with a trumpet blast,
And forth I sprang and seized the flag, and up the steep I bore,
And planted it in triumph there amid the battle's roar.
Around me gleamed the clashing steel, I felt the deadly thrust,
But down the rebel ensign tore, and tramp'd it in the dust,
I saw my comrades pressing on, and heard their rallying cry,

I heard their glad victorious shout and saw the foemen fly,
A moment more and sound and sight were fading fast away,
Bleeding and senseless on the ground beneath the flag I lay.

Women were involved in the Civil War as well as men. At the very
least, most had loved ones at the front about whom they worried while
they kept their homes, farms, and businesses functioning. But they
also played a more active role. At the start of the war, many supported
the troops by making handsome colors for the volunteer units. Some
worked in factories producing weapons and other war material. Later
they made bandages and dressings for the wounded, held gala events
where they raised money for the war effort, and, in some cases, served
as nurses in the many war hospitals.[64]
Many Northerners did not approve of women's work outside the
home, even during war, and clung to the belief that the battlefield was
no place for women—and that those who defied tradition to nurse
male soldiers compromised their femininity.[65] Currier and Ives did
not dwell on this aspect of the war, but they did memorialize it in a
few highly sentimentalized prints. In *The Angels of the Battlefield* (1865,
Fig. 16), they likened Civil War nurses to celestial guardians. A
winged angel hovers over a nurse, who attends to a wounded soldier
fallen on the battlefield. The winged angel from heaven shines light,
or healing rays, from a haloed, heavenly crown on the victim and on
the earthly angel-nurse who works to save her patient. The battle
rages on in the background, and dead bodies are strewn about the
field. An American shield and stars have been placed at each corner
of the print, adding a patriotic imprimatur to the scene.
The theme of children responding to the war occurs in *The Little
Recruit* (1863), in this case mimicking it in their play rather than
mourning their father's departure. During the early years of the war,
images of the dashing general George McClellan in full-dress uni-
form were everywhere. Not surprisingly, "Little Mac" became an idol
for Northern boys. In *The Little Recruit* a little boy wearing a military
costume, drawn from McClellan's image, stands at the knee of his
seated mother and plays a drum. His sister holds an infant in her arms
and waves a small Union flag in front of him. Through a door we can
see other boys playing soldiers.
In Thomas Nast's *Light Artillery* (1863) a little boy dressed in a
Union uniform consisting of a paper hat, hairbrush as an epaulet, a
sword, and boots stands next to his rocking horse ready for battle.
Bottles serve as cannons and protect a fort constructed of an upended

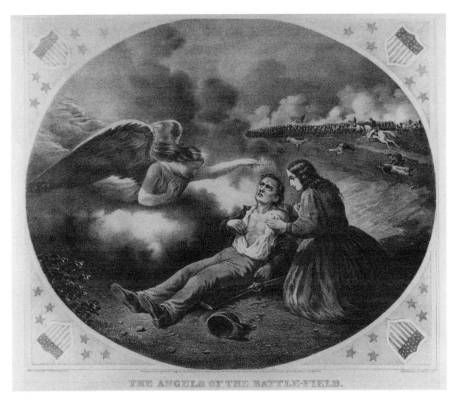

FIGURE 16. *The Angels of the Battlefield.* Currier and Ives (1865).

book topped by an American flag. In Nast's *The Domestic Blockade* (1862) a domestic servant, with comical brogans adorning her feet, raises her broom in mock defense as she confronts two children of the house, who have blockaded the entrance to the kitchen with furniture, tubs, and basins. The boy is dressed like a Zouave and carries a bayoneted stick; the little girl is dressed in a white dress, carrying a flag.

Portraits of Death

Finally, Currier and Ives had to deal with the loss of life caused by the Civil War and especially that the assassination of Abraham Lincoln. A few printers did so in gruesome detail, but most provided sanitized, even romanticized and sentimental scenes of dying soldiers.[66] Currier and Ives addressed the subject mainly in their memorials. In *The Soldier's Grave* (1862), to which personal information could be added to memorialize the fallen, a woman kneels, weeping at a tombstone bear-

ing the inscription: "In memory of ———— of the ———— Who Died at ———— 186————. A Brave and Gallant Soldier and a True Patriot. His Toils Are Past, His Work Is Done; And He Is Fully Blest; He Fought the Fight, the Victory Won, And Enters into Rest." The tombstone is surmounted by an American eagle and inscribed with other military symbols. A platoon of soldiers marches away from the grave. The next year the firm issued essentially the same print under the title *The Soldier's Memorial*, but it replaced the eagle with an urn, giving it a less patriotic tone and more personal sense of loss. It may be that the change was not welcome, because when Currier and Ives marketed the same picture in 1865 for the third time, the eagle was back.

Abraham Lincoln died at 7:22 A.M. on Saturday, April 15, 1865, only a week after Lee's surrender at Appomattox Courthouse, as much a victim of the war as any. He had been shot nine hours earlier in Washington, D.C., at Ford's Theater, where he had gone with his wife and two guests for a performance of the English comedy, *Our American Cousin*. It was Good Friday on the Christian calendar, a point not missed in this very Christian of nations.[67]

Harry Peters claimed that Lincoln "was made to order for the house of Currier, which made the most of him," but that assessment needs to be qualified. Before his assassination, except in a handful of campaign prints, Lincoln was mostly the subject of political cartoons, often caricatured for his ungainly appearance and criticized for his performance. After his assassination Currier and Ives pictured him as a national martyr. As Secretary of War Edwin M. Stanton reportedly commented at Lincoln's deathbed, tears streaming down his cheeks, "Now he belongs to the ages."[68] And indeed he did; the apotheosis of Abraham Lincoln had begun.

Before his assassination Lincoln had been many things to Americans: politician, president, commander-in-chief, and emancipator, as well as tyrant, usurper, dictator, and buffoon. After his death he became "the prophet, savior, and martyr." This redefinition of Lincoln's place in American thought, his swift transcendence from history into folklore, was one of the more remarkable cultural phenomena of our history.[69]

Like Moses, some claimed, Lincoln "had passed through battle, sorrow and war; had climbed the heights," and then, once the Lord had "showed him all the land," he died. To others he was Christ reincarnated, perishing in a modern "week of sorrows, in gloom and blood." Many pastors pointed out that "Good Friday was the day, of all days in the year, chosen by the murderer for his infamous deed."

The pastor of St. Paul's Church in New York City summed it up this way: "His death was on Good Friday, and his last official words [a reference to his Second Inaugural Address: "With malice toward none; with charity for all"], in substance, 'Father, forgive them for they know not what they do.'"[70]

Currier and Ives churned out many Lincoln pictures: assassination and deathbed scenes to respond to the need for visualizations of the awful deed and its aftermath; reverential portraits that celebrated the martyr in romantic picture and caption, disguising all flaws in an attempt to heroize and mythify; new emancipation tributes to the modern Moses; fanciful pictures of Lincoln with George Washington; scenes portraying the Lincoln family at home; and more.[71]

Abraham Lincoln: The Martyr President and *Abraham Lincoln: The Nation's Martyr* were reissued nine times—at least four in 1865, the rest undated. All but one of the prints picture a bust of the bearded president and bear the simple inscription "Assassinated April 14th, 1865." Another undated print, *Abraham Lincoln: The National Martyr*, depicts the slain president in the company of his generals, Ulysses S. Grant and Philip H. Sheridan.

To satisfy the national curiosity over details of the tragedy, Currier and Ives offered for sale a print of the assassination itself that was fairly accurate, in its presentation of the event and its placement of the principal characters, but that was also dramatic and patriotic. Titled *The Assassination of President Lincoln: At Ford's Theatre, Washington, D.C., April 14th, 1865* (1865), we see Lincoln being shot in the back of the head as he sits in a theater box. Maj. Henry Rathbone makes a futile motion to stop the assassin, while John Wilkes Booth stands behind Lincoln, pistol in one hand, dagger in the other. Also pictured is Mary Todd Lincoln and Clara Harris, who had accompanied Rathbone. In an artistic embellishment, Lincoln clutches the American flag, the symbol of the Union to which he had sacrificed himself. It drapes down from the ceiling to his left. Lincoln lifts his right hand, palm upward, toward the viewer, as if to ask, Why?

And, of course, Currier and Ives pictured Lincoln's deathbed and scenes from his lying in state or funeral, often sold as companion prints to their assassination pictures. In *The Death Bed of the Martyr President Abraham Lincoln*, Lincoln is pictured at the moment of his death, which, the subtitle tells us, is "Saturday morning April 15th 1865, at 22 minutes past 7 o'clock." He lies in bed, his right hand held by his surgeon. Lincoln is surrounded by important people, including Vice President Andrew Johnson, Secretary of War Edwin Stanton,

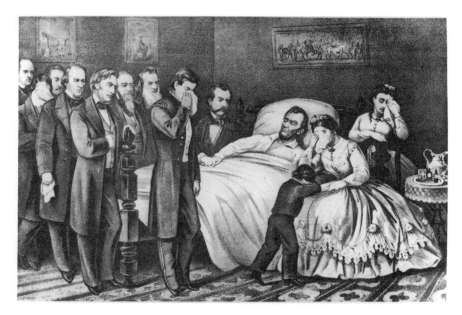

FIGURE 17. *Death of President Lincoln . . . The Nation's Martyr.* Currier and Ives (1865).

Charles Sumner, and Chief Justice Salmon Chase, as well as his son, Capt. Robert Todd ("Tad") Lincoln. Clara Harris, Mrs. Lincoln, and son Tad (Thomas) Lincoln can be seen through a door in an adjoining room. In another print of essentially the same scene, *Death of President Lincoln . . . The Nation's Martyr* (1865, Fig. 17), Harris, Mrs. Lincoln, and Tad have joined Lincoln; Mrs. Lincoln leans on the bed and weeps into a handkerchief, while Tad buries his head in her lap.

As one student of the event found in such deathbed scenes, Lincoln is shown without pain or even discomfort. His surgeons are depicted sitting stoically at his side and not frantically at work, laboring to keep Lincoln's wound open and free from clots so he could breathe and periodically cleaning the blood and brain tissue from his pillows. No blood is shown, and the number of people attending Lincoln's deathbed is exaggerated. Lincoln died in a tiny bed chamber capable of holding no more than six or seven people at a time, not the dozen or more commonly pictured (as many as forty-six in a later print, not by Currier and Ives). In reality Tad was not present at his father's deathbed, as he had not been allowed to leave the White House; neither were Salmon Chase, Andrew Johnson, nor even Mrs. Lincoln. Stanton barred her from the room when her outbursts grew

unbearable to the other attendants. But pictured she was, because her absence and that of her son would not have satisfied an American audience overcome with sympathy and sentiment, who wished the first family united in death.[72]

In *The Body of the Martyr President: Lying in State at the City Hall, N. Y. April 24th and 25th 1865* (1865), a viewing line passes by Lincoln's coffin en route to its final resting place in Illinois. It is positioned beneath a large, draped entryway, a bust of Lincoln sitting atop the drapes. That scene is continued in *The Funeral of President Lincoln* (1865), wherein, on April 25, Lincoln's funeral car, draped with black cloth trimmed with silver, passed Union Square. The funeral coach is drawn by eight pairs of horses bedecked with ostrich plumes, while soldiers stand in the background and mourners crowd the streets and peer from windows above. And then there is Currier and Ives undated print of Lincoln's tomb in Springfield, Illinois.

On Easter Sunday, ordinarily a day of joy at the Resurrection of the Christian savior and the hope he represented for the future, but known as Black Easter on this occasion, Americans mourned the martyrdom of the nation's savior and wondered as to the country's future. From every pulpit came the same questions: What was God's purpose—the same God who had chosen the nation as his own—in allowing Lincoln to be killed? What lessons were his people to draw from it?[73] Different people drew different lessons, from forgiveness to retribution or vengeance.

Lincoln had made clear that his great objective in the war was to preserve the Union. As he wrote in a famous letter to Horace Greely in 1862, "My paramount object in this struggle is to save the Union. . . . If I could save the Union without freeing any slave I would do it, and if I could save it freeing all the slaves, I would do it, and if I could save it by freeing some and leaving others alone I would also do that."[74] It was, therefore, natural that Americans would soon picture the slain Lincoln, who had saved the Union, with the president who had formed it. Funeral banners proclaimed, "Washington the Father, Lincoln the Savior," and orators explained that both men were necessary to complete our history; neither could have done it alone. Washington remained the most sacred of American heavenly hosts, but he was joined, if as a junior partner, by Lincoln.

Currier and Ives paired them pictorially in *Washington and Lincoln: The Father and the Savior of Our Country* (1865). Washington and Lincoln stand before the eternal flame of liberty with an American eagle

and shield. Lincoln's left hand holds the Emancipation Proclamation, pictorial proof of his twin claims to fame: he saved the Union and abolished slavery. Washington exudes a slight superiority, not only by the anointing motion of his left hand but also by his appearing a bit taller than Lincoln, when in reality it was the reverse. The Father remained superior, but not by much, to the Savior.[75]

Imagining the Frontier

Myth and ideology intersect in images of the American West. Those images serve as vehicles to convert traditional narratives into metaphors, explaining or justifying the way in which the nation perceives itself. In the case of the nineteenth-century West, myths were drawn from accounts of frontier life that exposed the process of nation building in sometimes raw and disagreeable ways. To make them more palatable they were assimilated into a broader, more reassuring evolutionary pattern. Like most myths, they functioned to control history, to shape it as an orderly, even ordained, sequence of events. Complexity and contradiction gave way to order, clarity, and direc-

tion. Myth also functioned as ideology, as an abstraction broadly defining the belief system of the nation.[1]

The frontier has been the single greatest influence in American history, as well as a great resource for images in the creation of a usable, heroic, and divinely inspired past. Americans have had a frontier since colonization began. As one recent observer has noted, the Pilgrims were sailing west when they landed at Plymouth, and from that early point, westward migration took on the dimensions of myth. Confronting each successive wave of settlers was not just the reality of a different geography, but the promise of a new world where Americans could shed the corrupting influences of an overrefined society and be reborn into innocence.[2]

In the second and third quarters of the nineteenth century, the West took center stage, continuing to be a dominant force not only in the geographic, demographic, political, economic, and social development of the United States but also in its cultural development. Whether accurate or not, the influence of the frontier was associated with the growth of democracy in the United States. With the shift from the Age of Jefferson to the Age of Jackson, the common people came into their own. Independent in opinion and self-satisfied, if not smug, with the nation's success, they proclaimed that all people—or at least all white American men—were created equal.[3]

But the art of the West perpetuated other myths as well. Deeply immersed in iconography and laden with symbols readily recognized by all Americans, artists portrayed westward expansion not only as progress but as Manifest Destiny. To most Americans progress was good, but the extension of Anglo-American civilization into the frontier was divinely favored. The West was a Garden of Eden, an unspoiled wilderness much like that into which the first colonists entered to establish their "city on a hill." It provided a gateway to political freedom, wealth, and upward social mobility.[4]

Artists also presented the West as a masculine domain. Gender roles were being rewritten in America, and representations of the West became the canvases upon which those roles were painted and repainted. Put another way, as Eastern urban men struggled with their new masculine identity, they projected their visions of that identity on a land and people they had never seen and knew little about. As these identities were later expressed in Western films, there was "an absolute and value-laden division between the masculine and feminine spheres," linking masculinity with such things as "activity, mobility,

adventure, [and] emotional restraint," and "femininity with passivity, softness, romance, and domestic containment."[5]

In the 1830s the frontiersman was seen as an anarchic figure, fleeing the civilized world of women and families to join the trappers and Indians.[6] Masculinity was equated with lawlessness, violence, savagery, and the abandonment of social restrictions. Western art employed the metaphor of the solitary man challenging and conquering the forces of nature. "Through his courage and skill," the artists' frontiersman "proves his mettle over the forces of nature and, because he accomplishes his task alone, shows that he requires no assistance from civilization."[7] Several decades later, he was presented as a representative of that civilization, blazing the trails for families of settlers moving West. Currier and Ives's images of the West and the Western hero were bracketed by those periods, but the reader should compare these images with those of the Victorian husband.[8]

Currier and Ives helped create and convey the myth of the American West with at least eighty separate prints, not including related cartoons. They witnessed the great drama of westward expansion: the California gold rush, trappers and pioneers traveling into unknown territories, armed conflict with Native Americans, the building of the transcontinental railroad, and the homesteading of the West.[9] Theirs was not a simple pictorial record of events, however: "The prints depicting these events reflect the then-prevalent belief in the right of easterners to dominate the natural environment and to control the political, economic, and cultural life of Native Americans. These prints express fears and fantasies about the West, which was perceived as a vast unknown, offering infinite dangers and rewards."[10]

The California Gold Rush

The California gold rush was an integral part of the westward movement. Nevertheless, as represented in popular culture, it is often treated as separate from but related to that movement. When James Marshall discovered gold in the American River at Sutter's Mill in January 1848, the population of California Territory was fewer than 18,000. The rush to "Eldorado" boosted that number to more than 100,000 by the end of 1849 and led to the petition for statehood that Congress granted in 1850. Eastern newspaper headlines that had for the past decade told stories of frontiersmen, Indians, and pioneers now switched to tales of the forty-niner and accounts of riches avail-

able practically for the taking. As such, at least in California, the West as Eldorado threatened to overwhelm Jefferson's agrarian West in the popular imagination.[11]

To artists the mining camp was more lucrative as a pictorial source than as a source gold. To some, prospectors were heroic characters, men with vision and unafraid of action. (Less than 5 percent of those who migrated to California in 1848 and 1849 were women.)[12] The majority of artists, however, painted the daily life of the gold miner—at work and at play—as tedious and not always harmless. Rufus Wright's *The Card Players* (1882), for example, represents ruthless skullduggery in which the loser threatens the incredulous winner. Some writers satirized such men: Mark Twain in *Roughing It* (1871) and Bret Harte in "The Luck of Roaring Camp" (1868). Their satirical approach was underscored with humor, however, and that was how much of the popular art of the day approached the subject, as well.[13]

In his search for California lithographs to include in his book *California on Stone* (1935), Harry Peters found approximately 750 prints of significance.[14] Most featured the much-vaunted California landscape—the Yosemite Valley, the Sierra Nevada, and the giant sequoias. Walt Whitman celebrated this aspect of California in "Song of the Redwood Tree" (1873–1874):

> The flashing and golden pageant of California,
> The sudden and gorgeous drama, the sunny and ample lands,
> The long and varied stretch from Puget Sound to Colorado south,
> Lands bathed in sweeter, rarer, healthier air, valleys and mountain cliffs,
> The fields of nature long prepared and fallow . . .
> .
> The slow and steady ages plodding, the unoccupied surface ripening . . .
> .
> A swarming and busy race settling and organizing everywhere,
> Ships coming in from . . . and going out to the world . . .
> .
> Populous cities, the latest inventions . . .
> .
> And wood and wheat and the grape, and diggings of yellow gold.[15]

Albert Bierstadt traveled to California in 1863 and again in 1871 and produced several oil paintings of the mountains and valleys, but such scenes were made more widely available in far less expensive, mass-produced lithographs. Such prints reassured Easterners that going to

El Dorado was acceptable. Although some prints satirized the desperation of those who sought only the easy wealth of the gold fields, others portrayed California as the fulfillment of the American Dream, as a terrestrial paradise of natural abundance that awaited those seeking a second, or better, chance.[16]

Representative are Currier and Ives's *Yosemite Valley—California: "The Bridal Veil" Fall* (1866) and *The Route to California* (1871). They might be seen as "before and after" pictures. *Yosemite,* by Frances Palmer (who never went to California), is idyllic and pristine, a straightforward rendering of the lovely Yosemite Valley, which Currier and Ives featured in at least a half-dozen other prints. It shows Bridal Veil Fall before the coming of the white man and his machines. Native Americans are camped along the river, unthreateningly, as if they belonged there as much as the mountains and trees themselves.

In *The Route to California* Currier and Ives picture a train passing through the rugged Sierra Nevada along the Truckee River en route to the Golden State. The Sierra Nevada range, along California's eastern border, served as a formidable barrier to those California bound until the Central Pacific Railroad broke through, just before this print was created—perhaps the event that caused this print to be created and marketed. In addition to the scenic beauty of its tall, rugged, snow- and pine-covered mountains, *The Route to California* may well have encouraged previously reluctant travelers to go West. As with most pictorial representations of the time, including those of Currier and Ives, it did not show the labor involved. When workers were included, as in artistic and photographic records of the joining of the rails of the first transcontinental railroad at Promontory Point, Utah, in 1869, omitted were the thousands of Chinese who were hired for the dangerous and difficult work but were not welcome to stay.

Artists such as James Walker produced somewhat romanticized paintings of the Hispanic past of "Old California." Anticipating pictures of life on the Great Plains, they portrayed vaqueros at the roundup and on long dusty cattle drives.[17] But none of these subjects made it into Currier and Ives's portfolio. Perhaps the Mexican War was still too vivid in the American popular mind to allow nostalgia over the lost culture. Currier and Ives's West belonged to the Anglo-American.

Currier and Ives supported the market for pictures of San Francisco, with its verdant setting, mushrooming and diverse population, and emergent high culture. The company produced at least five city views—in 1851 (two), 1877, 1878, and 1889—showing the city's dramatic

growth. But in notable contrast to the types that were the staple of genre prints in the pictorial rendering of the rest of the West, these did not appear to any significant extent in the popular art of California. There are simply none equivalent to Arthur Tait's frontiersmen. Some artists tried to incorporate the miner into the Western myths of American rugged individualism and self-reliance. In *Miners in the Sierras* (1851–1852), for example, Charles Nahl (with Frederick Wenderoth) shows miners working their claim with diligence and a kind of cooperative individualism. They are Anglo-Saxons, even though the California mining population included several other ethnic groups, most notably Mexicans.[18] But such images were rare, and they were not prominent in popular art. Currier and Ives and other lithographers and engravers depended on scenic vistas and on humor and satire, which reflected other strongly held attitudes of the time.

Currier and Ives published a serious print, *Gold Mining in California* (1871), that showed the major techniques of placer mining— pan, rocker, sluice, and hydraulic hose—and a few comics. The gold miner as a type, however, is missing. Only an antitype remains. In their caricatures of the California gold rush, Currier and Ives played on the themes either of the down-at-the-heels Easterners hoping to strike it rich in California or of those who abandoned respectable occupations to hunt for gold and on their quick return denied that they had gone broke. The exploitation of mineral wealth was usually associated with instability. The people who sought riches typically rushed in and established themselves during the first months after the discovery of gold, stayed while the mining was good, and then left. The forty-niner fit this description and was represented as simply a variation on speculating Americans everywhere who were ever after the main chance. The image conveyed the lesson that the haste to gain riches through such efforts leads to the wreck of individual and collective character.[19]

Nathaniel Currier published a series of such caricatures in 1849, titled *The Way They Go to California, The Way They Cross the Isthmus, The Way They Wait for "The Steamer" at Panama, The Way They Raise a California Outfit, The Way They Get Married in California*, and *The Way They Came from California. The Way They Go to California* (1849, Fig. 18) by an unnamed artist, depicts a frenzied mob of would-be miners trying to board a vessel bound for the gold fields. Overloaded ships sail toward the horizon as desperate passengers left behind wave picks and shovels in the air and jostle each other off the dock. Unique to this print are the wonderful and imaginative contraptions flying

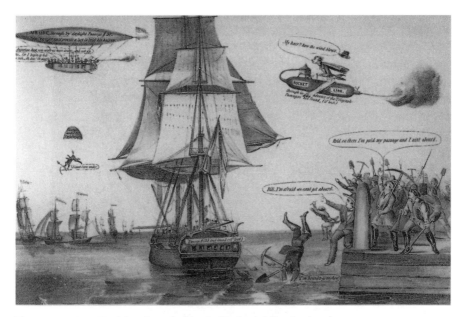

FIGURE 18. *The Way They Go to California.* Nathaniel Currier (1849).

above the ships—a dirigible, a hot-air balloon, and a sausage-shaped "rocket"—all intended to get Americans to California first.[20]

The Isthmus of Panama could only be crossed on foot, on pack animals, and on small boats. It could be dangerous, but it was faster than sailing around the tip of South America, so many took the chance. *The Way They Cross "The Isthmus"* (1849) caricatured that ordeal. Watched by an alligator, two small, overloaded boats transporting forty-niners approach the isthmus. A line of donkeys ridden by men carrying pickaxes heads into the hills. One man announces that he smells gold, but most worry about their safety—one announcing that he has cholera.

In *The Way They Wait for "The Steamer" at Panama* (1849), John Cameron continues the "story" by picturing a large, disgruntled crowd of prospective miners, many of them drunk, who have just completed the trek across the Isthmus of Panama. They strike a discordant note, one recalling the resentment Americans felt at the attraction of "foreigners" to the California gold fields. While the men wait for the steamer on which they will complete their journey, some hoist a banner announcing an "Indignation Meeting." In front of that banner a man makes a speech threatening war on all non-Americans who come

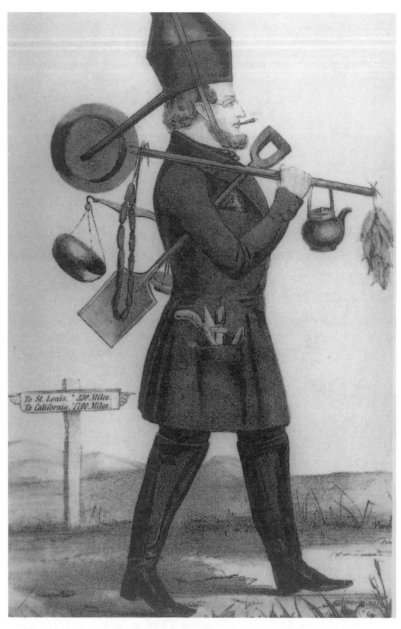

FIGURE 19. *The Independent Gold Hunter on His Way to California.* Nathaniel Currier (1850).

to California to dig gold. Another man holds up a proclamation asserting that all foreign gold diggers are trespassers.

Most forty-niners traveled overland to California, and Currier satirized their preparation for the trip in *The Way They Raise a California Outfit* (1849). The unknown artist shows a man in ragged clothes offering two scrawny dead chickens for sale. "Here saay, take the pair fur four shillin," he offers. "You won't? Well what'll you give—say I'm bound to sell um cause I'm up for Kaleforny." Written on the side of his wagon is "Overland route too Kaleforny."

In 1850 Currier produced a related but quite different caricature of forty-niners taking the overland route to California. *The Independent Gold Hunter on His Way to California* (1850, Fig. 19) shows a more composed but still humorously satirized gold seeker traveling overland on foot. Outfitted with the most practical equipment—a shovel, a set of scales, a kettle, a gold processor that doubles as a hat, a gold washing basin, and a frying pan, whose long handle also serves as a fishing rod—the prospector, who "neither borrow[s] or lend[s]," has already walked halfway to California. In the background a road sign confirms that St. Louis lies 350 miles (560 kilometers) behind him, and that California is 1,700 miles (2,720 kilometers) ahead.

Unlike the characters in the series *The Way*, this prospector remains completely composed. The long journey has not adversely affected the tidiness and the confidence of the "Independent Gold Hunter," set apart from the crowd. His unflagging determination is evident in the jaunty way he clamps his cigar between his teeth, grips his gear, and strides forward with confidence. But therein lies the irony of this particular print. In this print of the supremely confident and practical man, Currier "laughed at the impractical optimism of the nation's new universal man—the gold seeker."[21]

The Way They Get Married in California (1849) has been lost, as has been any description of it, but *The Way They Came from California* (1849) completes the story. It depicts a sailing vessel leaving California for New York, packed with homebound prospectors who had struck it rich, while hordes of similarly successful forty-niners mob the shore, even jumping into the water to swim to the boat, clutching large sacks of gold. One person aboard ship exclaims that they simply cannot take anyone else because they already are carrying enough gold "to sink a navy." Another expresses his fear that the ship may sink, and then: "What will become of our gold?" Nevertheless, on shore several voices beg to be allowed to board, one offering a million dollars for the privilege, another accusing the captain of reneging on

his agreement to provide return passage after he had received his portion of the prospector's wealth. A third laments, "You won't catch me going away from home again without my mother knows I'm out." The demand for a faster way to travel from the East Coast to the gold fields stimulated some creative inventions, like Rufus Porter's "Air line to California." At the height of the gold rush, Porter, founder of *Scientific American,* unveiled in New York a model of his 1,000-foot- (304-meter-) long propeller-driven balloon, to be powered by two steam engines. He predicted that the trip on his "Aerial Locomotive" would take no more than five days, and maybe only one. He quickly signed up two hundred passengers at fifty dollars a head, but many—including Nathaniel Currier—were skeptical. Thus the image of the sausage-shaped "rocket" in *How They Get to California.*[22]

Another satirical piece on the same theme is *Grand Patent India-Rubber Air Line Railway,* issued in 1849. The cartoon pictures eight people straddling a rubber rope that stretches through the air, visibly anchored on one end to a pole topped by an American eagle. A workman climbs the pole and prepares to cut the rope with an ax, presumably sending them "sailing" through the air across the continent to California. Above them a man rides through the air on one of Rufus Porter's "Aeroplanes." The inscription reads

> From the Atlantic to the Pacific, through in no time. The principle of the railway is such that if the passengers are nicely balanced both in mind and body, all that is necessary to land them at the "gold diggers" is to cut the line on the Atlantic side, then by one jerk, they reach in safety their place of destination. Reverse the above and they are back again—what is claimed in this patent, is having discovered the immense expansion and contraction of India rubber.

The series *The Way, The Independent Gold Hunter,* and *The Grand Patent* satirized those who succumbed to the lure of the get-rich-quick scheme, which the gold fields of California came to represent. Whether caricaturizing crowds of desperate travelers, the steely determination of the "Independent Gold Hunter," or far-fetched transportation designs, Nathaniel Currier's sardonic views gave voice to the misgivings of many who questioned how the unsavory scramble for wealth reflected on the American character and allowed those who resisted the temptation a sense of superiority for having done so.

The Chinese were not excluded from the California mining camps, any more than their labor was refused on the transcontinental rail-

road. An estimated seventy-five thousand Chinese came to the United States, especially California, before 1868. In that year, the Burlingame Treaty gave Chinese the right to immigrate to the United States, but anti-Chinese sentiment in California—including riots in San Francisco in 1871—caused President Rutherford B. Hayes to renegotiate the treaty. In 1880 the United States chose to "regulate, limit, or suspend" Chinese immigration but not to prohibit the entry of Chinese laborers. In 1882 the United States prohibited Chinese immigration altogether.

Currier and Ives represented animosity toward the Chinese in California in only one print, *"The Heathen Chinee"* (1871). Published during the year of the San Francisco riots, this print is a caricature drawn from Bret Harte's poem of the same title (1870). It shows a Chinese man with a long pigtail, playing cards with two white men in a log cabin. As the Chinese man plays a card and smiles—"inscrutably"—one man holds his cards tight and casts his eyes at the other man seated beside him. The second white man smokes a pipe and holds his cards below the table. Clearly, neither man trusts the Chinese. The following lines from Harte's poem explain why:

But the hands that were played,
By that Heathen Chinee,
And the points that he made
Were quite frightful to see—
Till at last he put down a right bower.
Which the same Nye had dealt unto me.

Then I looked up at Nye,
And he gazed upon me;
And he rose with a sigh
And said, "Can this be?
We are ruined by Chinese cheap labour"—
And he went for that heathen Chinee.

In the scene that ensued
I did not take a hand,
But the floor it was strewed
Like the leaves on the strand
With the cards that Ah Sin had been hiding,
In the game "he did not understand."

Images of the Frontier

By the time Nathaniel Currier began his work, the East Coast was settled and the Ohio and Mississippi River valleys populated. The Ohio area was already being referred to as the "Old Northwest." There were scattered small settlements on the far side of the Mississippi, but therein lay the West of Currier and Ives—the Louisiana Territory, purchased by Jefferson in 1803 and soon explored by Lewis and Clark and Zebulon Pike but still largely unknown to most Americans. In the 1840s Americans began moving westward in significant numbers over a frontier that by midcentury was expanded to the Pacific by annexation, purchase, war, and treaty agreement. "The trails of the pioneers are the warp threads in the fabric of a nation," one commentator has written. "The merchants and the businessmen who follow are the woof which completes the pattern."[23]

Ambitious young men were sure that the East no longer held any opportunities. They might find some chance of improvement if they could get to the West before too many others did the same; hence the speed with which the population moved. By wagon, flatboat, steamer, clipper ship, or railroad, to the Mississippi, the Missouri, the Great Plains, and the Pacific, by land or sea, the pioneer took to heart Horace Greeley's refrain: "Go West, young man, go West." Americans conjured up mental images of endless plains, tall mountains, buffalo, and Indians, and while newspapers provided verbal descriptions, artists and printmakers provided pictorial images and inspiration.[24]

Perhaps the most expressive print of this genre—giving visual form to the nation's romance with the West—was John Gast's *Westward Ho* (also titled *American Progress*), painted in 1872, then lithographed and distributed by the thousands. Gast represented the theme of westward migration made possible by the advances of civilization, which Americans would now bring to the frontier, in the lasting image of Manifest Destiny in the form of the goddess of liberty, or Lady Progress, floating westward through the sky. The painting resulted from a commission Gast received from George A. Crofutt, the publisher of *Crofutt's Overland Tourist and Pacific Coast Guide*. In what was to be the frontispiece for the 1878–1879 issue, Crofutt listed the elements that were to be included. He envisioned the

> beautiful and charming female . . . floating westward through the air bearing on her forehead the "Star of Empire." She has left the cities of the East far behind, crossed the Alleghenies and the "Father of Wa-

ters," and still her course is westward. In her right hand she carries a book—common school—the emblem of education and the testimonial of our national enlightenment, while with the left she unfolds and stretches the slender wires of the telegraph, that are to flash intelligence throughout the land.[25]

Frances Palmer's *The Rocky Mountains: Emigrants Crossing the Plains* (1866) and *Across the Continent: Westward the Course of Empire Takes Its Way* (1868) offer similar images. *The Rocky Mountains* is a visual tribute to those who made the arduous westward journey on their way to a new life.[26] Grandiose in scope, it captured the public's imagination with its panoramic view. Palmer provided a frontier scene in which a long line of ox-drawn Conestoga wagons rolls toward the horizon. The Rocky Mountains rise dramatically in the background, while, on a bluff above a rushing stream, two Indians on horseback watch benignly the advance of white civilization.

Palmer drew both the subtitle and theme of her 1868 print in *Across the Continent: Westward the Course of Empire Takes Its Way* (Fig. 20) from Leutze's masterpiece of the same title (1861–1862) for the nation's Capitol, arguably the most important expansionist mural painting and "the key iconic painting" of the period.[27] Palmer, like Leutze, incorporated all the elements necessary to record the "story" of the westward movement. In the foreground a small settlement of log buildings represents the advance guard of civilization, a recreation of an idealized East. The most prominent buildings in the frontier settlement are a public school and a church. Men fell trees, till the soil, and erect telegraph poles, bringing the blessings of civilization to the "uninhabited" wilderness. The open plains, including a herd of buffalo, can be seen in the distance.

Leutze did not include a railroad; Palmer did, and its cars bear the legend "Through Line, New York, San Francisco." It departs the settlement belching smoke, which startles two regally dressed Indians mounted on horseback nearby (separated from and overpowered by civilization), and it runs on tracks that disappear over the horizon. In an initial sketch of 1862, Palmer included a mountain range, but it was eliminated in the final print, allowing the railroad to advance unimpeded over a vast plain, thereby creating a powerful visual metaphor for the spanning of the country by rail. The tracks separate the habitat of the Indian from that of the white man; they also symbolize the civilization of the East being transported to the West. The right side of the picture represents the Indians' vanishing world and the natu-

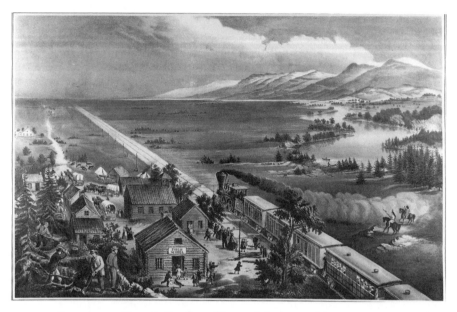

FIGURE 20. *Across the Continent: Westward the Course of Empire Takes Its Way.* Currier and Ives (1868).

ral harmony of their way of life. As the locomotive spews cinders and smoke across the land, to the left two wagon trains depart in the same direction on a dirt trail that parallels the train tracks.[28]

Currier and Ives published *Across the Continent* in 1868, the year before the first transcontinental railroad was completed. In 1869 the firm published two anonymously drawn prints, to which we might add a similar undated print, that took westward expansion "through to the Pacific." In *The Rocky Mountains* (undated) Currier and Ives returned to a Western scene simpler than that created by Frances Palmer. A herd of buffalo crosses a flat valley, and the Rockies loom majestically in the distance. Absent is any direct reference to emigration and Western settlement, both of which reappear in *The Great West* (1870). The mountains still loom in the distance, but the valley is now occupied by homesteads and train tracks that extend through a mountain pass. Gone are the buffalo.

And finally, as if to complete the story and celebrate the joining of the rails at Promontory Point, Utah, Currier and Ives offered *Through to the Pacific* (1870). In this bird's-eye view, a train travels through a valley toward the Pacific Ocean. It is about to cross a bridge over a river and enter a small Western settlement. At the right loggers cut

trees and build rafts from them on the riverbank for transportation downriver for the building of West Coast cities like San Francisco.

Currier and Ives artists painted Western scenes from the perspective of an Eastern studio for an Eastern audience. As such one of the greatest challenges for artists would be picturing the frontier for nineteenth-century Easterners. In the seventeenth and eighteenth centuries, public opinion was largely uniform in its view of the frontier as a marginal space dividing civilization from barbarism. Anyone who lived in that space was seen as someone who lived a marginal life, thereby posing a contradistinction, if not threat, to the more civilized life farther east. By the 1830s, as Americans moved onto the frontier in increasingly large numbers and as figures like Andrew Jackson and Daniel Boone became national heroes, that image changed or at least was seriously challenged.

Many nineteenth-century Americans continued to be concerned with the growing influence of the West on American society. At stake for non-Westerners were not only the political challenges westward expansion posed—already made a stark reality by the rise to power of Andrew Jackson—but also the social implications for those who stayed in "civilization." Was the Westerner an inspiration for the nation in his supposed insistently democratic ways, or a threat to the nation's development as a civilized nation? In their inability to resolve the two views, they created a "bifurcated geography" of the mind when it came to the West.[29]

Others avoided any such bifurcation and viewed westward expansion with greater optimism. They extolled the idea of progress, a concept that mid-nineteenth-century boosters of the West took seriously. "It was a religion, in a way, a belief in democracy and free enterprise as key factors in creating a superior civilization. And it presupposed industrial growth and territorial expansion as the means to accomplish that end."[30] From their very discovery of America, Europeans and then Americans, in their progressive orientation of history, tended to view the so-called New World as an opportunity for a new golden age.

In the early eighteenth century, the idealist philosopher Bishop George Berkeley proposed a scheme for establishing an experimental college in Bermuda to convert American Indians, subjects he considered more worthy of "enlightenment" than the citizens of his native Ireland. Berkeley's poem, "Verses on the Prospect of Planting Arts and Learning in America" (1726), expresses the yearnings of many eighteenth-century intellectuals for a new golden age. Berkeley viewed the New World as the "seat of innocence, where nature guides

and virtue rules . . . not such as Europe breeds in her decay." The sixth
and final stanza of the poem proclaims America not only as the next
stage, but as the grand culmination, of the progress of civilization:

> Westward the course of empire takes its way;
> The four first acts already past,
> A fifth shall close the drama with the day;
> Time's noblest offspring is the last.[31]

"Westward the course of empire" became the resounding chorus of
the nineteenth century. Emanuel Leutze paid homage to Berkeley's
sentiments when he painted his own apotheosis of the theme for the
Capitol in Washington, D.C. So too did Frances Palmer in *Across the
Continent*.

The Puritan minister Samuel Danforth was among the first to ar-
ticulate a contrasting theme—America as wilderness—in his election-
day sermon delivered on May 11, 1670, "A Brief Recognition of New
England's Errand into the Wilderness."[32] And that image continued
as well into the nineteenth century. William Cullen Bryant may have
optimistically referred to the prairies as the "gardens of the desert . . .
boundless and beautiful," but fellow New Yorker Washington Irving,
who had gone West to see for himself, wrote in 1835, "There is some-
thing inexpressibly lonely in the solitude of a prairie. . . . Here we have
an immense extent of landscape without a sign of human existence.
We have the consciousness of being far, far beyond the bounds of
human habitation; we feel as if moving in the midst of a desert world."
Following his exploration of the Trans-Mississippi West, Stephen
Long labeled much of that region "The Great American Desert."[33]

Henry David Thoreau, no opponent to nature to be sure, mused
that he had an inner needle that was constantly pulled westward, a
destiny that simultaneously attracted and repelled him because it rep-
resented "a wildness whose glance no civilization can endure." How
could he be sure, he asked, that such uncharted territory would kindle
authenticity instead of savagery?"[34] Although some cited the manly
competence in wilderness skills that Westerners necessarily possessed,
many Easterners clung to the view that those who moved westward
would become violent and uncivilized—in effect, Indians. For the first
group, the West became the subject of romance; for the latter, the ef-
fects of the trackless prairies on an ambitious citizenry were worrisome.

Westerners added a third perspective. They tended not to see the
land that they came to occupy as a garden, but neither did they see it

as a place wherein they would necessarily be thrown into barbarity. Instead, those who came to contribute to the thriving communities west of the Alleghenies, largely middle class themselves, without minimizing their struggle and the threats they faced from the climate and indigenous population, boasted that they carried with them the fruits of civilization at the same time that they were free from the social degradation and pretensions of urbanized Easterners. Echoing sentiments Easterners had expressed earlier toward European criticism of American civilization, Westerners asserted that class distinctions disappeared in the spirit of Western egalitarianism and that Western communities could serve as models for the nation.[35]

The struggle to define and represent the West was constantly contested and renegotiated. Western territory was appropriated at a rapid pace, both geographically and imaginatively, and so too were Westerners. Travelers reported on Western characters. Lore in both East and West began to accumulate around the wilderness skills and social reputability (or disreputability) of figures like Daniel Boone and Davy Crockett, both of whom became folk heroes. Daniel Boone became the mythological reincarnation of Christopher Columbus, or even Moses, in popular literature and in pictures such as George Caleb Bingham's *Daniel Boone Escorting Settlers through the Cumberland Gap* (1851–1852). Boone emerged as the quintessential pioneer, a national symbol, who exemplified the American spirit of adventure and accomplishment. He became the consummate empire builder.[36]

Marketed in much the same way, Davy Crockett became the best-known frontiersmen of the first half of the nineteenth century. Loosely based on the real-life Tennessee native, the largely fictional Crockett was as wild as the Victorian Easterner expected, given his environment, but he was also strong, independent, and resourceful. The mythic Crockett was vulgar and crude, especially compared with others in the American pantheon, like George Washington. But Crockett represented a break with the patriotic symbolism of the previous few decades. He stood for the common people rather than national leaders and for the frontier rather than the national community.[37]

A third image of the Westerner was based on literary sources like James Fenimore Cooper's five-novel cycle of *Leatherstocking Tales* (1823–1841). Perhaps more than all other fictional literature, *Leatherstocking Tales* shaped the popular image of the frontiersman in the American mind. Pictorial representations of Leatherstocking or Natty Bumppo did convey humor and some condescension, especially in the early years, but Leatherstocking was increasingly romanticized over

time until he became a bridge, or transitional figure, for the trapper-frontiersman of the plains. Although he lives on the frontier, he is nei-ther savage nor civilized, but somewhere in between—the model fron-tiersman, with all the goodness and greatness that frontiersman could have in the circumstances of the frontier. Leatherstocking mediates between the civilized and the savage, but he can be neither, exclusively. Symbolic of the fate of the trappers and frontiersmen he represents, he must die on the frontier, the victim—or the inevitable product—of the progress of civilization, which, although requiring the death of the frontiersman, is ultimately good.[38]

Middle-class males in the Atlantic region appropriated these fron-tier images as an integral imaginative dimension of their own per-ceived manhood. This meant that the male types they constructed as Western were never urban and never agrarian, but ambiguous. East-ern men created Western male types to function in an open territory in ways they could not—to live out options they could not openly en-tertain and to symbolize the myth they were building about them-selves as classless, individualist, and powerful. Frederick Jackson Turner credited that myth with constituting the national character it-self. In his paper "The Significance of the Frontier in American his-tory," delivered in 1893 at a meeting of the American Historical As-sociation at the Columbian Exposition in that most American of cities, Chicago, Turner defined the frontier as the "meeting point be-tween savagery and civilization." He distinguished between the fron-tier of the traders, farmers, and ranchers, and postulated that each frontier had contained simultaneously a wild and a cultivated aspect. Turner's categories apply as well to mid-nineteenth-century popular perceptions of the West as to the content of Currier and Ives's images of the frontier.[39]

A type that appears only once in Currier and Ives's representation of the frontiersman is the Mississippi flatboatman, made popular by George Caleb Bingham. The Mississippi River has had a mystique that has transfixed the popular imagination from the earliest days of the river's known existence. The earliest explorers carried back tales of its powerful flow, towering palisades, and Native American navi-gators. The nineteenth century ushered in the iconography of the Mississippi, and one of the principal elements of that iconography was Bingham's flatboatmen.[40]

The men who worked the riverboats were generally young, unat-tached, and carefree, but they were perceived differently from the frontiersmen. Boatmen had a reputation neither for hardiness, nor for

fearlessness against Indians and privation, nor even for near savagery, but for disrespect for social order, which they expressed in rough-housing, carefree idleness on the job, and drunken revelry on shore. To travelers and Eastern commentators, they were figures of disdain; they represented the drifting character of the ordinary men who moved west.[41] Therefore Currier and Ives left them alone. In *Low Water in the Mississippi* (1868), the lowly flatboat and its crew, much as they were drawn by Bingham, float downriver in the shadow of a majestic Mississippi sidewheeler and rugged sternwheeler. The flatboat-man was a thing of the past.

The Agrarian West

One group of Currier and Ives's Western prints continues the approach to California by concentrating on scenery—arcadia—with correspondingly less emphasis on human figures and habitations. Often panoramic in scope, they commonly exhibit a plenitude of trees, mountains, and bodies of water: rivers, lakes, ponds, and even waterfalls. The dry and treeless prairie is seldom present in these prints—as opposed to trapper prints—and in those prints where the cultivated prairie does appear, there is nothing to indicate that it is anything but abundantly fertile. Put another way, Currier and Ives's agrarian West is representative of that presented by Henry Nash Smith in book 3 of his classic, *Virgin Land* (1950). As one author put it, "Currier and Ives sang the praises of the West as a veritable garden, ignoring the serpent of aridity in that garden, together with all its consequences."[42]

Examples of straightforward, if idealized, views of the frontier are *Among the Pines: A First Settlement* (undated), in which a family of four is grouped around a campfire next to a log cabin; *"A Clearing": On the American Frontier* (undated), wherein a man and woman stand before a homestead in a valley, with a lake and mountains in the distance; and *The Frontier Lake* (undated), which shows two men in a rowboat in the center of a lake, on the shore of which stands a house surrounded by trees and a mountain.

Other prints feature farm life more prominently and as idealized as Currier and Ives's scenes of rural life back east. About half of them exhibit substantial frame houses, the other half log cabins. *The Western Farmer's Home* (1871) shows a settlement of large houses, some of estate size, surrounded by neat wooden fences. Stretching into the background is the open prairie, plowed in precise furrows. In the foreground a man and woman are chatting by the side of the road; there

is a figure on horseback and another in a wagon. In *A Frontier Settle-ment* (undated) the foreground is taken up by a lake on which there are a sailboat and two rowboats occupied by figures in a boating party. The background exhibits substantial New England–style houses, sur-rounded by mountains and trees. *The Mountaineer's Home* (undated) pictures a gabled house with such details clearly apparent as clapboard siding, a shingled roof, and a trellised doorway overhung with flow-ers. In the front yard, on the edge of a waterfall, a mother is sur-rounded by six happy children. The pastoral effect is enhanced by the presence of a few sheep.

Although less grand in scale, the prints that include log cabins are not substantially different. The effect remains snug, pleasant, and ro-mantic—a home in the garden. In *The Pioneer's Home: On the West-ern Frontier* (1867), Frances Palmer shows a mother and child stand-ing in the doorway of their cabin. Two other prettily dressed children are running to meet two men, who are carrying a pole on their shoul-ders from which hang a deer and five fowl. Chickens, two goats, a stand of wheat, a woodpile, and a haystack complete the impression of abundance and good cheer. Similarly, in *A Home in the Wilderness* (1870) we find a wife, a child by her side, feeding chickens; her hus-band and another child return from a hunting expedition, and a third youngster skates on a frozen pond.

Missing from Currier and Ives's portraits of life on the frontier is any reference to the rootless, shiftless individuals who populated the West as well—the "squatters." George Caleb Bingham shows his criti-cism of them in *The Squatters* (1850), for example. On a farm intended to provide temporary shelter only, Bingham's principal character, the one leaning on a stick staring directly into the viewer's eyes, is ready to meet the world. He is not necessarily malign but he is certainly not benign either. He gives every impression of being a formidable char-acter. None of the men are working. Only the sole woman in the pic-ture is at labor, bent over the washtub. Planted fields are not pictured, and the cabin is too small and in need of repairs or rebuilding, in which the men clearly have no interest.[43]

To Bingham and most Americans, squatters were shiftless va-grants. They arrived early, settled on the public domain, but were too shiftless and irresponsible to own land or even to cultivate it properly. Bingham, who opposed the extension of the suffrage to the prop-ertyless, wrote of squatters: "The squatters as a class, are not fond of the toil of agriculture, but erect their rude cabins upon those remote portions of the national domain, where abundant land supplies their

physical wants. When this source of subsistence becomes diminished, in consequence of increasing settlements around, they usually sell out their slight improvement with their 'preemption title' to the land, and again follow the receding foot steps of [the] savage."[44]

Currier and Ives did little with such negative images. Comics or caricatures meant to evoke humor by poking fun—like *A Howling Swell—On the War Path* (1890) and *A Howling Swell—With His Scalp in Danger* (1890), wherein two inebriated buffalo hunters (one resembling Buffalo Bill) are outwitted by two wiley Indians—were acceptable. Serious presentations that called the Western character into question, even squatters, were not. The only possible exceptions to this rule were John Cameron's pair of prints after the then-popular country song, "The Arkansas Traveler," done in 1870. Cameron's before-and-after cartoons show a hillbilly family rebuffing the inquiries of a stranger until he proves his usefulness by playing the song. In the first print, *The Arkansas Traveler: Scene in the Back Woods of Arkansas* (1870), the well-dressed visitor addresses the slovenly figure, who sits on a barrel playing a fiddle. Five children and a woman smoking a pipe are in the doorway of the cabin, over which hangs a sign marked "Whiskey"; a boy is seated to the left. The following dialogue ensues:

TRAVELER: Can you give me some refreshments and a night's lodging?
SQUATTER: No sir. Haven't got any room; nothing to eat.
TRAVELER: Where does this road go to?
SQUATTER: It don't go anywhere, it stays here.
TRAVELER: Why don't you play the rest of that tune?
SQUATTER: Don't know it.
TRAVELER: Here give me the fiddle.

In *The Turn of the Tune: Traveler Playing the "Arkansas Traveler"* (1870), the traveler, still on his horse, plays the fiddle while the hillbilly dances to the tune and the family joins in the merriment. The dialogue concludes:

SQUATTER: Why stranger I've been trying four years to git the turn of that tune. Come right in. Johnny take the horse and feed him. Wife git up the best corncakes you can make. Sally make up the best bed. He can play the turn of that tune. Come right in and play it all through stranger. You kin lodge with us a month free of charge.

Also missing is any representation of the frontier settler as voter, an also aspect covered in the nineteenth century by George Caleb Bing-

ham. Whereas the first and most enduring motivation that impelled Americans westward was their individual drive for economic success, another issue with which they had to struggle collectively was the establishment of political life. Many Americans, particularly Democrats—who identified their party as that "of the people"—argued that the common man had the purity, wit, and self-interest necessary to become a trusted and contributing member of the electorate. Not everyone agreed with that assessment, however, and no better cauldron existed to test such confidence than the West, where the political arena was still fluid and open.[45]

Beginning in 1847 with *The Stump Orator,* Bingham examined the Western electorate in action. It was a subject few other artists had attempted. He depicted those citizens as largely ordinary and yet empowered members of the body politic.[46] He continued the series with *The Country Politician* (1849), *Canvassing for a Vote* (1852), *The Country Election* (1852), and *Verdict of the People* (1854). *The Country Election* pictures a group of citizens casting their votes in an orderly Western town. Sixty or so white men wait in line, talk, listen, calculate, toss a coin, drink (or show the effects of having done so earlier), and, finally reaching the judge and clerk at the polling place, vote by oral declaration. The painting presents to the viewer young, middle-aged, and old men, with boys playing in the foreground. The men are well dressed and poorly dressed, some fat and prosperous looking, others lean and haggard, some smiling, others musing, still others looking befuddled. Two elements, which can be read as either celebratory or ironical, indicate the symbolic quality of the painting: The Union Hotel stands in the background, and a banner resting against the polling porch reads: "The Will of the People the Supreme Law." Bingham was amused, tolerant, and gently critical all at once.[47]

Currier and Ives did not follow Bingham's lead. Their critique of the electorate, and of American democracy, was more comic and less pointed. The single exception is the frontier scene by Arthur Tait, *Arguing the Point* (1855), based on his painting *Settling the Presidency* (1855). Reminiscent of Bingham's election paintings, Tait pictures a frontier farmer at his woodpile. His axe is idle, though much wood remains to be chopped, while he argues with a man who holds a newspaper and another looks on in amusement. So absorbed is the farmer that he pays no attention to his daughter, who tugs at his pant leg while pointing back to her mother standing in the doorway of their log cabin. Currier and Ives recognized nineteenth-century Americans' passion for politics, but not for prints conveying that passion.[48]

During the period from roughly 1850 to 1880, in which nearly all of Currier and Ives's frontier farming scenes appeared, an important ingredient in the political ideology of this country was the notion that "the American farmer, owning and tilling his own land, was an ideal citizen, possessed of dignity, inferior in no essential manner to anyone, and fulfilling in his person and way of life the democratic principle in general."[49] Currier and Ives reflected this idea relatively early and expressed it consistently and wholeheartedly in their prints of farmers in both East and West. No farmer is depicted as a boor, a comic, or a quaint rustic. There is no suggestion of a "squirearchy" and peasantry, and no indication that farmers are inferior to city dwellers. This description of Palmer's *The Pioneer's Home: On the Western Frontier*, summarizes all of Currier and Ives's prints of frontier homesteads:

[The print] depicts the blessings of one family's Western migration. Two hunters are returning home to a neatly constructed log cabin with glass windows. The bounty of the wilderness has been harvested, for upon their shoulders they carry one large deer, one turkey, two pheasants, and two prairie chickens. In the background of the scene, the hay is neatly stacked, and the sheaves of grain in the field are clearly stacked. A covered wagon, the vehicle of the family's odyssey into this Edenic wilderness, stands near the cabin door.[50]

The Frontiersman

Of all the fictional representations of frontiersmen who had probed the West before the first settlers, the trapper was the most complex in association. He was one of a distinctive group of Western adventurers—not the legendary sociable trappers of the upper western rivers, many of whom were French, but the solitary, mostly Anglo-Saxon trappers who roamed the vast mountain wilderness of the more southern Far West. Those trappers had done much to construct their own legend. They worked the high prairies and the southern Rocky Mountains, riding strong, swift Spanish horses. Some worked for companies, but many worked resolutely "on their own hook" as risk-taking entrepreneurs. They boasted of working conditions that included parching heat, devastating cold, encounters with hostile Indians and antagonistic competing traders, drought, and starvation, all endured in solitude. They called themselves "mountain men" to distinguish their own ardor from that of their predecessors.[51]

By the mid-1840s the trappers had virtually disappeared, but the character of the "typical" trapper had undergone a considerable transformation. Early on, the trapper had been cast as lower class by elite Eastern and European travelers. By the 1840s he became a classless ideal, credited with leading the way for more peaceful settlements. "What had been vulgarity became masculinity competent in outdoor skills and conscious of freedom. This new frontiersman became an independent, capable, and successful entrepreneur (a characterization that ignored his dependence on a vast economic power structure in which he was actually near the bottom), offering rich possibilities for vicarious experience to city-weary and competition-anxious Eastern males." His supposed personal heroism provided an answer to—or escape from or substitute for—the lack of autonomy and adventure that many Eastern urban men perceived in their lives. He sidestepped the "uncertainties of middle- and even lower-class Westerners' roles in the social structure that prevailed in more sophisticated discourse."[52]

Charles Deas and William Ranney paved the way for such representation of trappers, instilling a powerful sense of national identity with the frontier and its people. So too did Arthur F. Tait, who worked for Currier and Ives. As one critic wrote of Ranney but could have written of all three, "To portraying the picturesque costume and wild life of those hardy mountaineers, he at once devoted his pencil. . . . His work on these subjects will live as faithful historical representations when that race of men—who are even now fast disappearing—will have passed away. His subjects were purely and almost exclusively American."[53]

One of Deas's trappers, in *Long Jakes* (1844), is a latter-day Boone, Crockett, or Natty Bumppo. The red-shirted and bearded trapper, astride a gallant stallion, turns in his saddle to inspect something that has caught his attention and alarmed his horse. He is in control, secure in his isolation from the comforts of society. He is "the western hero as a wild man with a core of urban chivalry." He is "from the outer range of our civilization" and appears "wild and romantic," yet "there are traits of former gentleness and refinement in his countenance."[54]

In *The Death Struggle* (1845) the trapper is engaged in mortal combat. A dark-skinned Indian on a dark horse, even cast in a shadow, and the trapper dressed in red astride a white horse—each with knife in hand and locked in one another's grip—fall from a precipice to almost certain death in a chasm below.[55]

Deas's exhibition of *Long Jakes* at New York's Art Union caused a sensation. Although the pioneers and their prairie schooners crossing

the oceanlike plains were the symbols of westward progress, it was the
trapper who captured the popular imagination. He served as the link
between the old civilization in the East and the new and future one
in the West. This unconventional man proved irresistible to various
elements of society, including the romantic, who was intrigued by ad-
venture; the patriot and moralist, who hailed the trapper's courage and
resourcefulness as American characteristics; and the pragmatist, who
saw the trapper as paving the way for future commerce.[56]

Unlike Deas and Ranney, who actually lived in Texas during the
1830s, Tait, an English-born lithographer, never ventured farther west
then Chicago. He drew upon his imagination and literary sources to
depict dramatic encounters between trappers and Indians, but he took
his authority directly from the experience of Ranney, with whom he
was almost certainly acquainted, and Ranney's Indian artifacts. He
also learned from the works of George Catlin, Karl Bodmer, and Al-
fred Jacob Miller. Some sources report that he assisted with the ex-
hibition of Catlin's Indian gallery in London and Paris. Tait landed
in New York in 1850 and in 1851 or 1852 began work for Currier and
Ives. He produced genre scenes of hunters in the Adirondack Moun-
tains, but by 1862 he had provided Currier and Ives with twenty-two
Western paintings, after which the firm created as many as thirty-
eight prints. Because of the success of those prints and the withdrawal
of the Art Union from the print business, the public turned to Cur-
rier and Ives for its Western images.[57]

In 1852 Tait appropriated Ranney's *The Trapper's Last Shot* (1850) for
a large work he called *The Prairie Hunter—One Rubbed Out* (Fig. 21).
Whereas Ranney had preserved a certain bit of ambiguity, Tait banked
on his viewers' not wanting any doubt. The narrative key to *The Trap-
per's Last Shot* had been the viewer's curiosity about whether the trap-
per would survive. Tait kept several of Ranney's devices: the pursuit,
the trapper looking back, and the wide expanse of prairie. The trapper
again races for his life before a party of Indians, but unlike Ranney,
Tait made his trapper almost gleeful, the horse spirited, the muddy
prairie solid earth, and the sky clearer. The outcome of Tait's scenario
is not in doubt; his title tells all: One of the Indians in the background
is going down, shot by the trapper, but the trapper is not. It also em-
ploys the newly popular colloquialism "rubbed out" to give the image
vernacular authority.[58]

With Tait the Western type effectively left the specific arena of
genre painting in which Deas's images had functioned. Tait's West-
ern male addressed gender tensions rather than regional antagonisms.

FIGURE 21. *The Prairie Hunter—One Rubbed Out*. Nathaniel Currier (1852).

He transferred the specific identify of the male as a trapper, already dated in Western history, to the more general category of hunter. Tait brought the terms of Western experience to Easterners, who confidently enacted in their own wilderness—or what was left of it—earlier Western hunters' skills, courage, and hardiness. Critics like a writer for the *New York Herald* scorned Tait's derivativeness. "[Mr. Tait's] manner is a melange made up from the manners of many. . . . He seems to have been bitten by Mr. Ranney, and to have imbibed all his extravagance." The *Literary World* complained that such images were "becoming painfully conspicuous in our exhibitions and shop-windows, of which glaring red shirts, buckskin breeches, and very coarse prairie grass are the essential ingredients." But the public loved Tait's work.[59]

Historians too have been critical of the accuracy of Tait's work. One described it as "a curious mixture of truth and fantasy"; another criticized it as "purely pictorial and by no means factual."[60] Nevertheless Tait's Western pictures were very popular, and it was through Tait's lead that Currier and Ives established the formula for a major portion of their prints of the frontier and the message they would con-

vey. Theirs was a "saga of the winning of the West as a triumph not of white man over the wilderness but over the Indian, of noble masculinity over savage animality, and of autonomy over community." The conflict between Indians and the United States Army is missing. Instead, Currier and Ives chose to picture the more personal contest between Indians and trappers.[61]

With Tait's assistance and no doubt encouraged by their knowledge of the market, Currier and Ives locked into place the figure of the Western trapper-hunter: a reassuring ideal of individualism, hardiness, and masculine bravado that seemed to justify the individualistic economic and political behavior that citizens across their constituency were undertaking on a larger scale than ever. More specifically, their prints featured armed conflict between white men and Indians, a motif that appealed to the many mid-nineteenth-century Americans caught up in the spirit of expansion as the expression of the nation's identity and destiny. Perhaps because he had no first-hand knowledge of them, Tait made no attempt to paint Indians in any detail. Most of his Indians lurk in the distance, thereby inviting the viewer's imagination to visualize the enemy. Nevertheless, they were detailed enough to "awaken an anxious tension and palpable vitality" that Eastern audiences welcomed. Whether intended or not, by inference such prints also justified the conquest of the continent and the killing of Native Americans in the name of Manifest Destiny.[62]

In a two-part series titled *American Frontier Life*, Tait portrayed the Indian–white tension on the Great Plains. In *The Hunter's Strategem* (1862) three hunters in buckskin outfits take aim with rifles at three Indians from behind natural cover. The Indians have crept into their camp in the dead of night. One Indian raises a tomahawk in his right hand and is about to strike at two blanket-wrapped stick figures wearing hats near a campfire—a ruse intended to lure the enemy into revealing themselves. In *On the War-Path* a hunter, rifle in hand, peers over a rock at Indians sitting around a fire in the woods. In both cases, the hunters, having outwitted the Indians, are in control of the situation.

Another particularly good representation of the heroic frontiersman is Tait's *A Check: "Keep Your Distance"* (1853). It features a frontiersman on horseback, firing at an Indian and striking him from his mount. It was marketed as a companion piece for *The Prairie Hunter*. *A Check* caught the eye of Capt. Randolph B. Marcy, a veteran Great Plains explorer, who reprinted it in his *The Prairie Traveler* (1859) as an illustration of a life-saving tactic, with this description:

A small number of white men, in traveling upon the Plains, should not allow a party of strange Indians to approach them unless able to resist an attack under the most unfavorable circumstances. It is a safe rule, when a man finds himself alone in the prairies, and sees a party of Indians approaching, not to allow them to come near to him, and if they persist in doing so, to signal them away. If they do not obey, and he be mounted upon a fleet horse, he should make for the nearest timber. If the Indians follow and press him too closely, he should halt, turn around, and point his gun at the foremost, which will often have the effect of turning them back, but he should never draw trigger unless he finds that his life depends upon the shot; for as soon as his shot is delivered, his sole dependence, unless he has time to reload, must be upon the speed of his horse.[63]

Other Tait and Currier and Ives collaborations—and there is evidence James Ives worked closely with Tait—include *The Pursuit* (1856), wherein a horse-mounted frontiersman closes in on a fleeing Indian warrior; and *The Last War-Whoop* (1856, Fig. 22), as if it were the next scene in the narrative history of "life on the prairie."[64] This shows a warrior shot from his horse, wounded and dying. The Indian is making his "last war-whoop" to his conqueror, who remains on his mount, gun lowered, but with an arrow in his leg.[65]

It is important to note here that in Currier and Ives's anonymously drawn print, *Dying Buffalo Bill: Deadly Effect of the Indian Arrow*, undated but probably published before Tait's work, the white hunter dies. Such an ending is highly unusual for Currier and Ives, however, and never pictured in Tait's prints. It is also interesting to note that two years after Currier and Ives printed Tait's *The Last War-Whoop*, Louis Maurer composed a nearly identical scene for the firm, titled *The Last Shot* (1858). In this version of the confrontation between the Indian and white man, it is the white man who has fallen. The Indian dismounts and raises his tomahawk for the fatal blow, but the frontiersman is able to get off one last shot. Such scenes, it has been suggested, reflected a stereotype of the Indian as a savage who, "brave and cunning as he might be, was doomed to extinction because his technology was inferior to that of the Anglo-Saxon civilization."[66]

John Cameron and Frances Palmer produced Western scenes for Currier and Ives as well, although neither traveled West. Indeed Louis Maurer later admitted that Tait's knowledge of American Indians as well as theirs was so limited that Ives took all three to the Astor Library to show them George Catlin's and Karl Bodmer's Native

FIGURE 22. *The Last War-Whoop.* Nathaniel Currier (1856).

American illustrations.[67] Cameron relied on Tait's work, and even if he did make grass and cactus grow improbably together in *A Parley* (1866), the work was filled with drama. A group of frontiersmen or trappers are engaged in a parley with an assembly of Indians that outnumbers them. Both sides are wary and preparing for the breakdown of negotiations. Even the horses seem alarmed.[68]

In *Taking the Back Track: A Dangerous Neighborhood* (1866) Cameron shows two frontiersmen on horseback. They spy a band of Indians, also on horseback, and continue to watch them as their companions lead several packhorses off through a pass. In *The Surprise* (1858), a print suggestive of the anticipated final roundup of Plains Indians, a frontiersman on horseback chases a mounted and fleeing Indian brave and is about to lasso him. Another mounted frontiersman can be seen in the background.

Frances Palmer did two companion prints of this type in 1866, both titled *The Trappers Camp Fire.* In the first scene three men in buckskin are seated around a campfire, their horses nearby, while in the second, subtitled *A Friendly Visitor,* an Indian brave joins the white men. Such portraits of peaceful coexistence are rare among Currier

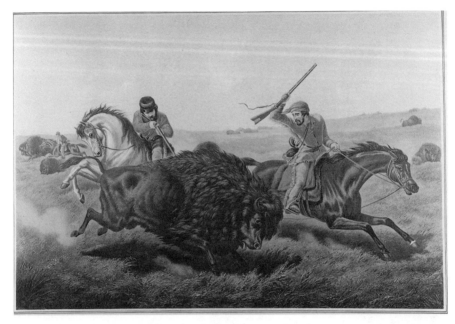

FIGURE 23. *The Buffalo Hunt.* Currier and Ives (1862).

and Ives's frontier prints. In the second print, the absence of the full moon and the light-edged clouds give it a more foreboding or ominous tone.

A few of Currier and Ives's Western prints address buffalo hunting. A print from Tait's *Life on the Prairie* series, *The Buffalo Hunt* (1862, Fig. 23), actually celebrates it. Although almost certainly not intended by Currier and Ives, to the contemporary eye the white hunters and the dead buffalo that litter the landscape forebode the slaughter of a species. The buffalo hunt was described as "the finest of all sports on this continent":

> Every variety of big game, from elephants to grizzlies, has its own devotees, but everyone who ever hunted buffalo on horseback in the West . . . found it the consummation of the sportsman's life. This was not because the buffalo was cunning or crafty, for it was the stupidest of mammals, nor because it was hard to come by, for it existed in far greater masses than any other large animal on earth, nor because it was dangerous in itself. What gave the hunt an emotion equivalent to ecstasy was the excitement, the speed, the thundering noise, the awe-inspiring bulk of the huge animal in motion, the fury of its death, and

the implicit danger of the chase. . . . For forty years this was a notable and unique American experience.[69]

Westerners, who killed buffalo for the hides, and Easterners, who shot them for sport, thought they would last forever. Reliable witnesses reported that they saw herds of bison miles long and wide. But the hunt was efficient. As early as 1840 one fur company shipped 76,000 hides to the East. In 1841 it sent 110,000 and recorded one hunting expedition into the Red River country comprising more than 1,600 men and 1,200 carts and wagons.[70] By 1875 the bison was nearly extinct.

Sharpes rifles were developed especially for the slaughter, and they made the work of men like J. Wright Mooar, the greatest buffalo hunter of all in the immediate post–Civil War period, devastatingly effective. Large profits were made, but the buffalo hunter's life remained dangerous and, to Easterners, heroic. Buffalo Bill Cody gained fame as a contract hunter for the Kansas Pacific Railroad, supplying meat for workmen. He is supposed to have killed more than four thousand head, giving rise to a workman's ballad:

Buffalo Bill, Buffalo Bill
Never missed and never will.
Always aims and shoots to kill
And the company pays his buffalo bill.[71]

Currier and Ives satirized the sport of buffalo hunting in at least two comics. In *A Swell Sport on a Buffalo Hunt* (1882), by Thomas Worth, a gentleman—British, to judge by the language—sits on a very small horse, unaware of a buffalo charging down a hill at him from behind. The rest of the herd appears in the distance, just as he exclaims: "Aw— I say! Don't see any buffalo!" In the sequel, *A Swell Sport Stampeded* (1882), the gentleman, his rifle broken in half and his clothes in tatters, and his horse are on the ground on their backs. The buffalo herd departs, as the hunter remarks: "By jove—I say! Was that an earthquake?" But buffalo hunting was serious business—for white men's profit, for Native Americans' survival—and even for those who sought to tame the West.

At the same time that Easterners saw buffalo hunters as representing American personal virtue and national character, Gen. Philip Sheridan reminded them that buffalo hunters did more in a year to settle the Indian question than the army had done in more than a generation: "They are destroying the Indians' commissary. . . . Send them

powder and lead . . . let them kill, skin and sell until the buffaloes are exterminated," and the Indian will disappear.[72] By midcentury the Indian was indeed disappearing, and that precipitated a change of heart on the part of many Americans, which in turn led to the creation of another line of frontier prints of Native Americans—a line that was distinctly different from Tait's scenes.

Native Americans

Indians were rarely represented as anything but cultural opposites of white people and either more or less children of nature, and never as individuals with a distinct set of cultural imperatives. They were subtly but effectively assigned racial stereotypes based on theories advanced in literary and anthropological studies. As a result Indians were represented with only two dimensions: a good one, combining the beneficent aspects of nature with superior cultural attributes, or a bad one, equating unrestrained nature with the latent savagery in white men. "Savagery meant hunting and gathering, not agriculture; common ownership, not individual property owning; pagan superstition, not Christianity; spoken language, not literacy; emotion, not reason."[73]

Artists drew on both interpretations, but more often at first (particularly in the 1830s and 1840s) on an idealized Indian representing the "natural" man conceived by whites as an alternate role model: the independent male who lived beyond the bounds of civilization but who embodied wilderness virtues. The darker side—the savage in conflict with white civilization—emerged on canvas in the 1840s and in popular lithographs in the 1850s. This quite likely followed on the heels of the U.S. government's more aggressive Indian removals policy and the nation's accelerated westward expansion.[74]

Karl Bodmer, George Catlin, and Alfred Jacob Miller are among the best of the first group. Beginning in the 1830s they portrayed Indians as untouched by white civilization, as if colonization had not yet introduced epidemics, alcoholism, and tribal disintegration. They ignored current realities in favor of earlier literary and artistic traditions, which placed Indians in remote and pristine environments—earthly paradises, where life, supported by the beneficence of nature, proceeded in an orderly fashion. At one with their surroundings, Indians were seen as innocent, simple, devoid of guile and deception.[75]

Such images, of course, drew on well-established European constructs regarding primitivism and the "noble savage" first developed by Rousseau, Voltaire, and Diderot. Although originally intended by

eighteenth-century writers and philosophers to critique contemporary French morals and practices, by pointing to the possibility of progress civilized man would make if left free and untrammeled by outworn institutions, by the nineteenth century the noble savage had become a primitive man of intuition and emotion, whose intelligence was shaped as much by intuition as by reason. That became one view of the American Indian.[76]

The most popular early pictures of Native Americans were those of George Catlin, and Currier and Ives reproduced at least fifteen of Catlin's paintings. From 1830 to 1836, and again in 1839, Catlin traveled the trans-Mississippi westward, sketching Native Americans. He described the West as "the great and almost boundless garden spot of the earth" and referred to its Native American inhabitants as "nature's proudest, noblest men," who lifted "their long arms in orisons of praise to the Great Spirit in the sun, for the freedom and happiness of their existence."[77] At the same time, however, he foresaw the Indians' doom, declaring: "The history and customs of such a people, preserved by pictorial illustrations, are worthy the lifetime of one man, and nothing short of the loss of my life shall prevent me from visiting their country and becoming their historian."[78] Catlin did much to perpetuate the spectacle of the noble savage, an image some Americans were reluctant to dispatch in favor of progress.

The nineteenth century witnessed a renewed emphasis on acculturation, a spirited alliance of government and religion in an attempt to advance their so-called civilizing process, whereby American Indians would be led—or forced—to adopt "civilized" white ways. But by the 1850s Americans had developed a belief in racial uniqueness, and that belief had a double edge for the Indian. On the one hand, Americans believed that the Indian was savage by nature rather than by circumstance, and therefore irredeemable. On the other hand, as savagery was overtaken by civilization, the Indian began to disappear, and he was increasingly valued as the natural man, "a vanishing counterpoint to the evils of civilization." The savage Indian forced Americans to reconsider what it meant to be civilized and what it took to build a civilization. "Studying the savage, trying to civilize him, destroying him, in the end they had only studied themselves, strengthening their own civilization, and giving those who were coming after them an enlarged certitude of another, even happier destiny—that was manifest in the progress of American civilization over all obstacles."[79]

Frontier accounts, including Tait's, still pictured the Indian as someone to be feared. The idea of the fight for survival was thus kept

alive. But the ultimate victory became less and less questioned, especially back East, and in many minds the Indian was increasingly seen as the once noble but now pathetic victim of white man's civilization, in general, and of that civilization's representative, the frontiersman, in particular. "Once the threat of resistance by Native Americans was minimal, it was safe for European Americans to eulogize, idealize, and memorialize the positive qualities of the 'natural man.'"[80] Catlin's Indians, made even more popular by Currier and Ives, reflected that sentiment.

Many Eastern inhabitants had never encountered an Indian, except perhaps those imported by P. T. Barnum to dance at his museum or by Buffalo Bill Cody for his Wild West show. Many who began to feel what they sensed were the debilitating effects of urbanization, saw the "red man" as the noble savage of Jean-Jacques Rousseau. They pictured him as a simple creature, like Adam and Eve before the Fall, in a state of natural goodness, not yet corrupted by the evils of civilization. And rather than join in the chant initiated by General Sheridan in 1869, that "the only good Indian is a dead Indian," they mourned the Indian's apparent passing, as if it were a part of themselves. They became the market for Catlin and Currier and Ives.[81]

Catlin, the showman, used many of his paintings in the first traveling Wild West show, which he organized in 1839 and called "Catlin's Indian Gallery." He also incorporated hundreds of engravings made from the sketches he made during his tour of the West during the 1830s into *Manners, Customs, and Conditions of the North American Indian* (1841) and *North American Indian Portfolio* (1844). The latter went through five editions. Because of the pronounced romantic majesty with which they were infused, Catlin's three hundred engravings took Easterners and Europeans by storm, more so than the paintings of Carl Bodmer and Alfred Jacob Miller.[82]

Nathaniel Currier's earliest Indian prints—*The Indian Warrior* (1845) and *The Indian Hunter* (1845)—suggest the company's interest in, if not entirely successful rendering of, the more dramatic elements of Native American life. Already "curiously outdated," as one critic put it, these prints were nevertheless well marketed, creating a desire for more, which in turn encouraged Currier to seek a better product.[83] Some of the company's better early prints include *The Huntress of the Mississippi* (1843), a full-length portrait of an elegantly costumed Indian woman; *Indian Ball Players* (undated), in which a group of Indians play what would be later called "lacrosse"; the sentimental *The Indian Family* (undated), in which an Indian hunter stares down at

his bare-breasted wife and the child she holds in her lap; *On the St. Lawrence* (undated), of an Indian encampment; and *Game of the Arrow: Archery of the Mandan Indians.* For *Headwaters of the Missouri* (undated), the sources are unknown.

Currier and Ives found particularly attractive and marketable, however, a number of prints Catlin reworked for his *North American Indian Portfolio.* In the three years that separated his *Portfolio* from his *Manners, Customs, and Conditions,* Catlin moved beyond his earlier anthropological, didactic, and romantic approaches—which actually did stimulate concern about the plight of the American Indian—to express his ideas in a more entertaining pictorial medium. Even if he did not have any such intention, that approach closely paralleled Currier and Ives's marketing strategy and brought the artist and the popular lithographers together.[84]

Catlin exhibited his Indian gallery in London's Egyptian Hall, and the changes he made in his *Portfolio* were in response to his European audiences. But they were welcomed by Easterners in the United States as well. The changes were intended to prepare his collection for a public that remained sympathetic to the romantic ideal of primitivism but that was increasingly drawn to the passion, drama, and dynamic character of life on the Great Plains that pitted white Americans against Native Americans.[85]

Hunting scenes, showing the flourish and excitement of the chase and, incidentally, something about Indian culture, were what Catlin's audiences really wished to see. Too much anthropology, he found, was of limited interest to his audience. Catlin turned to his *Portfolio* as a means of staging a tableau of primitive life, of demonstrating the struggle for survival that was thought to shape the force and independence of savage character. He focused on those qualities of Indian life and the Western wilderness that most intrigued his audience. And he, like them, found that the thrill of the chase was common language for testing the skill and courage of white and savage alike. The narrative that connects plates of the *Portfolio* and the fifteen plates Nathaniel Currier chose to reproduce during the 1850s reflects that theme and complements Tait's work on the frontiersmen.[86]

Among the Catlin *Portfolio* prints Currier and Ives chose to reproduce were *Capturing a Wild Horse* (undated), showing a wild horse being lassoed and brought under control by the ingenious methods the artist learned from the Osage and Comanche, and *Indians Attacking the Grizzly Bear* (undated, Fig. 24), where Catlin turned to Indian methods to hunt the grizzly, one of the formidable opponents

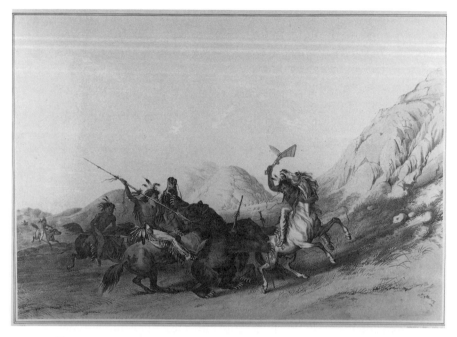

FIGURE 24: *Indians Attacking the Grizzly Bear.* Currier and Ives (undated).

on the Plains. Arrows would not penetrate the bear's tough hide, so the kill had to be made at close quarters with lances and clubs, after a party of mounted hunters encouraged the bear to attack. In *The Indian Bear Dance* (undated) Catlin pictures a group of Indians, several wearing bear-head masks, dancing in a circle to invoke the aid and protection of the Bear Spirit; in *The Snow-Shoe Dance* (undated) a group of ceremonially bedecked Indians dances to thank the Great Spirit for the first snow.

Currier and Ives also chose to include several of Catlin's Indian and buffalo prints. In *Buffalo Chase* (1844) Catlin provided a detailed account of how a mounted Indian riding at full gallop could kill a buffalo with just one arrow, carefully directed behind the animal's right foreleg. In *The Buffalo Dance* (undated) Catlin shows the dance used by Native Americans to "make the buffalo come"; in *The Buffalo Hunt: "Surrounding the Herd"* (undated) Indians riding bareback encircle and kill a small herd of buffalo; in *Buffalo Hunt under the White Wolf Skin: An Indian Strategem on the Level Prairies* (undated) Indians with wolf skins on their backs, holding bows and arrows, crawl toward a buffalo herd. Similar scenes appear in *Indian Buffalo Hunt: "Close Quarters"* (undated) and *Indian Buffalo Hunt: On the "Prairie Bluffs* (undated).

Certainly one of the more interesting and prophetic of Catlin's paintings to be picked up by Currier and Ives, in terms of the cultural encounter between Indians and whites, is *Wi-jun-jon—the Pigeon's Egg Head: Going to Washington/Returning to His Home* (undated, Fig. 25). In 1831 Wi-jun-jon, an Assiniboine warrior, was among a delegation of Indian chiefs recruited to go to Washington. Catlin met them on their way and painted them in their Indian regalia. A year later, Catlin met them on their return and was struck by the radical change in their apparel and their apparent discomfort with it. In this print Catlin shows Wi-jun-jon in the first panel dressed as an Indian chief, in the second panel wearing a top hat and full-dress military uniform—a colonel's uniform given him by President Andrew Jackson—and carrying an umbrella and a lady's fan.

Given the engravings' popularity, the firm might have simply copied Catlin's paintings, but instead they chose to alter scenes Catlin himself had already changed, to further please their audience. The Osage, Iroquois, and Pawnee in *North American Indians* (undated), for example, were combined from three separate Catlin paintings. The illustrations of the Sioux bear dance and the Chippewa snowshoe dance, in *The Indian Bear Dance* and *The Snow-Shoe Dance to Thank the Great Spirit for the First Appearance of Snow*, show alterations of figures and body paint from the original. *Indians Attacking the Grizzly Bear* and *Buffalo Bull Chasing Back*, although attributed to Catlin, appear to be at best what we might term "inspired" by the artist's work. It is quite possible that Currier produced these prints without the participation of the artist, a not-uncommon occurrence at the time. They also appeared without date or copyright.[87]

Louis Maurer provided Currier and Ives with Indian prints as well. His *Hiawatha* series came as close to national apologetics, and the noble savage school, as any popular prints of the day. Henry Wadsworth Longfellow took inchoate traditions and transformed them into poetic narratives. He published "Hiawatha" in 1855 and sold ten thousand copies in one month.[88] Currier and Ives provided illustrations of scenes from that poem in *Hiawatha's Wooing* (1858), *Hiawatha's Wedding* (1860), *The Death of Minnehaha* (1867), and *Hiawatha's Departure* (1868). If Pocahontas, probably done about the same time, offers a view of what might have been, *Hiawatha* gives its viewers a highly romanticized and metaphorical view of what came to pass.

In *Hiawatha's Wooing*, the first in the series chronologically, Hiawatha, the semilegendary chief of the Onondaga Tribe—said to have founded the Iroquois Confederacy—lays a dead buck on the ground

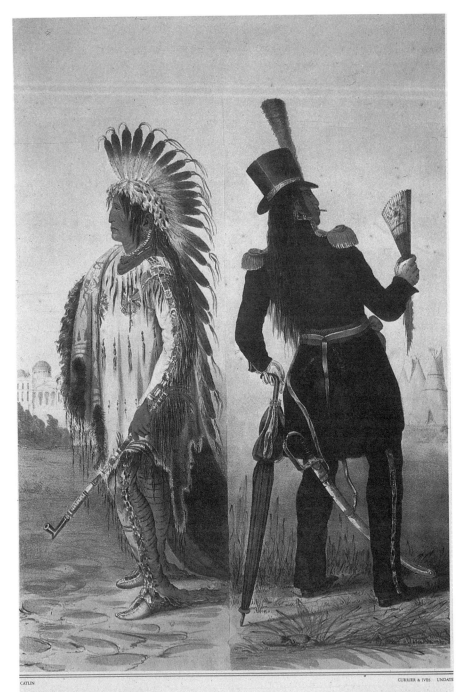

WI-JUN-JON—THE PIGEON'S EGG HEAD / GOING TO

FIGURE 25. *Wi-jun-jon—the Pigeon's Egg Head: Going to Washington/Returning to His Home.* Currier and Ives (undated).

before Minnehaha. Minnehaha sits next to her father in front of their teepee. The subject is a good one for Longfellow and Currier and Ives to romanticize because Hiawatha was said to have lived in the fifteenth century, among a tribe that no longer posed any threat to nineteenth-century Americans. Newspapers routinely published accounts of prehistoric Indian sites and ruins that had been found, and that, from a safe distance of time, proved intriguing and provoked public curiosity concerning prehistoric rituals, including marriage.[89]

The inscription for *Hiawatha's Wooing* explains that Minnehaha, "in all her beauty," responded to the warrior's gift "with gentle look and accent," saying: "You are welcome Hiawatha!" In *Hiawatha's Wedding* the two are pictured holding hands. Minnehaha's father continues to sit in front of his teepee, but a waterfall—"Minnehaha" means "laughing water"—appears behind them. The inscription taken from Longfellow's poem reads:

> From the wigwam he departed
> Leading with him Laughing Water,
> Hand in hand they went together
> Thro the woodland and the meadow
> And the ancient arrowmaker
> Sat down by his sunny doorway,
> Murmuring to himself and saying
> Thus it is; our daughter leaves us.

The narrative and the tragic romance are completed with *Hiawatha's Departure*. We are told that, "the evening sun descending,"

> Westward westward Hiawatha
> Sailed into the fiery sunset,
> Sailed into the purple vapours,
> Sailed into the dusk of evening.
>
> Thus departed Hiawatha,
> Hiawatha the beloved,
> In the glory of the sunset
> To the Kingdom of Ponemah,
> To the land of the hereafter.

Hiawatha stands alone in a canoe, which moves away from the shore into the sunset, symbolically connecting Hiawatha's fate to that of all Native Americans. On the shore Indians weep and bid him farewell.

In the same year that *Hiawatha's Departure* was published, Currier and Ives more fully and directly explained the reasons for the Indian's demise in *Across the Continent: Westward the Course of Empire Takes Its Way*. Indeed, although at a surface level they appear completely different, the two prints complement one another. Frances Palmer makes clear, in *Across the Continent*, that America's growth and expansion led to Hiawatha's demise. A community of settlers bustles with activity. The town's most prominent features are its public school and church, the foundation of an "enlightened" and "civilized" citizenry. Telegraph and railroad lines, symbolic of "progress," stretch to the horizon, linking the village to the rest of the nation and separating the two Indians in the picture, mounted on their horses, from civilization.[90] "Astride their horses, which suggest their nomadic lifestyles, partially obliterated by smoke from the train, they stand rooted, while lines of so-called progress reach toward the horizon."[90]

Many of Currier and Ives's Western prints that involved Indians showed the two cultures in conflict. Indians are never shown to triumph over their white adversaries, but they are invariably depicted with respect. They may be the white man's foe, and a dangerous foe, but they are also a worthy one. When pictured alone or among other Native Americans, the Indian is recognized as a dignified human being, with a legitimate life of his own.

Picturing Urban and Rural Life in America

By the middle of the nineteenth century, the United States was becoming increasingly urbanized, emptying the older, rural areas of the East. In any decade from 1830 to 1860, between 44 percent and 70 percent of adult males moved away from the Northeast. Many Americans were heading west, but others headed to the cities, as the percentage of Americans living on farms dropped to about 60 percent. Between 1830 and 1860, New York City grew from 200,000 to 800,000, Philadelphia from 161,000 to 500,000, and Boston from 61,000 to 133,000. Inland cities like Pittsburgh, Cincinnati, Louisville, Memphis, and Saint Louis mushroomed, too, as river commerce grew

increasingly vital. Internal migration to urban areas was supplemented by an equally impressive increase in immigration. Half a million immigrants arrived in America's port cities in the 1830s, a fourfold increase over the previous decade. And that figure grew until, during the worst years of the potato famine in Ireland, 1847–1854, more than 1.2 million immigrants arrived in the United States from Ireland alone. Overwhelmingly they stayed in the cities.[1]

For many Americans the change was traumatic, not only for those who chose to move to the cities, leaving behind generations of family in rural America, but also for those who remained behind but worried about their future in the face of such profound changes. Many believed what Jefferson had written in his *Notes on Virginia* (1784–1785), that a republic depends on the virtue of those citizens who cultivate the earth—not, by implication, on city dwellers, especially factory workers. Whither would go the nation, then, as the United States faced the onslaught of urbanization, industrialization, and immigration?[2]

The Civil War added to Americans' concern for the future of their nation. It pitted not only Northerners against Southerners, but also neighbors and family members against one another, and it took more American lives in war than in any other military action before or since. Preachers North and South proclaimed from the pulpits that God had turned his back on his chosen people and would totally abandon them if they did not recommit themselves to him. The nation had reason to be hopeful; the war had affirmed its unity. But major new changes presented themselves, and with mixed feelings Americans associated them with their burgeoning cities—proud, on the one hand, because of the progress the cities reflected, and, on the other hand, critical of the lifestyle they produced.[3]

Views of the City

Criticism of the city was muted until the second quarter of the nineteenth century. Many in the middle class, especially those who had come in from the countryside, found themselves caught up in a whirlwind of excitement about personal potential in the city. Merchants saw it as a place of commercial opportunities that could be found nowhere else. Visitors frequently commented on the breakneck pace of New Yorkers, who spawned one project after another. They pushed out the city's boundaries and in the inner city replaced old buildings with new, establishing hotels and theaters and scheming to connect the nation with canals and railroads.[4]

But Americans remained suspicious and doubted the compatibility of cities and republicanism. The mingling of large numbers of people in cities, especially young men eager to make their fortune but lacking stabilizing connections to families and other traditional social structures, was seen as dangerous to character and judgment. By the 1840s cultural critics identified New York, especially, as the locus of severe threats to the still-young nation. The rapid accumulation of wealth and its ostentatious display, overt class divisions, manipulative mass politics, and corrosion in the traditional relationship between employer and employee were ominous.[5]

These circumstances posed a problem for visual representation, especially for a firm that prided itself on providing cheap prints for the people. They had to factor in these conflicting perspectives for those who themselves were conflicted in their attitudes toward cities. In the 1830s American printmakers published European-derived city scenes that showed the hustle and bustle of commercial life, including merchants, busy wharves, shoppers, carters, and peddlers. But beyond such representations of urban life, they were reluctant to develop recognizable urban types. Although a small literature of city types—con men and city slickers, self-important merchants and industrialists—appeared in the 1840s, it did not begin to match that of European writers. With the exception of Richard Caton Woodville, an American who painted his urban scenes from Europe, little was done in the visual medium either, and nothing by Currier and Ives. Perhaps such representation relied on the recognition of a reality with which Americans remained uncomfortable.[6]

Even rarer were images of the poor. Gambling, chicanery, and cutthroat competition notwithstanding, what aroused citizens' most profound fears in connection with cities was the influx of immigrants. By 1845 more than 30 percent of the population of New York City was foreign born; by 1850, nearly 60 percent. By 1860 the foreign-born accounted for more than half of the population of Chicago, Milwaukee, Saint Louis, and San Francisco. Newspapers and journals thundered daily about the ominous development of a permanent underclass. Trained neither in government nor in Anglo-Saxon middle-class manners, many immigrants presented what seemed to be unassimilable social differences. They brought few job skills and settled in already crowded areas that rapidly became slums. So intense was the anxiety of the elite about immigrants' influence on crime in the city that Philip Hone began the new year in 1840 with the following lament in his diary: "Riot, disorder, and violence increase in our city;

every night is marked by some outrage committed by the gangs of young ruffians who prowl the streets insulting females, breaking into houses of unoffending publicans, making night hideous by yells of disgusting inebriety, and—unchecked by the city authorities—committing every sort of enormity with apparent impunity."[7]

Images of such poverty and urban blight, as well as concern with urban disorder, were common in Europe, but they were largely absent in America. Europeans pictured urban filth, degradation, and riot in detail; American artists largely ignored it. So too did Currier and Ives. They no doubt calculated that prospective customers would be less likely to buy dismal images that implied a threat to a stable society. In Europe artists painted beggars and street children to prick the conscience of the elite and comfortable and rouse them to perform acts of charity for those beneath them. In the United States, by contrast, sympathy was unlikely to be directed at those who had both the vote and, it was believed, equal economic opportunity.[8]

Beginning in the 1840s, immigrants, laborers, and the urban lower class received the disdain of their "betters" for vices of which the middle class perhaps feared they were guilty or were sorely tempted to be. If poverty itself was the cause of such disdain, then the poor were still to blame, because poverty was their own fault; they deserved to be poor. As one writer of the time put it, "We have no 'lower orders,' except such as are made by their own folly and wickedness." If an American artist painted one of the urban poor, which was rare, he almost always did it in such a way as to provide a typically American moral lesson. The lad in Henry Inman's *News Boy* (1841), for example, may have been poor, but, anticipating the work of Horatio Alger at the end of the century, he was not obligated to remain so. He was the prototype of American self-help; he would rise from poverty if he were diligent and honest.[9]

David Gilmour Blythe was an exception. His pictures were neither attractive, as were Inman's, nor optimistic. In dark, menacing colors, Blythe depicted the urban poor—especially children—jockeying for power in their own world, taking advantage of one another. Compared with Inman's paintings of the same subject, the youngsters in Blythe's series *The News Boys* (1848–1852) and *Street Urchins* (1856–1860) lived a social world distinct from and threatening to that of middle-class Americans, a world of small criminals. As Blythe sees them, "sullen, mean, and vicious, they are young but also ageless. They are among the future citizens of the Republic."[10]

Currier and Ives made no such references in their work. The firm

published hundreds of prints of children, none of which gave any hint of depravation. Neither did the firm offer for sale prints depicting life in the nation's factories. Obviously Currier and Ives saw no demand on the part of its buying public to picture, or exploit, this phase of the nation's development. The life of the industrial worker, as distinguished from that of the farmer, did not appeal to the public's imagination or taste.[11]

The only significant exception to this rule of exclusion was those prints that constitute temperance sermons, but they served a larger purpose. Several tell the story of a mechanic's or worker's downfall through drink and his subsequent reformation, as in the four-part series, *The Bible and Temperance* (undated). In the first of the series, in a spartan but pleasant domestic interior, a man is prepared to leave with a roguish friend as his family puts tea on the table. His wife, wearing a bonnet and an apron—simply but respectably dressed— puts her hand on her husband's shoulder. His son holds his hat. In the second part, the man has returned home intoxicated. He lies on a bed, while his wife and two children gather around a seated minister, who reads to them from the Bible. In part three the man has risen from his bed to stand and read the Bible. His daughter embraces him, and his wife kneels in thanksgiving that he has redeemed himself through the word of God. In the final scene the reformed drinker, with his well-dressed family, meets the minister and his wife on a path leading to the church. The minister warmly shakes the man's hand. The following excerpts from the inscriptions on the four prints summarize the story:

William White, a mechanic, and a single man, having had a small sum of money left him, calls upon his friend and fellow-workman, Henry Brown, a respectable mechanic, married to a steady industrious wife, persuades him to go with him, and make a merry night of it; Brown's wife and daughter seem to say, pointing to the tea-table, "how much better it would be to take a cup of tea with them!" However, he is so weak as not to like to refuse his friend, and goes out with him.

[Part Two] From once going out with White, he goes again . . . until he loses his situation, and his character as a steady workman; and becoming careless in person, and idle and dissolute in manners, brings his family to want and extreme wretchedness. . . . The parish minister steps in and reads from the Bible to the mother and daughter.

[Part Three] The words of the sacred volume touch the heart of Brown, who, waiting the departure of the minister (a feeling of shame for being seen in his present condition having passed across his mind),

jumps up, and taking the Bible, the minister had left, swears, upon the book of salvation, to reform and lead a new life. . . .

[Part Four] Brown now being reformed, becomes steady, sober, and industrious, finds constant employment, which enables him to save a little money; he is thus enabled to take a small cottage and gradually gets his furniture again; grateful to his maker for the happy change, he regularly attends his church, to return thanks for his conversion, and to pray for that of others.

The companion pieces, *The Fruits of Temperance* and *The Fruits of Intemperance*, first published in 1848 and reissued in 1870, tell a similar story. In the first of these anonymously drawn prints, the "son of temperance, with buoyant heart and step," carrying one child and leading another by the hand, walks up the front path to his house. His wife and infant greet the prosperous-looking gentleman, returning from his work in the factory seen in the distance. In the sequel, the same man, now homeless, walks down a windswept path followed by his wife and children. *The Fruits of Intemperance* was also published as *The Bad Husband: The Fruits of Intemperance and Idleness* (1870).

Although Currier and Ives included well-dressed members of upper-class society in its temperance prints as well, these prints, at least, suggest identification between laborers and hard drinking, if not any overt recognition that factory life might have caused such hard drinking.[12] Indeed alcohol, idleness, and lack of resolve are more often blamed. Otherwise, Currier and Ives avoided all such sordid scenes and instead printed flattering views of cities, as well as the nostalgic views of idyllic life in the country. Tellingly, the latter increased in number over time and came to outnumber the former in response to America's growing concern for the rise of cities and the decline of rural, small-town life.

Beginning in 1835 with *New York from Weehawken*, Currier and Ives issued more than a hundred lithographs of the wonders of New York City. They made no attempt to document the city, but rather to depict scenes Americans would find most pleasing. Many may well have been produced in response to demands of the tourists the city was increasingly attracting, who would want prints to show folks back home what there was to see in New York.[13] Currier and Ives did offer the occasional comic of New York: *Life in New York: The Breadth of Fashion: Fifth Avenue* (undated), wherein Thomas Worth poked fun at the pretentious dress of some New Yorkers; and *Life in New York: That's So* (undated), also by Thomas Worth, picturing a collision between an

aggressive cart driver, a dog cart, and two pedestrians. But they are always gentle and humorous, hardly challenging the city's appeal to outsiders or its residents' pride of place.

Bridges were a popular subject, and one of the most popular New York City bridges was the subject of Currier and Ives's *Great East River Suspension Bridge* (1881). It was the first of three spectacular bridges that would link Manhattan with Brooklyn, and at its completion, its towers were taller than any buildings in either city. One commentator later observed, "Poets have sung of this thing of beauty. Great artists have painted it, and men have come from the most remote corners of the earth to look upon and to know the lyric impulse it inspires."[14]

Designed by John A. Roebling, who was fatally injured while surveying the site, and constructed by his son Washington A. Roebling, who became an invalid before construction was completed, the Brooklyn Bridge cost fifteen and a half million dollars. It was built in thirteen years and officially opened by President Chester Arthur on May 24, 1883, amid fireworks and great celebrations. May 24 was dubbed "The People's Day," and indeed the bridge was constructed with German and Irish immigrant labor. But May 24 was also Queen Victoria's birthday, so the Irish boycotted the event. Currier and Ives did many lithographs of this spectacular urban structure while it was being constructed and after it was completed.[15] The most colorful, indeed spectacular, print was *The Grand Display of Fireworks and Illuminations at the Opening of Brooklyn Bridge* (1883, Fig. 26), a rare chromolithograph issued by the company. The print depicts a river crowded with large and small boats amidst fireworks, celebrating not only the technological achievement but also the bridge's aesthetic lesson—that undisguised steel can be handsome.[16]

Also pictured as an engineering marvel was New York City's reservoir. *View of the Distributing Reservoir: On Murrays Hill—City of New York* (1842) provides the reservoir's measurements and capacity. It presents the structure with people standing in small groups, on a walkway that runs around the top of the four walls, looking at the water. Tree-shaded houses can be seen nearby, beyond which rise city buildings, some of which emit dark smoke. The reservoir was located between 40th and 42d Streets on Fifth Avenue, the current site of the New York Public Library.

Another attraction, for the relatively short term of its existence, was New York's Crystal Palace, erected "for the exhibition of the industry of all nations." Built along the lines of London's famous glass and iron

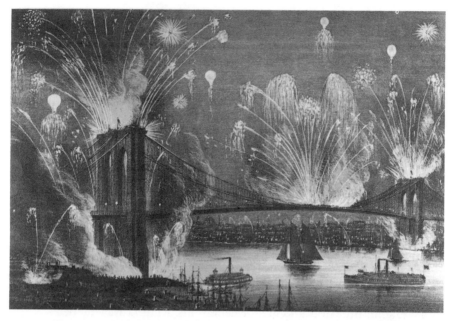

FIGURE 26. *The Grand Display of Fireworks and Illuminations at the Opening of Brooklyn Bridge.* Currier and Ives (1883).

exhibition hall of the same name, this structure housed America's first world's fair, in 1853–1854. Frances Palmer designed a print of the palace, commemorating its opening in 1853, that included the dimensions of the main and additional buildings. It shows the huge octagon of the first floor, surmounted by a second level in the form of a Greek cross, both capped by a 148-foot (45-meter) dome. The fair's six thousand exhibits failed to draw enough visitors from outside New York to turn a profit. Making it available as a site for balls and fairs did not help, and the property soon passed into the hands of receivers. Nevertheless, when in 1858 the supposedly fireproof palace burned to the ground in about twenty minutes, the firm did a print of the spectacular conflagration.[17]

Currier and Ives issued numerous views of New York from nearby scenic points. Two of the most attractive were drawn by Frances Palmer in 1849. Palmer drew *View of New York: From Weehawken* from the western side of the Hudson and sketched *View of New York: From Brooklyn Heights* from a high bluff on the East River opposite lower Manhattan. Both capture not only the buildings, bridges, and other structures of the city, but also a leisured life of strollers and picnick-

ers, and afternoon cruises in sailboats, ferries, paddle-wheel steamers, and rowboats, all idealized for both the urban and rural consumer.[18]

Frances Palmer designed several other urban scenes of New York with a similar message. In *View on the Harlem River* (1852) three men fish from a rowboat in the Harlem River in front of Macomb's Dam. Several other men fish from a low wooden structure on stone pilings, the tall arches of Highbridge looming in the background. In *Staten Island and the Narrows* (1861) Palmer focused on Fort Hamilton, which guarded the entrance to New York Harbor; Fort Richmond, on Staten Island; and even old Fort Lafayette, which served as a prison for Confederate soldiers during the war.[19] Perhaps this served to reassure New Yorkers troubled by Southern belligerence at the start of the Civil War. But in this as in so many of her urban prints, the setting is both impressive and lovely, a mix of human creation and natural landscape, to which the residents treat themselves as they sail, stroll, or ride in carriages through the city.

Some New Yorkers may have been comforted in a somewhat different manner by Palmer's 1862 view of Blackwell's Island. This 107-acre (43-hectare) rocky strand in the East River was bought by New York in 1828 to isolate the city's outcasts. An 1868 guidebook described the island as follows: "Perhaps no place in the world is better adapted to the purposes for which is it used. Here may be seen the penitentiary, a noble structure, sufficiently large to accommodate eight hundred to a thousand prisoners. There is also the almshouse for the city poor and a workhouse, a spacious edifice, to give employment to the prisoners. The lunatic asylum occupies the north end of the island and the smallpox hospital the south." Despite the rather morbid subject, Palmer provides a panoramic view of the river and island on a spring day and includes in the print a Long Island Sound steamboat and two Hudson River sloops. "Family" rowboats are available for fishing or casual rowing on the placid waters' pedestrians stroll nearby. It was renamed "Welfare Island" in 1973 to honor President Franklin Roosevelt.[20]

Somewhat lacking in the lighter touch, but just as impressive, is the anonymously drawn *Halls of Justice* (1838). Perhaps because it was among the firm's earliest city prints, there is little attempt to work what became one of the city's most notorious prisons, erected between 1836 and 1838, into a more pleasant vista. Rather, it is a straightforward rendering of this imposing structure. The wave of penal reform sweeping America in the 1820s and 1830s created challenging architectural problems, which, combined with the cult of romantic eclec-

ticism, resulted in a wide range of complex public structures. An English architect, John Haviland, who came to the United States by way of St. Petersburg at the invitation of U.S. Ambassador to Russia John Quincy Adams, was responsible for some of the most monumental and trendsetting prisons built in the century.[21]

Haviland designed the Halls of Justice in New York in the popular Egyptian style, and Nathaniel Currier's lithograph of the prison conveys much of the sense of gloom the structure projected. As one critic described it, "Set low on the horizon, little activity relieves the sullenly picturesque mass, which, architecturally, deserved its morbid epithet, "the tombs." Charles Dickens, who visited the United States in 1867–1868, hated the prison, assailing it as "a dismal fronted pile of bastard Egyptian, like an enchanter's palace in a melodrama."[22]

Currier and Ives offered for sale views of several other buildings in which New Yorkers took pride, including prominent civic structures, halls of commerce, and grand hotels. New York's City Hall was pictured in at least three prints, all undated. The anonymously drawn *City Hall and Vicinity, New York City* (Fig. 27) includes adjacent buildings, streets, and a park. The "New Court House," Staats Zeitung, French's Hotel, and the Sun Building are identified. A fountain stands in the middle of the park. Horse-drawn trolleys and carriages ply the street, and people stroll along the sidewalks. New York Harbor is visible in the distance. The two prints titled *City Hall, New York*, signed by J. Schutz, focus more exclusively on city hall, flags flying from it and flanked by trees.

Currier and Ives selected some buildings because of their association with prominent architects. While still a partner in Stodart and Currier, Nathaniel Currier issued an architectural plan for New York's Custom House. *Custom House and Main Floor Plan: Designed by Ithiel Town and Alexander Jackson Davis, Architects* (undated) offers two perspectives: a three-quarter view of the Custom House and a floor plan of the main floor, key measurements included. The building was quite grand with its multiple columns, domed roof, and impressive courtyard. A later but undated print issued by Currier alone shows the completed structure.

Currier and Ives pictured both the old and new New York City post office. The first, featured in an undated print but done before Ives became a partner in 1857, sports a prominent clocktower and is situated behind a fence on a street crowded with carriages and pedestrians. The second, prepared sometime later, is presented in an architectural print that shows the front and side facades of the imposing,

FIGURE 27. *City Hall and Vicinity, New York City.* Currier and Ives (undated).

five-story multidomed structure. Traffic surrounds the building, including a trolley car that reads: "4 Avenue via Post Office."

Nathaniel Currier's print of the burning Merchant's Exchange in 1835 had helped establish his reputation. In 1848 he issued a lithograph of the new building, titled *Merchant's Exchange, New York: Wall Street.* It provides an architectural view of a building distinguished by its multicolumned facade and large dome, situated in a large plaza in an area filled with carriages and pedestrians.

Among the grand hotels the company chose to feature were the City Hotel, the Astor Hotel, and the Union Place Hotel. In an undated print, William K. Hewitt showed the City Hotel on lower Broadway as a five-story, Federal-style building. It faces the street, where a parade—complete with marching band—is passing, as well as two trolleys. The steeple of Trinity Church can be seen nearby.

The Astor Hotel is featured in at least six Currier and Ives prints, all of which provide architectural perspectives of the building and attribute the design to architects Town and Davis. The most detailed print, issued by Stodart and Currier, offers a three-quarter profile showing the hotel's entrance porch, with its four Ionic columns, reached by a stairway. At each corner of the building is a square tower,

and a domed cupola graces the center of its flat roof. People appear on the ground and balconies. Other undated prints picture the hotel's Gothic Hall, courts, basement, stores, and even windows—the last praised for their size and ability to light the interior spaces.

Frances Palmer focused on the Union Place Hotel in Union Square in an undated print that offers praise in words as well as image. The hotel occupied an entire city block, but Palmer manages to include a circular park and the Union Square fountain as well. Although there is no evidence that the hotel actually ordered the print, the following advertisement is inscribed: "The hotel is situated in the most fashionable and elegant quarter of the city, and is unsurpassed in all its departments for convenience, quietness and luxury. J. C. Wheeler, John Wheeler proprietors." Such promotional pieces were not uncommon among Currier and Ives prints.

Currier and Ives offered for sale a dozen editions of *The Great Bartholdi Statue, Liberty Enlightening the World* (Fig. 28)—the Statue of Liberty—the earliest being a sketch published in 1882, two years before it was actually presented to the United States and four years before it was dedicated. They issued six prints with the same title in 1885. Each offers essentially the same view of the statue, with parts of Manhattan Island and Brooklyn on the horizon. Boats fill the waters around it. All prints include detailed descriptions of the statue, including its dimensions, noting that it is to be erected on Bedloe's Island in New York Harbor. Some mention that "this magnificent colossal statue (the largest ever known in the world) is of copper bronzed"; that "forty persons can stand comfortably in the head"; that "the torch will hold twelve people"; that "the torch at night displays a powerful electric light"; and that by night or day the statue presents "an exceedingly grand and imposing appearance." Most of the prints identify the statue as the gift of France to the American People, and one goes so far as to identify the ships in the harbor.

No single New York City landmark, however, garnered as much attention as Central Park. George Templeton Strong spoke for all New Yorkers in 1871 when he proclaimed in his diary, "The Park is a priceless acquisition. Thank God for it."[23] Currier and Ives no doubt agreed. Social activities in the country involved family, relatives, neighbors, or friends in the community. Much of the time some form of productive work was performed at the gathering, like raising a barn, husking, or quilting—the useful task providing the opportunity for sociability. In cities like New York there were few such common objectives to bring people together. Sociability existed for its own sake,

FIGURE 28. *The Great Bartholdi Statue, Liberty Enlightening the World.* Currier and Ives (1885).

in the streets or squares, along riverbanks or on docks and piers, on the rivers or in parks. Castle Garden, represented by Currier and Ives in a print of the same name in 1848, was built as a fort but by 1848 was being used as a garden, theater, and concert hall. But then there was Central Park.

When the city's future street grid was ambitiously planned for almost the entire island in 1811, no thought was given to creating public parks above 14th Street, the outer limit of urban habitation at the time. By the 1850s, however, the city fathers began to realize that the opportunity for public control of development beyond 59th Street would soon pass if they did not act quickly. In 1857 the city purchased and cleared 840 acres (336 hectares) of land and charged a board of commissioners with responsibility for creating a large public park in the still-unsettled space in central Manhattan. The commissioners held a competition and from the thirty-nine designs submitted chose the "Greensward Plan" submitted by Frederick Law Olmsted and Calvert Vaux. Its creators designed the "Greensward Plan" to improve the quality of life for New Yorkers by ensuring an expanse of nature in their urban environment. There would be one large park, rather than the series of smaller ones in London, and that park would follow the more "natural" English garden form than the more rigid French gardens. On June 1, 1858, work began on creating a "natural landscape," almost the entirety of which was constructed and involved the planting of 320,000 trees and shrubs.[24] In the midst of the panic and depression that began in 1857, New York City launched its greatest public works project to date.

Olmsted and Vaux intended Central Park to become a recreational center for the city—rich and poor alike—the mix intended to help civilize the poor, especially immigrants, and ease growing tensions between the two. The plan, as Vaux put it, was to "translate Democratic ideas into trees and dirt." Some sixteen hundred working-class African, German, and Irish Americans had to be evicted to make way for the park, but many of those same Irish and German laborers helped construct it. And during the first year after the Civil War ended, more than eight million people visited the park.[25]

Central Park may have been "the jewel in the reformers' crown," but its location and rules made it less democratic than it might have been, at least to start.[26] Central Park was located so far north of the low-income sections of the city that the poor had to take mass transit to visit it, an expense many could not afford on a regular basis. And by requiring special permission for group picnics, "strenuous activi-

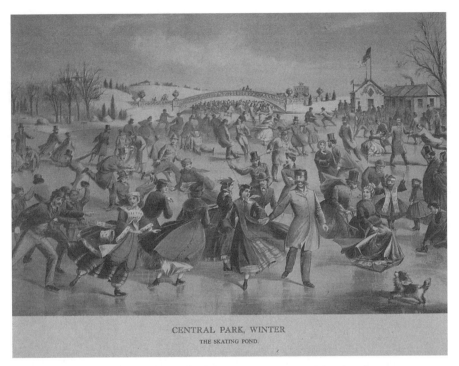

CENTRAL PARK, WINTER
THE SKATING POND.

On the cover: *Central Park, Winter. The Skating Pond.* Currier and Ives (1862).

ties" (like baseball), and even walking on the grass, park rules discouraged the activities in which the poor, more than the rich, likely wished to engage.

Currier and Ives published at least a dozen lithographs of the park, emphasizing the many pleasurable activities it offered city dwellers, such as *Central Park, the Lake* (1862) and *Central Park, Winter. The Skating Pond* (1862, on the cover). An early 1859 newspaper reported that the new pond in Central Park was "quite a fashionable resort for skaters." An annual report of the park stated, "It is undeniable, that the concentration of such numbers of pleasure-seekers upon the little space of twenty acres, while it imposes some restraint upon the skaters, and calls for constant exercise of skill to avoid collisions, adds vastly to the general gayety, and thus causes an excitement of healthful hilarity. . . . None of the various exhibitions of crowded life of this metropolis are more interesting, or can be viewed with more unmingled satisfaction than the skating scene upon the park."[27]

The *Skating Pond*, by Charles Parson, illustrates this account. Parson shows more than seventy-five distinct figures, whose winter out-

fits were carefully drawn for the viewers—especially rural folk, who might be curious to know what city dwellers were wearing that season. City residents appear to be having a wonderful time, belying any stories about the sordid conditions of city life in America. A small dog barks at the skaters from the edge of the ice, a child on wobbly ankles learns to skate, some beginners fall on the ice, and experts show off their talent. The park's artificial lake was not completely finished until 1859, but the skaters were on it as soon as its rising waters froze. By 1862 the populace was notified when the ice was safe by a large red ball hung from a tower near the reservoir, which could be seen for a considerable distance in the absence of any tall buildings.[28]

During the prosperous years following the Civil War, Central Park was clogged with fashionably attired strollers and horse-drawn carriages. In *Grand Drive, Central Park N.Y.* (1869), Currier and Ives pictured crowds of well-dressed individuals and couples meandering along the park's paths. The men generally sport top hats; the women wear hats and full-skirted dresses of the period. A road that crosses the middle of the scene is thronged with horse-drawn carriages, a phenomenon on which Thomas Worth focused exclusively in his collage of horses and carriages, *Fashionable "Turnouts" in Central Park* (1869). The outfitting of such rigs could run into thousands of dollars and be the source of great pride and ostentatious display. In this parade of fine horses, considerable attention was paid not only to the horses and rigs but also to the women's and men's clothing. It was incumbent on both to look sharp.[29]

New York City dominated Currier and Ives's urban prints, but the firm included other cities and several small towns and villages in their inventory of images as well. One source commented, "Such collections not only give pleasure to the eye and educate the mind, but stimulate civic pride and patriotism." They could be sentimental or nostalgic of past generations in small towns or villages or reflect pride in the growth and prosperity of booming town or city.[30]

Views of smaller towns tended toward the picturesque. They exuded prosperity and often included a hint of future growth and development. *View of Alton, Illinois* (undated) combined all of these elements. Drawn "from the river," the anonymous artist included and labeled the town's major buildings: churches, mills, warehouses, residences, and the state penitentiary. Two steamboats cruise on the Mississippi River, which flows past the town, and two others—one named the *Alton*—are docked at the foot of town.

S. H. Donnel provided Currier and Ives with a similar view of

Madison, the capital of Wisconsin (undated). As pictured from Lake Menona, the Madison skyline consists largely of low structures punctuated by church spires and other larger buildings. Currier and Ives's view of Saratoga Springs, New York (undated), offers some variation on the small-town theme by virtue of its being a noted resort and thoroughbred racing center. It features a tree-lined street passing between two porticoed hotels on one side and a third on the other. Several horse-drawn carriages move along the street, and people stroll along the sidewalks and in a park.

Large urban cityscapes ruled the day, however, even if they were not of New York, such as *View of San Francisco... from Telegraph Hill* (1851). Chicago was pictured too (undated), of course, as were other major American cities, some of which were marketed abroad. Baltimore and Boston, for example, were printed in French and German and sold in France and Germany, if not elsewhere in Europe. *View of Baltimore* (1848), anonymously drawn, provides a perspective of that bustling port city from the harbor. A slim monument topped by twin spires towers above the densely packed buildings spreading at its foot and up a small rise. Several ships sail through the harbor, while on shore, in a curious juxtaposition, one woman carries hay and a man and woman hold pitchforks. *View of Boston* (1848) offers a similar perspective—a view from the harbor of the city's skyline topped by its domed capitol. Boston Harbor is crowded with boats, the streets with horsecarts and pedestrians.

It has been argued that the lithographic urban view, though not unknown in England or on the continent, can be regarded as a uniquely American phenomenon. "The sheer number of images, the reasons why they were produced, the eagerness with which they were acquired, their artistic style, their wide geographic scope, and their range of subjects—from tiny villages to metropolitan centers—all stamp them as the product of the open, optimistic, curious, unsophisticated, materialistic, and egalitarian society that characterized nineteenth-century America."[31] Indeed, "it was only with the advent of the full-blown city-view lithograph that American printmaking reached its first plateau of originality, making a historical contribution to the graphic arts."[32]

Prints of Rural America

Americans took pride in their cities, but as the century wore on, among those who had moved to the city a yearning set in for a life

they had—or imagined they had—left behind. Even those who re-
mained in the country or small towns seemed to long for a life they
thought was being lost. To satisfy that need Currier and Ives produced
a large number of genre prints of rural life in America, or at least of
rural life as it was imagined in the mid-to-late nineteenth century.

The theme that ties most Currier and Ives rural prints together is
that home is best found in the country. In the third quarter of the
nineteenth century, when such prints proliferated, the nation's popu-
lation was still about 60 percent rural and agricultural.[33] Many people
who lived in cities had spent their childhood on family farms. Mov-
ing to the city, with its quite different and more hectic way of life, no
doubt kept alive fond, even nostalgic, memories of that earlier life.
New York newspaper editor Horace Greeley gave voice to this senti-
ment when, in 1852, just after turning forty, he bought a farm in what
was then rural Chappaqua, New York: "And so I, in the sober after-
noon of life, when its sun, if not high, is still warm, have resolved to
steal from the city's labors and anxieties at least one day in each week
wherein to revive as a farmer the memories of my childhood's humble
home."[34] The farm was pictured in Currier and Ives's *Chappaqua
Farm, Westchester County, N.Y.: The Residence of the Hon. Horace Gree-
ley*, issued upon Greeley's death in 1872.

The full flowering of genre art of rural America dates to the work
of William Sidney Mount, essentially the first American painter to
devote his major efforts to this branch of painting. Mount happened
along at just the right time. His brand of genre art, having at its cen-
ter the common people in rural America, was eminently in tune with
the widespread interests of middle-class America. Like Bingham,
Mount elucidated the tenets of Jacksonian democracy. His adherence
to these principles shows in his often-quoted remark, "Paint for the
many, not the few." But Mount did so by focusing on rural America,
not the frontier. He gave all of his attention to the rural life of the
Long Island countryside, depicting his friends and neighbors making
cider, dancing in taverns and barns, sharpening axes, trading horses,
talking politics, courting, or otherwise engaged in the activities that
made up their daily experience. And his work was imbued with a joie
de vivre that was immediately appealing.[35]

Mount's paintings are seldom ambiguous; the message or story can
be read at once. They require no supplementary explanation. Little in
Mount's work reflects contemporary events and nothing reveals in
him any reformer's fervor. His subject matter avoided anything that
could be interpreted as editorializing. That is not to suggest that

Mount's work was not without meaning to his nineteenth-century observers. Although committed to the idea of creating paintings that emphasized rural simplicity, with more than a touch of nostalgia, Mount also created a type that was recognizable to city and country folk alike, the Yankee farmer.[36]

Mount represented the country population variously as lovely, earnest, and silly. Yeomen were his main actors; rural women instructed boys or served as romantic foils for young men, and blacks were amusing servants. Although his works provided an endearing, nostalgic glimpse of rural life as many urban dwellers liked to believe it once was, they also provided enough of a hint that despite all the charm it may have lost, the more sophisticated life of urban dwellers was ultimately preferable, or at least a progressive step forward.[37]

Mount's types appeared even in his earliest works. In *Rustic Dance after a Sleigh Ride* (1830), for example, Mount included the African American as fiddler, bellows pumper for the fireplace, and coachman. He pictured white women as well, but his focus was on the Yankee farmer. We see in his characterization a gentle urban satire of the farmer's old-fashioned New England ways and questionable adaptation to nineteenth-century democracy and free enterprise.[38]

In *Farmers Bargaining* (1835) and *Farmers Nooning* (1836), Mount critiqued the Yankee yeoman and his economic and political behavior, but he did so subtly and without losing an essentially positive, affectionate, and nostalgic view of a vanishing rural life for a receptive and appreciative urban audience. He was by nature an observer of humanity and a philosopher, not a propagandist. Currier and Ives avoided even that level of social critique in their genre prints of rural America. The bulk of Mount's work preceded Currier and Ives's major foray into rural genre prints. The firm never printed any of Mount's paintings, but he clearly paved the way for their work.[39] Nor did Currier and Ives reproduce the paintings of the other great genre painter of the nineteenth century, Winslow Homer. But Homer's best work in this vein came in the last quarter of the century, when genre prints ceased to be Currier and Ives's stock-in-trade.

Many Currier and Ives rural genre prints were sentimental. *The Thatched Cottage* (undated) would seem more at home in the English than the American countryside; the idyllic *Home Sweet Home* (1869, Fig. 29) was inspired by the equally sentimental hit song (1823) of the same title by John Howard Payne; and *Home to Thanksgiving* (1867, Fig. 30) evoked the peace, contentment, and serenity promised to urban folk who could return home to the country for Thanksgiving. *Home*

FIGURE 29. *Home Sweet Home.* Currier and Ives (1869).

to Thanksgiving, a particularly evocative nostalgic print for urbanites by George Henry Durrie, pictures a prosperous-looking young family alighting from a handsome, horse-drawn sleigh at the husband's or wife's modest boyhood farm, to which they have come to celebrate New England's quintessential family holiday. Snow covers the ground, but the mother and father offer them a warm welcome on the porch.[40]

"Old" was fashionable, and Currier and Ives capitalized on the trend with at least eighteen prints with "old" in the title—from *The Old Barn Floor* (1868) to *The Old Windmill* (undated)—and many more with "old" subjects. Most pictured a scene of rural peace and plenty in a bygone day, with men, women, and children living contented meaningful lives. *The Old Farm Gate* (1864), drawn by Frances Palmer, pictures a sentimental childhood scene in which two little girls ride a farm gate pushed by two young boys. It includes the following verse, attributed to Eliza Cook:

'Twas here where the urchins would gather to play;
In the shadows of twilight or sunny mid day;
For the stream running nigh, and the hillocks of sand,

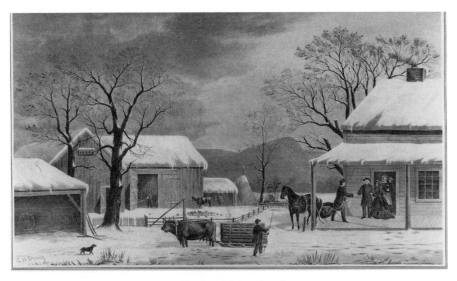

FIGURE 30. *Home to Thanksgiving.* Currier and Ives (1867).

Were temptations no dirt loving rogue could withstand;
But to swing on the gate rails to clamber and ride;
Was the utmost of pleasure, of glory, and pride;
And the car of the victor, or carriage of state;
Never carried such hearts as the old farm gate.

By midcentury and especially after the Civil War, American rural genre artists, including Currier and Ives, focused even more intently on New England or New England–like settings. "Old New England," as it came to be known, was near New York City, the center of arts activity; many migrants to the cities of the Northeast were from rural New England; and, historically and culturally, as well as militarily, New England had triumphed over the South in the Civil War. Rural New England—rather than the antebellum South—became the source of nineteenth-century nostalgia, and Currier and Ives encouraged that nostalgia. Nineteenth-century rural-genre artists persuaded their patrons that they were encountering an authentic old New England, a place that they believed remained largely untouched by the willful and chaotic present they were experiencing in the nation's rapidly growing urban centers. Such images "function both internally and externally; they are as much an exercise in wish-fulfillment as they are representations of an actual place."[41]

Old New England images, including those by George Henry Dur-

rie for Currier and Ives, described the present in terms of an ideal past, a past that many believed, and artists showed, was continuous—a repository of ideas and values that had endured, unbroken, for three centuries. The creation of such an ideal past had begun earlier in the century, when the purveyors of American culture sought to create a usable past by reinterpreting historical events to support the nascent ideology of the New Republic. Increasingly, they focused on elements of New England's past for that history, especially after the Civil War. History was not the only focus of popular art, however; so too was an idealized, rural New England way of life. As postwar Americans moved to urban areas in search of a new way of life, one that was initially as unsettling as it was promising, they sought to hold on to a stable, preindustrial, preurban idealized past.[42]

The modernization of America evoked a vision of cities and factories, turmoil and divisiveness, and unending change. But contrary to the images evoked in rural genre prints, modernization affected New England as well as New York. By 1865 New England became the most highly urbanized region of the United States. Rhode Island was the single most densely populated state, with Massachusetts coming in a strong second. By 1875 more than half the inhabitants of Massachusetts lived in cities, and an increasingly large percentage of those urban inhabitants were immigrants. What had meant growth for New England cities meant crisis for its countryside. For decades before 1865, New England's rural families lost their children to the more abundant lands farther west. Whereas between 1860 and 1910 the population of America's largest cities (those with a population of 100,000 or more) grew by 700 percent, the population of small towns peaked in 1830 and declined for the next eighty years. This was especially true in New England. Between 1850 and 1900 about 40 percent of those born in Vermont moved out of state in each decade.[43]

Many of those rural areas adversely affected by this modernization process capitalized on their "backwardness"; indeed it became a valued attribute. Promoters of tourism fashioned a self-consciously antiquated New England as an antidote to modernization. Entrepreneurs in many farm towns and seaports seized on the opportunity to put their dilapidated buildings and grass-grown streets to work as waves of tourists set out in search of a nostalgic New England experience. Places bypassed in the surge of industrialization began to look attractive to urbanites fatigued and stressed by the rush of business. Such visitors did not seek primitive simplicity but the grace and elegance they associated—realistically or not—with old New England.[44]

Landscape artists fed the nostalgic imagination with pictures of scenic and pristine New England and nearby rural New York, occasionally including the "old" New England village. In *New England Scenery* (1866) Frances Palmer created a lovely rural scene in which a river winds past a small village of tidy houses and a church. Two children walk along a woodland path in the foreground, the entire scene framed by large trees.

An anonymous artist provided Currier and Ives with *New England Coast Scene* (undated). Strollers and picnickers dot the high rocks that jut out of the coast. The water is full of sailboats and fishermen, and a lighthouse stands in the distance. Palmer takes us inland in *The Rural Lake* (undated), providing a serene landscape featuring a small lake surrounded by weeping willows, and to the mountains in *The Mountain Spring* (1864). The spring flows from the side of a rock into the Hudson River, which can be seen through a fissure in an outcropping of rock. In nearly all of these scenic prints, people fish, picnic, sail, and otherwise commune with nature in a relaxing, wholesome, and beneficial way.

Rural genre artists contributed scenes of calendar-perfect farms and villages steeped in tradition, serenity, and cohesion. It is not that Americans rejected the modern; in fact they commonly boasted of modern, progressive America. Rather, they were not prepared to let go of life, as they recalled it, in premodern America. A rift or tension developed between the two, which was not necessarily destructive but instead helped Americans cope with the rapidly changing world around them. They found in an idealized old New England a code of values and a language for a lost way of life, either as a form of nostalgia or as a protest against the present.[45]

Such an urban commercial reaction helps explain the popularity of Currier and Ives rural genre prints. Husbandry had been a struggle for survival, but as it waned, it became romanticized and fixed in its traditional, pretechnological era. On Currier and Ives's pastoral farms, men appear strong and healthy and often exude quiet dignity, and well-fed farm animals abound. Women are plump and attractive, and both men and women are well dressed, even when at work. Children are commonly presented as playing—skating, sledding, or fishing—or standing close to, and relating lovingly to, their parents or grandparents, especially their mothers.[46]

Farmhouses reflect agrarian prosperity and stand in notable contrast to existing rural poverty as well as urban tenement conditions. Most rural homes have at least two storeys, and many have three, plus

capacious wings. Winter is the most common season, which may have provided the rather noticeable emphasis on leisure. Many of Currier and Ives's prints of rural America pictured various types of recreation, as well as receiving visitors or riding in a sleigh, buggy, or wagon for purposes other than work.[47]

Where Currier and Ives pictured work, it was seldom arduous and usually engaged in by only a few of the people included in the print. The farmer is seldom behind the plow, and when he is there is little sign of exertion. No matter what he does, he radiates composure, dignity, even nobility. Most are involved in more leisurely pursuits, playing or socializing. When women work, they are almost without exception feeding their children, gathering fruit or vegetables, sitting in a barn, feeding the chickens, or pursuing some other similar activity in an almost leisurely manner. Few woman are seen washing clothes, fetching wood, milking cows, hoeing the garden, or even carrying water.[48]

Louis Maurer fixed that image in *Preparing for Market* (1856, Fig. 31) by making the farm a bounteous place. As a catalog notes, "This is one of those agreeable domestic scenes which are sure to please everybody who loves (and who doesn't) the attractive features of an American farmhorse."[49] Maurer compresses the seasons to assemble the surplus produce used for barter or sale at the village market: carrots, cabbage, apples, turnips, onions, eggs, butter, a coop of chickens, and a barrel of sorghum syrup, kraut, some pickled delicacy, or corned meat. Buildings are well kept, haystacks scaffolded, and farm animals paraded in variety as if ready for the Ark. In 1860 Currier and Ives described the print in its catalog:

> The time is early morning, in summer. A white horse stands facing the observer, in front of a country wagon, to the pole of which he is harnessed. On the right, a boy is holding the nigh horse, a bright bay, whose appearance and condition are creditable to his owner. The farmer stands in the wagon, taking from his buxom dame a basket of eggs, which she is handing up to him. On the stoop of the farm-house stands a two-year-old specimen of Young America, who has evidently come out on his own responsibility, with nothing but his nightgown on, endeavoring to attract the notice of a noble Newfoundland dog, standing by his mother. Nearby are baskets of vegetables, and bunches of carrots, beets, and garden stuff, ready for market, and a goodly number of fowls, turkeys, ducks, and chickens, promenade the dooryard.[50]

The idea of preparing for market contradicts the common characterization of the nineteenth-century American farmer as self-sufficient,

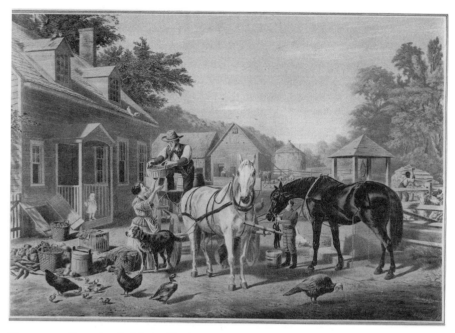

FIGURE 31. *Preparing for Market*. Nathaniel Currier (1856).

but in this case, at least, it appears to be an economically beneficial dependence.[51]

Life in the Country: The Morning Ride (1859) shows rural Americans in a moment of leisure, enjoying life as only country folk could—excluding, of course, urban folks who were wealthy enough to take morning carriage rides in Central Park. The print, done by Louis Maurer, shows a family of five on a country road early on a summer day. The family gives the impression of being prosperous, as judged by their clothes, horses, and carriage, which one critic has identified as a Germantown Rockaway, very much in style at the time. The homestead in the print is likely theirs, and one can imagine that it is Sunday morning and the family is off to church.[52]

Among the most famous of Currier and Ives's prints were *American Forest Scene: Maple Sugaring* (1856, Fig. 32), from a painting by A. F. Tait, and *Husking* (1861), after the painting by Eastman Johnson. Both represent the mix of rural work and entertainment, namely the pleasant experiences of work, the sociability that comes from work, and the leisure time with which life in rural America appears to abound. Tait, who had become widely known for his Western paint-

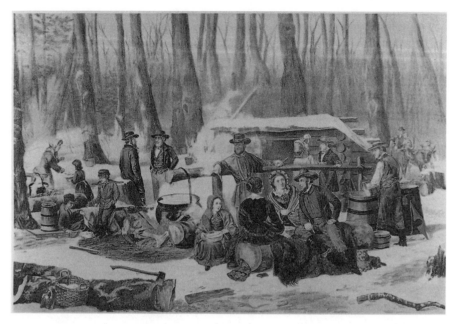

FIGURE 32. *American Forest Scene: Maple Sugaring.* Nathaniel Currier (1856).

ings, painted *Maple Sugaring* only six years after arriving in the United States from England. It was an immediate success. Johnson had a long and distinguished career as a genre and portrait painter, but *Husking* was his only work destined to be reproduced for the masses.

Maple sugaring heralded the end of winter and the promise of warmer days, with the sap running in the maples. The process of making sugar from sap was demanding and tedious; the heat had to be kept constant and never too great, since the syrup was easily scorched and rendered worthless. Work in the "sugar shanty" required twenty-four-hour vigilance. Such hard work is absent from the print. Instead it takes on a holiday atmosphere, with farmers, neighbors, and visitors joining in activities that make it a social event. A man is emptying a pail into a barrel and a woman is feeding a child. There are fifteen other figures in the picture, many looking quite urban. Four are sitting in a group talking to one another. Three other groups consist of two individuals each, also talking to one another. One man leans against a pole, while in the background, four figures stand beside a yoke of oxen. Only the final four appear to be working.

Rather than showing men hard at the work of maple sugaring, Currier and Ives elected to picture one of those occasions when city

folk joined in, as well as children who were rewarded by being allowed to make sugar cakes in the snow. Perhaps Currier and Ives described this print best themselves, in the firm's 1860 catalog:

An agreeable picture of a peculiarly American character, showing a maple sugar grove in the early springtime. A light snow has apparently fallen over night, and the ground is thinly covered with a mantle of white. On the logs, near the fire where the sap is boiling, are seated two ladies with a male companion, apparently city folks come out to taste the sweets of the country. In the distance, an ox-cart is approaching with another party of the same sort. On the left, two "natives" seem engaged in a discussion, either on the sugar trade or the next election. A number of boys and girls are tending the kettles, bringing up the sap in buckets, or having a good time generally at "sugaring off."[53]

The scenes Eastman Johnson did in Nantucket are often seen as among his best. Critics argue that he was at the peak of his powers in those decades and that he found the temperament and characteristics of the islanders akin to residents of his native Maine.[54] *Husking* is among the best of the Nantucket group, and it had wide appeal, both as a painting and as a print for its immediate audience and later generations as well. In addition to its quality of nostalgia, summoning up an American countryside rapidly disappearing, it was familiar to most Americans. The homely Nantucket farm scene was rich in detail, portraying the work of America's farmers, their division of labor, as well as the socializing such labor often brought. It surely appealed to city dwellers who trudged off to the tedious and less social work in the nation's shops and factories.

In *Husking* several men, women, and children gather in the barn to husk corn. The oldest and wisest farmer, a grandfather wearing a coat, beaver top hat, and vest, no longer fit for heavy tasks, has winnowed out the finest ears for seed corn, upon which the next year's crops will depend. He painstakingly braids their husks so that each ear will stand out alone, untouched by its neighbors, ensuring perfect drying when the seed is hung in the barn. The strongest young workman carries out a basket of corn, the husks removed so that the animals will not choke on them, while, at the right of the picture, a couple sits among cornhusks, raptly absorbed in intimate conversation. Although the message of the scene is clearly one of work, of labor that is necessary on the farm, it is also rewarding and pleasurable and social. It is touched with romance and dignity—dignity for which, no doubt, many of its urban viewers yearned.

Currier and Ives sent similar messages with *Haying Time: The First Load* (1868) and *The Last Load* (1868), the combined efforts of Frances Palmer, John Cameron, and James Ives, and the *Farmer's Home* series, designed by Palmer and George Durrie. In *Haying Time: The First Load* a young man leads a cart drawn by two oxen and carrying two children and two adults toward the viewer as a dog jumps playfully at its side. Men pitch hay in the background, which in *Haying Time: The Last Load* has been loaded into the cart. The two children now ride atop the hay, while the young man leads the cart over a small bridge away from the viewer. An older man, presumably the father, carrying a rake and pitchfork, his jacket slung over his shoulder, walks behind the cart and gestures to the children.

The four-part *Farmer's Home* series is subtitled *Summer* (1864), *Autumn* (1864), *Harvest* (1864), and *Winter* (1864). In *Summer* a mother and child wait on the porch of their farmhouse for a carriage approaching the driveway. Lush green foliage surrounds the house and barn. In *Autumn* people gather apples in an orchard, as a horse-drawn cart loaded with fruit moves toward the house. Two women pick grapes under an arbor nearby. In *Harvest* farmhands pitch bundles of grain onto an oxen-drawn cart, while a woman watches them from the porch and two children play in the yard. Finally, in *Winter*, amidst haystacks and cows, a man hauls hay across a snowy yard. Both of these series boast of the prosperity, abundance, and tranquility of life on the farm. People gather apples in orchards, grapes under an arbor, and hay and grain from the fields, while children play nearby. Even the winter scene is marked by haystacks and cows.

A characteristic aspect of practically all the Currier and Ives prints of homes is their picturesque privacy amidst bucolic surroundings. They were idealized, but they conveyed enough reality either to recall nostalgic memories or to seem attainable by city dwellers, many of whom lived in cramped tenements but remained inspired by the American dream of home ownership. Among the most popular of Currier and Ives's prints, reproduced in the largest numbers and offered for sale for the longest periods, were those featuring houses that were actually quite unpretentious. They appear to be "real homes," in many cases with extensions added later for growing families and reflecting financial success. They are built of simple frame construction, clapboarded, and to judge by the majority of the pictures, lived in by ordinary, if prosperous, folk.[55]

Currier and Ives issued prints of homes from every section of the country. *A Home on the Mississippi* (1871), a picturesque glimpse of life

in the nineteenth-century South, may hold the record for being re-produced: an estimated 3.5 billion times on the label of Southern Comfort liquor. This highly sentimental portrait of life on the Mississippi appeared in 1871, in the wake of the Civil War and in the midst of Reconstruction and Union occupation of the South.

Yet rural New England was clearly the favorite subject of Currier and Ives home prints.[56] The firm reproduced ten of George Durrie's paintings on the subject during the 1860s. Representative is his New England seasons series. In his *Autumn in New England: Cider Making* (1866), for example, we see trees touched by the chemistry of the season, the last harvest taking place, and the cider-making process. All surround a rural New England homestead; the entire scene quite likely not only pleased the eye of rural residents everywhere but also evoked fond memories of those who had left the country for the city.

Similarly constructed to evoke such nostalgic memories was Durrie's *Winter in the Country: The Old Grist Mill* (1864). City dwellers might have been attracted to the scene because the miller was the lone manufacturer and the most skilled artisan in rural America. He was also the first specialist in rural economy, even though most of the time he labored for goods in kind, including a percentage of the meal or flour he ground. The mill, like those of antiquity, was constructed of massive timbers and giant stones and powered by water, and it ground meal "as warm as the underside of a settin' hen."[57]

Life in rural America during the winter could be difficult, of course, but Durrie could make even difficult tasks appealing. *Winter in the Country: Getting Ice* (1862) pictured the cutting of ice, a lucrative chore for the nineteenth-century American farmer. Some historians believe the scene is of Rockland Lake in New York, but it could well be of any lake in New York or New England. For all those who engaged in such an enterprise, it was hard work, but the ice could be either kept for home use or sold. The blocks kept for the farmer's use were hauled off to an ice shed where, packed in sawdust, they would keep for several months. Ice cut for sale was shipped to the cities, even in the South, or packed in straw in clipper ships and sold as far as away as India.[58]

The American Dream

Some Currier and Ives prints, including a number of rural scenes, have been cited as evidence of an effective propaganda campaign that did much to underscore the American dream at home and abroad, promoting the idea of a promised land. Currier and Ives certainly lent

support to this charge in their two series, *The American Homestead* and *American Farm Scenes*. The home that Currier and Ives chose—and that the American public accepted as typical—was pictured in a rural setting. By the mid-to-late nineteenth century, it would have been re-alistic and understandable, given the demographic changes taking place, to include city dwellings as home, but they did not. They might have chosen a single family house in the "streetcar suburbs," to which middle-class Americans were moving in increasing numbers away from urban business and manufacturing centers. Instead, they chose as their model the "traditional" simple, rural New England homestead.[59]

In the wake of the Union victory, or the South's defeat, the New England homestead became "the American homestead" celebrated in prints such as the Currier and Ives series of that name. Subtitled *Spring* (1869), *Summer* (1868), *Autumn* (1869), and *Winter* (1868), all four feature essentially the same house: constructed of lumber, squar-ish but sporting dormers and porches, little European influence in its architecture, neat, sturdy, and given a sense of modest prosperity by its setting amidst bountiful fields, pastures, and orchards. Along with *American Farm Yard—Morning* (1857) and *American Farm Yard—Evening* (1857), both by Frances Palmer, such prints celebrated the beauty, order, and prosperity of the growing nation, as if all Ameri-cans shared the ideal state.

One of the repercussions of this propaganda was the idea of a sec-ond home among the nation's new leisure class. An increasingly large number of those who had moved to the city and grown wealthy sought to recapture the rural life that filled their nostalgic memories, as did Ho-race Greeley, "returning" to his Chappaqua Farm. They were joined by many who had never lived in the country but had been persuaded to seek its beauty from idealistic renderings of that lifestyle. Varied sources provided inspiration for the buildings, most of which greatly exceeded the residences owned by native country residents, both in size and opulence, but most were copied from drawings in magazines and Currier and Ives's prints. Such houses were included in Frances Palmer's *American Country Life* series, all done in large folio formats.

Currier and Ives advertised its *American Country Life* series as being "interesting and pleasing illustrations of the life of an American coun-try gentleman in the four seasons." In the course of her four scenes, Palmer presents nature's cycle of seasons as the backdrop for an American arcadia. Each scene features a country villa and an affluent family at leisure. Gentlemen farmers ride, hunt, and fish; wives and children adorn porches and gardens. In the background tenant farm-

ers, hired hands, and domestic servants work the land and serve their employers. As one critic observed, "the well-tended country houses seen in these prints conform to those designed and published by Alexander Jackson Downing, a leading spokesman for the therapeutic and moral benefits of rural life."[60]

To be more specific, in *May Morning* (1855) a gentleman on horseback and his young son on a pony are taking a morning ride. They pass a garden, where two ladies attend flower beds and a little girl plays with her pet lamb. An elegant house stands behind them, as well as a stable, outside of which a man is grooming his horses. A plowman can be seen guiding his team of horses. Other farmhouses occupy the idyllic spring scene, as well as orchards, all overlooking the ocean with white sails far off on the horizon.[61]

In *Summer's Evening* (1855) a country gentleman and his family enjoy a warm evening of leisure. In the foreground, a fashionably dressed couple stand in the shade of a spreading oak tree, gazing at the landscape. Their two children chase a butterfly and gather wild flowers. In the fields nearby farmers rake hay and tend to their animals, and in the distance the "setting sun bathes with golden light the white church spire and houses of the little village."

October Afternoon (1855) is dominated by a large, shuttered country house, topped by four brick chimneys and a widow's walk and balanced in the front and rear by sweeping porches. In the foreground two well-dressed gentlemen hunters—advertised as "a happy husband and his bachelor friend returning from a hunting excursion"—encounter at the gate the wife of one of the men, carrying a small child.[62] They proudly display a brace of rabbits and other small game. A boy and two dogs play nearby; he has taken his father's hunting rifle and, in paper cap and feather, marches like a soldier. As one critic described the scene, "almost every detail was carefully calculated to tug at heartstrings or fan pride in national progress. Not only are the woods full of game, the streams full of fish, crops ready for harvest, and dogs and children happy; a busy gristmill speaks of ceaseless industry, the distant sailboats of recreation, travel and trade—and the bristling lightning rods on the mansion speak of an era of supersalesmen."[63]

Finally in *Pleasures of Winter* (1855) Currier and Ives show that "the country is delightful, even in the winter." A black servant leads a team of horses, hitched to a sleigh, up to the porch of the elegant house, where the fashionably dressed gentleman, woman, and children wait to take a sleigh ride. In the distant woods, men fell trees and skaters move about a lovely pond.[64]

Two prints clearly intended by Currier and Ives to appeal to wealthy urbanites contemplating a move to the country were *A Suburban Retreat* (undated), the title itself suggesting its audience, and the *Life in the Country* series. *A Suburban Retreat* shows a lovely, some might say pretentious, home on a river, situated on the banks of an expanse of water on which sail a half-dozen small recreational sailing vessels. *Life in the Country—Evening* (1862) creates a similar scene, both reflecting and no doubt encouraging the rural estates being created in the Northeast by those who had already made their fortunes as merchants or industrialists. Theirs, these prints suggest, was the American dream.

Ფ SIX Თ

Views of the American Family

Central to Currier and Ives's nostalgic view of rural life in nineteenth-century America was the home, which is not surprising because the home was central to Victorian American culture. The home was hallowed as a link to a simpler past but also as a safe haven from the sometimes dangerous and morally destructive society that many feared was developing in industrial, commercial America. The model Victorian woman presided over that safe haven, but her assumption of that role did not occur in a vacuum. The roles of men and children changed as well, and Currier and Ives represented all three gendered and social reconstructions.[1]

The Home

To help the Victorian woman achieve that perfect home, several "manuals" were available. As early as 1828 Mrs. William (Frances Byerly) Parkes published the first American edition of her *Domestic Duties or Instructions to Young Married Ladies on the Management of Their Households.* The first American edition, based on the third London edition, was published in New York "with notes and alterations adapted to the American reader."[2] *Domestic Duties* and other similar books guided young wives through the intricacies of family psychology, social interchange, and the home furnishing necessary to create a healthful, comfortable, and intellectually and morally nurturing environment.

The classic treatment of the new American woman in the Victorian home, however, was *The American Woman's Home* (1869) by Catharine Esther Beecher and Harriet Beecher Stowe.[3] The authors were daughters of the Reverend Lyman Beecher. Catharine founded women's schools and wrote several books on women's education; Harriet authored *Uncle Tom's Cabin* (1852). The purpose of *The American Woman's Home* was to explain and illustrate the proper system of running an efficient, harmonious Christian household. Replete with moralistic do's and don'ts, the book "represented the most advanced form of its medium, while socially and culturally it found security in old-fashioned standards."[4]

A woman's "great mission," wrote the Beechers, is "self-denial." As chief minister of the family, a woman is called to train "its members to self-sacrificing labors for the ignorant and weak: if not her own children, then the neglected children of her Father in heaven. She is to rear all under her care to lay up treasures, not on earth, but in heaven. All the pleasures of this life end here; but those who train immortal minds are to reap the fruit of their labor through eternal ages." Because almost all Victorians agreed that the woman's sphere was the home, only a small percentage of married Victorian women worked for pay outside their homes, thus defining Victorian culture as essentially middle class. Upper-class Americans shared in Victorian values but otherwise answered to their own cultural norms.[5]

Man was assigned to outdoor labor, "to till the earth, dig the mines, toil in the foundries, traverse the ocean . . . and all the heavy work, which most of the day, excludes him from the comforts of a home." But the home was man's reward: "The great stimulus to all these toils, implanted in the heart of every true man, is the desire for a home of

his own, and the hopes of paternity."[6] As temperance leader Timothy Shay Arthur wrote in *Our Homes; Their Cares and Duties, Joys and Sorrows* (1888), "All men . . . are trying to make a home, or are striving to keep one that they have. Everybody has his or her ideal of something or someplace of rest, of complete satisfaction, where the roar and din of the great world may not enter, or if heard at all, would be esteemed for its contrast to the serenity within—a home, in fact, for without serenity there is no home."[7] John F. W. Wake's *Home Life: What It Is, and What It Needs* (1864) was even more insistent: "Probably no four letters in the English language have so much significance, and call out such deep and varied feelings as the four letters which spell that little word *Home*! Probably no other thing has so much to do with making the man, and shaping his destiny in both lives."

In the midst of the Civil War, however, Ware reflected on the New England home in particular:

It is the high tone of our homes, the peculiar home life obtaining in them, which has made the supremacy of the New Englander, and enabled him, child of a colder clime, and a sterile soil, to triumph over the merely adventitious of other sections of the country, and become the master spirit of this continent—will it be going too far to say the master spirit of the day? . . .

If the prairie, the mountain, the seaside, the environment of nature, are felt to have large influence shaping the character—things whose influence is external and must be superficial—why shall not much more the house, the center of our daily action and affections mould and control our lives?[8]

The American Women's Home was based on the then-modern theory of domestic environmentalism, which taught that the home's physical environment helped mold human character. And central to the Victorian home's physical environment was the parlor. In Anglo-America the term *parlor* had long been used to describe what was also called the "best room" in a house, but this room was supposed to retain the identity of a family sitting room even as it also served more public and formal uses.[9] "Victorians could not have been Victorians without their parlors. Families assembled in parlors, met their guests, and entertained themselves and others there, playing games, putting on plays, viewing stereographs, singing and enjoying music, writing letters, and engaging in the paramount parlor activity, reading." Books such as M. E. W. Sherwood's *Home Amusements* (1881), and *Home Culture* (1884),

for which no author is listed, provided appropriate parlor activities that would make serious use of the family's leisure time for the mind and soul. Such activities included "brain games," arts and crafts of various sorts, dancing, and music.[10]

The parlor was a serious setting for serious events. Although they also gave pleasure, furnishings served as the communicative medium for higher ends, pursuant to Victorian thought. Every furnishing had the potential to remind people of the ultimate world to which they belonged. Victorian conventions of furnishing represented two poles of thought about the appropriate character of the parlor: its domesticity (comfort) and its cosmopolitan character (culture). *Comfort* suggested not only physical pleasure but also the presence of family-centered values associated with the home—domesticity, sincerity, and moderation. *Culture* meant a cultivated worldview of educated, genteel, and cosmopolitan people.[11]

In reference to pictures, in particular, advice writer Clarence Cook insisted in 1878 that it was "no trifling matter" whether the pictures that people hung on their walls were good or poor, first or second rate: "We might almost as well say it makes no difference whether the people we live with are first-rate or second-rate."[12] For those with limited incomes, lithographs met this prescription, and those that conveyed an appropriate sentiment, an atmosphere of religiosity, education, or growth, were preferred. Catharine Beecher and Harriet Beecher Stowe devoted a chapter apiece in *American Woman's Home* to "The Christian Family" and "A Christian Home." They argued that the "family state" was designed "to provide for the training of our race . . . with chief reference to a future immortal existence"; it was, they believed, "the aptest earthly illustration of the heavenly kingdom." As its "chief minister," each woman required "a home in which to exercise this ministry," and the physical qualities of each house were to support "a style of living . . . conformed to [that] great design." The private home became as important a sanctuary as the church building, and its contents thus took on the symbolism of religious objects.[13]

Currier and Ives produced approximately 350 prints on religious subjects for most faiths then present in America—Protestant and Catholic, and even Mormon and Shaker. Biblical scenes dominated the prints, but they also offered portraits of saints and church leaders, trees of life and death, and cemetery scenes with religious messages of consolation. Revivalist themes were common, as were religious scenes for children. Related but more general prints on moralistic themes added another 150 or so images.[14]

Decorative compositions of fruit and flowers were also popular, and Currier and Ives alone offered more than two hundred such prints. Frances Palmer's *American Autumn Fruits* (1865), for example, displays the bounty of the American soil. The pineapple—an expensive import of the time—was the traditional symbol of hospitality, and the crystal bowl implies that the table belongs to a well-to-do city dweller.[15]

Anything violent was ruled out, unless the event fell into the category of being an "act of God" or of nature, like fires and shipwrecks. Dramatic deathbed scenes were common, given the rather morbid Victorian sentiment on the subject, and especially if they pictured the death of a hero like Lincoln. Wartime battles were portrayed, but they tended to be bloodless, patriotic renditions of well-known battles— of the Civil War, for example.[16]

As the Beechers explained, proper lithographs helped instill healthy attitudes: "Surrounded by such suggestions of the beautiful, and such reminders of history and art, children are constantly trained to correctness of taste and refinement of thought, and stimulated—sometimes to efforts at artistic imitation, always to the eager and intelligent inquiry about the scenes, the places, the incidents represented." Simply put, sentiment ruled the Victorian parlor. According to the Beechers, "The great value of pictures for the home would be, after all, in their sentiment. They should express the sincere ideas and taste of the household and not the tyrannical dicta of some art critic or neighbor."[17]

Sentiment in this context can be defined as something susceptible to tender, romantic, or nostalgic feeling. The emotional content of any era, however, can be difficult for later generations to comprehend. "It grows out of the course of daily life. When the tenor of the times changes, the older sentiments seem outmoded and fall to ridicule. Homely truths of one generation become the joke of the next."[18] Such was the case with many of the Currier and Ives lithographs intended for the home. The emotions they evoked expanded to the needs of their nineteenth-century viewers. Regardless of how they might be viewed today, they elicited a common feeling that helped people relate to one another and thereby constituted an essential ingredient in the chemistry of Victorian life.

Currier and Ives issued more than 50 lithographs with the word "home" in the title, and many more—about 350 according to one estimate—that pictured a home in some way.[19] *Home to Thanksgiving* (1867) was very sentimental; equally so was *Home Sweet Home* (see page 167),

first printed in 1869 but reprinted four times after that. It also provides an idyllic rural autumn scene. A man approaches his home on foot along a dirt road. His coat is slung over his arm; his dog, on hind legs, welcomes him. His two young children rush through the front gate, their arms extended to greet him, while his wife waits at the front door. The print's inscription is from the song of the same title:

> Mid pleasures and palaces, though we may roam,
> Be it ever so humble, there's no place like home;
> A charm from the skies, seems to hallow us there,
> Which seek through the world, is ne'er met with elsewhere.
> Home, home, sweet, sweet home,
> There's no place like home.
> An exile from home, splendor dazzles in vain,
> O, give me my lowly, thatched cottage again;
> The birds singing gaily that came at my call,
> Give me them with the peace of mind, dearer than all.
> Home, home, sweet, sweet home,
> There's no place like home.

One can easily imagine such a home proudly displaying the ubiquitous Currier and Ives "motto" print, *God Bless Our Home* (undated).

Prints depicting scenes, especially nostalgic ones, from the popular poets of the day were common to Victorian parlors. Currier and Ives produced a series of prints with verses of Lord Byron and other European Romantic poets, as well as scenes described by American writers. Currier and Ives interpreted artistically several images from the poetry of Henry Wadsworth Longfellow, perhaps the best-known American poet of his time, including "The Village Blacksmith" (1864), *Evangeline* (1847), and *Tales of a Wayside Inn* (1863). Longfellow's sentimentality made his work ideally suited to the Victorian parlor. These well-known lines are from "The Village Blacksmith":

> Under a spreading chestnut tree,
> The village smithy stands;
> The smith, a mighty man is he,
> With large and sinewy hands;
> And the muscles of his brawny arms
> Are strong as iron bands.

But to this portrait of masculinity, he added a sentimental note: Children "coming home from school . . . love to see the flaming forge, and

hear the bellows roar," and when the "smithy" hears his daughter singing in the nearby church, he is reminded of "her mother's voice singing in Paradise!" Currier and Ives pictured both messages in three different versions of *The Village Blacksmith*.[20]

Very popular then, if less well known today, was Samuel Woodworth, newspaper publisher, playwright, and author, as well as poet. Woodworth's best-known poem was "The Bucket," more commonly known as "The Old Oaken Bucket." The first line is pure sentimental Americana: "How dear to this heart are the scenes of my childhood." Frances Palmer captured the spirit of the poem in the print, *The Old Oaken Bucket* (1864). In her rural scene, a boy drinks from an oaken bucket at a stone well. To his left cattle and ducks wade in a pond in front of a mill; to his right stands an attractive, large house with a gambrel roof. Mountains rise in the distance. The print, including several lines from the poem, was so popular that it was reissued in 1872.

Equally popular in this line of Victorian parlor prints were family prints, and prime among these were *The Four Seasons of Life: Childhood—The Season of Joy* (1868); *Youth—The Season of Love* (1868); *Middle Age—The Season of Strength* (1868); and *Old Age—The Season of Rest* (1868). The only works known to be lithographed by James Merritt Ives, all were published in large folio size, sentimental and inspiring in their picture of the family. One critic remarked that by combining the cycle of nature with the cycle of human life, the series proclaims a timeless ideal, thoroughly grounded in mid-nineteenth-century American culture. The prints preach the traditional virtues of piety, family loyalty, and hard work and present an idealized, modern success story.[21] On each print appear two stanzas of suitable verse by an unidentified poet. The lines on *Middle Age* read:

> But as the hues of summer fade away,
> And varying tints, the days of autumn brings;
> So life's Autumnal season, brings its gray,
> And cares like ivy, to our pleasures cling.
> Sweet care when home, and loving hearts, are ours.
> And loving lips, breathe forth their welcome song;
> For them we labor through the passing hours,
> And back our burdens, thankful we are strong.

In *Childhood* youngsters frolic with lambs on the lawn of a modest but lovely rural American home, equating the ideal childhood with a

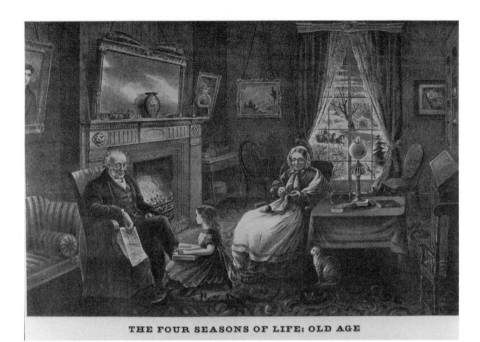

THE FOUR SEASONS OF LIFE: OLD AGE

FIGURE 33. *The Four Seasons of Life: Old Age: The Season of Rest.* Currier and Ives (1868).

simple rural past. In *Youth* a couple walks a rural road, arm in arm, gazing into one another's eyes. A field of ripened wheat nearby, and homes and a church steeple in the distance, suggest the fertility of their future life, their assuming the station to which all adult Americans aspired, and the purity of their intentions.[22] *Childhood* and *Youth* were drawn by Frances Palmer and John Cameron.

Middle Age and *Old Age,* both drawn by Charles Parsons and Lyman Atwater, are set inside middle-class, rural Victorian homes. In *Middle Age* the father happily returns to his adoring wife, children, and dog, who greet him at the doorway of a prosperously appointed house situated by a mountain lake. The furnishings, which bespeak a family of means and fashion, include a large Currier and Ives print. In *Old Age* (Fig. 33) grandparents sit before the fireplace on a winter's day. Grandmother does her needlework, and grandfather takes a break from reading his newspaper to attend to his granddaughter, who sits on a stool at his feet reading the Bible. The final lines of the poem beneath the print conclude the sequence and underscore the importance of home and hearth: "We rest secure, and calmly wait His will, / To call us hence, to His eternal rest."[23]

Were Currier and Ives's renderings of the American Victorian parlor accurate? Given their prodigious publication of pictures for the nineteenth-century home, they certainly had the opportunity to influence taste in such matters, to prescribe as well as describe. In fact, according to one persuasive case study, they did both. In 1990 E. McSherry Fowble compared the detailed presentation of the parlor in *The Four Seasons of Life: Old Age—The Season of Rest* with what we know about Victorian parlor furnishings and published commentaries, descriptive and prescriptive. The results were consistent with what we have found concerning Currier and Ives's worldviews: It both idealized and reflected the Victorian parlor.[24]

The Season of Rest pictures, in minute detail, a comfortably furnished parlor. The room is flooded with light from a double-curtained, floor-length window. A coal fire in the fireplace adds warmth to the room, as does light reflected off the large, gilt-framed chimney glass. A patterned carpet covers the entire floor, and the room is filled with items that provide both the "proper" parlor atmosphere and the personal touch of the mistress of the house—candlesticks, a vase, and seashells on the mantel; peacock feathers on the mirror; a comfortable sofa, two armchairs, and a cloth-covered rectangular table, upon which appear two books, presumably being read by the house's elderly occupants. A secretary bookcase is centered on the wall opposite the fireplace; on the walls appear gilt-framed portraits and a landscape painting. One might best describe the furnishings as "eclectic."

American women had many reference books to help them design a proper Victorian parlor, even at a modest expenditure—modest by middle-class standards. As Fowble points out, the parlor in *The Season of Rest* meets most of the guidelines set forth in these books and reflects what was actually done in middle-class Victorian homes. Most manuals emphasized the importance of natural light in all rooms but particularly in the parlor, where the family gathered to share conversation and to offer hospitality to visitors. And in the era before central heating, the fireplace, with its warm glow in the cold months and dark days, was both a necessity and an extension of that hospitality. The parlor in *The Season of Rest* meets those requirements, as it does the inventory of appropriate furniture with which Victorian women furnished their homes. Even the two portraits flanking the fireplace and the landscape to the left of the window were approved.

That no piano is present might be attributed to the family's modest means. The number of pieces of furniture and other decorations

are another matter. Although the artifactual evidence suggests that Victorian parlors tended to be cluttered with furniture and pictures, manuals warned against it. To the arbiters of taste, too much furniture was both extravagant and in poor taste. But, much as today, nineteenth-century housewives apparently felt free to violate this rule—as can be seen in *Season of Rest*, whether copied from an actual parlor or the artist's perception of the typical Victorian parlor. As Fowble concluded from the case study of *Season of Rest*, Currier and Ives generally remained true to the image of their time. In looking at their interior scenes, we are "looking through time to a reliable picture of the past," Fowble claimed; "Currier and Ives lithographs echo the dictates of the leading household writers, and yet, at the same time, incorporate details indicating that the artists and housewives were not totally enslaved by the dictates of the writers."[25]

When the Victorian women's sphere became the home, and they the guardians of that safe haven, they also became the principal consumers of home furnishings and decorations and patrons of domestic art, including lithography. In *The American Woman's Home* the Beecher sisters recommended that housewives spend 20 percent of their living-room expenses on pictures and then proceeded to instruct women on what was appropriate in such art for the home. Much as in other cultural areas in which they became the predominant consumers—in popular literature, for example—women would profoundly influence the content of this line of Currier and Ives's lithographs.[26]

Without doubt, especially to contemporary eyes, Currier and Ives's pictures for the Victorian home appear picturesque, cute, or sentimental. But there was more to them. Writer and editor Nathaniel Parker Willis observed in the 1850s that it was the "women who read, who are the tribunal of any question aside from politics or business . . . [who] patronize and influence the arts, and exercise ultimate control over the press."[27] Popular art was considered the expression of feminine taste, and in his essay "The Prospects of Art in the United States," the Reverend George W. Bethune applauded that influence on lithography in particular: "The lithographs may be rude and gaudy but you will rarely find, in a humble family, a taste for these ornaments unaccompanied by neatness, temperance, and thrift. They are signs of a fondness for home and a desire to cultivate virtues, which make home peaceful and happy."[28]

The purpose of this popular art was to "soften the harsh features" of life in America, to give "a moral scope and bearing" to the "indus-

trial and commercial spirit." It was a firm but gentle hand, and to the nineteenth-century mind, it was female. The illustrated magazines and women's publications of the day, as well as Currier and Ives, were both guided by, and helped to guide, that female hand.[29] They further cultivated and then met the need for mass-produced, inexpensive prints that covered every appropriate subject, from which the American housewife could choose pictures with certainty and frugality. And they did not have to live in large Eastern cities to do so. The Beechers reminded their readers in *The New Housekeeper's Manual* of 1873 that "by sending to any leading picture-dealer, lists of pictures and prices will be forwarded to you."[30] Currier and Ives were still the leading picture dealers of the time, and American housewives availed themselves of their services to cover their walls with lithographs designed for that very purpose.[31]

Victorian Women and Men

The economic and social changes of nineteenth-century America posed challenges to male and female social and cultural identity, and Currier and Ives's prints reveal a discourse on gender in response to those changes.

Currier and Ives employed the common vocabulary of their day to define womanhood and manhood, a set of recurring images deployed for particular rhetorical purposes. Overall, they constituted an antidote to change, or at least to challenges posed to gender roles established in the first half of the nineteenth century. If not prescriptive, their images of women and men were descriptive and didactic models of middle-class America's ideals, fantasies, and social visions of how women and men ought to live—even though many did not, and could not, especially if they were black, immigrants, or the working poor.[32]

Until 1800 in America, the division of labor fell to traditional sexual roles. Each member of the household contributed to the well-being of all, in a manner consistent with a world of farms, small shops, and cottage industries, in which young and old, male and female, had a place. Economic development after 1800 changed that by widening the range of available careers and by altering the chances for individuals to rise or sink on the social scale. The best of the new opportunities were reserved largely for males and required spending long workdays away from the rest of the family. The self-made man, the new model of manhood, derived entirely from a man's activities in the public sphere, measured by accumulated wealth and status, by geo-

graphic and social mobility. His proving ground was no longer the home but the workplace. The middle-class home increasingly became a female domain, cut off from business and public affairs, and the middle-class woman no longer worked in ways society recognized as labor.[33]

Antebellum images of masculinity and femininity both reflected those social changes and helped shape them. Men, according to most writers, were naturally strong in body and mind, aggressive, and sexual. Women were innately weak, passive, emotional, religious, and chaste. Religious doctrine and scientific and medical evidence "proved" that women were neither theologically nor biologically capable of moving into the public sphere. The "true woman," this ideology explained, exemplified four cardinal virtues: piety, purity, submissiveness, and domesticity. "Put them all together and they spelled mother, daughter, sister, wife—woman. Without [the four virtues], no matter whether there was fame, achievements or wealth, all was ashes. With them she was promised happiness and power," to be exercised within her own sphere, in the confines of the home.[34]

These were complementary virtues and vices: men supported women, and women provided the sensitivity men lacked. Such stereotypes reassured each sex that it belonged where it was: "Woman was too fair a flower to survive in business or politics, where man's cunning and intellect were prime virtues; in the home she was protected, her goodness blossomed, and she refined man's coarseness." Antebellum American society associated certain values with women—care, nurture, and morality—thereby exalting women's capacity to mother, indeed conflating women with mothers, while insisting that in employing that capacity as mothers, women performed an essential service to the state.[35]

Historians have argued that a level of ambivalence resulted from those gender roles. "Mobile, competitive, aggressive in business, . . . the self-made man was also temperamentally restless, chronically insecure, and desperate to achieve a solid grounding for a masculine identity." Alternatively, however, "those who articulated the ideology of Republican Motherhood sought to draw together the political, biological, and economic reality experienced by free white women and to redefine the role of women in the new post-Revolutionary era in a way that reflected realistically the constraints of their lives but also emphasized that women, too, were part of a deeply radical republican experiment."[36]

The opportunities for women to pursue higher education multiplied. The first of the great private women's colleges in the East were established: in New York, Vassar in Poughkeepsie in 1865, and in Massachusetts, Smith in Northampton and Wellesley in Wellesley in 1875. In the Midwest, states receiving land-grant funds from the Morrill Act (1862) either began to admit women to their universities or founded state universities that admitted women from the start. By 1872 ninety-seven colleges and universities admitted women, and by 1880 women represented one-third of all college and university students in the United States.[37]

Not all Victorians shared the belief that women could or should enjoy intellectual development. The Reverend John Todd, a Calvinist minister and best-selling advice-book author of the mid–nineteenth century wrote that education "would only confuse these feebleminded creatures, bring them into contact with polluting ideas whose misunderstood complexity would contaminate the virginal purity of their minds, and hence interfere with their role as soul-keepers."[38]

Maria Mitchell, a professor of astronomy at Vassar who was famous for her discovery in 1847 of a new comet (named after her), often reminded fellow women intellectuals that most "Americans don't believe in education for women." They wanted women, she said, to be useful in the kitchen and ornamental in the parlor and to know no more mathematics than they needed to be able to count. Gradually educators adopted a more progressive view of women's destiny and their role in a republic to argue for women's higher education. Women should be well educated, wrote Matthew Vassar, because "the mothers of a country mold the character of its citizens, determine its institutions, and shape its destiny."[39]

Horace Greeley of the *New York Tribune* continued to express the prevailing sentiment among middle-class men and women: "The best possible employment for most women is to be found in the care and management of their households respectively, and with the rearing and training of their children." Greeley did hire Margaret Fuller as his first female columnist, but he nevertheless concluded, "Noble and great as she was, a good husband and two or three bouncing babies would have emancipated her from a good deal of cant and nonsense."[40] Such notions implied female inferiority, but many antebellum commentators argued that females had a great social role to play, if not in politics and the professions, then through their influence over men and children in the home. Although a woman "may never her-

self step beyond the threshold," one clergyman gushed, "she may yet send forth from her humble dwelling, a power that will be felt round the globe."[41]

The rhetoric of the "cult of domesticity" described only some women's lives, of course. To poor women, who often worked outside the home, it represented at best a standard to which they might aspire; at worst, it was a measure of their failure. Some females discovered that the common assumptions about them could justify activities other than being a housewife. Reform was one of these. If woman's influence was so beneficial, why should it be kept at home? Why not bring to the outside world all those feminine virtues necessary to counteract masculine vices? As Margaret Fuller said in 1845 in *Woman in the Nineteenth Century*, a new era had arrived for humankind in which "the feminine side, the side of love, of beauty, of holiness, was now to have its full chance."[42]

The first step was to work toward the moral improvement of one's family. "Improvement in the daughters," Fuller wrote, "will best aid in the reformation of the sons of this age."[43] The next step involved women, the majority in many church congregations, participating actively in early-nineteenth-century religious and charitable enterprises. By the 1830s they moved into more secular causes—health reform, temperance, antislavery, campaigns to redeem prostitutes and curb licentiousness, and women's rights.[44]

In *Woman in the Nineteenth Century* Fuller expressed a commonly held belief that America was to play a significant role in the redemption of the world: "This country is as surely destined to elucidate a great moral law as Europe was to promote the mental culture of man." America's failure or delayed realization of its destiny, she continued, lay in woman's inability to exercise her proper influence. She must claim her rightful place in society and use it to help the nation elucidate the great moral law.[45]

Women were especially supportive of the temperance movement, perhaps because they and their children were often the victims of male drunkenness. The American Temperance Society was formed in 1826 and by 1834 claimed a million members. A children's temperance society, active in the 1830s, urged people to "pledge damnation to the Friendly Creature in Daddy's Bottle." In the many temperance plays, the plot was almost always the same: "The young husband and his fondness for liquor, the temptations that led from moderate drinking to drunkenness, the suffering of the family from neglect and an occasional cuffing, the gentleman's highly gymnastic heebie-geebies,

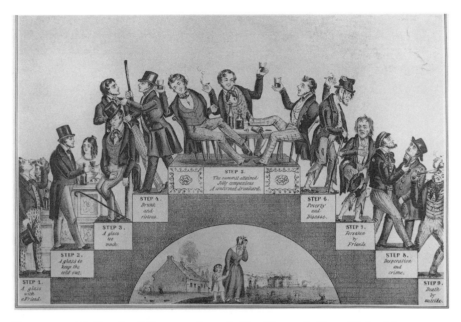

FIGURE 34: *The Drunkard's Progress—From the First Glass to the Grave*. Nathaniel Currier (1846).

the decision to end it all in the river, the rescue by the temperance worker, the reform, and the finale of bliss."[46]

Currier and Ives offered their versions of this morality play in at least thirty temperance prints, such as *The Drunkard's Progress—From the First Glass to the Grave* (1846, Fig. 34).[47] In nine steps the hero moves from "a glass with a friend," through marriage and high society, to "death by suicide." On each step of a stepped arch, various characters enact the dissolution of a gentleman because of drink. In the space beneath the arch, a weeping woman with a child beside her walks away from a burning house. Among the other temperance lithographs published by Currier and Ives are the companion prints *The Fruits of Temperance* and *The Fruits of Intemperance*, published in 1848 and again in 1870, and the six-part series *The Progress of Intemperance*, issued in 1841.

In *The Fruits of Temperance*, a woman with an infant in her arms awaits her husband in the doorway to their home. Her prosperous-looking husband, carrying one child and leading another by the hand, walks up the front path. The inscription reads: "Behold the son of temperance, with buoyant heart and step, returning to his home; the partner of his bosom looks up and smiles his welcome; his children fly to meet him, their little arms about him, and with lip and heart they

bless him." *The Fruits of Intemperance* pictures the ill effects of drink-
ing on the same family, as the now-homeless man walks down a
windswept path, followed by his wife and children.

In the first scene of *The Progress of Intemperance, The Invitation to
Drink,* a husband and father is invited by some unsavory-looking
characters to join them for a drink. In *Sick and Repentant,* he sits in a
wicker chair at home, penitently holding his head. His young daugh-
ter hangs on his knee, as his wife and other children entertain a guest
and play. In *The Relapse* the profligate has returned to his drinking
companions and is pictured squeezing the chin of a woman who
stands nearby, two children in tow. The inevitable results are pictured
in the next three scenes: *The Ruined Family, The Expectant Wife,* and
The Robber. In scene four the man and his family walk along a dirt
road, destitute and carrying their remaining worldly belongings, while
the guest from scene two, astride a horse, takes pity and reaches into
his purse for some money for them. In scene five the despondent wife,
now living in a shack and surrounded by her children, awaits the re-
turn of her husband, who, destroyed by drink, has turned to crime in
the final scene. With two companions he waits behind rocks to am-
bush a man who walks toward them.

Such references to women in temperance prints—as passive vic-
tims, or at best working through moral influence—contrast with their
more active role in the Currier and Ives print of Carry Nation. The
famous temperance leader best known for her ax-work in saloons, Na-
tion explained that she launched her crusade mostly because of the
damage drunkenness did to the home.[48] Linking her crusade to moth-
erhood and the right to vote, she declared that

> the loving moral influence of mothers must be put in the ballot box.
> Free men must be the sons of free women. To elevate men, you must
> first elevate women. A nation cannot rise higher than the mothers. . . .
> I would rather have my son sold to a slave-driver than to be a victim
> of a saloon. . . . The aroused motherhood of this nation shall rescue
> her children and stop the soul-destroying, vote-protected, licensed-for-
> money liquor traffic in its annual slaughter of a hundred thousand of
> her sons.[49]

Currier and Ives celebrated Carry Nation and her mission to rid the
country of the curse of demon rum in *Woman's Holy War: Grand
Charge on the Enemy's Works* (1874). An ax-wielding woman on horse-
back, portraying Nation as a Joan of Arc figure—properly mounted

sidesaddle, of course—leads a line of similarly garbed women in smashing and spilling barrels of distilled spirits, labeled "beer, gin, whiskey, and rum," "in the name of God and humanity."

This rendering of women's involvement in the temperance movement has a certain satirical quality to it, but not so the membership certificate Currier and Ives provided the Washington Temperance Benevolent Society, formed in 1840 by "reformed drunkards." The certificate, designed by Nathaniel Currier, certified that the "reformed drunkard" whose name was inscribed was a member "in good standing with his brethren in the cause, and is hereby recommended to the respect and consideration of all whom it may concern." To be a member in good standing one had to pledge not to drink "any spirituous or malt liquors, wine or cider." Central to the certificate is a domestic scene showing a man proudly presenting the certificate to his wife.

Few of the first generation of female reformers posed any direct challenge to the status quo. By midcentury, however, that was no longer the case and resistance to their efforts grew. Some became involved in efforts like the antislavery movement, where they were not welcome. By the 1850s most reformers, including women, began to realize that moral suasion, which had been at the heart of their involvement in the public sphere, had failed to transform American society. Increasingly, they turned to electoral means, which had largely excluded women. "Voteless, women discovered that benevolent work's growing dependence on electoral means had by the 1850s rendered 'female' means for change less effective and thus less popular."[50]

There was talk of creating a formal institutional structure to advance the cause of women. In 1840 Elizabeth Cady Stanton traveled to London with her abolitionist husband, a delegate to the World's Antislavery Convention. After an acrimonious debate, female representatives, largely in the Massachusetts and Pennsylvania delegations, were excluded from the convention. They were forced to follow the proceedings from a curtained-off area. Wendell Phillips, a Massachusetts delegate, later attempted to mollify the ladies with the promise, "After the slave, then the woman," but the women would not be mollified. Stanton's indignation at the insult coincided with her discovery of those whom she later called "the first women I had ever met who believed in the equality of the sexes." Among them was an American Quaker and abolitionist, Lucretia Mott. The two became close friends and resolved to hold America's first women's rights convention as soon as they returned home. That convention was held in Seneca Falls, New York, on July 19, 1848.[51]

For the opening of the Seneca Falls convention, Stanton, Mott, and others prepared their "Declaration of Sentiments," modeled on the Declaration of Independence. Reminding Americans of the natural-rights philosophy of the American Revolution, their declaration began with the premise that "all men and women are created equal" and substituted "man" for "King George" as the tyrant: "The history of mankind is the history of repeated injuries and usurpation on the part of men toward woman, having indirect object the establishment of an absolute tyranny over her." They submitted "to a candid world" a bill of indictment against male domination, just as their forefathers had done against the British seventy-two years earlier.[52]

Stanton and her collaborators accused man of endeavoring "in every way that he could, to destroy [woman's] confidence in her own powers, to lessen her respect, and to make her willing to lead a dependent and abject life." They specifically objected to the lack of the vote and educational and professional opportunities for women, as well as to laws depriving wives of control over property and awarding children to fathers in cases of divorce. They included eleven resolutions asserting sexual equality, advocating a single moral standard for males and females, and urging women not simply to stay at home but to "move in the enlarged sphere which her great Creator has assigned her." They added a resolution calling for "the overthrow of the monopoly of the pulpit, and for the securing to woman an equal participation with men in the various trades, professions, and commerce."[53]

The women's rights movement did not end with the Civil War, the "great disappointment" for most antebellum reformers, including women who saw black men get the vote, but not themselves, black or white. After a momentary lull during the war and the immediate postwar years, it surged ahead again with what to many seemed alarming tenacity and in the process drew considerable resistance. Opponents of woman's rights, including woman's suffrage, argued that these reforms would fundamentally alter social arrangements. One critic of the movement wrote, "The quiet duties of daughter, wife and mother are not congenial to those hermaphrodite spirits who thirst to win the title of champion of one sex over another."[54]

Victoria Claflin Woodhull became a symbol of the extreme to which opponents feared the women's rights movement might lead. "The Woodhull," as she was known, became a dangerous icon of the movement, if not its scapegoat. With railroad tycoon Cornelius Van-

derbilt's help, Woodhull and her sister, Tennessee Claflin, established their own brokerage house and became quite wealthy. They used that wealth to publish the *Woodhull and Claflin's Weekly*, in which they took comparatively radical positions on sex and politics. In 1871 they assumed the leadership of the American branch of Karl Marx's International Workingman's Association and in 1872 published the first English translation of Marx's *Communist Manifesto* in their weekly. Also in 1872 Woodhull ran for the presidency on the Cosmo-Political People's Party ticket, with Frederick Douglass as her running mate. She was charged with advocating a number of unseemly ideas, including free love. She became a lightning rod for the women's movement, causing even advocates to move away from her to a more "maternal" and more acceptable position from which to lead their charge.[55]

Currier and Ives published surprisingly few lithographs that criticized women for seeking to leave or substantially change their sphere of influence. When they did, the criticism was set in comic form. *The Age of Brass—or the Triumphs of Woman's Rights* (1869, Fig. 35) and *The Age of Iron: Man as He Expects to Be* (1869), are two good examples. In *The Age of Brass*, a woman, with her legs crossed high, smoking a cigar (one of the few prints by any company showing women smoking), sits near a poster that reads: "Vote for the Celebrated Man Tamer Susan Sharp-Tongue." Another sign reads: "For Sheriff Miss Hangman." Other women, all in ostentatious hats, mill about her and a ballot box, preparing to vote, while a man stands to the side. He bears an expression of fear as his scowling wife orders him to hold their baby while she votes. In this print, spoofing the reversal of sex roles the women's rights movement portended, a fantastically dressed woman is about to step into a coach "manned" by a coachwoman and footwoman. Their men are left at home sewing, washing clothes, and watching the children.

In a far larger number of prints—"serious" prints, as opposed to comics—Currier and Ives chose to support or confirm the "women's sphere," showing women in their "proper sphere" and enjoying it. Two important points should be made: first, women are generally absent from nineteenth-century genre art; artists' concern, whether in paintings or prints, was with the male image. Second, where women do appear in genre art, they take a place "not only subsidiary to but different in its very grounding from that of men." As if in recognition of the boundaries of the female presence, artists typically depict women one to an image and restricted to her own sphere, in or near the home-

FIGURE 35. *The Age of Brass—or the Triumphs of Woman's Rights.* Currier and Ives (1869).

stead, distant from male activity nearby. Men are seen hunting, engaging in farm work, or discussing politics; women do the housework, prepare the food, and take care of the children.[56]

This ideology of femininity, masculinity, and the domestic sphere was particularly useful to men of the new urban middle classes, who wished to be at once essentially male (independent and strong) and successful in the social world of the city. To achieve this identity, they needed the "natural" arrangements of urban, middle-class gender definitions. Sweet domestic influence in the parlor and female subservience to male authority obviously could not be exercised by women who did half the outdoor work on a farm as well as the washing, sewing, gardening, and cooking. Neither could those responsibilities, or privileges, be implemented by the new group of women in towns and cities entering industry, working in other people's homes as domestics, or doing piece work in garrets as seamstresses.[57]

Although Currier and Ives produced hundreds of prints that included women, they followed this "rule" of representation. They produced dozens of portraits of women, but these numbered fewer than one-fifth of those of men. Moreover, portrait-worthy women were usually wives of famous men or women who either had achieved fame

as actresses or singers, like Jenny Lind (undated), or had an inherited position, like Queen Victoria (1848). Whether of famous men or women, however, such portraits served the same purpose. When Victorians brought images of famous people into their parlors, they brought the influence of public figures into the private realm. Such men and women served as models, especially for the young, and they represented yet another way to reconcile individualism with community values. Like George Washington, Jenny Lind taught a lesson of individual achievement. At the same time, like most of the great people the Victorians venerated, they merited special reverence because they subordinated private interest to public service. Lind was admired for her lovely voice, but she also was venerated for her charity; she gave much of what she earned from her lucrative singing tour of the United States to charity. American women hoped their young sons would want to be like George Washington when they grew up. Daughters who chose to leave the home to pursue a career, it was similarly hoped, would follow Jenny Lind's example.[58]

The largest number of female portraits were what might be termed "stock," or idealized and anonymous, portraits. Much like photos of magazine models today, they were intended to portray what would be considered the beautiful Victorian woman, in terms of wardrobe, hair style, physical characteristics, and even composure or demeanor. As in magazines like *Harper's Bazaar* and *Godey's Lady's Book,* current fashions constituted a major portion of Currier and Ives prints. Many pictured fashions mainly for the wealthy, those who could afford to be fashionably attired in such outfits as morning gowns, at-home gowns, visiting gowns, dinner gowns, ball gowns. But such prints kept all women informed and provided something to which they could aspire or of which they could dream. They also provided color advertisements for Ebenezer Butterick, a Massachusetts tailor who produced the first paper sewing patterns for women who sought fashionable but less expensive clothes.[59]

Currier and Ives occasionally poked fun at female fashion. Thomas Worth, for example, satirized one facet of female fashion in an 1868 print called *The Grecian Bend/Fifth Avenue Style.* In the 1860s women began to participate more in outdoor activities, and their long dresses, which dragged on the floor and ground, were shortened to create the "walking costume," with excess material gathered and puffed up around the hips, leading to the bustle. Out went the conical figure and hoopskirt. In came the ever-growing bustle, elaborate hairdos, and larger hats. Worth pictured and poked fun at the modish posture

women assumed, thrusting the upper part of their bodies forward to make the bustle extend even farther.[60]

In *Life in New York: The Breadth of Fashion: Fifth Avenue* (undated), Worth parodied both male and female fashions. The comic satirizes the short-lived fashion for crinolines, seen on a woman, child, and even a doll perched in a townhouse window. The fashion lasted only a few years in the early 1860s. Also ridiculed are the affectations of an ultrafashionably dressed male, with wide, fur-lined cuffs and a tiny pet dog tucked under his cravat.

Currier and Ives also satirized that dress produced by the women's rights movement. In 1851, three years after the Seneca Falls convention, the company published *The Bloomer Costume*, introduced by Elizabeth Smith Miller as "a symbol of the suffrage movement." In 1851 Miller, a daughter of New York Congressman Gerrit Smith, visited Elizabeth Cady Stanton in Seneca Falls. She "dressed somewhat in Turkish style," as one contemporary put it, and women reformers immediately seized upon the outfit as another step toward freedom. That step consisted of a knee-length dress worn over full pantalettes buttoned at the ankles. The idea of trousers for women, as well as other changes in women's dress, was avidly publicized by Amelia Jenks Bloomer of Seneca Falls and editor of the feminist newspaper *The Lily*. Because of the editor's strong advocacy, Miller's outfit became known as the "bloomer," and the movement as "Bloomerism."[61]

Although not noticeable in the print, save in its being referred to as a "costume" perhaps, the bloomer endured several years of notoriety and ridicule before vanishing. Jeers abounded, including the following song lyrics:

Heigh ho! In rain and snow,
The bloomer now is all the go!
Twenty tailors take the stitches!
Twenty women wear the breeches!
Heigh ho! In rain and snow,
The bloomer now is all the go!

Women reformers soon returned to more traditional garb. Lucy Stone announced that the dignity of advancing years demanded a return to the conventions, and Amelia Bloomer, who moved with her husband to Iowa, gave up because the high winds of the Great Plains "played sad work with short skirts."[62]

The supposed suppression of sexuality in the Victorian period has been stated so often as to became commonplace in American popu-

lar culture. As one writer later commented, if sex "raised its ugly head in the Garden of Eden," it buried it once again in 1837 when "a very young lady was called from her too, too virtuous couch to become the Queen of England." Victoria, it was said, was never seen without her dressing gown, presumably even by her husband, and, this writer continued, "it took the [English-speaking] world . . . a great many years to rediscover what was underneath the dressing gown."[63]

Current scholarship substantially limits the extent to which sexual repression actually existed in Victorian America—pointing to an apparent gap between the chaste ideal and reality—but the degree to which it remained a publicly pronounced ideal remains high. To judge by British and American popular literature and art, the model Victorian woman was an angel, living in the protective confines of her home and church under the protection of her father, husband, and minister. Gentlemen, one contemporary wrote, "had no legitimate reason to suspect that women had legs. Never, under any circumstances, could she hint that she had them. She had a waist—that much could be seen. She had feet. Men who were unworthy of the name sometimes peeked as ladies were descending staircases and made the discovery that she had ankles. The rest was mystery."[64]

Such modesty, or at least feigned modesty, applied to art as well. The human form was subject to the same censorship. Victoria herself, it was said, refused to permit an artist to adorn her garden home with nudes. She could not trust herself not to swoon at the sight of them. In America, it was reported, ladies appearing nude in paintings displayed in galleries or in the home had petticoats painted on them. It is not surprising, then, that nothing overtly erotic was found among the thousands of Currier and Ives prints. The only avenue of representation for nudes was that taken by "high art," namely what might be received by the individual viewer from suggestive elements in the wave of established artists or classical art or literature. Such an approach to nudes, necessitating that the viewer regard the object as a work of art rather than a reflection of his or her own real world, ran contrary to what Currier and Ives intended and what people expected, ensuring that nudity would have no place in the firm's inventory.

One of the few examples of nudity, under the guise of "high art," is Nathaniel Currier's *Queen of the Amazons Attacked by a Lion* (undated). In this early print by an unknown artist, taken from ancient mythology, bare-breasted amazon warrior women, armed with bows and arrows, battle axes, and spears, fight off a lion that has attacked the queen's white horse. Another example would be the two-part se-

ries, *Adam and Eve in the Garden of Eden* (1848) and *Adam and Eve Driven Out of Paradise* (undated), in which both figures are naked. Adam is turned with his back to the viewer, and Eve, facing the viewer, has her pubic area covered by her long hair. Only her breasts remain exposed, in classical style.

A third example is *The Three Graces,* similarly undated and unascribed as to its artist but likely done early in the firm's history, as it too bears only the name of Nathaniel Currier as publisher and signs of his early experimentation in content. The print shows the graces, personified by the dancers Fanny Cerito, Fanny Ellster, and Marie Taglioni, as three rather plump and nude ladies. Ellster was an Austrian dancer, Taglioni was a member of a well-known Italian ballet family, and Cerito was also Italian born. Thereafter, with only one exception—an Indian woman who appeared naked above the waist in only one edition of *The Indian Family* (undated)— Currier and Ives clothed all their women.[65]

French lithographers briefly crowded the American market during the 1840s and 1850s, while demand was still inadequately served by domestic lithographers. French prints reflected the fashion for romantic and erotic subjects, and such prints briefly influenced the work of the young Nathaniel Currier. The influence of Eugène Guérard's prints of prostitutes can be seen in Currier's *Star of the North* (1847) and *Star of the South* (1847). When the firm came to dominate the domestic market and French prints largely disappeared from mass-produced lithographs, so too did even this hint of the erotic.[66]

Eighteenth- and early-nineteenth-century American cartoonists had no qualms about picturing female breasts, at least in their cartoons, but not so Currier and Ives.[67] Flirtatious encounters with the erotic appeared in the satirical companion prints *The Wedding Morning* (undated) and *The Wedding Night* (undated) by J. Schutze. On the wedding morning, the couple kneels on prayer stools at the altar, the groom places a wedding ring on the bride's finger, and they exchange their wedding vows. She lowers her eyes demurely. On the wedding night, in their bedroom, the groom kneels, sporting a leering, wanton smile. He gazes up at his bride and undoes her corset. The young woman, no longer demure and not feigning any modesty, faces the fireplace, hands on hips, head coquettishly bowed down and at a slight angle, and eyes closed but with a knowing, confident, and flirtatious smile. Somewhat surprisingly for Currier and Ives, the young woman is clearly aware of, and ready to employ, her sexuality. *The Wedding Night* evidently went too far, and as with other controversial prints

(mostly political cartoons), when the firm strayed into uncharted or uncertain territory, the name of the publisher was not shown on the prints—only the name of artist and the firm's stock number. In its 1851 catalog Currier left the entry blank. As one observer later remarked, "Apparently Currier felt that his reputation in Victorian America would not be enhanced by this particular image."[68]

Otherwise, Currier and Ives's prints were playful when it came to sexuality. *Kiss Me Quick* (undated, Fig. 36) is typical—it shows a presumably married couple stealing a quick kiss while taking a stroll. The woman, wearing a cross, is obviously uncomfortable with such a visible display of affection in front of her children, because she quickly reaches down to adjust their hats, turning their eyes away. The caption quotes the mother's explanation for her actions: "Children, this is the third time within an hour that I have placed your hats properly upon your heads. There!!"

Courtship provided images for several of Currier and Ives prints, as it did for nineteenth-century genre art generally. Courtship was among the most complex experiences in men's association with women. In America's socially fluid society, in fact, it was a conundrum, potentially both traumatic and comic. Critics have argued that the varieties of subtle shared experience in courtship that had found expression in English and German paintings—shyness, longing, sexual energy, even sentimentality—were not explored by American genre painters. Instead, they insist, American artists interpreted the activity as a proving ground of the middle-class male. For females, marriage marked the exchange of relative freedom for domestic servitude to their husbands and Victorian motherhood. For males "it was a milestone of mastery and liberation."[69] As represented by Currier and Ives, however, courtship was not that simple.

Courtship proceeded according to codes of genteel behavior. Cultural perceptions of male anxiety in the ritual were embodied in stories of courtship that projected the social awkwardness of the urban suitor onto the laconic, graceless Yankee rustic. "In the early years of the antebellum era, courtship as a cultural theme seems to have served much the same function as stories of horse trading—courting stories poked fun at the 'new man,' the bumpkinish, inexperienced, but ambitious sovereign, making his way in a strange world of social (and thus economic and political) exchange."[70]

Some male artists constructed flattering treatments of the theme of "female influence." The role of women as social agents found its way onto the canvas, as did the more socially acclimated urban male.

FIGURE 36. *Kiss Me Quick*. Currier and Ives (undated).

They depicted such group activities as picnics, maple-sugar parties, and apple pickings as occasions that made possible the comfortable radiation of collective female influence on males. The ostensible purpose of such excursions, where the pleasures of urban citizens were carried out in the country, was to remove men from the corroding influence of the city and place them in the healing embrace of nature—but in the company of women. Such scenes were distinctly different from the entirely masculine hunting scenes produced by Currier and Ives and other lithographers and popular artists. In these "female influence" prints, both nature and man have been tamed, but the latter appears completely at ease. In contrast to the earlier courtship pictures and themes, the men know how to dress, to talk, and to enjoy female company. In terms of the audience for whom these prints were intended, the only people who seem out of place in these scenes are the rural folk who wander into the picture but clearly do not belong there.

A careful comparison of these prints, which glorified the family, with others on the themes of the frontier or the sporting outdoor life indicates the conflicted nature of nineteenth-century definitions of masculinity. For example, recall that Currier and Ives had pictured Confederates as effeminate in their Civil War comics, and that American men began to have sympathy for the defeat of the Native American when it became clear that the savage brute was being transformed into a helpless, dependent child, emasculated or feminized. Clearly, in the midst of this idealization of the home and its civilizing influence, "men feared being swallowed whole by an infantilizing and insatiable mother" and wife. Given the insecure world into which he was thrust and forced to compete to prove his worth, he found himself in constant need of demonstration. "Everything became a test—his relationship to work, to women, to nature, and to other men."[71]

As "domesticators," women were expected to turn their sons into virtuous Christian gentlemen—dutiful, well mannered, and feminized—and to be sure that their husbands remained that way. Men felt the need not only to resist in some way but even to escape from the Victorian parlor. They resonated with the words of Huckleberry Finn: "I reckon I got to light out for the territory ahead of the rest, because Aunt Sally she's going to adopt me and sivilize me, and I can't stand it. I been there before." And escape they did. Some men actually went West to test their mettle on the frontier; others just read about it or imagined themselves in popular literature on heroes such as Natty Bumppo, Daniel Boone, or Davy Crockett, or in pictures of lone frontier figures like the trappers of Currier and Ives. Most sim-

ply grew beards and mustaches and went hunting, fishing, or camping closer to home.[72]

Currier and Ives issued several satirical prints on marriage, employing humor to raise questions concerning the most venerated of Victorian institutions. One such print never made it to the streets, while another failed to bear the firm's name. In an unfinished cartoon, *Love, Marriage, and Separation* (undated), Frances Palmer—herself reportedly trapped in an unhappy marriage—traced the course of an ill-fated union from courtship to the disaster caused by the husband's infidelity. *The Seven Stages of Matrimony* (undated), which the firm refused to identify as their own on the actual print, satirized marriage in a manner more interesting for the time. The first four steps lead the couple from their meeting to marriage, the top level in a step pyramid—the apex of the relationship. In step five the couple brings a baby into the world, but in step six they quarrel. She threatens him with a broom, he shakes a stick at her, and, in the seventh and final disastrous step, they end up divorced. Holding their baby and an "annuity" sign, the wife thumbs her nose at her husband. He holds a "Bill of Cost," suggesting the price he has paid for the failed marriage.

The Seven Stages of Matrimony calls into question women's motives in marriage. It implies a certain disingenuousness on their part to disguise their true selves during the courtship process and then, upon revealing their true nature, attempting to dominate their husbands and, if that fails, taking advantage of the increasingly favorable divorce, custody, and support laws to punish their unsuspecting mates. Two-line poetic couplets explain each of the seven matrimonial stages. Couplets one to four speak of the woman's beauty, her smile and "fluttering heart," and the man's considerable efforts to "snare the silly bird." Then: "The fatal knot has tied them fast / Oh happiness too sweet to last." And the happiness does not last; the "bird" proves not to be so "silly" after all. Following the birth of a baby, which delights them both, she is pictured as having "let her hair down," and, the print informs us, "The leaves desert the rose / And ragged thorns themselves disclose" a different woman. As the final verse reports, "She sues her Lord she's bound to win / She leaves his house but keeps his fin." The final step of the matrimonial pyramid is built on an image of an attorney's office.[73]

In a theme related to the thorns of marriage, Currier and Ives could not resist mother-in-law comics. In *His Mother-in-Law* (1872) Thomas Worth pictured a forbidding dowager in high-necked dress and tall hat, standing on a front stoop, pulling a doorbell. A trunk, a

parrot in a cage, and a hatbox (labeled "Mrs. M. A. Snarleyow") rests on the stoop behind her, indicating her intent to move in. Her son-in-law, unseen by her, cowers behind the stoop, hair standing on end in terror.

The importance of these exceptional prints notwithstanding, in the majority of their courtship and marriage prints Currier and Ives provide a positive view of the institution. Their courtship prints cover every aspect of the ritual: *The Declaration* (1846), *Popping the Question* (1847), *The Rejected* (undated), *The Accepted* (undated), *The Marriage Vow* (1846), *The Day before Marriage* (1847), and *A Year after Marriage* (1847) being just a few examples. In *The Declaration*, reproduced at least six times, a young couple holds hands in a grape arbor. He gazes at her; she looks away, modestly, at the ground. In *Popping the Question*, a young man struggles to find the words to propose to his lover, while in *The Rejected* and *The Accepted* we see the two possible results, despair or contentment, contentment leading to *The Marriage Vow*.

In *The Day before Marriage*, reissued four times with only small changes, the bride-to-be sits alone before her mirror, no doubt contemplating her future. Does she understand that she is about to barter her freedom for domestic servitude and Victorian motherhood? Or is she looking forward to leaving her childhood domicile to create a new home for herself and her family with the man of her dreams? There is no way to tell from her facial expression. In *A Year after Marriage*, a companion piece to the previous print, the young woman sits gently rocking her baby in a cradle, holding her sewing in the other hand, apparently content with her choice.

The effect of marriage on young men is seen in pairs of prints such as *Single* (1845, Fig. 37) and *Married* (1845), which show a young man alone and then in the company of his wife and child. In *Single*, the man sits in a high-backed chair before his hearth and fire. He smokes a long-stemmed pipe, wears a cap, smoking jacket, and slippers, and rests one foot on the grating in front of the fireplace. He is surrounded by the possessions of the young single man, including two pairs of boxing gloves, two fencing masks, crossed sabers, and a foil. In the second scene he enjoys his family in a more genteel Victorian parlor. He sits beside his wife with his daughter on his knee. This print may have provoked mixed emotions among male viewers as to the price to be paid for marital bliss, but other prints made it appear worth the sacrifice. In *The Lovers' Quarrel* (1846) and *The Lovers' Reconciliation* (1846), we find yet another couple, at first apparently displeased with one another and then reconciled in a loving, but still innocent, em-

FIGURE 37. *Single*. Nathaniel Currier (1845).

brace. But perhaps the prints that best summed up the joys of marriage were the *Four Seasons of Life* series. They seem to say that there is nothing quite like love and marriage, if it be chaste. One observer later said that marriages were always happy, or at least that was the story to which the age of innocence stuck. It was a strange era, with virtue blind and deaf to everything but sentiment.[74]

Victorian Children

The most important task assigned to the Victorian woman was bringing up her children. This was not new, of course, but as the home became exclusively her sphere, so too did child raising. Moreover middle-class Victorian parents adopted a different strategy in raising children from that of their grandparents. In contrast to earlier theory, especially in—but not limited to—Puritan New England, predominant mid-nineteenth-century religious thinking included the belief that children were naturally innocent. Parents believed that childhood should be an extended, protected period that allowed children to develop their innate goodness and to acquire the skills necessary for their eventual participation in the larger society. To devote more attention to each child, midcentury parents had fewer children. The birth rate in 1860 for white women surviving to menopause was approximately five children, down from seven in 1800. Members of the middle class tended to marry later—in their midtwenties—and to practice sexual continence.[75]

Holding to absolute standards of right and wrong, Victorians insisted that only their way of seeing the world was right; they did not entertain the possibility of multiple viewpoints or of relative degrees of righteousness. This made the education of children a relatively simple, or at least quite narrowly focused, process.[76] It also helped to identify what images were acceptable or desirable for young people. In addition to "parlor prints" that were appropriate for all ages, *Robinson Crusoe and His Pets* (1874), *Noah's Ark* (undated), and *Adam Naming the Creatures* (1847) appear to have been children's favorites. They went through several editions and variations.[77]

Puzzle pictures were also popular, wherein children and their parents could search for hidden figures drawn into the background of pictures. A best-seller was *The Puzzled Fox* (1872), in which the viewer could find hidden a horse, a lamb, a wild boar, and men's and women's faces. Others included *The Bewildered Hunter* (1872), *The Old Swiss Mill*

(1872), *A Puzzle for a Winter's Evening* (1840), *The Shade and Tomb of Napoleon* (undated), and *The Shade and Tomb of Washington* (undated). One historian has observed that "children were a favorite subject of nineteenth-century genre painting, and nowhere so much as in America, where society had turned so passionately from the old to the new and was itself so much a child."[78] When picturing children for a largely female audience, it was important to provide a flattering assessment of mothers and their positive influence on children. But such prints also reflected the reality of a world in which motherhood was advancing and fatherhood was in retreat. Perhaps because most artists were male, boys tended to outnumber girls in such prints. The gender and focus also suggest the centrality of the male to the ideals of the republic and the importance of the republican mother in his proper education. In Victorian domestic ideology, the mother existed to serve her sons.[79]

Nineteenth-century adults looked at childhood as a time when a boy could be a boy. A son was carefully nurtured in the home—assuming that the home was a middle-class home, dominated by the ideals of domesticity—and he had freedom to play and loaf and cavort, but within limits. It was a period in which boys were malleable, so in prints both serious and comic the "mothering functions of domestic life" revolved around sons, whose mischief (or self-discipline) portended the behavior of the grown citizenry and, therefore, could not be excessive. In the view of the older generation, naughty boys were considered all the more admirable because they were unedited by social restraints. By contrast, even in Jacksonian times, girls had to behave, so they were largely excluded from the earlier pictures. From the 1850s on, however, misbehaving boys vanished from pictures as well, and were replaced by well-behaved boys and girls. Mischief, beyond midcentury, could go no further than endearing waywardness that might make a mother exclaim, "Aren't they darlings!"[80]

Pictures of adolescents were almost entirely absent. In adolescence the social strains on young men were intense. In an increasingly urban versus rural world, they had no specific place, they were no longer under their mother's care, but they could not yet take an explicit place in the adult world beside their fathers. This anomalous, amorphous stage in human development did not lend itself to popular art.[81]

As studies of the period make clear, the relationship between a mother and her young son created a double bind for women. Women were given all the responsibility for nurture but little of the social power that would underscore that responsibility. Male critics com-

plained about the terrible behavior of young American boys and lamented the future of the Republic as these youngsters became men. Almost always the blame fell to women, as mothers. As the editor of *Putnam's* magazine wrote in 1853, "The Ideal American Woman—would that her time were come!—will govern her children, which certainly the American woman of today does not. We will venture to say that so many utterly uncurbed children are not to be found anywhere as in the United States."[82]

More favorable assessments of children and their mothers were also put forth, especially by women and in sources for women, including journals and prints. Women wrote essays that rhapsodized about the special nature of childhood, which somehow compensated for children's mischief and thus exempted their work from criticism. In 1832 *Godey's Lady's Book* praised children as having "a holy ignorance, a beautiful credulity, a sort of sanctity, that one cannot contemplate without something of the reverential feelings with which one should approach beings of a celestial nature." In 1841 J. M. Van Cott, editor of the Democratic magazine *Arcturus* wrote, "It is an article of our creed, that the American mother is the best mother in the world; and that the best elements of the American character, those which mark us as a peculiar people, and have most contributed to make us a great nation, were fashioned and molded by the plastic hands of American mothers."[83]

For the most part Currier and Ives followed this more positive road. When they were critical they used humor to make the point, as in comics that paired helpless mothers with mischievous young boys. But these were few; instead, in more than two hundred separate lithographs, Currier and Ives's portraits of the child-centered family are affirming and supportive of the woman's traditional role therein. Representative of this line of prints are *Father's Pride* (1846) and *The Guardian Angel* (1846). *Father's Pride* is a portrait of a loving young wife and child. In *The Guardian Angel,* two children appear before an angel, who represents as well the idealized wife and mother. Children, much like their mothers, came to be thought of as active forces for godliness. James Russell Lowell expressed that sentiment in "The Changeling" (1847–1848):

> I had a daughter,
> And she was given to me,
> To lead me gently backward
> To the Heavenly Father's knee,

That I, by the force of Nature,
Might in some dim-wise divine
The depth of His infinite patience
To this wayward soul of mine.[84]

Such idealized portraits of childhood fell short of reality for many children. Many children worked full-time in America's factories and on farms from dawn to dusk. There were few legal or moral restrictions on child labor. As early as 1832, according to one estimate, two-fifths of all New England factory workers were children. According to the census of 1870, three-quarters of a million children between the ages of ten and fifteen worked full-time, and the number increased every year until 1910. In 1881 only seven states required a minimum age of twelve for gainful employment; no national restrictions on child labor were adopted until 1938. And the growing tide of immigration only added to the problem, introducing a new phenomenon to American streets—roving bands of unemployed and homeless boys. Jacob Riis estimated that in 1863 more than ten thousand "motherless children" roamed the streets of New York City.[85]

Currier and Ives were not the only the purveyors of popular culture to ignore the problem; this was also the age of Horatio Alger Jr. and his tales of poor newsboys and bootblacks who made it to the top through personal effort and resistance to temptation. To quote one successful gentleman's advice to a young bootblack: "I hope, my lad . . . you will prosper and rise in the world. You know in this free country poverty is no bar to a man's advancement." In the case of popular prints, one critic said, "Many of those who bought the prints were reared with a different concept of early life, but to the end of the Victorian era adults chose to picture children not as they really might have been but as symbolic in a Gilded Age of their own lost innocence."[86]

SEVEN

Images of African Americans and Irish Americans

It has been argued that fear of pollution arises during periods of up-heaval, whether or not the pollutants have anything to do with the upheaval. Such was the case in nineteenth-century America, as re-flected in American attitudes toward African Americans and immi-grants. Given Currier and Ives's finger on the pulse of the nation, we would expect to find this attitude reflected in their work—and it was, but with some interesting twists seen in the firm's representation of African Americans and Irish Americans.[1]

African Americans

In our discussion of Currier and Ives Civil War prints we made reference to how the firm pictured African Americans during that bloody conflict. What we find in the fifty-year run of prints is an initial inclination to picture the horror of slavery, from which Currier and Ives quickly retreated. African Americans were at first innocuous, even contented, elements in the background; then they were summoned and blamed for the Civil War; and, finally, they were shown as incapable of advancing beyond their dependent, childlike state to assume roles similar to those played by more "civilized" whites.

By the middle of the nineteenth century, white, Protestant, Anglo-Saxon countries most fully embodied the American ideal of civilization. People living outside the influence of those civilizations were thought to be savages—brutish, out of control, ruled by their passionate and animal natures.[2] In the 1870s and 1880s a crude and derisive vein of ethnic and racial humor appeared in American popular literature and art. Currier and Ives exploited the genre's popularity in a running series of strongly racist cartoons, known as the *Darktown* series. These prints demonstrate less an editorial racism on the part of the firm than an indiscriminate instinct for marketable themes—and racism was marketable.

Such attitudes did not appear for the first time during the 1870s; they were part of American thinking from the start. By the 1830s, when Nathaniel Currier began his business, whites justified setting blacks apart with extensive psychological buttresses. Most argued that the fundamental factor determining blacks' place in the social order was that blacks were racially—that is, essentially—different from whites as human beings. White Americans assigned character traits to blacks to demonstrate that they were physiologically and intellectually inferior. With such stock assessments as childlike, lazy, and "natural"—that is to say "sensual"—they distinguished blacks from the majority of otherwise undistinguished white citizens who, they believed, had innate capacities for equality: mental acumen, economic drive, and self-control. Englishwoman Harriet Martineau, who toured the country in 1836, saw the major function of this differentiation as maintaining the fiction (important to both the dominant and the under groups) that all whites were of the same class. American society was divided into two classes, she wrote, "the servile and the imperious."[3]

Cartoons have special power to sway public opinion because they capture the passions and presumptions that shape the minds and ac-

tions of the people. Sustained by bias and bigotry, they have proven to be "a devastating weapon in the hands of clever satirists and social critics," a form of stigmatizing that could leave an entire community, as well as individuals, psychologically scarred. Such comic art "involves a reciprocal relationship between those who create it and those who consume it."[4] Cartoonists do not work in isolation from the culture that surrounds them. Rather, they work within that culture; they live and practice that culture's ideology, drawing literally and figuratively on prejudices that already lurk in their audiences.[5] Such was the case with Currier and Ives's depictions of African Americans.

As one might expect, slavery was the subject of hundreds of prints in the antebellum period. The great majority reflected the prevailing stereotypes, which did not differ greatly from one section of the country to another. Southerners generally preferred the image of Uncle Tom, the "happy, contented slave," a laughing, simple-minded retainer who thrived under the paternalism of his kindly master. Their "peculiar institution," they added, was preferable for such people than "wage slavery" in the industrial North. This belief allowed Southerners to ignore the sorrow and resentment that was often disguised behind the grinning black faces and also provided a "rationale and a kind of reversed penance for men otherwise hard pressed to justify their exploitation of slavery."[6]

The Northern stereotype was just as patronizing. It assumed the African American's innate incapacity to progress politically, economically, or socially, seemingly proven by his happiness with small favors and his apparent pleasure with his role as social buffoon. It suggested that the African American was not dissatisfied with his circumstances and indeed was indifferent to the abolitionist concerns about him. "Just as Southerners were unwilling to admit that their Negroes might have been restless in slavery," it has been noted, "so Northerners were most comfortable in arguing that Northern Negroes were fundamentally contented with their role in free society." As the historian and diplomat John Lathrop Motley wrote at the time, "The black race is not by nature capable of social or intellectual equality with the white; nor have they ever desired it so far as I know."[7]

Considerable antislavery sentiment did exist in the North, of course, and many prints were published that were highly critical of Southern slavery. See, for example, David Claypoole Johnson's *Early Development of Southern Chivalry* (undated), in which a smiling Southern boy, much to the amused admiration of his sister (who holds a black doll by the hair), whips a black doll that is stripped to the waist

and tied to the chair.[8] As far as we know, Nathaniel Currier took this approach—exposing the evils of slave trade—only once, in *Branding Slaves: On the Coast of Africa Previous to Embarkation* (1845, Fig. 38). A pipesmoking sailor casually brands the back of a manacled African kneeling in front of him. Next to him another white man, clearly disinterested or bored, holds a lantern, while in the background a line of yoked African captives is led toward the ships anchored in the harbor. It is a very powerful print, conveying a message Currier and Ives chose not to repeat.[9]

Currier and Ives did issue a print with a scene from Harriet Beecher Stowe's *Uncle Tom's Cabin*, which had been serialized in 1851 and published in book form the next year. Unfortunately it is not dated, and there is no way to tell exactly when it was issued. It depicts little Eva, in a straw hat and pantalets, putting a wreath of roses around Tom's neck, while her parents look down on the scene from a window balcony of an elegant plantation house. Eva exclaims, in merriment: "O, Tom, you look so funny!" Given its source, this print might be seen as critical of slavery as well, but its purpose was commercial: to promote the novel and, quite likely, the many "Tom plays" that were staged in the 1850s. As such the firm avoided any direct association with the controversy Stowe's novel generated over slavery. Lincoln greeted Stowe at the White House in 1862, saying, "So this is the little lady who made this great war." He would not have greeted Nathaniel Currier in the same manner.[10]

In most prints published before the Civil War, including the vast majority of Currier and Ives prints, African Americans were simply part of the environment, so to speak. To the antebellum American eye such prints were inoffensively pleasant. They were of like mind with the majority of the American white population, North and South. When they ran against the current, the response was immediate and definite; Currier and Ives's notable silence on slavery following publication of *Branding Slaves* spoke legion.

Picturing the nation's heroes amidst their slaves posed no problem. In *Washington at Mount Vernon 1797* (1852), for example, George Washington is shown two years before his death, at his beloved plantation. Wearing a broad-brimmed hat, Washington sits astride his horse in his fields, talking to two of his slaves, who are cutting and bundling hay. Washington is clearly at ease with the situation, and his slaves seem content. The print bears as its inscription Washington's admonition: "Agriculture is the most healthy, the most useful, and the most noble employment of man." In *Death of Washington* (1846), the

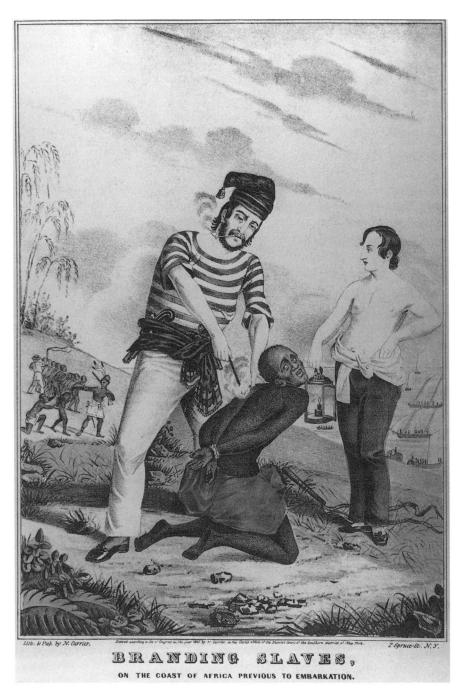

BRANDING SLAVES,
ON THE COAST OF AFRICA PREVIOUS TO EMBARKATION.

FIGURE 38. *Branding Slaves: On the Coast of Africa Previous to Embarkation.*
Nathaniel Currier (1845).

firm's deathbed scene of the nation's preeminent historical figure and major slaveholder, Washington is attended by four faithful black slaves as well as family and friends. A black man stands behind Martha Washington; three black women can be seen through an open door in the next room, weeping.

The same indifference or blindness to the conflicting message of independence, equality, and liberty and slavery reappeared during the nation's centennial. In 1876 Currier and Ives published the patriotic *General Francis Marion of South Carolina*, wherein the hero of the Southern theater, despite the primitive conditions of war on the frontier, is so "civilized" or cultured that he invites his opponent, a British general, to share his dinner of sweet potatoes and cold water in his "swamp encampment." A black man, presumably his slave, kneels by the campfire preparing the food.

Other examples include *Catching a Trout* (1854) and *American Country Life* (1855). In the first, by Otto Knirsch after a printing by Arthur Tait, and one of the firm's many popular sporting scenes, two white men in a fishing boat watch as a black man lifts a fish, hooked by one of the white men, out of the water with a net. As part of the subtitle, the black man exclaims, "We hab you now, sar." One critic described the servant as appearing competent and obliging, even addressing the wily trout deferentially. In the words of a Currier and Ives catalog, "The face of the old negro wears an expression of triumph as he secures the fish, and he shows his ivories in a manner which seems to say, 'you gib us some trouble to catch you, massa trout, but we hab you now, sar!'"[11]

In *American Country Life: Pleasures of Winter*, a black man leads a pair of horses pulling a sleigh up to the portico of a house, where a well-dressed family of four descends the stairs to meet him. A young boy is about to throw a snowball at the black man, who smiles and raises one hand to protect himself. The Currier and Ives catalog explains, "The darky shows his ivories in evident delight at the youngster's antics."[12]

Currier and Ives continued this approach during and after the Civil War. In *"Wooding Up" on the Mississippi* (1863), a group of black men load wood onto a paddle wheeler as its well-dressed passengers watch from the upper decks. In 1884 they issued a similar scene, with blacks working the docks of New Orleans, in *The Levee—New Orleans*. In 1871, in *A Home on the Mississippi* (see page 23), blacks are strategically placed, nearly invisibly, in a scene of a plantation. One is a servant rid-

ing behind a white couple in a carriage, two stand near the house's front gate, and a mother and child walk along the river.

The two most interesting prints in this group may be *"High Water"* *in the Mississippi* and *A Cotton Plantation on the Mississippi.* Sketched by Frances Palmer three years after the Civil War, in 1868, *"High Water"* pictures a flooded plantation. In the background the plantation house can be seen underwater up to the second floor, its occupants standing on the upper porch and widow's walk. In the foreground a large black family (or perhaps families) floats by on the roof of their house, trying to salvage furniture and a mule from the water. As if a painful reminder of an already devastated South, the paddle wheeler *Stonewall Jackson* passes by.

In *Low Water in the Mississippi* (1867), the companion piece to *"High Water,"* Palmer offers her perspective on what the plantation might have looked like before the flood—or the war. Several black adults and children dance in front of a log cabin on the riverbank. A plantation house stands behind the cabin, and two riverboats float by on the river. One, the *Robert E. Lee*, passes a small barge with a cabin on it labeled "Grocery."

The scene in *A Cotton Plantation*, drawn in 1884, might have been attributed to the Deep South during the antebellum period as well, in that it pictures black cotton pickers working the fields and driving a mule cart loaded with cotton bales. Instead it recalls the state of affairs for blacks nearly twenty years after the war and seven years after Reconstruction ended. Blacks and whites work and play, side by side, in a world of peace and beauty.

Blacks are shown dancing and enjoying music in *The Old Barn Floor* (1868) and *The Old Plantation Home* (1872). In the first, situated inside a barn, a black man sits on a stool playing a banjo, while a young black child dances joyfully. In this case, rather than simply coexisting harmoniously in the scene, whites are closely observing and even joining the fun. A young white girl holds a baby as she looks on. An older white man, probably her father, leans against the open barn door and looks on with condescending approval. Everyone is clearly enjoying the moment. In the background the barnyard is full of cows, pigs, chickens, and ducks, and an attractive farmhouse can be seen. In *The Old Plantation Home* eight blacks of all ages, this time without any whites present, have gathered in the yard beside their cabin, adjacent to a large plantation house. Four dance while one plays the banjo.

If Currier and Ives seldom show whites working very hard, blacks

appear to work even less. Indeed relaxing, dancing, and enjoying music seem to be the order of the day among African Americans before and after the Civil War. There is, by way of one last example, *Good Times on the Old Plantation* (undated), wherein a black family rests by its cottage. An elderly man sits contentedly, smoking his pipe, while two children watch. In the background a barge loaded with produce passes on the river.

More positive images of blacks began to appear during the war. Heightened hostility to Southern whites generated a corresponding greater sympathy for the African American and respect for his contributions to the war, and the Union, as a soldier.[13] When Lincoln issued the Emancipation Proclamation, making the war no longer only a struggle for union but also a war to end slavery, all publishers, including Currier and Ives, had little choice but to respond. Currier and Ives published prints of John Brown, Frederick Douglass, and black Union soldiers.

Currier and Ives published three prints of the abolitionist hero, Kansas Free Soil crusader, and leader of the march on Harpers Ferry, Virginia. In 1863, the year of emancipation, they issued *John Brown: Meeting the Slave-Mother and Her Child on the Steps of Charlestown Jail on His Way to Execution*. Artist Louis Ranson placed Brown at center on the jail's doorstep. He looks down on a slavewoman, who sits with her child on the banister. A stern soldier stands nearby, a flag with the words *Sic Semper Tyrranis* (uttered by John Wilkes Booth two years later when he assassinated Lincoln) flying above Brown. Four allegorical figures, including the "Spirit of '76," surround him, while on the ground lies a broken statue of blindfolded Truth. The inscription makes sure the viewer does not miss the point: "The artist has represented Capt. Brown regarding with a look of compassion a slavemother and child who obstructed the passage on his way to the scaffold. Capt. Brown stooped and kissed the child—then met his fate." The undated but respectful portrait, *Frederick Douglass: The Colored Champion of Freedom*, probably dates to this period, as well.

In *The Gallant Charge of the Fifty-Fourth Massachusetts (Colored) Regiment* (1863), reissued in 1888 on the twenty-fifth anniversary of that battle, the company publicized the role that blacks played in the war fighting for their own freedom and the Union.[14] The scene depicts the black regiment's attack on the rebel stronghold, Fort Wagner, on Morris Island, near Charleston, South Carolina, on July 18, 1863. The Union force is composed entirely of black men, many of whom are engaged in hand-to-hand combat, with the exception of

FIGURE 39. *The Great Republican Reform Party: Calling on Their Candidate.*
Nathaniel Currier (1856).

the leader of the charge, Col. Robert Gould Shaw, a white man who
stands on a prominence above the rest of the scene. He has just been
shot and is dropping his raised sword as he falls. This battle "made
Fort Wagner such a name to the colored race as Bunker Hill had been
for ninety years to the white Yankees," observed the *New York Tri-
bune.* "Through the cannon smoke of that dark night," said the *At-
lantic Monthly,* "the manhood of the colored race shines before many
eyes that would not see."[15]

Beginning in the mid-1850s, Currier and Ives produced a much
larger number of political cartoons that were critical of, and even held
up to ridicule, the influence of blacks on politics and the nation's drift
toward civil war. Early as 1856, in *The Great Republican Reform Party:
Calling on Their Candidate* (Fig. 39), the company pictured an osten-
tatiously dressed caricature of an African American standing at the
head of a line of "types," "calling on their candidate," John C. Fre-
mont. The others advocate prohibition of tobacco, meat, and alcohol;
the right of women to vote; equal distribution of property; free love;
and the power of the pope. The black man adds, "De poppglation ob

color comes in first—arter dat, you may do wot you please." Fremont, the Republican Party candidate, promises to satisfy them all if elected.

The Democratic Platform, also produced for the 1856 campaign, sent a similar message. Three men in dark suits kneel, supporting a similarly dressed James Buchanan (the party's candidate) lying across their backs. A white Southerner—pistol in hand—and a young black man, his slave, sit facing each other on the "platform" created by the group of four. The Southerner proclaims, "I don't care anything about the supporters of the platform as long as the platform supports me and my niggers." Buchanan complains that he is "no longer James Buchanan but the platform" of this party. Uncle Sam, standing off to the left of the group, warns the Southerner, whom he refers to as "Mister Fire Eater," that he shouldn't "rely too much on the supporters of that platform, they are liable to give way at any moment."

In the election of 1860 the Republican Party rejected its more radical wing, led by Charles Sumner, in favor of moderates who might win election. It rallied behind Abraham Lincoln. Lincoln made his personal distaste for slavery clear, as well as his intention of opposing its extension into the new territories of the West. But he also pledged not to attack the institution where it already existed. Many saw Lincoln's and the Republicans' position on slavery, though not as divided as the Democrats, as a bit of a balancing act, bordering on subterfuge.

Currier and Ives picked up on this compromising position in their political cartoons critical of the Republican Party in the 1860 election. In *The "Nigger" in the Woodpile* Louis Maurer satirized the party's efforts to minimize the role of abolition in its platform. He pictures Horace Greeley, editor of the *New York Tribune*, trying to convince a white man, identified as "Young America," that the Republicans had no connection with the abolitionist party. The young man, however, points to a pen made of rails behind Greeley, inside of which crouches a black man, and replies, "It's no use, old fellow! You can't pull that wool over my eyes, for I can see the Nigger peeping through the rails." The enclosure is labeled "Republican Platform," and Lincoln sits atop it, remarking, "Little did I think when I split these rails that they would be the means of elevating me to my present position."[16]

In *The Great Exhibition of 1860* (1860) Maurer shows Lincoln straddling a wooden rail, labeled the "Republican Platform," and riding it like a hobbyhorse. His lips are padlocked. Horace Greeley, as an organ-grinder, represents the *Tribune* once again, but he is joined by caricatures of *New York Times* editor Henry Jarvis Raymond and *Courier and Enquirer* editor James Watson Webb (whom Raymond

FIGURE 40. *The "Irrepressible Conflict" or the Republican Barge in Danger.* Currier and Ives (1860).

once served as apprentice). A diminutive Raymond, axe in hand, clings to Webb's arm and assures him, "I'll stick fast to you, General, for the present, because I have my own little axe to grind." Webb holds a tambourine and pleads for a dole for the group and the Republican Party: "Please Gentlemen! Help a family in reduced circumstances. We are very hard up, and will even take three cents if we can't get more, just to keep the little nigger alive."[17] Behind Lincoln, Sen. Charles Sumner, dressed as a nurse, holds a black baby and remarks, "It's no use trying to keep me and the 'Irrepressible' infant in the background; for we are really the head and front of this party."

Currier and Ives tied the image of a black man to the supposed "irrepressible conflict" again in *The "Irrepressible Conflict" or the Republican Barge in Danger* (1860, Fig. 40). The larger message is the way the Republican Party had silenced the voice of the more extreme abolitionist and party leader William Seward. The cartoon depicts him being thrown overboard from the Republican barge by other party leaders. "Don't throw me overboard," he cries out in dismay, "I built this boat and I alone can save it." Lincoln has seized the rudder and confidently declares, "I'll take the helm. I've steered a flat boat before," in a reference to one of his earlier jobs.

Seated at the center of the foundering boat, however, is a smiling black man, wearing a "Discord's Patent Life Preserver." Standing on the bank and gazing disapprovingly on the scene, Uncle Sam warns the Republicans: "You won't save your crazy old craft by throwing your pilot overboard. Better heave that tarnal Nigger out." Horace Greeley, who had led the opposition to Seward's nomination, ignores the warning. He shouts, "Over you go, Billy. Between you and I there is an 'Irrepressible Conflict.'" The black man observes, "If de boat and all hands sink dis Nigger sure to swim. Yah, yah."

Currier and Ives published similar images in *The Rail Candidate* (1860) and *The Republican Party Going to the Right House* (1860), but in terms of depicting the African American, *An Heir to the Throne, or the Next Republican Candidate* (1860, Fig. 41) may be the most devastating of the election year. Lincoln, Greeley, and a black man are once again represented. Greeley introduces the black man, who is half the white man's size, wears short pants—suggestive of African garb—and leans on a staff as an "illustrious individual" who combines "all the graces and virtues of Black Republicanism, and who we propose to run as our next candidate for the Presidency." Lincoln, with a troubled look on his face, comments, "How fortunate that this intellectual and noble creature should have been discovered just at this time, to prove to the world the superiority of the Colored over the Anglo Saxon race. He will be a worthy successor to carry out the policy which I shall inaugurate." In faint type on the wall behind the pigmylike figure are the words: "Barnum's What Is It/Now Exhibiting," a reference to P. T. Barnum's exhibit of a microcephalic black man as "the connecting link between man and the ape" in his New York museum. The black man's bewildered response to Greeley's and Lincoln's praise is "What, can dey be?"

During the 1864 presidential election, Northerners were still far from unanimous in their support of emancipation and unsure as to the role slaves had come to play in national politics, but their opinions had tempered and even become noticeably supportive of emancipation. The Democrats opposed the reelection of Abraham Lincoln with their candidate, George McClellan. When they met in Chicago, they sought to bridge the gap between McClellan's supporters and the party's "Peace Democrats" by letting the latter group write the platform and name the vice presidential candidate. They named George Pendleton of Ohio and called for immediate efforts to arrange for a cessation of hostilities and for talks to reestablish the Union. This, of course, raised questions as to the status of the freedman.[18]

FIGURE 41. *An Heir to the Throne, or the Next Republican Candidate*. Currier and Ives (1860). Courtesy of the Museum of the City of New York.

Currier and Ives did produce a few prints supportive of McClellan's candidacy. Most were opposed, calling into question the Democrats' plan for the slaves if McClellan were to be elected. In *Desperate Peace Man*, undated but almost certainly done in 1864, Pendleton, stepping on an eagle, approaches Jefferson Davis with a female figure of Liberty in chains under one arm and a kneeling, chained slave under the other. He tells Davis, "I bring you willingly everything, only give us peace." McClellan is pictured in the distance, spying on Pendleton with a field glass, saying, "All right Brother Pen. My old boss will not carry me much out of your way. I'll be soon enough with you." Davis sits on bales of cotton and barrels of gunpowder. He carries a whip and rests his feet on a step labeled "slavery." He says nothing, but his advisers refer to the Democratic candidates as "cowards"

and warn Davis, who himself had been critical of the South's conduct of the war, to keep his mouth shut. "Another of your whining speeches," one explains, "might even bring those fellows to their senses and lose us the game!"

Currier and Ives sent a similar message in *"Your Plan and Mine"* (1864), a two-panel political cartoon. In the left panel McClellan offers an olive branch to Jefferson Davis, who, dressed as a Southern frontiersman, holds a kneeling black man by the hair and threatens him with a knife. In the right panel, Lincoln holds a rifle on Davis, who sits on the ground offering his pistol in surrender, while a black soldier stands in the background. In the first panel, the black man pleads with McClellan not to return him to slavery: "I am a Union soldier. I have shed my blood in defense of liberty and law." In the second panel, the black soldier taunts Davis, calling him "Massa Sesech" and exclaiming that Davis would no longer be able to mistreat "this child" any more.

Given the unease with which many in the North greeted Lincoln's Emancipation Proclamation, and even the riots that occurred during the summer of 1863 in New York City that were related to the proclamation, it is not surprising that Currier and Ives pictured the unsettling nature of emancipation as well—even in the case of "the Great Emancipator," as he came to be known. In the political cartoon *Abraham's Dream!: "Coming Events Cast Their Shadows Before,"* attributed to Louis Maurer, Lincoln sleeps on a bare-mattressed bed under a starred sheet, dreaming that he has been defeated in the 1864 election. In his dream—or nightmare—the figure of Columbia, goddess of liberty, representing the nation, stands under an archway labeled "White House," brandishes the severed head of a black man, and kicks Lincoln away. The fleeing Lincoln is dressed in a Scotch cap and long cape, symbols of cowardice dating to the disguise he supposedly used to elude potential assassins and enter Washington from Harrisburg in 1861. He carries a suitcase and a scroll (the Emancipation Proclamation), marked "to whom it may concern," and exclaims, "This don't remind me of any joke!!" George McClellan, suitcase in hand, climbs the steps to the White House.[19]

Lincoln's assassination encouraged many publishers in the North, including Currier and Ives, to issue positive pictures of emancipation. Typically, *Freedom to the Slaves,* undated but quite likely done immediately after the assassination, is more of a testament to Lincoln than it is a sympathetic or even supportive portrait of the slave. A black man kneels to kiss the hand of Lincoln, whose right foot stands on

broken shackles. Lincoln raises his right hand, pointing toward the sky, as if signaling that emancipation is God's will or that the former slave should no longer kneel for any white man. In a reference to the impact of the institution of slavery on the institution of marriage, Currier and Ives include the black man's wife and children, who watch from behind him. The inscription is taken from Leviticus 25:10, "Proclaim liberty throughout all the land unto all the inhabitants thereof."

In 1865 Currier and Ives issued *President Lincoln and Secretary Seward Signing the Proclamation of Freedom: January 1st, 1863.* In this print Lincoln and Seward are seated at a table with the Emancipation Proclamation in front of them. Lincoln signs the document, from which is excerpted and inscribed: "Upon this act, I invoke the considerate judgment of mankind, and the gracious favor of almighty God." No blacks are included.

After the war, during Reconstruction and beyond, Currier and Ives began gradually to distance themselves from emancipation—and the Radical Republican plan to "reconstruct" the South—and to return to earlier negative images of the African American. In *"The Freedman's Bureau"* (1868) Currier and Ives returned to the issue of emancipation with a cartoon that verges on being a caricature of the freedman, or the newly freed slave. In the end, however, the picture is ambiguous; indeed, it might be viewed in entirely different ways depending on one's sympathy toward the freedman. On the one hand, the freedman appears respectable enough, though living in a shabby and slightly disheveled room, tying his tie while he looks out the window. His hat and coat lie on the chair behind him, and a picture of Lincoln, the Great Emancipator, is mounted on the wall above him. On the other hand, the freedman's African features are exaggerated to the point of caricature, making the tie seem inappropriate. A fiddle and bow—continuing the stereotype of the African American's great love of music—is mounted on the wall next to the picture of Lincoln. The print's intent is muddled even more when we realize that it was done by the artist Thomas Worth, who would later produce some of the infamous *Darktown* series prints.

In *Reconstruction, or "A White Man's Government,"* undated but probably done in 1868, a white Southerner with a wide-brimmed feathered hat is being swept along in a river toward a waterfall. A black man on shore, clinging to the "tree of liberty," extends his hand to save the white man. He shouts, "Give me your hand master, now that I have got a good hold of this tree I can help you out of your trouble." The white man rejects the help, responding, "You go to thun-

der! Do you think I'll let an infernal nigger take me by the hand? No sirree, this is a white man's government." Ulysses Grant, the Republican Party's presidential candidate in 1868, advises the imperiled white man, "My friend, I think you had better use all means to get ashore; even if it is a black man that saves you."

In another cartoon of the same period Currier and Ives returned to their theme of the black man leading the Republicans to ruin. In *Fate of the Radical Party* (undated) a train engineered by Thaddeus Stevens, Ulysses Grant, and other Republicans, but powered by a caricatured black, whose head sticks out of the engine's smokestack, speeds toward a hole in the ground labeled "Dutch Gap." President Andrew Johnson stands over the hole with a shovel full of dirt labeled "veto," representing his attempts to stop Radical Republican Reconstruction. The train's locomotive is a bottle on its side, labeled "A Radical Cure!! Lowell Bitters. One Spoonful Is Sufficient." A monument, topped by a seated black man and inscribed with the word "Fame," stands in the background, and a faceless dark figure with a carpetbag sits in the train's first car. In *A "Dodge" That Won't Work*, issued during the election of 1872, Jefferson Davis, carrying manacles and a whip, stands behind Horace Greeley, who asks two black men to vote for him. Greeley was the liberal Republican candidate for the nomination against Ulysses Grant. The black men refuse Greeley's entreaty, saying that they see Jefferson Davis with the "old lash and bondage" behind him. They intend to vote for "Lincoln's friend General Grant," as will "all true hearted colored men," because Grant "conquered the rebellion and secured our freedom."

A foreign policy fiasco of Grant's first term that became a campaign issue in the election of 1872 involved Grant's attempt to annex Santo Domingo. The project grew out of a revival of Manifest Destiny and was encouraged by land speculators, commercial developers, and naval officers who wanted a base in the Caribbean and dreamed of an isthmian canal. The annexation treaty was defeated in the Senate by antiexpansionists and those opposed to extending citizenship to blacks as well as to Catholic "mixed-bloods."[20] In *Red Hot Republicans on the Democratic Gridiron: "The San Domingo War Dance"* (1872), John Cameron shows the devil roasting on the "Democratic gridiron" six Republicans, including Greeley, who were using the Santo Domingo fiasco in an attempt to derail Grant's reelection bid. Greeley exclaims, "Anything to get office." Another Republican shouts, "Anything to beat Grant," while Charles Sumner calls to two blacks standing nearby, "Come Sambo! Jump right on the Gridiron

with the rest, while it's hot and lively." They respond, "No you don't Maasa Sumner. Old Secesh Debble hold dat gridiron and I guess you burn your foot."

In the midst of this ridicule of blacks Currier and Ives not only returned to their earlier rendering of African Americans as "content on the plantation" but also published at least a few positive, even lovely, prints of Africans and African Americans. There is, for example, the undated print after the artist G. Kramm, titled *The Young African*. It is a quite sentimental portrait of a young African woman wearing a tiara headdress with tree feathers and strung with pearls, which hang to her bare shoulders. She wears a bodice and pearl-trimmed armband and holds a cloak over one arm. A river and palm trees are visible behind her. They also published *The Colored Beauty* (1872), which pictures a lovely black woman. She has short hair and wears dangling earrings and three necklaces, one with a pendant. The firm issued a second print under the same title but picturing a different woman in 1877. She has long curly hair, earrings, and a white bow tied at her throat. Although no doubt done with sales and profits in mind, these prints do indicate a level of respect for African American leaders, beauty, and even culture that appears not to have conflicted with the firm's use of racial stereotypes elsewhere. But such positive prints number only a handful and should be interpreted in the context of the firm's more negative representations and Currier and Ives's apparently growing sympathy for the South's fate. An example is *The Lost Cause* (1872), which shows a Confederate soldier weeping at a gravesite and a dilapidated cottage—notably not a grand plantation house—standing in the background.

The *Darktown* series consists of more than a hundred individual prints produced from the mid-1870s into the early 1890s for Currier and Ives, most by Thomas Worth. Those associated with the firm at the time reported later that the series was very popular and profitable. Worth claimed that seventy-three thousand copies of one particular *Darktown* comic were sold, but he did not identify the print. The series reinforced the widely accepted stereotype that pictured the African American as a kinky-haired, thick-lipped, wide-eyed, simian creature and satirized his or her every attempt to act in a "civilized" manner.[21]

Currier and Ives described the *Darktown* comics as "pleasant and humorous designs, free from coarseness or vulgarity, being good-natured hits at the popular amusements and excitements of the times."[22] That the company intended no harm, but rather sought only

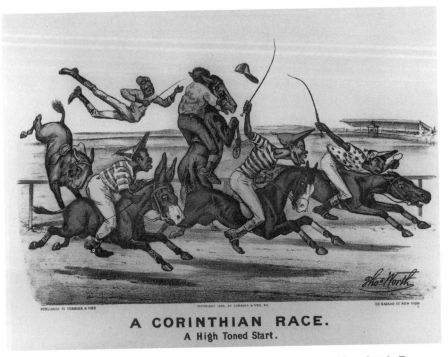

FIGURE 42. *Corinthian Race: A High Toned Start.* Currier and Ives (1883). Courtesy of the Museum of the City of New York.

to join in the humor of the times, can be supported, at least to a limited extent, by the previously noted handful of prints that pictured African Americans in a flattering manner. It has even been suggested that the *Darktown* comics may have served as satires on polite white behavior as well.[23] Nevertheless, they clearly exploited, capitalized on, and reinforced the negative racial stereotypes of the Jim Crow South.

Worth burlesqued African Americans performing actions that were more or less normal for "ordinary" folk, meaning whites. The humor results from their ludicrous ineptitude, the implication being that the African Americans could not execute even the simplest tasks of everyday life without making themselves appear ridiculous. It is no accident that the series appeared at a time when scientists and social scientists were propounding the natural inferiority of African Americans and the inappropriateness of their attempting to live in the white man's world—presuming to live above their true station in life, even putting on airs in the process.

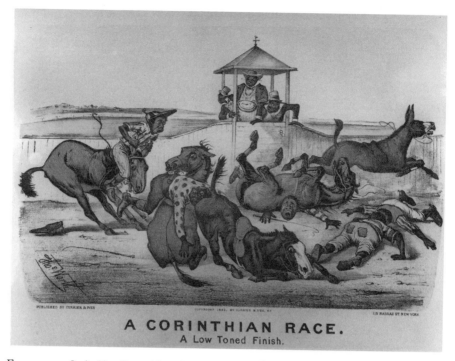

FIGURE 43. *Corinthian Race: A Low Toned Finish.* Currier and Ives (1883). Courtesy of the Museum of the City of New York.

Pictures of horseracing and carriage riding, featuring the finest horses of the day and their stylish white owners, constituted a major portion of Currier and Ives's prints. In at least eighteen separate *Darktown* prints the firm ridiculed any attempt on the part of blacks to engage in such activity. In the pair of prints, *Corinthian Race: A High Toned Start* (1883, Fig. 42) and *Corinthian Race: A Low Toned Finish* (1883, Fig. 43), Thomas Worth caricatured black men riding donkeys and horses. They begin a race in great disarray; one donkey bucks its rider into the air and another rears almost straight up on its hind legs. In the second print, all but one of the black jockeys have fallen off their mounts before they reach the finish line, and many of the horses and donkeys have tumbled to the ground.

In the two-part *Darktown Riding Class* (1890) four black women and a black man in elegant attire mimic the leisured white class with much the same results. In *The Trot* riders and their mounts alike bear strained expressions and appear in awkward postures. In *The Gallop*

the riders lose control of their bucking and rearing horses and don-keys, and one is dismounted in the process.

As common as caricatured racial facial features are to Currier and Ives prints, so too are phonetic renderings of African American lan-guage. *A Darktown Race—Won by a Neck* (1892) is captioned, "Golly Dat Gyraffy Neck Does de Bizness!" In the companion pieces *Dark-town Sports—A Grand Spurt* (1885) and *Darktown Sports—Winning Easy* (1885), in which a black man on a high-wheeled bicycle is shown defeating another African American driving a mule-drawn sulky, the victor proclaims, "I'll Beat Dat Old Pelter, or Bust!" and "I Know'd I'd Send Him in de Air!"

In *A Darktown Trotter Ready for the Word* (1892) Thomas Worth satirized black pretenses to the white sport of sulky racing by provid-ing a comic scene, wherein the trotter's name is a variation on that of a well-known mare, Nancy Hanks, depicted in several other Currier and Ives prints. The sulky driver, ludicrously dressed in a long-billed cap and a long-tailed coat, mimicking a white jockey, exclaims to the starter, "Now Den Say Go! And See Fancy Pranks Bust de Record wif Dis Ball Bearin Bike." In *Jay Eye Sore—De Great World Beater* (1885), an unsigned print, the firm takes the same humorous liberty with the name of a famous trotter, Jay Eye See. There is no evidence that Worth was responsible for the language employed in the *Darktown* series. If he was involved, his wording almost certainly was scrutinized and even modified by the firm's owners.

In *The Boss of the Road*, first published in 1877 but reprinted at least three times during the next decade, Thomas Worth pictured a black man causing mayhem by riding a donkey down the center of a busy road. The disheveled man, mounted on a sorry-looking animal, car-ries an open, tattered umbrella and a jug, likely of liquor. He forces two horse-drawn carriages with white drivers off the sides of the road, and similar wrecks litter the road behind him. Worth presents a sim-ilar scene in the two-part series, *Bound to Shine/Bound to Smash* (1877). In *Bound to Shine*, captioned "Or a (Blacking) Brush on the Road," a black couple races their horse-drawn wagon between two white driv-ers, only—in *Bound to Smash*—to lose control and crash into a ditch. In the latter print, the woman grabs her husband by the hair; thus the subtitle *"Or Caught by the Wool."*

Black women more often take the brunt of the *Darktown* prints dealing with pretensions to fashion, but men appear occasionally as well. Representative is Thomas Worth's *De Cake Walk: For Beauty, Grace and Style; de Winner Takes de Cake* (1884), which ridicules the

very idea that black women might have "beauty, grace, and style." Three black women wear fancy dresses in loud colors and patterns and outrageously overdecorated hats. Their huge feet stuffed into delicate shoes, they promenade in front of a stage and three formally dressed judges. The prize cake sits on a table on the stage while a crowd of blacks watches admiringly nearby.[24] In *Dude Belle* (1883) Worth caricatures a black woman in elegant dress, carrying a small, puglike dog whose face resembles hers. In *Dude Swell* (1883) a black man, dressed to the nines, wearing a monocle and carrying a walking stick, struts past a café window from which two other black men observe him.

Lawn parties and tennis were part of fashionable life in nineteenth-century America, and Currier and Ives could not resist producing comic scenes of blacks engaged in such activities. *A Darktown Lawn Party: Music in the Air* (1888, Fig. 44), pictures a lawn party in which blacks dress and act in an elegant manner. In *A Darktown Lawn Party: A Bully Time* (1888, Fig. 45), however, a bull charges through the affair, wreaking havoc. It disrupts tables, scatters people in various directions, even up a tree, and ends up wearing a woman's parasol like a tutu. Similarly *Lawn Tennis at Darktown—A Scientific Player* (1885) and *Lawn Tennis at Darktown—A Scientific Stroke* (1885) poke fun at the very idea that African Americans could play tennis or that they would even pretend to take a scientific approach to the game, given their limited intelligence. In this case, the carefully measured serve ends up in a woman's mouth as she stands with her partner on the receiving side of the net. The server plunges his head through the net after his serve.

In the two-print series *The Darktown Yacht Club—Hard Up for a Breeze: The Cup in Danger* (1885) and *The Darktown Yacht Club—On the Winning Track: The Cup Secure* (1885), two black men try to increase the speed of their "yacht" by using a bellows and fan to blow on the sails. In the second print the victorious crew cavorts around their yacht, the *Pure-Rat-tan*, while the captain holds the winner's cup in his right arm and an American flag in his left.

In *The Darktown Hunt* (1892), also a two-part series, blacks gather in hunting attire. They are depicted in attitudes of extravagant pretension, but they are mounted on broken-down nags and adorned with ridiculous costumes. Two women and two men are mounted; a fifth man leans against his horse. Whoever reaches the end of the course first will get a brush for a prize, thus the subtitle: *The Meeting: "Keep You Tempers Ladies. De One Dat Gits Tother End Fust Gits de Brush."* Their dogs relax on the ground nearby, oblivious to the fox

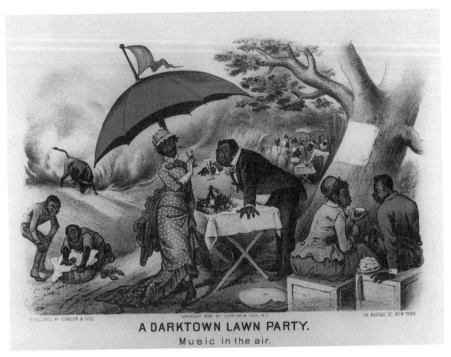

A DARKTOWN LAWN PARTY.
Music in the air.

FIGURE 44. *A Darktown Lawn Party: Music in the Air.* Currier and Ives (1888). Courtesy of the Museum of the City of New York.

that appears in the distance. In *Presenting the Brush: "You Done Better Keep It Kurnel to Polish You Check,"* one of the black men returns, riding a dripping, exhausted horse, the back seam of his swallowtail coat ripped to the collar. He nevertheless tips his hat to one of the black women and hands her the bristle brush.

Currier and Ives also skewered black attempts at high culture. In the *Darktown Sociables* (1890) series, the first subtitled *A "Fancy Dress" Hoodoo*, the second *A "Fancy Dress" Surprise*, an unknown artist imagines blacks staging a costumed musical before a poster announcing their "Grand Opera." Five black men and two women in elaborate costumes play musical instruments, dance, and sing. Two black men enter the stage wearing sheets, a rather blunt reference to Ku Klux Klan activities in the South during the post–Civil War and Reconstruction era. One wears a death's-head mask, causing panic among the performers. Four of the actors cower in a group, one in a dead faint, while the rest flee through a door at the right.

In *The Serenade: "Come Lub Come de Moon Am in de Sky,"* the first

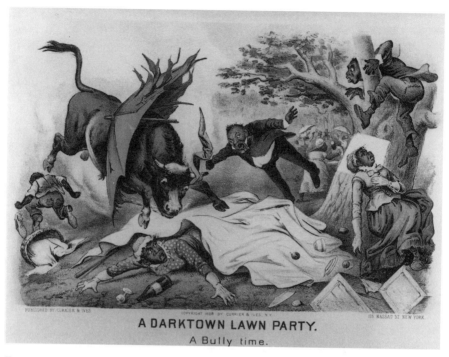

A DARKTOWN LAWN PARTY.
A Bully time.

FIGURE 45. *A Darktown Lawn Party: A Bully Time.* Currier and Ives (1888). Courtesy of the Museum of the City of New York.

of two prints in the company's *Darktown Opera* (1886), a black actor playing a banjo serenades a young black woman, who appears in a window above the stage. In *The Lovers Leap: Whar Yer Givine to, Dis Ain't in de Book,* the young actress falls from the window onto her suitor, and once again confusion reigns.

Thomas Worth provides a similar scenario in the two-part *A Literary Debate in the Darktown Club* (1884). In the first scene, *Settling the Question,* two black men in motley attire on a stage square off in debate. Portraits of Washington, "Linkum," and Grant hang on the wall behind them, as does a poster that advertises "De Lions ob Debate," three black heads on the bodies of lions. In *The Question Settled* the debate has ended in violence. The two black debaters have knocked each other down, and the props on the stage are wrecked. A portrait of Washington is broken over the head of one debater, and a police constable enters the scene from a door at the rear of the stage.

In *The Aesthetic Craze: What's de Matter wid de Nigga? Why Oscar You's Gone Wild* (1882) a thin African American male is pictured in

knee britches, jacket, and a hat with a peacock feather. Sunflower in hand, he strikes a pose suggestive of Oscar Wilde. The locale, however, is a backyard occupied by a large washerwoman at her tub, to whom the black man offers the flower with a grand gesture. A younger woman, hands clasped in utter romantic amazement, looks on from the side.

Dueling was still a part of nineteenth-century American culture, so it too was grist for the Currier and Ives *Darktown* mill. In the two-part *An Affair of Honor* (1884), for which the artists listed are King and Murphy, we see that blacks are not even capable of dueling correctly. In part one, *The Critical Moment: Now Den Brace Em Up—One!— Two!!*, the two duelists are held up from behind by their seconds. An elderly black man stands to the left, holding a wooden toolbox with the word "Surgeon" carved on its side. In *A Stray Shot: "Whar Yer Givine to Nigga? You Done Shot Old Sawbones"!* the duel is over, the contestants have fallen over one another, and the only one who is shot is the black surgeon, in the thigh.

The *Darktown* comics also take on black fraternal organizations and blacks in the military. In *Initiation Ceremonies of the Darktown Lodge* (1887), for example, absurdly costumed black lodge members conduct an equally absurd initiation ritual, which of course ends in chaos. In *Cavalry Tactics, by the Darktown Horse Guards* (1887), subtitled *"Now, Win Yours Spurs To- day,"* military blacks are made to look ridiculous, despite their demonstrated courage in the Civil War and in the Indian wars. In this print black men, wearing a variety of silly hats, ride horses and donkeys, raising their swords in a "ferocious" charge that sends a small black boy and his dog scrambling to get out of their way.

Political cartoons were a Currier and Ives mainstay, and although blacks were occasionally props in those cartoons, especially during the 1850s and 1860s, politics were also the focus of at least a few *Darktown* comics. The theme is much the same: black attempts at engaging in white activities end in chaos. In the first part of *A Political Debate in the Darktown Club, Settling the Question* (1884), Thomas Worth pictures two black men on stage in animated debate. On the wall behind the debaters hang several pictures, including portraits of James G. Blaine and Grover Cleveland, the 1884 presidential candidates and presumably the subjects of the debate. Interestingly, given the time and the growing involvement of the Irish in American politics in the urban Northeast, as well as the strained relationship there between blacks and the Irish, another poster on the wall nearby is labeled "The

Irish Vote," and it pictures a man sitting on a lion. The lion represents Tammany Hall, where the Irish were riding a rising tide of political involvement, a prospect no doubt of some concern to the debaters. Nevertheless, in the second part, *The Question Settled*, the two debaters have concluded the debate with a brawl and sit bruised amidst the resulting rubble. The "Irish Vote" picture has been smashed over the head of one of the men, and a policeman peeks in through a door at the back of the stage.

If there is any theme for which Currier and Ives are especially well known, it is firefighting—pointing to the romance and glory of New York City's volunteer firefighting units. Black firefighters are not so romanticized. Between 1884 and 1891 Currier and Ives produced thirteen separate prints under the general title *The Darktown Fire Brigade* and three more titled *The Darktown Hook and Ladder Corps*. In each case, black firemen engage in activities incumbent upon firefighters but which end in humorous disasters or at least unexpected consequences. In *All on Their Mettle: "Git Dere Fust if You's Bust You Trousers!"* (1889) and *Slightly Demoralized: "I Know We'd Make Em Take Water* (1889), three black fire-brigade units converge at top speed from separate roads on a one-lane bridge, resulting in a collision and wreck of all three units.

In *Hook and Ladder Gymnastics: Brace Her up Dar! And Cotch Her on de Fly!* (1887), a black fireman rescues a woman from a burning building. He manages to swing her out to the top of the ladder, but her backside is about to be speared by the sharp pike of a fireman standing below. In *Saved* (1884), one of only two in the series actually attributed to Thomas Worth, a black woman, modestly carrying a fan, jumps from a burning building into a tattered blanket. A fireman staggers under the weight of another woman, as he carries her out the front door over his shoulder, while a third victim is hosed down as he crawls through a hole in the roof. In *Under Full Steam: Now Den Squirt, for All She's Wuff* (1887), a black fireman hoses a nightgown-clad black woman on the backside as she descends a ladder to escape a burning building.

Currier and Ives offer similar parodies in their *Darktown* series on black policemen and lawyers, and even preachers, the last of which is noteworthy given the firm's emphasis on piety. In *A Change of Base: I Jist Done Got a Call to Anodder Congregation!* (1883), Thomas Worth pictures a black preacher racing across snow-covered ground, holding a chicken under his right arm and pursued by a crowd throwing bottles at him. In the two-part *A Darktown Donation Party* (1893) a

black woman enters the meetinghouse and places a cradle before the minister. In the first print, subtitled *A Doubtful Acquisition: Dere Parson You Kin See de Debble Hisself in Dat Mirror*, a black man holds up a mirror so that the parson sees himself in it. In the second, *An Object Lesson: Ah Brudder Jonsing I Hab Only to Hol de Mirror Up to Natur to Show You de Debble*, the parson holds the mirror up to the other black man.

An "obdurate mule" keeps a black preacher from delivering his sermon in the print of the same title (1890). As a train approaches, a mule refuses to budge from the tracks, despite a black woman pulling on the reins, the black preacher striking the beast with an umbrella from behind, and another black man lighting a fire beneath it. The preacher's sermon sticks out of his pocket. The print is subtitled: *Going Back on the Parson: "Now Den All Together and Sumfin's Got Ter Come."* In *A Penitent Mule—The Parson on Deck: "Nebber Mind de Sermon Parson, We Sees de Pint"* (1890), the minister has arrived at the church to greet his expectant parishioners, who crowd through the front entrance to witness his arrival. His rig is wrecked, his mule battered and bandaged. The preacher, whose clothes are tattered and disheveled, holds a torn sermon, as a fallen angel in disarray looks on from the left.

Currier and Ives published dozens of prints—most serious, but a few comic—extolling the virtues of marriage and virtuous courting, but black courting and marriage, in their view, was an altogether different experience. In the two-part *The Darktown Elopement* (1885) an unknown artist offers a predictably comic scene of a black couple attempting to elope on a moonlit night. In *Skip Softly Lub, Don't Sturb de Ole Man an old Bull Pup!* a young black woman descends a rope ladder from a trapdoor in the roof of a shack, stepping onto the back of a young man who has bent over to help her. A donkey stands nearby waiting to carry them away. Around the corner of the shack, her father, with a shotgun and a small dog, peers out the door. In *Hurry Mr. Jonsing, Dars Dat Chile Lopin wif de Coachman* the father rushes forward, his wife urging him on from a window. The donkey throws the black couple, who were riding it backwards.

In the two-part *A Darktown Wedding—The Send Off* and *The Parting Salute* (1892), a boy throws a boot at a black bride and groom departing their marriage ceremony, striking the groom in the head. In *A Lovely Calm* (1879) a black couple sits in the stern of a small sailboat, clearly enjoying a romantic interlude. He holds the rudder; she holds a parasol, as they kiss. In *A Black Squall* (1879) the boat is about

to sink. The woman now steadies the rudder with one hand, while she shakes her other fist at the black man, who has fallen, or has been pushed, into the water. He hangs on to the stern of the boat, while his hat floats behind him.

Whites pictured blacks as "naturally" drawn to music, and the banjo as their preferred instrument.[25] Thus, the banjo became a common prop in Currier and Ives prints concerning blacks, especially in the *Darktown* series. The message is that even if the banjo is their preferred instrument, blacks do not play it particularly well. *The Darktown Banjo Class* series (1886) is representative. In *All in Tune: "Thumb It, Darkies, Thumb It—O How Loose I Feel!"* three black men and two black women play the banjo with great enthusiasm. In *Off the Key: "If Yous Can't Play de Music, Jes Leff de Banjo Go!"* the same banjo players sit and look at each other in dismay.

Similarly, watermelon is commonly featured among *Darktown* comics that poke fun at blacks' eating habits. In the first scene of the two-panel *Darktown* comic, *Magic Cure* (1890), a sullen, depressed black man waves away a woman who approaches, holding a watermelon. In the right panel, the man is jubilant, having been revived by a bite of watermelon, and the woman now holds up a pint of liquor. In *"O Dat Watermillion!"* (1882) two black boys sit in a watermelon patch, eating wedges from a large melon. A sleepy-eyed black man holding a stick sits and watches the boys from behind a fence.

Other foods were commonly featured in *Darktown* comics, including oysters. It is unclear whether the common association of oysters with erotic behavior is implied here. In *On de Haf Shell!* (1886) a black man looks down with a large grin at a huge oyster on the half shell that he has just shucked. The two-part *Great Oyster Eating Match between the Darktown Cormorant and the Blackville Buster* (1886) shows two black men, bellies bulging and eyes rolling in their heads, gorging themselves with oysters. The first print is subtitled *The Start—"Now Den Don't You's Be Too Fresh. Wait for de Word—Gulp."* The second is *The Finish—"Yous Is a Tie—De One Dat Gags Fust Am a Gone Coon."*

Currier and Ives's prints of the West, especially of the frontiersman, did not include blacks, even though African Americans were a sizable part of the westward movement.[26] An exception, found in the *Darktown* series and therefore comic, is the two-part *The Wild West in Darktown.* In *Attack on the Deadhead Coach* (1893) a stagecoach races through town, full of excited African Americans firing pistols at spectators who line both sides of the streets. The undaunted crowd throws

stones at the coach, and one woman threatens the ineffectual outlaws with her broom. In *The Buffalo Chase* (1893) black cowboys on horseback chase and fire at four men draped in the full skins of two buffalo, two men to a skin.

Given the company's many prints featuring children, generally intended to support the widely held belief in the centrality of the family and motherhood to the American experience, it is not surprising to see several of Currier and Ives's *Darktown* comics focused on black children. In contrast to how the company pictured white children, however, black children are pictured as mischievous and out of their parents' control, showing no respect for their elders. In *"Breaking In": A Black Imposition* (1881) and *Breaking Out: A Lively Scrimmage* (1881), for example, Thomas Worth shows a group of young black boys, grinning mischievously, climbing onto a wooden fence and clearly intending to pester a horse tethered there. One boy whittles a branch with a knife. In the second print the boys have done their deed; the horse rears, crashing through the fence and sending the boys flying through the air, some still gripping pieces of the fence in their hands.

In the companion pieces *A Put Up Job* (1883) and *A Fall From Grace* (1883), Thomas Worth pictures five young black children ambushing with snowballs a pious-looking, elderly black couple walking through the snow with their prayer books, knocking them to the ground. John Cameron pictures three boys in tattered clothes smoking a box of cigars behind a building, one mimicking the posture of a sophisticate, in *High Old Smoke: "Go in Fellers, Dese am de Best in de Market!"* (1888). Cameron presents a similar scene in *A Swell Smoker—Getting the Short End* (1888) and *A Swell Smoker—Giving Long Odds* (1888), wherein a caricatured, foppish black man has lent his cigar to a black schoolboy, who wants to light a cigar butt, and is aghast to see the boy keep the cigar and return the butt.

An unknown artist provided a particularly insensitive, even vicious, print involving a young black child, but with a deeper message than usual, in the two-part *Cause and Effect* (1887). In *A Timely Warning*, an older black man warns a black boy not to wash because it will spoil his color. The boy grasps the washtub with one hand and a bar of soap in the other. In *A Natural Result* the boy has washed and bleached his hands white. The man exclaims in consernation, "Dar, I tole yer so! Now yous done gone spile a little nigger."

Equally insensitive prints in the *Darktown* series parody the Currier and Ives patriotic Statue of Liberty prints. In Thomas Worth's *Barsqualdi's Statue Liberty Frightening the World: Bedlum's Island, N.Y.*

FIGURE 46: *Brer Thuldy's Statue/Liberty Frightenin de World/To Be Stuck Up on Bedlum's Island—Jarsey Flats, Opposit de United States.* Currier and Ives (1884). Courtesy of the Museum of the City of New York.

Harbor (1884), a parody of the firm's *The Great Bartholdi Statue, Liberty Enlightening the World* (1882), a black woman poses as the Statue of Liberty, holding a burning branch and an unwieldy book labeled "New York Port Charges." She wears an apron of stars and stripes and stands on a platform of wooden crates, a rooster at her feet. This print was also published under the title *Brer Thuldy's Statue/Liberty Frightenin de World. To Be Stuck up on Bedlum's Island/Jarsey Flats, Opposit de United States* (1884, Fig. 46).

Irish Americans

Given the firm's negative representations of blacks in its *Darktown* series and the anti-immigrant mood of the nation, one would expect Currier and Ives to be similarly satirical in its treatment of immigrants. And they were, but not to the same extent. Currier and Ives published a few prints, mostly cartoons, that could be classified as overtly anti-immigrant. The *"Heathen Chinee"* (1871) might be a case in point, but Currier and Ives based the print on Bret Harte's doggerel of the same title about the cunning Chinese euchre player in a California gold-mining camp. In stereotypical Chinese peasant attire, with a long pigtail, he plays cards with two white men in a log cabin. As the Chinese man plays a card and smiles (his skull and face typically distorted in simian fashion), one man holds his cards tight to his chest and casts his eyes at the man seated at his right. The other man smokes a pipe and holds his cards below the table. Harte's readers no doubt were amused by the wordplay on the man's name—Ah Sin— and by nativist Bill Nye's parroting of the popular refrain, "We are ruined by cheap Chinese labor" and the Chinese man's conquest of the double-dealing whites. The relevant lines of doggerel inscribed on the print are:

> But the hands that were played, by that heathen Chinee
> And the points that he made were quite frightful to see
> Till at last he put down a right bower
> Which the same Nye had dealt unto me.

Chinese immigrants began arriving in large numbers on the Pacific Coast soon after the discovery of gold in California. There were approximately 35,000 in the state by 1860 and 75,000 by 1880; two years later, in 1882, the Chinese Exclusion Act was passed.[27] In the beginning they were welcomed as household servants and menial workers

for low wages, but soon they were resented, as the opening stanza of a popular gold-rush song put it in the mid-1850s:

John Chinaman, John Chinaman
But five short years ago,
I welcomed you from Canton, John—
But wish I hadn't though."[28]

In less understated slurs, they were called "chinks," "celestials," "coolies," "slant-eyes," "moonfaces," and "heathens," and they were viciously caricatured in print. Currier and Ives indulged in such caricature only once, and then to illustrate the popular poem. In that same year, a riot in Los Angeles devastated the Chinese sector. Twenty-one were killed, most of them Chinese, by lynching, but the number included some of their white employers as well.[29]

"The Heathen Chinee" contributed to the popular images of the Chinese as pollutant and deviant. What is surprising is how few anti-immigrant prints Currier and Ives produced, even on the Irish, who constituted the largest and most troubling such group of the period. It is clear that Currier and Ives shared the same negative stereotypes held by most Americans, but just as clearly, in marked contrast to their treatment of blacks, they chose not to exploit those stereotypes.

Currier and Ives published prints of scenes from the homelands of a number of immigrant groups, but they chose not to comment on the nativist sentiment such immigration aroused. The firm produced more than two hundred prints on Irish and Irish American subjects, of which an estimated one hundred thousand copies were sold.[30] Many of them included stereotypical images, but few could be classified as intentionally negative. In fact many are quite positive, even heroic, even though they were produced during the heyday of anti-Irish sentiment and activity in America.

The firm had a number of possible reasons for this. It may simply have been a business ploy, to include the rapidly growing Irish American population among its customers, especially in New York City. P. T. Barnum, for example, displayed a model of Dublin in his New York City museum to attract Irish visitors. And it is clear from the number of prints Currier and Ives produced that it was a lucrative line. It may be that the pro-Irish position was the result of an anti-British sentiment felt by many Americans at times in the nineteenth century or of popular sentiment for the underdog in the continued struggle of the Irish against British rule. Irish Americans also may have incurred

favor for their service in the Civil War. Regardless of the reason, however, Currier and Ives chose to create a positive documentation of the Irish, and that ran contrary to the opinion of many, if not most, Americans.

The Irish received a stormy reception in America, especially during the swelling immigration of the 1840s. In 1848 the immigrant tide rose to two hundred thousand and maintained that level for the next six years. The vast majority of those immigrants were peasants, and Americans were horrified by their poverty and lack of education. Currier and Ives pictured the Irish immigrant's squalid condition in *Outward Bound—Dublin* (undated), in which a peasant, carrying all his possessions in a bag tied to a pole and balanced on his shoulder, holds in his hand his last copper as he reads a poster advertising the vessel *Shamrock's* imminent departure for America.

Outward Bound should be compared with *Homeward Bound—New York* (undated). There, Currier and Ives present a much more prosperous-looking individual, studying a poster addressed "emigrants returning" and advertising a ship about to depart New York for Dublin. He has the resources to return, but unlike the peasant in the previous print, he shows no inclination to do so. He carries no bags; no trunks sit nearby. His home is now the United States, and Ireland is a place of nostalgic memory.

Once in the United States the Irish were free from landlords, but they arrived as poor as when they left, if not poorer, and they had to find jobs. Some were exploited by their employers and many could only find jobs in mines; building roads, canals, and railroads; as laborers in building construction; and in factories. And, of course, there was discrimination. Many Americans focused their resentment on the Catholic faith of these newcomers, perceived by many as a direct threat to the nation's Anglo-Saxon Protestant heritage.[31]

In 1845, as what were characterized as "hoards" of Irish began to invade the eastern seaboard, the Native American Party, later known as the Know-Nothing Party, was founded. The Order of the Star Spangled Banner pledged to fight the menace posed by Irish Catholics to American ideals. They and their sympathizers generally relied on political opposition, but occasionally that resistance degenerated into violence, riots, and the burning of Catholic churches and convents.[32] Currier and Ives not only excluded such nativist images from their inventory but also included a large number of Catholic prints. They published at least six portraits of Pope Pius IX, the last showing him lying in state in 1878, as well as a portrait of his succes-

sor Pope Leo XIII (1878). The inscription beneath Pope Leo describes him as "bestowing the papal benediction on all true Catholics throughout the world," which is the same wording used in an earlier print of Pius IX. And the pope to many nativist Protestants constituted the anti-Christ!

Similarly Currier and Ives published portraits of some of the most respected but controversial American Catholic leaders of the day, including Cardinal John Hughes, archbishop of New York (1864); Cardinal John McCloskey, also of New York (1875); Cardinal James Gibbons, archbishop of Baltimore (undated); and Archbishop M. J. Spaulding, also of Baltimore (undated). To this list of notables Currier and Ives added a complete array of the most venerated Catholic saints, all no doubt welcome in Irish American Catholic homes. As one would expect, St. Patrick (undated) was prominently featured, but nearly forty other male and female saints, all appropriate for adoration, were also pictured.

In addition to the prints of Catholic leaders and saints, Currier and Ives produced portraits of the leaders of the Fenian movement and Irish leaders—especially revolutionary leaders—as well as scenes of areas of Irish natural beauty, historical moments and monuments, and well-known Irish Americans in the United States. They published more than fifty different views of Ireland, documenting the history of the Irish from ancient times through the middle of the nineteenth century—the largest such collection of a foreign country and people produced by the firm. Moreover the prints emphasize the Irish people's good times more than the bad, and their victories more than their defeats.[33] Some journals, for example, claimed that the Fenian Brotherhood hurt Ireland's interest, and Fenian leaders were portrayed as "dynamiters" or terrorists. Currier and Ives showed them as heroes.

Irish Americans have been described as "believing that once upon a time they were a noble people in a fairy-tale country."[34] Currier and Ives reinforced that fantasy by selling them images of Ireland that showed a land of verdant valleys, magical mountains, lyrical winding rivers against a backdrop of beautiful natural wonders, and remains the mansions and castles, large and small, where these enchanted people lived. Some of those images include *The Gap of Dunloe* (undated), *Lismore Castle—County Waterford* (undated), and *A Scene in Old Ireland* (undated).

Similarly evocative are Currier and Ives prints of Irish heroes, past and present, and religious and secular historic sites. Among those prints devoted to religious figures and sites are *The Apostle of Ireland*—

Saint Patrick (undated), the subject of which is credited with bringing Christianity to the Irish and ridding Ireland of "all the poisonous creatures." Another is *The Holy Well* (undated), which reflects the pre-Christian Irish belief that the water from certain wells had healing power. Unable to distract the people from these wells, Christian missionaries simply made them sacred, blessing them, using the water for the sacrament of baptism, and renaming them with a saint's name, in this case Saint Finian's Well.

Brian Boru—Monarch of Ireland and Hero of Clontarf (undated) is a good example of the legendary hero presented in print. Boru, a warrior-chieftain, defeated an invading and marauding Viking army in 1014 at Clontarf. Boru was killed in the battle, but the victory ended the Viking threat to Ireland.[35] Most of Currier and Ives's gallery of heroes is devoted to the period beginning with English occupation of Ireland, from the seventeenth century on. The Battle of the Boyne, fought in 1690 and involving the defeat of the Irish-supported Catholic James II, who had been removed from the English throne by Parliament, and his successor, the Protestant William III (of Orange), is the subject of at least three separate prints (undated). So too is a subsequent battle involving William, fought in August of the same year, *The Siege of Limerick* (undated). Both resulted in Irish defeats, but only, at least in Irish eyes, after valiant efforts on the part of the defenders of their homeland.

Leaders of the various Irish uprisings and rebel groups were very popular. These figures included Robert Emmet (undated), an Irish Protestant who led a body of Catholic Dubliners in a rebellion against the English in 1803, only to be hanged and beheaded; and Daniel O'Connell, who devoted his public life in the nineteenth century to gaining a repeal of the Act of Union and to the reestablishment of an Irish parliament. Currier and Ives produced at least ten different prints of this figure, as *Champion of Freedom* (undated), *the Liberator* (undated), and the *Champion of Catholic Emancipation* (undated), as well as of a funeral parade organized in O'Connell's honor in New York City upon his death in 1847.

The year 1848 saw the spread of revolution throughout western Europe, and Ireland was no exception. Though the revolution was on a comparatively small scale, that did not prevent it from becoming a part of romantic Irish American lore. The revolutionaries were called "Young Ireland," but they had no generals and few weapons. They were easily defeated and sentenced to death, but most of the sentences were commuted and the rebels sent into exile to Van Diemen's Land

(now Tasmania) in Australia. Many escaped and found their way to America, where they were welcomed as heroes by their Irish American cousins.[36]

Among the heroes of the Irish Revolution of 1848 included in the Currier and Ives gallery was John Mitchel, in *The First Martyr of Ireland in Her Revolution of 1848* (1848). Mitchel was convicted of sedition in 1848 for advocating rebellion against English rule, as publisher and editor of the newspaper, *United Irishman*. He was sentenced to prison on Van Diemen's Land, from which he escaped to the United States. The Currier and Ives print shows Mitchel seated pensively with his newspaper in his right hand, glancing at the convict ship in the bay that would transport him to prison.[37]

Prints of heroic sites associated with 1848 included *Signal Fire on Slievenamon Mountain* (1848). It pictured the fires built on that promontory to rouse the local population located near the English garrisons in the towns of Clonmel and Carrick-on-Suir. Thomas Francis Meagher spoke to a gathering of Irish revolutionaries, and those sympathetic to the revolution, on Slievenamon on July 16, 1848. He too was convicted of treason and sentenced to penal servitude on Van Diemen's Land; he too escaped to America, where he served as a Union general and led the Irish Brigade in the Civil War. He later was appointed acting governor of Montana by President Andrew Johnson. Currier and Ives told Meagher's story in *Trial of the Irish Patriots at Clonmel* (1848) and *General Meagher at the Battle of Fair Oaks, Va., June 1, 1862* (1862).[38]

More than 145,000 men born in Ireland and some thirty-eight different Irish regiments fought for the Union in the Civil War (about 40,000 fought for the Confederacy). The first two regiments to reach the field at Bull Run were Irish. In New York the first regiment to volunteer for active duty was the 69th, led by Michael Corcoran. Upon his arrival in the United States, Corcoran became a member of the Fenian Brotherhood, but he was a Civil War hero as well. Currier and Ives did two prints of Colonel Corcoran at the Battle of Bull Run (1861) as well as the portrait *Brigadier General Michael Corcoran at the Head of His Gallant Irish Brigade* (undated).[39]

Currier and Ives produced an interesting historical commentary on Irish American involvement in the Civil War in *A Disloyal British Subject* (undated). In November 1863 the Union warship *Kearsarge*, under the command of Capt. John Winslow, docked at Queenstown, Ireland. Word spread that men could sign up on board to join the Union navy, collect a bounty of four hundred dollars, and get free pas-

sage to the United States. It was an offer that many Irishmen wel-
comed, and soon the ship was swamped with recruits. Local British
authorities got word of the recruitment and stopped it, implementing
the Foreign Enlistment Act. In *A Disloyal British Subject*, a finely
dressed John Bull holds the Foreign Enlistment Act under his arm
and threatens that if Pat fights for the Union he will be treated as a
pirate. The bedraggled and bearded Irishman, Pat, responds that as a
member of the navy, he would have the Union's protection from his
old enemy, John Bull. The American flag flies from a ship in the har-
bor, and the men stand before two posters affixed to the wall. The first
reads, "The Union Forever / U.S. / Down with Secession / Death to
Traitors / Volunteers Wanted for the U.S. Navy." The other counters,
"Victoria R. / The Belligerents Strict Neutrality / Blockade / British
Interests / Privateering / Letters of Marque."[40]
 Another popular historic print associated with the rebellion of 1848
was Currier and Ives's *Attack on the Widow McCormack's House on
Boulagh Common, July 29, 1848* (1848). The attack on the house, to
which a force of about forty constables had retreated to defend them-
selves against the larger but far less well-equipped band of rebels, was
vintage Irish insurrection. "The print, one of the best that Currier and
Ives ever published, captures the spirit of the moment even for some-
one who knows nothing about the incident."[41] It pictures the attack-
ing force, with their variety of primitive weapons—pikes, spears,
pitchforks, shovels, stocks, stones, and only a few muskets—involved
in an absurdly hopeless cause. In the aftermath, its leaders were tried
for treason and sentenced to death, but once again all sentences were
commuted to exile on Van Diemen's Land.
 Currier and Ives pictured James Stephens (undated), Terence
McManus (1848), and John O'Mahoney (undated), but the most no-
table Irish leader of those who rose to fame after the 1848 rebellion
to be included in Currier and Ives's gallery was Charles Stewart Par-
nell (1881). Parnell was the grandson of the American naval hero of
the War of 1812, Charles Stewart, whose daughter married the son of
the Anglo-Irish aristocrat, John Parnell. Although a Protestant land-
lord, Charles Stewart Parnell became a friend of the Fenians and was
elected a member of the Irish Parliamentary Party to the House of
Commons in England in 1875. He took as his goal the creation of an
independent Irish parliament.[42]
 More than any other Irish leader up to that time, Parnell had wide
support in America. He visited the United States in 1880 to raise
funds and drum up political support for his cause. His brother re-

ported that "the whole of New York after this went mad over the Irish cause, and the Ambassadors of home rule were cordially received by all grades of society." Parnell even addressed the House of Representatives in Washington. Parnell's political career was cut short, however, by the scandal that erupted when his affair with the married woman Kitty O'Shea was made public.[43]

Addressing fighters of a very different kind, pictures of prizefights and portraits of Irish American prizefighters constituted a considerable number of Currier and Ives prints. For many Irish immigrants, climbing into the ring was a step along the path to success; for their fans it was another source of ethnic pride. The first international fight in which an Irish American carried the Stars and Stripes into the ring pitted the "Bernicia Boy," John Heenan, against English champion Tom Sayers on April 17, 1860, in England. Currier and Ives captured the scene in *The Great Fight for the Championship* (1860).[44] On a more humorous note, the fight ended in a melee involving Heenan and several spectators, also pictured by Currier and Ives in *Yankee Doodle on His Muscle, or The Way the Bernicia Boy Astonished the English Men* (undated). Among the other popular prizefighters in the firm's gallery were John Morrissey (1860), John L. Sullivan (1883), and Paddy Ryan (undated).[45]

Currier and Ives prints were not entirely without derogatory caricature and stereotypical references to the Irish and their lifestyles. Such images no doubt both reflected and reinforced anti-Irish sentiment in nineteenth-century America. All too commonly, even in the work of Currier and Ives, Irish Americans were portrayed as subhuman. The apelike faces they employed did not spring full-blown from the artists' own imaginations. Rather, they owed much to conventions of graphic satire and prevalent attitudes about anthropoid apes and also the Irish nationalists who employed violent means to attain independence. Such caricatures of the "bestialized Paddy" originated in England but soon found their way to America. In both locales, the image was constructed on the newly published Darwinian theory of evolution, which postulated that humankind had evolved from the apes. Some, it was argued, evolved less than others, showing the lesser stage of evolution, or "grades of intelligence," in the remaining degree of apelike features of their physiognomy.[46]

Nineteenth-century Irish caricatures stood at the juncture of social Darwinian thought, satire, and Anglo-Irish political problems. In Britain and America they called into question his inherent fitness for self-government in Ireland and participatory citizenship in the democratic republic of America. As pictured in both countries, the unfor-

Figure 47. *The Man of Words, the Man of Deeds. Which Do You Think the Country Needs?* Currier and Ives (1868).

gettable image of Paddy was that of a less than fully human creature trying to subvert law and order. Such images became a regular feature in the New York weeklies, but Currier and Ives largely refrained from such imagery. There were exceptions, most notably during the Civil War, in response to Irish American involvement in the New York City draft riot of 1863, and later to the growing Irish involvement in politics, especially the corrupt politics of Tammany Hall, from which emerged the image of a brutal and slow-witted Democratic thug.[47]

Three cartoons are representative. In *The Great Match at Baltimore* (1860) a caricatured Irishman represents immigrant members of the Tammany Democratic machine in New York City. In *The Chicago Platform and Candidate* (1864), a Peace Democrat is represented as an Irish American with apelike features (especially the skull and face, but also the hands) carrying an Irish shillelagh, suggestive of a primitive club. Holding the club on his shoulder and gesturing menacingly with a closed, apelike fist, he offers to "knock any man on the head that votes against" the Democratic candidate, George McClellan, as long as McClellan is "in favor of resistin the draft, killing the Nagurs, and pace wid the Southerners."

In *The Man of Words, the Man of Deeds. Which Do You Think the Country Needs?* (1868, Fig. 47), John Cameron depicts Irish Americans similarly in the 1863 New York City riot. Historians usually attribute the riot to Irish American discontent with implementation of the Emancipation Proclamation on January 1 and passage of the first mandatory military service act in the spring of 1863. Many Irish had volunteered to fight early in the war, forming Irish brigades and distinguishing themselves on the battlefield. They often met with nativist anti-Irish sentiment for their efforts, but as the war dragged on, given their socioeconomic situation, they assumed an increasingly large role on the front lines. Then the new draft law and Emancipation Proclamation appeared to them to transform the war from an effort to save the Union to forcing the Irish poor (who could not afford the three-hundred-dollar fee to buy their way out of the draft) to fight to free slaves, thereby making worse their struggle with African Americans for economic survival.[48]

The riot lasted three days, July 13–15, during which the mob stormed the draft office, looted and burned the armory, cut telegraph lines, and laid siege to the homes of politicians and newspaper offices. They also attacked the city's black residences and an orphanage for black children and tortured, burned, lynched, and mutilated several blacks they found on the streets. The rioters caused five million dollars in damages, left 3,000 or more homeless, and drove scores of blacks from the city. By the time order was restored—by five Union army regiments ordered back from the just-completed Battle of Gettysburg—at least 119 lay dead, including 18 African Americans, 16 soldiers, and 85 rioters.[49]

Although historians have pointed to complex origins for the riot, the popular press of the day, and Currier and Ives, did not hesitate to affix responsibility for the riots.[50] In the first panel of an 1868 print, *The Man of Words*, for example, Horatio Seymour appeals to the ape-like, club-carrying—clearly Irish—mob that is engaging in violent acts, including lynching a blackman and burning New York's Colored Orphan Asylum. Seymour tells the mob ironically that he relied on them "to defend the peace and good order of the city," in return for which he would see to it that all their rights would be protected. Nearly everyone, including Currier and Ives, was convinced that the "worst elements" of the city's population—meaning the Irish—were to blame, as well as those unscrupulous Democratic political leaders (Copperheads, some insisted) who egged them on. Currier and Ives's print was not uncommon, though it was tame in comparison to oth-

ers, which held up for ridicule "besotted Irishmen in a bacchanalian orgy, burning, killing, and plundering in the streets of New York to the delight of their shrieking wives and squat-faced offspring."[51]

Currier and Ives made another reference to Irish violence in *Great Riot at the Astor Place Opera House, New York* (1849). The Astor Place Riot, which began on May 10, 1849, was a bizarre, tragicomic incident of a sort that happened often in mid-nineteenth-century New York City. Irish immigrants played a major role in the riot, which was ignited by a stage rivalry but which also had ethnic and class origins. The stage rivalry pitted Philadelphia's Edwin Forrest, a Shakespearean actor, against his major British competitor, William Charles Macready, who had become the favorite of New York's theater-going elite. Irish Americans and other members of the lower classes rallied to Forrest's support, and on May 10, 1849, when Macready took the stage at the Astor Place Opera House, they broke into the theater and threatened the occupants. The Seventh Regiment was called, but the mob was not quieted until the militiamen fired into the crowd, killing twenty-two people and wounding many others; it was estimated that an additional nine died later of their wounds.[52]

Life in America for Irish immigrants was difficult, but the life they had escaped was one of poverty and violence, not only in rebellion but simply in their daily lives. It also included occasional riotous fun. In picturing the latter, Currier and Ives may have intended to provide Irish Americans with humor and nostalgia. In the process, however, they provided anti-Irish groups further visual evidence of Irish degradation. In *A Pattern in Connemara* (undated) we see a group of barefoot, country pilgrims gathered to pray, only to dissolve into riotous fun and rough athletic games. *Paddy and the Pigs* (undated) is a mix of poverty, coy storytelling, and camaraderie. It pictures an Irishman in patched clothing, leading a pig to town presumably to be slaughtered. He passes another Irishman standing in his doorway, and they exchange greetings. The scene may have been inspired by the popular song, "The Irishman's Shanty" (1859), by Henry Tucker, three verses of which went:

Did you ever go into an Irishman's shanty?
Ah! There boys you'll find the whiskey so plenty
With a pipe in his mouth there sits Paddy so free
No King in his palace is prouder than he

There's a three legged stool and a table to match,
And the door of the shanty is locked with a latch;

FIGURE 48. *The Man That Gave Barnum His "Turn."* Currier and Ives (undated).

There is a neat feather mattress all bursting with straw,
For the want of a Bedstead, it lies on the floor. . . .

He's a pig in the sty, and a cow in the stable
And feeds them on scraps, that left from the table
They get sick if confined, so they roam at their ease,
And go into the shanty whenever they please.[53]

"Auld Times" at Donnybrook Fair (undated) emphasizes music, dancing, and young and old gathered together to have fun, but in the background it also shows violence and the use and abuse of alcohol. Before the British ended the "auld times" in 1854, the name of this fair had worked its way into the language—as in a *donnybrook*, or "brawl." It was famous for its wild merrymaking, eating, drinking, cardplaying, lovemaking, quarreling, and fighting. The fair may have continued to evoke nostalgic memories among American Irish, but it also reinforced the stereotype of the Irish as hard drinkers and a violent people.[54]

To conclude with one of Currier and Ives's most curious references to Irish Americans, the message is sufficiently ambiguous to be left to

the eye of the beholder. *The Man That Gave Barnum His "Turn"* (undated, Fig. 48) is taken from an actual incident at a barbershop in which P. T. Barnum, in order to be served first, offered to pay for whatever an Irish American patron was about to have done. The Irish American proceeds to have a bath, shave, shampoo, hair cut, hair dye, and hair curling, whereupon—as the before and after pictures show—the rather grizzly, apelike Irishman is transformed into a far more presentable, even fashionable, figure. Has grooming changed the man, or just his appearance?

EIGHT

Graphic Humor and Political Commentary

Laughter is the great vinculum,
the binder uniting the disparate
elements of society by ridiculing
the importance of their
differences. The humorous
artist, even in his most ferocious
cartoon, smothers fear with
laughter, he allays suspicion
with a jibe, and above all he
continually reminds us that we
are none of us without our
weaknesses and none perfect.[1]

Although Currier and Ives's use of humor has been alluded to earlier, the purpose of this chapter is to examine more thoroughly the firm's use of graphic humor for political commentary. Currier and Ives attended to political actors and events in three ways. One was the election banner, or heraldic double portrait of a presidential ticket. The firm printed one to three banners for each major party during every presidential election from 1844 through 1880, apparently not entirely on commission but also in response to public demand. Similarly, they published more than 180 portraits of presidents and other political figures. Finally, and of greatest interest, Currier and Ives produced

at least eighty political cartoons over roughly the same period. Most appeared in black and white, but some election-year caricatures nevertheless had print runs as large as one hundred thousand. Clearly, they were very popular.[2]

The political cartoon came into its own in the United States in the nineteenth century. Indeed it was the central type of caricature of its day, mostly because of its new and inexpensive means of reproduction and distribution, the rise of political parties, and the greater involvement of the public in politics. Although the cartoons are occasionally criticized today for being lifeless, stilted, and wordy, Currier and Ives's lithographic and mass-marketing success earned their political comics a major place in that medium.[3] In examining their content, we find support for a point made by Jeff MacNelly, of the *Chicago Tribune*, who once wrote that the greatest political cartoonists would have made excellent "hired assassins," if they had been unable to draw.[4]

The type of graphic humor embodied in Currier and Ives's comics of the nineteenth century was rooted in the British tradition of comic art that began decades earlier with William Hogarth, in what has become known as "the century of caricature" in England and which continued with the younger George Cruikshank.[5] Like its British counterpart, American graphic humor made a forceful presentation by means of exaggeration of a topical political, social, or moral issue. It was intended for a wide audience, and it made use of popular symbols and slogans. But in its use of such symbols and slogans, and in its choice of subjects, it was distinctly American. As those symbols and slogans are often meaningful, or even intelligible, only when interpreted in the context of the period during which the cartoon was created, they provide a window through which we can more clearly view that age—including its popular prejudices and its opinions.[6]

Graphic satire can be broken down into two subsets: caricature and allegory. Caricature relies on the distortion of concrete things; allegory gives essentially abstract political opinions or principles figurative form. Caricature is best adapted to attacks on the personal character or behavior of individuals or classes of people as ludicrous or wicked.[7] Given the nation's more utilitarian than intellectual worldview, as well as its still-immature people's well-noted sensitivity to criticism of its institutions, culture, and values, we might expect a greater acceptance of caricature than allegory. And indeed, with respect to Currier and Ives political cartoons, that is the case; but allegory is not entirely absent.

Graphic satire, employed for either social or political commentary, was given a boost in nineteenth-century America by the appearance of illustrated newspapers and magazines. We need only recall William Marcy Tweed's response to Thomas Nast's legendary cartoon that appeared in the August 19, 1871, issue of *Harper's Weekly*, charging the Tammany boss and three of his cohorts with stealing the people's money: "Stop them Damn pictures. I don't care so much what the papers write about me. My constituents can't read. But, damn it, they can see pictures."[8] Graphic satire was also well represented in the work of Currier and Ives. It depended for its success on the artist's effectiveness in exposing individual physical peculiarities and idiosyncrasies of manner, as well as the artist's psychological penetration of the subject. Diminution and exaggeration were among the most effective tools of graphic mockery. Satire inevitably victimized and pilloried its subjects. It parodied manners and gestures and manipulated facial expressions to say the unsayable, to convey meanings that words could not as effectively express. It was deliberate misrepresentation with a purpose.[9]

A Brief History of Political Cartoons

The earliest forms of political and social satire in America were literary. The lampoon and the parody, the satirical ballad and the prophetic hoax were published in almanacs, broadsides, small volumes, and newspapers. By the 1730s instances of graphic humor began to appear. Graphic artists began to use symbols and allegories with a touch of exaggeration and of the incongruous, but the degree of ridicule and burlesque that marked the nineteenth-century cartoon developed more slowly. At first merely a weak carbon copy of the European model, American cartooning displayed only modest wit and originality until the mid–nineteenth century.[10]

It has been argued that "political caricature in a young democracy is likely to precede social caricature. One can flourish in a new and immature country; the other cannot."[11] Such was the case in the United States, with pro-union, or anti-British, political cartoons. Among the best known are *Join or Die*, which first appeared in Benjamin Franklin's *Pennsylvania Gazette* on May 9, 1754, urging the colonies to unite against the French and their Native American allies, and Paul Revere's engraving of the Boston Massacre (1770). Franklin's cartoon, which featured a serpent divided into eight parts, accompa-

nied his proposed "Plan of Union" for the colonies and was based on the popular superstition that a snake that had been severed would come back to life if the pieces were put together before sunset.[12]

Revere's piece was so inflammatory that when the British soldiers responsible for the four fatal shootings were brought to trial, one of their lawyers warned the jurors not to be biased by such prints that added "wings to fancy." Revere did take considerable liberty with the facts, but he also "borrowed" the design, without attribution, from the work of artist Henry Pelham.[13] Such cartoons moved the art form in America forward incrementally, but many of the best caricatures to appear in the colonies up through the American Revolution were drawn and published in England, the Netherlands, and France.[14]

The War for American Independence elicited other native caricatures, notably by Paul Revere, the engraver as well as midnight rider. His allegorical compositions, *A View of the Year 1765* and *Stamp Act Repealed* (1766), both dealing with the Stamp Act, were quite popular. Other period caricatures include *The Rescinders, The Able Doctor, or America Swallowing the Bitter Draught* (1774), which portrays Britain forcing tea down America's throat; *The Mitred Minuet* (1774), on the Quebec Act; and *America in Distress* (1775), in which Revere crossed the traditional image of Britannia with that of an Indian princess. All three were published in the *Royal American Magazine*.[15]

Among the most popular of the political cartoons of the next few decades were the several anti-Jefferson cartoons, one typical print showing the president kneeling at the "Altar of Gallic Despotism," about to throw the Constitution into the flames, and those produced in response to the fight between Republican Matthew Lyon of Vermont and Federalist Roger Griswold of Connecticut, on the floor of the House of Representatives in 1798, over the Alien and Sedition Acts.[16] The first is typical of the illustrated responses Jefferson received to his justification of what most Americans saw as the extremes of the French Revolution. In one example of the second, a lion, with a wooden sword slung at his side (Griswold accused Lyon of having been sentenced to wear a wooden sword for cowardice on the battle field), is standing before a man who, with a handkerchief in hand (looking like a "dandy"), expostulates, "What a beastly action." The "fretful porcupine" in the left lower corner remarks, "My quills shall pierce, and my press shall black."[17]

The most famous of the early-nineteenth-century cartoons was Elkanah Tisdale's *The Gerry-Mander* (1812), often misattributed to Gilbert Stuart. Legend has it that when Stuart visited the office of

Massachusetts Centinel editor Benjamin Russell in 1812, he observed a map of the newly created Essex County senatorial district. With a few strokes of his pencil, Stuart added a head, wing, and claws to the map and observed, "That will do for a salamander." Russell responded, "Salamander? Better call it Gerrymander." Unfortunately Stuart did not draw the cartoon, and the details of its origins have been lost.[18]

In part because of the success of these popular cartoons, the early nineteenth century witnessed the rise and refinement of graphic humor. Artists grew bolder, often signing their work for the first time, suggesting less fear of the repercussions of offending their subjects. William Charles's cartoons of the War of 1812 led the way, but upon his death in 1820 cartoonists lapsed in popularity until the 1830s provided ample fodder for their canon. It was during the 1830s that an unbroken production of humorous illustrations and political and social caricature began. "For variety, spontaneity, and individuality," one source has concluded, "the graphic humor of this decade, although comparatively small in quantity, was equal to any appearing in the following fifty years."[19]

Stimulated by the heightened popular interest in politics generated by the colorful figure of Andrew Jackson and the more democratic campaigning that marked the age that came to bear his name, political cartoons increased in number and improved in wit. To some Jackson was the savior, the people's friend, or a military hero; to others he was a tyrant: "King Andrew the First." But nearly everyone felt strongly about him, one way or the other. The characters in these cartoons were instantly recognizable, despite their distortions; the situation presented, whether it be the president's war on the Bank of the United States or his defense of Peggy Eaton, possessed a rough fidelity to fact; and they had moral purpose. They represented the leading political figures of the day, but they also focused on the legislative issues associated with those individuals and their political parties. They began to employ stock figures that were instantly recognizable to all, like Uncle Sam, whose first known appearance occurred in 1832 as a sick man surrounded by quack doctors—political figures such as Thomas Hart Benton, Amos Kendall, Andrew Jackson, and Martin Van Buren—and the Democratic donkey, which first appeared at about the same time.[20]

American cartoons in this period were encouraged by similar work abroad, especially by Honoré Daumier, "the Michelangelo of caricature." Beginning in July 1830 during that revolutionary period in France, Daumier led the still comparatively small international crowd

that publicly mocked people and events through political and social cartoons. In 1831 he was employed by the satirical weekly, *La Carica-ture*, and later *Le Charivari*, a daily. His lithographic caricatures in-cluded a series of attacks on King Louis-Philippe and his regime—reflecting the bottled-up disappointment, indignation, and anger in France over political developments—as well as social critiques of the petit bourgeois. As one critique put it, "Daumier made lithography a weapon in the struggle of the mind against power, hypocrisy, and the distortion of true values." In return he was imprisoned for six months in 1832–1833 and fined five hundred francs. When *La Caricature* was banned, he published a series of four large satirical prints, *Bring Down the Curtain, the Farce Is Over* (1834), but some of his best work did not come until the great social upheavals of 1848.[21]

Daumier was unique in "his combination of a keen sense of obser-vation combined with a humorous and compassionate eye for ordi-nary folk, and his realization that both a moral and aesthetic point could be made with an expressive line."[22] If, however, Daumier's graphic humor represented a level of sophistication to which Ameri-can artists had yet to reach, they did nevertheless reach a remarkable level of maturity in the mid–nineteenth century. The work of artists such as Edward W. Clay, Louis Maurer, Benjamin Day, and Thomas Nast, whose cartoons were published by Currier and Ives as well as the leading magazines of the day, were considerably less caustic than Daumier's. Most appear good-humored in comparison. They were not as well drawn, but they were vastly improved from their antecedents and rapidly closing the gap between them and their European models.[23]

Enter Currier and Ives

Until commercial lithography was established in America, all cartoons were engraved, etched, or cut on steel, copper, or wood. Beginning in the 1830s the publication of lithographed cartoons on separate sheets became popular. These sheets ranged in size from 10 by 12 to 14 by 20 inches (25 by 30.5 to 35.5 by 51 centimeters). Before Currier and Ives entered the market, Henry Robinson of New York domi-nated the field. He sold single lithographed cartoons for twelve to twenty-five cents apiece.[24] As with all types of prints the firm issued, however, Currier and Ives lowered the price for those cartoons by half or more, thereby significantly increasing the market. They were not topped in their efforts for fifty years, until the rise of the daily news-

paper, and in that period they printed more than five hundred comic prints.[25]

By 1850 the center of American political satire was New York City—more specifically, in the Chatham Square area. There, on Nassau Street, lower Broadway, Fulton Street, and half a dozen neighboring thoroughfares, was an extraordinary milieu of playwrights, actors, and artists. It was the headquarters for the city's flourishing publishing industry, including the nation's fledgling illustrated newspapers and magazines. In 1860 New York issued approximately one-third of the aggregate circulation of the country's periodicals, almost twice that of its nearest rival, Philadelphia. And according to Charles Dickens, who visited New York at about this time, the press stood accused of "pimping and pandering for all degrees of vicious taste, and gorging with coined lies the most voracious maw; imputing to every man in public life the coarsest and vilest motives"—all most appropriate, of course, for graphic, political humor.[26]

Publishers of crude woodcut satires, dime caricatures, and comic almanacs and journals operated their storefront printing plants near Chatham Square. So too did Currier and Ives. Not surprisingly the firm imbibed much of the satirical spirit of the area and channeled that spirit into one of its most popular lines of prints. "Of these caricatures drawn on stone and issued in separate sheets, those bearing the name of Currier and Ives, who entered the field about 1848, are best known and most numerous." As those associated with the firm later recalled, their political cartoons were highly sought nationwide, but their content reflected their New York origins.[27]

Although Charles Ives drew several of the firm's cartoons, especially during the presidential campaigns of 1856 and 1860, most were purchased from independent or freelance artists like Thomas Worth, John Magee, Louis Maurer, Ben Day, John Cameron, and even the great Thomas Nast.[28] Noticeably absent were David Gilmour Blythe, arguably the major American genre satirist of the nineteenth century, and D. C. Johnston, the chief representative of the British/Hogarthian edition of comic art in America. But therein may have been the problem. The American public, at least the Currier and Ives buying public, was probably not ready for, or at least not ready to buy, Blythe's or Johnston's perceptions of life in America. One critic remarked that Blythe "brings out as did no other American painter of the nineteenth century the pathos of the common people." Similarly Johnston was a social satirist of broad scope, who called into question many sensitive aspects of the new and unsophisticated democratic society. Even

if offered in cartoon form, middle-class Americans, and therefore Currier and Ives, would have little to do with such perspectives.[29]

Currier and Ives produced political cartoons for nearly forty years, and those cartoons tended to follow national trends, flourishing when major political figures and events held the national stage. Not surprisingly the firm's most productive period was at the height of American sectionalism, 1856–1872. During that period Currier and Ives made political cartoons a staple and issued them regularly on nearly every political issue or event of consequence. Senior partner Nathaniel Currier was "a Republican in politics," according to his obituary, "though he never took part in the councils of his party." Ives was described as "an ardent and consistent Republican," who campaigned for the minority party in his hometown, Rye, New York.[30]

Perhaps because they were more moderate than not, and almost certainly for marketing purposes, Currier and Ives caricatured all political candidates, although not uniformly. Major candidates dominated minor candidates. Controversial subjects in the urban North, especially the New York City area, received greater attention than others. And in certain cases, especially during the Civil War, they took a stand, but "on the side of the heaviest artillery." For the first few years that the firm issued political cartoons, it often employed the pseudonym "Peter Smith" or no name at all, simply adding the line, "For Sale at 2 Spruce Street." By 1856, however, it largely abandoned this precaution, even when political feeling was running dangerously high.[31]

Currier and Ives's political cartoons were not appropriate for the Victorian parlor. They were advertised for bulk sale throughout the North and quite likely were purchased by political party headquarters, which distributed them to be hung in Union League clubs, Democratic clubs, and partisan newspaper offices. Some cartoons had exceedingly large runs: fifty thousand for *The Irrepressible Conflict* (1860), for example, and one hundred thousand for *Why Don't You Take It?* (undated). By and large, company policy was business above politics, as they produced cartoons on both sides of most issues or campaigns. But this did not always result in even-handed production.[32] In the period 1856–1872 the "Negro issue" was the driving force, and, as the nation learned, remaining neutral on that issue, even for the commercial firm of Currier and Ives with patrons on both sides of the issue, was impossible.

Slavery became a political issue as early as 1820, and it was never far beneath the surface in any of the presidential elections thereafter. By 1848, the year Nathaniel Currier issued his first political cartoons,

FIGURE 49. *The Presidential Fishing Party of 1848.* Peter Smith (1848).

it had become a major issue. The presidential election pitted Mexican War hero Zachary Taylor, the Whig candidate and eventual victor, against the Democratic nominee Lewis Cass and the Free-Soil nominee Martin Van Buren.

In *The Presidential Fishing Party of 1848* (1848, Fig. 49), "Peter Smith" showed the presidential candidates fishing from both banks of a river filled with fish bearing the names of the states. The fish cluster around the line of Zachary Taylor, who stands on "Constitution" Rock and has already hooked "Ohio." Taylor was a Southern slaveholder, and his platform opposed congressional control over the expansion of slavery into the new territories, thereby forcing antislavery Whigs in Ohio to leave the party. Nevertheless, Taylor claims the fish are always "sure to come back to this spot knowing that here they will find the most wholesome food." Van Buren, on the other side of the river, stands on "free soil." He was the candidate of the antislavery Whigs, who refused to support Taylor, and of former members of the Liberty Party. He admits that his line has grown "old and rusty" from overuse, a reference to his having run several times for president already. "New York," his home state that he failed to carry, swims off with his broken line. Cass bemoans his lack of chance, as well.

The "Negro issue" does not appear in Nathaniel Currier's other po-
litical cartoons for the election of 1852, but he employs it once again
in two of his commentaries on the 1856 presidential race. In *Manag-
ing a Candidate* (1852), once again published by "Peter Smith," Win-
field Scott, the Whig Party candidate, carries a man (perhaps his run-
ning mate, William Graham) on his shoulders across the "Baltimore
Bridge." Baltimore was the site of the Whig's nominating convention,
where Scott was nominated on the fifty-third ballot. His platform ac-
cepted the Compromise of 1850, condemned further agitation of the
slavery question, and affirmed states' rights. Scott is trailed by Horace
Greeley, who carries a bowl labeled "Free-Soil Soup" and Henry Jarvis
Raymond, who carries the *New York Times* under his arm. Greeley was
the editor of the *New York Tribune*; Raymond edited the *Times*. The
Democratic Party, led by Franklin Pierce, took essentially the same
position on the Compromise and Congress's role in determining the
spread of slavery, but the Free-Soil Party nominated John Hale on a
platform that condemned the Compromise and called for federal ac-
tion to block its extension.

In *Pap, Soup, and Chowder* (1852), published by "Peter Smith" after
an image by John L. Magee, the three candidates for the Whig nomi-
nation are having a "duck fight" and eating from labeled bowls. Each
candidate is seated on the shoulders of a man bearing the title of a
newspaper that was supporting him: Millard Fillmore, the incumbent
president, eats "government pap" and sits on the *Mirror*; Winfield
Scott, whose position on "free soil" was unclear, eats "soup" and sits
atop the *Tribune*; and the New Englander, Daniel Webster, eating
"chowder," rides the *Courier and Enquirer*. A Southerner attempts to
pull down Scott. In the background Franklin Pierce, racing toward
the White House on an emaciated horse, says, "It's wind not bottoms
that carries the day." He totes a banner reading "the Union and the
Compromise," referring to the Compromise of 1850.

The candidacy of John C. Fremont for the American presidency in
1856 on the newly formed Republican Party ticket brought slavery to
the fore. The party's opposition to the extension of slavery into the
territories, as well as its alliance with other controversial movements
and groups, caused considerable public reaction upon which cartoon-
ists capitalized. In *The "Mustang" Team* (1856), for example, a light,
two-wheeled wagon drawn by a despairing nag is held up at a Union
tollgate by the keeper, who fears the weight of the load. The "load" is
mainly on the horse; Horace Greeley of the *New York Tribune*, James
Gordon Bennett of the *New York Herald*, and Henry Jarvis Raymond

of the *New York Times* are all on his back. James Webb, of the *New York Courier and Enquirer*, clings to the rear of the wagon, urging them on. Fremont is seated on the backboard, bearing a large cross symbolic of his Roman Catholic ties. In the wagon is a sack of gold for "Bleeding Kansas," as well as a female figure—possibly Mrs. Fremont—bound for Kansas.[33]

The Republican Party, built on the ruins of the Whig Party, grew out of the moral indignation produced by the Kansas-Nebraska Act of 1854 and attempted enforcement of the Fugitive Slave Act and other proslavery measures. It attracted reformers of all types, not only abolitionists and free-soilers. Currier and Ives as well as much of the nation feared the divisions it portended. In *The Great Republican Reform Party: Calling on Their Candidate* (1856) (see page 223), Louis Maurer presented half a dozen assorted and appropriately dressed would-be supporters stating their demands to Fremont, who promises them all they desire. The line of petitioners includes a prohibitionist-vegetarian, a feminist, a socialist, a free-love advocate, a Catholic priest, and a free black. The overdressed black man demands equality. An aging spinster advocates free love; a rough-looking laborer, whiskey bottle in hand, a general division of property; a feminist, wearing bloomers and smoking a cigar, recognition of women as equal to men and the right to vote and hold political office; a well-dressed reformer, abstinence from tobacco, meat, and beer; and a priest (rumor had it that Fremont was Roman Catholic) "the power of the Pope on a firm footing in this country."[34]

Louis Maurer provided the firm with a variation on this message, this time painting the third-party candidate in a favorable light in *Fancied Security, or the Rats on a Bender* (1856). In this cartoon, Millard Fillmore, presidential candidate of the American or Know-Nothing party, watches from behind the "Government Crib" the predatory antics of the rats, Democrat James Buchanan and Republican John C. Fremont. Fillmore, pictured as an honest farmer, wields a club and warns the two and their followers that he intends to keep them away from the crib for the next four years. Eyeing the crib, Fremont exclaims to his running mate, William Dayton, who clings to his tail, that the mere sight of the fodder makes his mouth water. John C. Breckinridge, the Democratic vice presidential candidate, pleads with his head of the ticket, James Buchanan, not to "scratch so feeble on that post . . . like a regular old buck rat." Buchanan can only respond that he lacks the strength to do any better, having lost his "Democratic blood" when he was young—a reference to his once hav-

ing been a Federalist. Newspaper editors Greeley and Bennett cheer Fremont on, the former seeking "one more squeak for freedom." As the American Party candidate, as yet unseen, steps forward to fend off the rats, one rat explains to the others that he doesn't feel safe in attacking the "government crib," because he fears "Old Fillmore is only laying low and will knock us in the head after all." Another calms his fears, explaining that Fillmore didn't have "the ghost of a chance" to catch them, a prediction that came true when Buchanan won handily.

The Right Man for the Right Place (1856) provides another positive view of Fillmore's candidacy. An unknown artist has Fillmore separating candidates Fremont and Buchanan, who are attacking one another. Fremont, the "pathfinder," aims a rifle at Buchanan, while Buchanan, the veteran politician, brandishes a dagger. Fremont calls Buchanan a "border ruffian," a reference to Buchanan's apparent proslavery position in the "Bleeding Kansas" affair, and a "slave-holding villain." Buchanan accuses Fremont of being a "rascally abolitionist."

As we have seen, the eventual victor in the 1856 election, Democrat James Buchanan, received his fair share of barbs for what many saw as his proslavery position. Some of that criticism grew out of his association with the attempt to annex Cuba. No sooner had the Mexican War ended than American expansionists turned their eyes toward Cuba. Annexation particularly appealed to Southerners, who saw expansion of potential slave territory as essential and, after 1850, as just compensation for admission of California to the Union as a free state. In 1852 England proposed that the United States, England, and France enter into a tripartite agreement not to permit any nation to acquire Cuba from Spain. American Secretary of State Edward Everett refused. Instead, in 1854, Buchanan, then minister to Great Britain, Pierre Soulé, minister to Spain, and John Mason, minister to France, presumably with President Franklin Pierce's concurrence, presented to the ministers of Britain, Spain, and France at Ostend what became known as the Ostend Manifesto. It asserted that American acquisition of Cuba was of "paramount importance," that any delay in its acquisition would be exceedingly dangerous to the United States, and that the United States could never rest content until it possessed Cuba. Spain ought to sell it, the document continued, but if a fair purchase price were not offered, then "it is not improbable . . . that Cuba may be wrestled from Spain by a successful revolution. . . . By every law, human and divine, we shall be justified in wrestling it from Spain if we possess the power." Buchanan was believed to be the moving force behind the manifesto.[35]

The Ostend Manifesto ignited indignation in Europe and polarized sentiment in the United States. As a result the U.S. State Department promptly repudiated it. Louis Maurer provided Currier and Ives with a cartoon, *"The Ostend Doctrine"* (undated), opposing the manifesto and annexation. The print was subtitled *"Practical Democrats Carrying out the Principle."* Maurer pictured four thugs explaining to Buchanan, the dismayed U.S. representative, that "considerations exist" which render it of "paramount importance" that he hand over his wallet, watch, and hat. The language used in this armed robbery parodies the language of the manifesto. If he should refuse, one of the ruffians explains, "I'll feel justified in taking it out of ye wid a touch of this shillaly as I pozzis the power," the "shillaly" being associated with Irish Americans, who were seen as thugs for the Democratic Party. Another figure points a pistol at Buchanan, explaining that if he does not comply, "its not improbable that it may be wrested from you by a successful revolution of this six barrel'd joker." Buchanan resists, protesting, "Why this is rank robbery! Help! Help all honest men!"

Buchanan's role in the Ostend Manifesto affair was recalled when he stood for election to the presidency in 1856 in *A Serviceable Garment, or Reverie of a Bachelor* (1856). In that cartoon Buchanan sits on a kitchen chair mending his once-Federalist, now-Democratic coat, which he thought would continue to serve him well despite its rather "unsightly" Cuba patch. Currier and Ives made little of Buchanan's being a bachelor beyond this print.

An unknown artist satirized all of the 1856 presidential candidates for Currier and Ives in *The Great Presidential Sweepstakes of 1856* (1856), subtitled *Free for All Ages, "Go as They Please."* The cartoon includes the candidates and several supporting figures in a race to the White House along a road lined by cheering partisans. Millard Fillmore is seated in an open buggy marked "American Express." He leads the race, followed by Franklin Pierce, who runs behind the buggy with James Buchanan on his shoulders. John C. Fremont, pictured much as he was in *The "Mustang" Team*, brings up the rear, his carriage mired in the mud from which Henry Ward Beecher seeks to extricate it with his rifle—a reference to the "Beechers Bibles," actually rifles that Beecher is alleged to have sent antislavery settlers in Kansas during that territory's civil war. At the bottom of the print, Currier and Ives added the following assessment: "Young America—Enters Fillmore by Honesty out of Experience (trained on the Union track)." Fremont is described as entering "by Wooly Head," a reference to African

Americans, while Buchanan, "Old Buck (alias Platform)" is described as "'Fillibuster' out of 'Federalist' Exercised on the Ostend Course." Many cartoonists, including Currier and Ives, also employed sports motifs. During presidential election years these included the horse race, as well as footraces, boxing matches, poker, pool or bagatelle, cockfighting, hunting, fishing, and baseball. Louis Maurer shows Buchanan, "Old Buck," besting the pack in Currier and Ives's hunting vignette, *The Great American Buck Hunt of 1856* (1856). In this political cartoon Buchanan, standing on the "Union Rock," fires a rifle at Fillmore, whose face is attached to a buck. Fremont's rifle explodes in his face when he attempts to fire it. Buchanan chides Fremont, "Ah! Fremont, your sectional gun has exploded just as I predicted, but my American rifle will bring down that Old Buck." Fremont and his supporters Horace Greeley and Henry Ward Beecher stand up to their knees in "Black Mud" and the "Abolition Bog."[36]

The Election of 1860

Although Currier and Ives took all of the presidential candidates and their parties to task in the 1856 election, the uncertainty and unrest engendered by the irrepressible and divisive issue of slavery, and concern for the new Republican Party in particular, dominated the political cartoons of 1856. Currier and Ives continued to reflect those sentiments, no doubt the sentiments of the nation, in their representations of the presidential campaign of 1860.

In *The Great Exhibition of 1860* (1860), the Republican candidate Abraham Lincoln is presented in shirtsleeves, riding a rail like a hobbyhorse, with a padlock on his lips—implying that party leaders had silenced him on the issue of slavery. His rail is attached by a tether to Horace Greeley, who is grinding a hand organ labeled *New York Tribune*. Behind Lincoln stands William Seward, dressed as a nurse and holding a black baby in his arms. At the left are Henry Jarvis Raymond of the *New York Times* and James Watson Webb of the *New York Courier and Enquirer*. Webb holds out a tambourine and begs "help for a family in reduced circumstances." They are directing the campaign, Maurer suggests, and slavery is driving it.[37]

In *The Republican Party Going to the Right House* (1860), perhaps Currier and Ives's most cutting commentary, Greeley bears Lincoln, seated on a rail, on his shoulders, reminiscent of *The Great Republican Reform Party*, issued four years earlier. Greeley staggers toward the open doorway of a lunatic asylum, followed by a crowd of malcontents

and radicals, including a feminist, a free black, a socialist, and a free-love advocate. A Mormon stands next to the proponents of free love, arms linked for maximum associative effect. Although he later recalled having voted for Lincoln, Louis Maurer admitted that he could not resist commenting on the "strange" elements the new Republican Party attracted.[38]

Currier and Ives further represented fears that the Republican Party was being driven by the slavery issue, and its impact on the Union, in *The Irrepressible Conflict; or the Republican Barge in Danger* (1860) (see page 225). A black man is seated in the Republican barge as it heads for some rocks. He wears a "Discord's Patent Life Preserver" and boasts that he will not drown, even if the boat sinks. Other figures loom large in the pending disaster. Horace Greeley and Francis Blair throw William Seward, foremost leader of the forces opposed to the extension of slavery, overboard. Seward protests that he "alone had built this boat," and that he alone could save it, but his "irrepressible conflict" between slavery and freedom and defense of a "higher law" than the Constitution had scared off many voters. The party had turned to the more moderate, dark-horse candidate, Abraham Lincoln, who is shown here taking the helm. Brother Jonathan—still the symbol of the United States, not yet replaced by Uncle Sam—stands on the shore and suggests that those in the doomed skiff rid themselves of the "nigger" instead of Seward, but no one is listening.

Currier and Ives further emphasize Greeley's role in the Republican Party's ridding itself of William Seward's potential candidacy in the anonymously drawn *"The Impending Crisis"—or Caught in the Act* (1860). Maurer pictured Seward in the water, about to go down for the last time, while he holds "Greeley's letters" above him with one hand. James Webb, holding an issue of his *New York Courier and Enquirer* with the headline "Principles Not Men," urges an officer of the law to arrest Greeley for pushing Seward off the dock. Greeley denies the charge, explaining that Seward simply went "too near the edge and fell off," but the officer insists that Greeley pushed Seward off "for revenge."[39]

Maurer criticized the "spirit of discord" unleashed by Seward and Charles Sumner, another Republican abolitionist, in *Letting the Cat Out of the Bag!!* (1860). In this cartoon, issued in the closing weeks of the campaign, Sumner, who complains that he wasn't even "mentioned" at the Chicago convention, explains that he has decided "to do something desperate," namely release a wild animal labeled "Spirit of Discord" from a "Republican Bag." Sumner, who had only recently

recovered sufficiently to return to public action, after his beating at the hands of South Carolina Congressman Preston Brooks on the floor of the Senate, explains his desperate action: "I can't afford to have my head broken and kept corked up for four years for nothing." Standing behind Sumner, Seward warns Greeley, Lincoln, and Henry Jarvis Raymond, editor of the *New York Times*, to be careful because only he knows how "to manage that animal," not they. Greeley accuses Sumner of spoiling things, as the "spirit of discord" was not supposed to be released until after Lincoln's election to the presidency. Lincoln, fending off the cat with a rail, protests as well, saying that he thought they had safely "bagged" the animal at the Republican convention and that he would have to contain it again. Raymond adds, "Scat! Scat! Back with her or our fat will all be in the fire."[40]

The black man appears in several Lincoln-Republican Party cartoons of the 1860 election, nearly all of which raise the question of slavery's divisive influence in that campaign. Already discussed (see page 224) is *The Nigger in the Woodpile* (1860), a title indicative of the uncomfortable presence of the slavery issue, and *An Heir to the Throne* (1860), in which P. T. Barnum's "What is it?" is proposed as a worthy successor to Lincoln (see page 226). The black man also appears as Lincoln's second in *The Undecided Prize Fight* (1860), with Lincoln and Stephen A. Douglas squaring off in the ring, as he does assisting Horace Greeley with shouldering Lincoln and the "Republican Platform" in *The Rail Candidate* (1860).

Lincoln is constantly referred to as the "rail candidate" in the election of 1860, and indeed he had split rails thirty years earlier. The image may have been used pejoratively at first, but it quickly became an appealing part of Lincoln's campaign. "Among the common people," Ida Tarbell wrote, "the jeer that Lincoln was but a rail splitter was a spur to enthusiasm. Too many of the solid men of the North had swung an axe, too many of them had passed from log hut to mansion, not to blaze with sympathetic indignation when the party was taunted with nominating a backwoodsman. The rail became their emblem and their rallying cry, and the story of the rail fence Lincoln had built became a feature of every campaign speech and every country store discussion." Within a week of his nomination, two rails that Lincoln allegedly split were put on exhibition in New York, and zealous Pennsylvanians sent to Macon, Illinois, to buy the whole fence. As Tarbell concluded, "There was something more than a desire to stand by the candidate in the enthusiasm. At bottom it was a vindication of the American way of making a man."[41]

Concern for Lincoln and the Republican Party may have dominated Currier and Ives's pictorial commentary on the election of 1860, but they did not spare other candidates their fair share of political humor. In one of their earliest satires on the large crowd of likely presidential candidates for that election, *The Political Gymnasium* (1860), Louis Maurer pictured all of the major candidates getting into condition for the contest. Horace Greeley, with "Tribune" written across the seat of his pants, tries to swing himself onto a high bar marked "Nom. for Governor" (of New York), observing that he had practiced a long time, but he could never get up enough muscle "to get astride the bar." William Seward, who eventually lost the Republican nomination to Lincoln, looks on and warns Lincoln not to "tumble off," as he had. Lincoln has climbed onto a sawhorse marked "Nom. for President." Stephen Douglas (the Northern Democratic candidate) and John C. Breckinridge (the Southern Democratic candidate) box at Lincoln's feet, while a muscular Edward Everett of Massachusetts supports the Constitutional Union candidate John Bell on a barbell. James Webb, editor of the *New York Courier and Enquirer*, does backflips across the floor, claiming that he can beat any man at turning political "summersets."[42]

Perhaps the most interesting figure in this cartoon, however, is Republican Senator William Seward, who is pictured crippled by an untimely fall from the nomination bar. He borrows a crutch and cane for support and cautions his more successful Republican opponent, "You'd better be careful, my friend, that you don't tumble off as I did before I was fairly on, for if you do you'll be as badly crippled as I am." For a brief period after losing the Republican nomination to Lincoln, Seward was inclined to "sulk in his tent," but he soon rallied to support Lincoln's candidacy. When Lincoln was elected, he named Seward his secretary of state.[43]

Currier and Ives represented the complexity of the 1860 political contest in *Political "Blondins" Crossing Salt River* (1860). The title referred to Charles Blondin, a French tightrope walker who crossed Niagara Falls in 1859. The unknown artist pictured John Bell (Constitutional Union Party candidate) and Edward Everett looking down from "Constitution Bridge," which spans the "Salt River" that separates "North" and "South." Everett observes that the bridge, built by "Washington, Jefferson, and the Patriots of '76," is the "only structure that connects these two shores in one indissoluble Union." "It's no use," Bell warns the other presidential candidates, "you'll all go overboard, because you were not satisfied to stand upon this bridge but

must needs try some other way to get across." Below them Lincoln and Greeley seesaw on a rail set across "Abolition Rock"; as Greeley tumbles off, Lincoln bemoans his lack of other support. "Confound Greeley!" he exclaims. "He told me that it was not necessary for this end of my rail to rest on anything so long as he sat on the other end, and I believed him and am lost." Greeley resigns himself to being "dipped" in the Salt River once again, as long as he is not killed in the fall, "for a bag of wool won't sink"—a reference to the staying power of the slavery issue.

Two tightropes are also stretched across the river. On one, labeled "Hon. Intervention," Stephen Douglas, trying to balance with the help of a pole labeled "Squatter Sovereignty" (a reference to his earlier idea that popular sovereignty might solve the conflict over the extension of slavery into the West), complains that it is a "dead weight" and that it had ruined him. On the other high wire, "Slavery Extension," John C. Breckinridge is riding on the shoulders of James Buchanan, the president under whom he served as vice president. Breckinridge urges Buchanan to hurry for fear of what might happen if the rope breaks. Buchanan, the incumbent president, tries to calm him, explaining, "Hold on tight, Johnny! And trust 'an old public functionary' to carry you safely over." Currier and Ives used these images repeatedly, in different contexts, throughout the campaign.

In *The National Game: Three 'Outs and One Run'* (1860), by Louis Maurer, the game is decided or at least its outcome predicted. The principal interest of this cartoon lies in its use of baseball as emblematic of the game of politics, rather than horse racing, cockfighting, or boxing. Baseball was already popular in New York, but it had only recently attracted sufficient attention nationally to be used as a vehicle for political humor.[44] Lincoln is the victor, proclaiming to his opponents that if they "should ever take a hand in another match at this game," they should remember to have "a good bat," "strike a fair ball," and "make a clean score and a home run." His right foot planted firmly on home base, he holds a ball and a rail as a bat labeled "Equal Rights and Free Territory." Bell's, Douglas's, and Breckinridge's bats read "Fusion," "Non-Intervention," and "Slavery Extension," respectively. Each uses baseball jargon to comment on the election and Lincoln's victory. Bell wonders "why we three should strike 'foul' and be 'put out.'" Douglas muses, "I thought our fusion would be a 'short stop' to his career," and Breckinridge, slinking back to Kentucky with his fingers sealing his nostrils, complains that "we are completely 'skunk'd'"—a popular term for a rout or shutout.

A major theme in Currier and Ives's focus on the Democratic Party in the 1860 election was dissent within that party's ranks. In an anonymously drawn political cartoon titled *"Taking the Stump," or Stephen in Search of His Mother* (1860), Currier and Ives set up the contest as matching Stephen Douglas, walking on a wooden "stump" on one leg, and James Buchanan's handpicked successor, John C. Breckinridge. Douglas, hat in hand, seeks the support of other party leaders. He reports that he had fallen over "a big lump of Breckinridge" and been lame ever since, but that he intended to see "his mother" to help him seek the party's nomination. Two of his party are persuaded to help, but Buchanan offers Breckinridge a "stump" for himself. Breckinridge accepts Buchanan's entreaty to run but adds, "I know it will be of no use, for I feel that I haven't got a leg to stand on." Lincoln, leaning against a split-rail fence and observing both scenes, comments with confident good humor, "Go it ye cripples! Wooden legs are cheap, but stumping won't save you."

The Republicans triumphed in Maine's state election in September 1860, leading Currier and Ives to issue a sequel to *Taking the Stump*, titled *Stephen Finding "His Mother"* (1860). Stephen has found "his mother," but it is Columbia, an allegorical figure for America. And rather than lending support, she holds Douglas across her knees and beats him with a switch titled "News from Maine." She berates him for his Kansas-Nebraska Bill, which had only "made a great deal of trouble in the family," and informs him that he now must pay for it. Uncle Sam encourages Columbia, "for he richly deserves it." Douglas begs to be freed, promising he will not do it again.[45]

In *The Great Match at Baltimore* (1860), another anonymous artist, but probably Louis Maurer, pictures the results of the competition for that party's nomination between "the Illinois Bantam," Stephen Douglas, and "The Old Cock of the White House," James Buchanan. When the party met in Charleston, Douglas, the Northern popular sovereignty advocate, won a majority of the delegate votes, but, because of Southern opposition, not the two-thirds majority necessary to gain nomination. The convention adjourned to Baltimore, where, in the absence of four Southern states (having withdrawn to support slavery protectionist John C. Breckinridge), Douglas finally carried the day.[46] In *The Great Match* Douglas, a bantam cock, stands crowing on incumbent Buchanan's prone body, boasting that he could beat "Old Kentucky" (Breckinridge), who is about to be placed in the ring, and "the Lincoln Cock," as well.

Compromise Doctors (1860) shows Buchanan as a woman beside a

bed on which lies the snake, slavery. He explains to a group of doctors standing nearby that his "darling child" is very sick: "I have kindly nursed it for four years. I took it to Kansas for its health, but the vile inhabitants gave it a severe blow in the head." One of the doctors, all of whom represent slavery expansionists' designs, replies: "Your child will die if you keep it confined; let it have a journey to Mexico or a voyage to Cuba." One schoolboy comments to another, "Charlie, these old quacks are preparing plenty of business to do when we are men."

Democratic schism made a Republican victory all but inevitable, and Currier and Ives showed that prospect in *Progressive Democracy—Prospect of a Smash Up* (1860). In that print, probably by Louis Maurer, the Democratic wagon, representing the two platforms of the two Democratic candidates, is stalled on the railroad tracks. At each end of the wagon, a team of mules with human heads pulls in opposite directions. The Tammany Indian, labeled "a squatter sovereign," holds the reigns of the Northern Democratic ticket. Hearing "a rushing sound that bodes no good," he exclaims, "Tammany to the rescue" and whips up the Douglas-Johnson team. Buchanan exhorts the Breckinridge-Lane mules, proclaiming that he would rather see "the machine . . . smashed than have them [Douglas and Johnson] run away with it." In the meantime Lincoln's and Hamlin's "Equal Rights" engine, with clanging bell and shrieking whistle, bears down on the wagon.

Currier and Ives sent a similar message in *Storming the Castle "Old Abe" on Guard* and *Honest Abe Taking Them on the Half Shell* (1860), both of which have been attributed to Louis Maurer.[47] In the first print, Lincoln is dressed as a Wide-Awake, a member of a marching club of young Republicans, in an army cap and cape, carrying a railroad night watchman's lantern and a fence rail. He stands guard at the White House, while Douglas attempts to open the door with "Regular Nom," "Nonintervention," and "Nebraska Bill" keys. Buchanan tries to pull up Breckinridge through a window, while John Bell keeps watch. Bell urges Douglas to hurry, as he sees Lincoln coming, but Douglas complains that none of the keys works. Buchanan admits that his strength is failing and that he will not be able to pull Breckinridge in, while Breckinridge, too, fears he is losing strength and that, as a result, they will be compelled to "dissolve the Union." Observing the goings-on, Lincoln says, "Ah ha! Gentlemen! You needn't think to catch me napping; for I am a regular wide awake."[48]

In *Honest Abe* Maurer shows Lincoln contemplating with delight consuming both candidates as they recline on oyster half shells.

Democrats were referred to as either "soft-shell" (moderate on slavery) or "hard-shell" (proslavery). "These fellows have been planted so long in Washington," Lincoln remarks, "that they are as fat as butter. I hardly know which to swallow first." Soft-shell Douglas and hard-shell Breckinridge bemoan their all-but-certain fate. Douglas cries out, "I'm a gone sucker"; Breckinridge laments, "Alas, that ever I should live to be swallowed by a rail splitter." A sign on the wall reads in part, "Political Oyster House . . . Democrats fried, stewed, roasted or on the half shell."

And consume the other candidates Lincoln did, as Currier and Ives showed in *"Uncle Sam" Making New Arrangements* (1860) drawn by Louis Maurer. In that cartoon—issued at the end of July and reflecting the growing confidence in Republican victory—Uncle Sam stands in the doorway of the White House, taking down a "wanted" sign for the job of president. He announces to the other candidates that they are "too late" and that he has decided to let Lincoln have the White House: "I find his record all right and can safely trust him with the management of my affairs." Bell, Breckinridge, and Douglas continue to beg for admission, while Lincoln, ax and valise in hand, thanks Uncle Sam, promising to do his duty. Buchanan can be seen in the window packing his "dirty linen" and bemoaning his fate, that he had been given "notice to pack up and quit, without a character" and with no place else to go.[49]

The Election of 1864

Political cartoons published during the presidential race of 1864 fall into four categories: Lincoln's conduct of the war, McClellan's war record, comparisons between the Republican and Democratic platforms, and alleged Republican beliefs in race mixing. Currier and Ives made their fair share of contributions to the first three. Perhaps for fear of offending the buying public, they dwelled less on the last theme.[50] Most of the political cartoons appeared in September and October, because the Democrats did not hold their convention and nominate McClellan until late August 1864.

The Lincoln administration came under considerable criticism for its conduct of the war, and the Democratic Party took full advantage of that criticism to attack the incumbent. Moreover, both political parties ignored any constraints the Civil War might have imposed on politics as usual and ran the usual boisterous political campaign, complete with torchlit parades, fireworks, pig roasts, and marching bands.

Scurrilous attacks on both candidates in speeches and newspapers, as well as in political cartoons, abounded. One result was a larger number of voters in 1864 than in 1860; another was a spate of political cartoons that were, as some historians have remarked, as "personal, mean-spirited, cruel, race-biting, and divisive" as ever.[51]

The Democratic platform of 1864 resolved "that immediate efforts be made for a cessation of hostilities, with a view of an ultimate convention of the States, or other possible means, to the end that, at the earliest practicable moment." It recommended that peace be restored on the basis of a federal union of the states. Many Americans saw this resolution as tantamount to surrender. Even McClellan tried to distance himself from it, noting in his letter accepting the party's nomination that: "I . . . could not look in the face of my gallant comrades of the Army and Navy, who have survived so many bloody battles, and tell them . . . that we had abandoned that Union for which we had so often periled our lives." His opponents, however, fought to keep McClellan tied to the peace plank, and cartoonists could not resist the opportunity for caricature that it offered.[52]

Currier and Ives did show some support for McClellan's and the Democratic Party's call for peace and reunion, especially where Lincoln's quest for unconditional surrender appeared to be based on the South's acceptance of abolition and therefore likely to prolong the war. In *The True Issue or "That's What's the Matter"* (1864) Lincoln and Jefferson Davis are having a tug-of-war over a map of the United States. Lincoln proclaims that there will be no peace without abolition; Davis counters, "No peace without separation." McClellan, who stands between them holding each by the lapel, trying to prevent them from tearing the map apart, says, "The Union must be preserved at all hazards." By and large, most of Currier and Ives's political cartoons favored Lincoln's reelection, reflecting the majority opinion in that contest.

One early historian of the 1864 campaign suggested that whenever Lincoln was assailed that year by unflattering pictures, "the Republican Party answered promptly with the aid of Currier and Ives."[53] In the 1950s another student of the period concluded that Currier and Ives cartoons "played no inconsiderable part" in Lincoln's election in 1860 and 1864.[54] More recently others have found no evidence to suggest that Republicans collaborated with Currier and Ives to respond to the attacks of Lincoln's opponents or to take his side in any other way. "Political images in the 1860s," they explain, "were created from the bottom up—invented and supplied by artists and their publish-

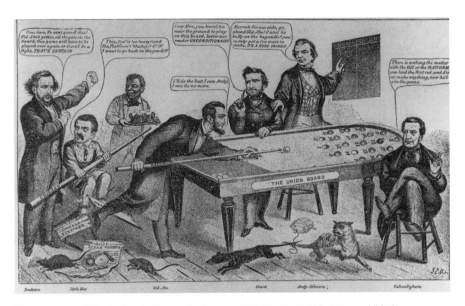

FIGURE 50. *A Little Game of Bagatelle, between Old Abe the Rail Splitter and Little Mac the Gunboat General.* Currier and Ives (1864).

ers, then sold to interested customers—and not from the candidates and office holders down, as most campaign-generated graphics are created today. For Currier and Ives, like other Northern printmakers, the 1864 campaign invited commercial opportunity, not political commitment." This explanation is correct, but so is the overall assessment that Currier and Ives contributed to Lincoln's success, insofar as the number of pro-Republican-Lincoln cartoons outnumbered pro-Democratic-McClellan ones. Put another way, the "bottom up" process achieved the same result, intended or not.[55]

That the Democratic Party would not be able to capitalize on the charges brought against the Republican leadership in the 1864 election is given graphic representation by Currier and Ives in cartoons like J. L. Magee's *A Little Game of Bagatelle, between Old Abe the Rail Splitter and Little Mac the Gunboat General* (Fig. 50), offered in September 1864. Lincoln confidently and skillfully wields a "Baltimore" cue, representing the Republican convention that nominated him and the platform the party adopted supporting his war effort. His opponent George McClellan, who in the early years of the war had been pictured as a larger-than-life military hero despite his small stature, is shown here in diminutive form sitting on the "Chicago platform," which is collapsing beneath him. He holds a "Chicago" cue, which he

complains is too heavy, and argues that the platform is too "shaky." They play on "the Union Board," which is surrounded by four other major figures of the day: George Pendleton, Ulysses Grant, Andrew Johnson, and Clement Vallandigham.

Pendleton, McClellan's vice presidential running mate, protests Lincoln's win and insists on a rematch. Grant pokes fun at McClellan for "traveling too near the ground to play" on the same board with Lincoln and suggests he "surrender unconditionally," a critical reference to the Chicago platform. Johnson keeps score on a board labeled "Coppers" (copperheads, or Northerners who sympathized with the South), and "Unions" and celebrates Lincoln's almost certain victory. Copperhead leader Vallandigham, however, offers the most biting remark. Originally an architect of the Democratic platform and a McClellan supporter, he now tells McClellan that there is nothing wrong with the cue or platform. He had simply done nothing with either and therefore would lose the game. Vallandigham had paid a dear price for his opposition to Lincoln and the war, including losing reelection to Congress from Ohio in 1862, arrest by Union military authorities in 1863, banishment to the Confederacy, and exile to Bermuda and Canada before being permitted to return to the United States for the Chicago convention. A black servant looks on from behind them all, carrying a tray of drinks.[56]

If McClellan had hoped to be pictured as the candidate who best understood how to conduct the war, or even as the much-maligned war hero, he instead became the target of cartoonists who skewered him for being the failed military man who now ran on a peace platform.[57] Currier and Ives reduced McClellan's leadership to the point of being seen as a coward. Only a few years earlier the "Young Napoleon" had proudly posed as the quintessential military officer. In 1864 Currier and Ives recalled his ineptitude and timidity. A good example is *The Gunboat Candidate at the Battle of Malvern Hill*, which was critical of McClellan's conduct in that 1862 battle but was not published until he became a presidential candidate in 1864. A similar point was made comparing McClellan to his more successful successor, Ulysses Grant, in *The Old Bull Dog on the Right Track*, published during the same election year.

In *The Chicago Platform and Candidate: A War Candidate on the Peace Platform* (1864), an unknown artist pictured McClellan standing on a collapsing "Chicago Platform" being held up by "Jeff's Friend" (Satan), Jefferson Davis, Clement Vallandigham, and Congressman Fernando Wood (former New York City mayor), a leading

Peace Democrat. A Union soldier and a Peace Democrat heckle McClellan. The soldier accuses McClellan of speaking "blarney," while the Peace Democrat, caricatured as an Irishman carrying a club, threatens to knock any man on the head who votes against McClellan, as long as the candidate favors "resistin the draft, killing the Nagurs, and pace wid the Southerners." McClellan is shown with two faces, one accepting, the other rejecting, the Chicago platform. Davis laments his continued losses in the war and loss of support in holding up McClellan's platform. Vallandigham threatens to bolt as well, but Wood urges him to stay, as McClellan's "little game"—his hedging on the Chicago peace platform—is "his little game to ring in the war men. If he is elected he is bound to carry out our policy and nothing else."

Currier and Ives, with another unknown artist, conveyed a similar message in *The Political "Siamese" Twins* (1864), subtitled *The Offspring of Chicago Miscegenation*—an interesting play on the final word, as the Republican Party was often charged with favoring miscegenation, racial intermarriage or "mixing of the races." In this case the offspring of the "Chicago Miscegenation," a reference to the merging of "peace" politicians from various previously separate parties under the Democratic banner, is the "Siamese" pairing of McClellan and Pendleton. Two Union soldiers criticize McClellan for the Democratic Party's peace platform. They say that they would vote for McClellan, if McClellan were not "tied to a peace copperhead [Pendleton], who says that 'treason and rebellion ought to triumph.'" That being the case, they intended to vote for Lincoln. McClellan, who had tried to distance himself from that plank in the platform in private letters that had been made public, responds: "It is not I that did it fellow soldiers! But with this unfortunate attachment I was politically born at Chicago!"

Pendleton, speaking to Vallandigham and Horatio Seymour, a New York congressional Democrat and chairman of the Democratic National Convention, also opposed to the Republican war effort, picks up on the reference to McClellan's letters. He explains that he doesn't care how many letters McClellan has written, as long as they bring in votes. Vallandigham and Seymour concur, Vallandigham adding that he supports the ticket for only that reason: "If you are elected both Jeff [Davis] and I will be triumphant." Seymour adds, "With Pendleton as Vice [President], Val [landigham] Secretary of State, [Fernando] Wood in the treasury, we will have peace at any price our friends choose to ask for it."

An unmarked political cartoon attributed to Currier and Ives presented a more personal and poignant critique of the 1864 Democrats.[58] Undated but clearly done in the election year, *A Thrilling Incident during Voting—18th Ward, Philadelphia, Oct. 11* shows a confrontation at the polls between two men, the younger man noticeably less well dressed than his elder. The following explanation, attached to the print, says it all:

> An old man over seventy years of age advanced to the window, leaning tremblingly on his staff, when an officious copperhead vote distributor approached him and thrusting a ticket in his face said: "Here is an old Jackson Democrat who always votes a straight ticket." The old man opened the ballot and held it with trembling fingers until he had read one or two of the names, when he flung it from him with loathing, and in a voice husky with emotion, exclaimed: "I despise you more than I hate the rebel who sent his bullet through my dead son's heart! You miserable creature! Do you expect me to dishonor my poor boy's memory and vote for men who charge American soldiers, fighting their country, with being hirelings and murderers?"

Emancipation was the major issue of 1864, and it was bitterly debated at every level. Currier and Ives supported Lincoln's controversial stand for the most part, publishing in response prints sympathetic to emancipation and the slaves' plight. So too in the 1864 election Currier and Ives made the case for Lincoln and emancipation. In *Your Plan and Mine* (1864), a two-paneled political cartoon by an unknown artist, McClellan offers an olive branch to Jefferson Davis, who holds a kneeling black Union soldier by the hair, threatening him with a bowie knife. McClellan refers to Davis as "Mister Fire Eater." He suggests that Davis had waged an unsuccessful war against the Union for the past four years and that the South was "nearly used up." The party he represented, McClellan continued, wished to extend the olive branch to Davis, begging him to accept it and return to the Union with the promise that Davis could "take back your nigger" and do as he pleased in the future "with both White and Black men." The black man protests that he is a Union soldier, and that he had shed his blood "in defense of liberty," only to be given back into slavery. Davis responds, "I see the olive branch, and take the nigger, and am glad to hear that you are willing to be governed once more by your Southern masters."

In the second panel Lincoln holds a rifle on Davis, who sits on the ground, a black Union soldier standing in the background. Davis begs

Lincoln not to kill him, offering to surrender unconditionally and "own up that the rebellion is a failure." He begs to be allowed to reenter the Union and that Lincoln not punish him too severely for his "madness and folly." Lincoln responds that all he demands is "unconditional submission to the government and laws," and that "the great magnanimous nation" had "no desire for revenge." He insists that those who had been made free by the rebellion would never again be enslaved, whereupon the black Union soldier observes: "Ha, ha, Massa Secesh, guess you won't fool time with this child any more."[59]

That Lincoln's plan for emancipation continued to be seen in some quarters as a potential political liability is evident in the previously discussed *Abraham's Dream* (1864)—actually Lincoln's nightmare over the prospect of his defeat as the result of his position on slavery. In the November election, however, no doubt encouraged by a series of Union victories also rushed to press by Currier and Ives, Americans supported Lincoln. In January 1865 Congress voted for the Thirteenth Amendment, which abolished slavery when three-fourths of the states ratified it.[60] Currier and Ives best represented this sentiment for Lincoln in *"The Rail Splitter" at Work Repairing the Union* (undated, but clearly done in 1864). Lincoln is pictured holding a globe with a map of the United States on it, keeping it from rolling with a rail, while his running mate, Andrew Johnson, once a tailor, sits on the globe sewing a torn map of the United States. Johnson suggests to "Uncle Abe" that he "take it quietly" so that he can "draw it closer than ever." Lincoln responds, "A few more stitches Andy and the good old Union will be mended!"

Lincoln's choice of Johnson over the vice president of his first term, Hannibal Hamblin, was a political and strategic bombshell. Johnson, senator from Tennessee, remained faithful to the Union when his state chose to secede, and many in the North praised him for his courage and patriotism at the risk of his life. The Republican Party in convention concurred, if only by a narrow margin. At first publishers favored Johnson, but after Lincoln's death, when Johnson got into difficulty for opposing Radical Republican Reconstruction, the tide turned against him.

The Political Cartoons of 1868–1876

Most of Currier and Ives's cartoons concerning Reconstruction were discussed in chapter 7, but not those on the impeachment of Andrew Johnson, of which there were at least two. Much as Currier and Ives's

political cartoons became increasingly critical of the Radical Republican plan, so too they questioned the motives of those who led the impeachment effort. In *"Spoons" as Falstaff Mustering the Impeachment Managers* (1868), Thomas Worth pictured the managers of the impeachment, all members of the House of Representatives: Thaddeus Stevens of Pennsylvania, Benjamin Butler of Massachusetts, John Bingham of Ohio, Thomas Williams of Pennsylvania, James Wilson of Iowa, George Boutwell of Massachusetts, and John Logan of Illinois. Stevens was the actual leader; Boutwell presented the articles of impeachment to the House, but Worth made the cross-eyed Butler the center of his composition. As one critic said, "He looked more like Falstaff than any other, he was an object of suspicion and amusement even among Radicals, and his military record possessed some comic touches." Cartoonists later labeled him "Spoons," because it was said that no bit of silver was safe in New Orleans while he ruled that city. Butler made the opening argument for the prosecution before the Senate.[61]

John Cameron commented on the results of the impeachment effort in *The Smelling Committee* (1868), satirizing the House members charged with preparing articles of impeachment for trial in the Senate following the lower house's vote to impeach Andrew Johnson and with serving as impeachment managers. The House adopted eleven articles of impeachment, none of which received the two-thirds majority required to find Johnson guilty, though three fell short by only one vote.[62]

In the cartoon George Boutwell pulls on the tail of a horse lying prostrate in the dirt, still wearing a blanket labeled "Impeachment." He comments, "I fear we are getting mired in, but I certainly smell corruption." James Wilson holds his nose and asks if it is possible that their "hobby [horse] is decaying already," to which Benjamin Butler responds, pointing to a "weed" bearing Thurlow Weed's head (Weed was one of the few Republicans to oppose impeachment), "No, it's this confounded old Weed called Thurlow that makes the bad smell." Thaddeus Stevens, contemplating the dying horse, suggests that if they "could get another charge into him, he might pull through yet." But John Bingham concludes in despair, "Alas! Seven has proved a fatal number to him," a reference to the seven Senate Republicans who failed to vote to convict Johnson. Johnson, observing the entire operation with one hand resting on a ram labeled "$30,000," tells them all, "It's no use gentlemen—your nag is dead and you can't ride it any more. My Woolley friend finished him."

Currier and Ives satirized talk of retaliation against the seven "recreant" Republicans in *Impeachment of Dame Butler, Fessenden, Butler, and Ben Wade* (undated). The inscription quotes *The Exchange*: "It is rumored that the 'recreant' Senators are to be punished for their votes acquitting the President by being placed at the foot of the committees of which they are respectively 'chairmen.'"

Currier and Ives also satirized the Democratic Party's continued struggle to find a viable presidential candidate in the election of 1868 in *The Democracy in Search of a Candidate* (1868). Several Democratic Party leaders, including the eventual Democratic nominee Horatio Seymour, seek to enter a small boat en route to boarding the ship of state, in the guise of a Union gunboat, only to be tossed about on the shore by the pounding surf, threatening to dump them all. The common ground among most of the figures is a condemnation of Radical Republican Reconstruction and support for Horatio Seymour. Tombstones for McClellan and Pendleton stand on shore. Pendleton is just being placed in his coffin, while the head of Horatio Seymour on a goose soars above the crowd commenting: "Who said goose? I aim to be an Eagle!!" While the others offer varying amounts of praise for Seymour, James Gordon Bennett, editor of the *New York Herald*, pleads with Adm. David Farragut, commanding the Union gunboat, to save them. Farragut, hero of the Civil War Battle of Mobile Bay (1864)—where, when warned of "torpedoes ahead!" he replied, "Damn the torpedoes"—warns them all to back off or he will give them "a broadside": "You're the same kind of craft as those we sunk in Mobile Bay."

Ulysses Grant's reputation grew in leaps and bounds because of his military triumphs. By 1864 his image was used to help Lincoln in his reelection bid. With Lee's surrender to Grant at Appomattox, his place on the editorial page and in lithographed political cartoons was assured. Cartoonists had plenty to work with when he became the Republican Party candidate in the election of 1868. The "Old Bulldog" could be trusted to complete what Lincoln had started and Johnson had failed to press.

If the contrast between candidates Ulysses Grant and Horatio Seymour was not sufficiently clear in the election of 1868, John Cameron made it clearer in *The Man of Words. The Man of Deeds. Which Do You Think the Country Needs?* (1868, Fig. 47). As noted earlier, Seymour, the "man of words," stands amidst the New York City rioters of 1863, one black man having been lynched and several black children thrown from the windows of a "Colored Orphan Asylum." He exhorts the un-

ruly crowd: "My friends! I rely on you to defend the peace and good order of the city. I will see to it that all your rights shall be protected." In reality Seymour had called for peace and order, but he had earlier refused to cooperate with Lincoln and even attacked the president for alleged infractions of personal liberty, perhaps fanning the flames that led to the riots. Grant, the "man of deeds," shown in military garb, one foot on the head of a slain snake of rebellion, accepts Lee's sword in surrender.[63]

James Merritt Ives and John Cameron teamed up to convey a different outlook on the election in *The Radical Party on a Heavy Grade* (1868), an outlook not necessarily critical of Grant but calling into question his ability to carry the party to victory given the growing opposition to the Radicals. Grant and Colfax are shown pulling a wagon labeled "Chicago Platform," full of major Republican figures, up a steep grade toward the White House. Horatio Seymour's head looms over the White House. Grant fears he cannot "fight it out" much longer "against the rising sun," a reference to the rays of sunshine that emanate from Seymour's face. Colfax, however, pleads with him to hold on, because if they let go of the wagon, "the whole party will go to destruction." Those in the wagon reflect varying degrees of confidence in the Grant-Colfax team; Thaddeus Stevens has fallen off the wagon/platform altogether.

Otherwise Currier and Ives conveyed a sense of almost certain Republican victory. In *Blood Will Tell!* (1868) an anonymous artist employs the horse-race motif yet again. Grant, the thoroughbred "Western War Horse," ridden by Republican vice presidential candidate Schuyler Colfax, streaks to victory past Uncle Sam at the finish line, defeating "the Manhattan Donkey," who is rearing up and bucking off his rider, running mate Francis P. Blair.

In *The Great American Tanner* (1868) Thomas Worth shows "The Great Sachem of Tammany" presenting Seymour and Blair to Grant. Grant is wearing a butcher's apron and smoking a cigar, having already tanned several other figures including Robert E. Lee. Here, General, the sachem says, "is a couple more hides to be tanned. When will they be done?" Grant replies, "Well, I'll finish them off early in November."

And finally, in *An Impending Catastrophe* (1868), John Cameron raises the prospect of the Democratic Party's total destruction at the hands of the Republican candidates. Much as Louis Maurer had done in *Progressive Democracy—Prospect of a Smash Up* (1860), Cameron employs a locomotive speeding toward a wagon on the tracks. Re-

publican candidates Grant and Colfax serve as engineers for the "Reconstruction" train, which is bearing down on Democrats Seymour and Blair. Grant shouts, "Clear the track, I propose to move immediately upon your works," Colfax adding that the Democrats cannot stop the train. Blair, sword in hand, urges Seymour to stand fast, insisting that if the train does not stop, they must derail it. Blair is not convinced, responding that they had better get out of the way because "another revolution will be the death of us." Reflecting the greater appeal of Grant's Republican Reconstruction platform, James Dixon, a Republican who had nevertheless opposed Republican Reconstruction earlier, and even George McClellan, the 1864 Democratic candidate, are shown supporting the Republican Reconstruction train. Dixon announces that all "true Democrats" should climb aboard; McClellan wishes he were on the same train.

With Grant's election to office in 1868, the "negro question" began to fade as the nation's principal political issue. The Radical Republicans had won the battle of silencing Andrew Johnson, but they were losing the war as an increasing number, even in their own party, supported Grant's more moderate position toward the South. Other issues began to surface. Grant was implicated in a series of financial scandals that plagued the federal government, even though he almost certainly was not directly involved. In an attempt to corner the market for gold and drive up prices, financiers Jay Gould and James Fisk bought up what gold they could and induced Abel Rathbone Corbin, lobbyist and President Grant's brother-in-law, to exert himself to prevent the government from selling its supply. Despite Grant's refusal to agree, they spread the rumor that the president opposed such sales, and prices soared. Grant responded by ordering Treasury Secretary George Boutwell to sell 4 million dollars in gold, which drove the gold price down and ruined many speculators in the process, but not Gould. He sold his gold while prices were still high.

In the *"Boy of the Period" Stirring Up the Animals, Black Friday, September 1869* (1869), an unknown artist for Currier and Ives shows Fisk wearing the ships *Providence* and *Bristol* as epaulettes. An "Opera House" is pinned to his cravat, and he carries an "Erie R.R." train in a trouser pocket. He pokes a stick that reads "160 for a million," reflecting the supposed profit on his investment, into a cage labeled "N.Y. Gold Room" that is filled with animals with human heads representing other Wall Street investors. Grant dashes from the U.S. Treasury toward Fisk, waving one hand and carrying a sack marked "$5 Million Gold" in the other. John Cameron produced another po-

litical cartoon three years later related to other scandals that surfaced during the Grant administration. In *A Nice Family Party* (1872) Grant, in a rumpled top hat, stands holding a large cake labeled "Government Cake." Christlike, he implores those around him, saying "Let us have peace," but the twelve men around him frantically tug at his coattails and legs, crying, "Let us have a piece."

Grant came under fire in 1870 when he proposed annexing Santo Domingo. To that end, Grant submitted a treaty of annexation to his cabinet, which unanimously rejected it, and to the Senate, where it was rejected as well. During that debate Sen. Charles Sumner delivered his famous "Naboth's Vineyard" speech, a scathing denunciation of the plan, the result of which was open warfare between Grant and Sumner that lasted through 1872 and included Sumner's opposition to Grant's reelection. Grant and his supporters took revenge on Sumner by deposing him as chairman of the Foreign Relations Committee.[64] In *Selling Out Cheap!* (undated) Currier and Ives picture Sumner striking a bargain with the devil. Sumner sits at a desk, which has two pieces of paper tacked to it. The first is titled "Letter to Colored Citizens," a reference to Sumner's championing emancipation and black civil rights. The second is "Sumner's Speech against Grant." Sumner says to the devil, "The country may go to you—what I want is revenge." The devil, with a beard, bats' wings, a tail, and pointy feet, responds, "All right Senator, I'll take charge of your case."

In 1872 a group of liberal Republicans disenchanted with Radical Republican Reconstruction bolted the party and nominated Nathaniel Currier's good friend Horace Greeley for the presidency. The Democrats also gave Greeley their nomination. Currier and Ives responded by issuing a charming cartoon called *A Philosopher in Ecstasy* (1872). In the print, Greeley, known for his philosophical idealism, leaps joyfully into the air and snatches a butterfly labeled "the Nomination." He exclaims: "By George! I've got it." Greeley was a foe of slavery and the abolitionist movement, but at the start of the war he criticized Lincoln for his tameness in prosecuting the war. Upon Confederate surrender, however, he opposed Radical Reconstruction and favored amnesty for the South.[65]

Currier and Ives pictured the potential impact of Greeley's unusual cross-party constituency in *The End of Long Branch* (1872) and *Splitting the Party* (1872). In *The End of Long Branch* John Cameron pictured Greeley on the "Cincinnati Ladder," leaning against the "Presidential tree" and chopping off the "Long Branch" on which Grant sits, dangling a fishing line into the water below. The "Cincinnati Ladder"

refers to the meeting in that city of liberal Republicans that led to their defection from the Republican nominee and support for Greeley. Greeley remarks, "They make fun of me, for what I know about farming, but I guess some folks will soon find out what I know about chopping." Grant, facing the other way and oblivious to what is happening, remarks, "How nice it is to sit here and enjoy the sea breeze, knowing that everything is safe behind me."

In *Splitting the Party* Cameron pictures Greeley being driven like a wedge into a boulder labeled "Republican Party." An unidentified man wields a mallet labeled "Cincinnati Nomination" and succeeds in splitting the boulder. Greeley holds up a sign in each hand, one reading "Free Trade," the other "Protection," representing the conflicting platform planks of the two parties that have endorsed him on that issue. Grant stands to the left of Greeley on the boulder, observing that the mallet will kill Greeley. Its wielder replies that he does not care as long as they succeed in preventing Grant's election, a position echoed by several prominent Democrats, including William Marcy "Boss" Tweed of Tammany Hall, and Republicans lurking about the boulder. Greeley's only comment is, "This is a novel position for a staunch old Republican like me. I begin to feel as if I was in a tight place."

Friendship notwithstanding, the reference to Greeley as philosopher, snatching the butterfly of nomination from the air, implies a level of skepticism that appears in John Cameron's *The Elephant and His Keepers* (1872) and *The New "Confederate Cruiser"* (1872). In *The Elephant and His Keepers* Greeley is being wheeled in a baby carriage by Theodore Tilton and Victoria Woodhull, both well-known reformers of the day. In 1874 Tilton, a supporter of woman suffrage, sued the Reverend Henry Ward Beecher, his parish minister, for adultery with Mrs. Tilton, setting off one of the greatest scandals of the century. Woodhull was an infamous advocate and, some would insist, practitioner of free love and a candidate for president. Greeley, carrying a tiny tree and hatchet, reminiscent of the story of George Washington and the cherry tree, pleads—incongruously—"Let me speak just once. I want to call somebody a liar." Fellow journalist August Belmont, editor of the *New York World*, lectures Greeley to keep quiet or he will "spoil the whole plot," while Tilton seconds Belmont's motion and Woodhull admonishes the two for deserting her for Greeley after promising to support her.

In *The New Confederate Cruiser* Cameron reflects on Greeley's ultimately disastrous bid for the presidency. Twelve men, including

Greeley, are tossed about on rough waters in "an old white hat" turned upside down. They have fashioned a sail from his jacket, the white hat and jacket being Greeley's trademarks. A thirteenth man has been tossed overboard, while another still in the "boat" exclaims: "An old white hat isn't the thing for a Democrat to go to sea in."

Cameron offers the same message of impending disaster in *The "Last Ditch" of the Democratic Party* (1872). In this instance, Greeley, holding a hatchet in one hand, wraps his free arm and both legs around a tree stump labeled "Cincinnati." The stump sticks out over a flood ditch labeled "Baltimore," in which several prominent Democratic politicians are struggling to keep from drowning. Grant soundly defeated Greeley in the election of 1872. Greeley died on November 29, 1872, unbalanced by the death of his wife a few days before the election.

Among those Democratic politicians in the flood ditch was "Boss" Tweed. Currier and Ives did not often refer to Tweed in their cartoons, but 1872 was a particularly notable year for the Tammany boss. The year before, George Jones of the *New York Times* had initiated an expose of Tweed's corrupt regime, which, it was alleged, had systematically plundered the city treasury of from $75 to $200 million. Tweed was arrested in October, convicted on November 5, 1872, and sent to jail, where he died. In response to the *Times* articles, it will be recalled, Tweed is reported to have said he did not care what they wrote, because his supporters could not read. He was much more concerned about being skewered in political cartoons, especially by Thomas Nast, because the audience could understand pictures!

The issues of corruption and Grant's fitness for office, not Reconstruction, dominated the election of 1872. During his first term Grant crushed the power of the Ku Klux Klan, whose actions only served to provoke remaining Northern antipathy toward the South. Southern Democrats quietly "redeemed" the Southern states, and Grant began to withdraw federal troops. Radical Reconstruction officially came to an end as the result of a political compromise reached in the election of 1876. Democrats agreed to award the Republican Rutherford B. Hayes the contested electoral votes he needed to become president in return for his pledge to end the North's occupation of the South.

Currier and Ives made no mention of any of this and, in fact, published only a few political cartoons in that election. By 1880 they had ceased to publish political cartoons altogether, but perhaps it was appropriate that in 1876 Currier and Ives bid farewell to Reconstruction

and celebrated the nation's centennial with one of its most patriotic and timely prints, *The Spirit of the Union*. It features a full-length portrait of George Washington in military uniform and the following inscription:

> Lo! On high the glorious form
> Of Washington Lights all the gloom.
> And words of warning seem to come
> From out the portal of his tomb;
> Americans your fathers shed
> Their blood to rear the Union's fame,
> Then let your blood as free be given,
> The bond of union to maintain.

Currier and Ives had published the same composition in 1860. It included Washington, framed by clouds, the nation's Capitol, Washington's tomb, and Mount Vernon. Sixteen years later the Capitol is missing but so too are the clouds, and light continues to radiate from Washington's head.

American Pride
and Play

The optimistic, materialistic society that took pride in the accomplishments of urban America also marveled at the nation's technological advances. At the same time, as the Industrial Revolution proceeded to transform the nation, it provided Americans—especially urban Americans—with leisure time, which they filled with old and new ways to play. Nineteenth-century Americans pursued both invention and play with pride and enthusiasm. In 1876, for the nation's centennial, Currier and Ives produced *The Progress of the Century* (1876, Fig. 51), noting the major advances in communication and transportation that transformed the American economy, including the

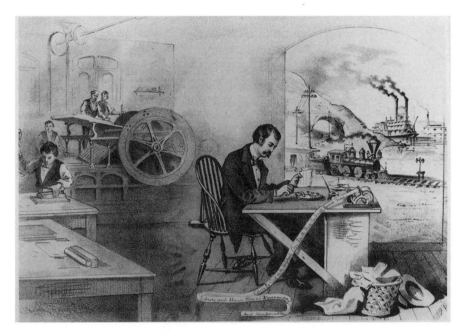

FIGURE 51. *The Progress of the Century.* Currier and Ives (1876).

steam press, the telegraph, the locomotive, and the steamboat. The print even attributed Union victory in the Civil War to such technological advances—as well as divine will—by having the telegraph print off the message: "Liberty and Union now and forever one and inseparable. Glory to God in the highest. On earth, peace, good will toward men." But Currier and Ives also boasted of clipper ships and yachts and gloried in pastimes such as horse racing, hunting, fishing, and baseball.

Symbols of Progress and Prosperity

Currier and Ives sold hundreds of prints that represented the nation's progress and prosperity; they worshiped technological beauty and power. Clipper ships were things of beauty and speed; they were pleasing to the eye and useful as well, and no one drew them better than Currier and Ives. Clippers stemmed from trim little French luggers and the "Baltimore clippers" that began to appear in the early 1800s and were used as privateers in the War of 1812. Ever larger and faster clippers were built in response to the demand for the speedier shipping of goods and people to the gold fields of California, reducing the

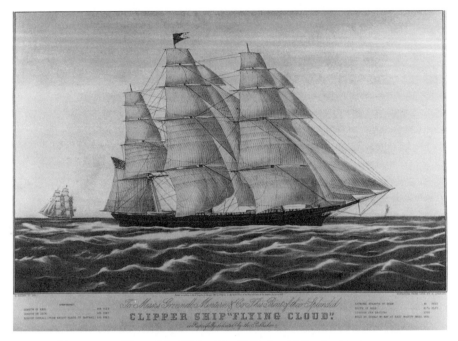

FIGURE 52. *Clipper Ship "Flying Cloud."* Nathaniel Currier (1852).

trip from New York to San Francisco from thirteen months to four. Soon they crossed the Atlantic in just twelve days and sailed from Liverpool to Melbourne in sixty-nine days, surpassing even the British East India men in the lucrative tea trade. Long, lean, and flat-bottomed, with immense spreads of canvas, curved hulls, and convex bows, they cut the waves with little resistance to wind and water and soon captured the hearts of many Americans. One early marine historian described clipper ships as "perhaps the most beautiful and life-like thing ever fashioned by the hand of man," and most Americans agreed.[1]

During the 1850s, when clipper ships ruled the seas, Currier and Ives published no fewer than seventy-five clipper ship lithographs, most of ships built in America. Many, like *Clipper Ship "Flying Cloud"* (1852, Fig. 52) and *Clipper Ship "Great Republic"* (undated), pictured the majesty of the most magnificent clippers at sea. The first, by Edward Brown Jr. after a painting by James E. Butterworth, one of the best-known clipper-ship artists of his day, is dedicated to the ship's owner. Both prints are inscribed with the clippers' measurements of length,

breadth, depth, and tonnage, reflecting once again the appeal that such utilitarian beauty had to nineteenth-century America.[2]

Designed by John Griffiths and Donald McKay of Boston, the *Flying Cloud* may have been the greatest clipper of its day. The ship was of such beauty that the shipping firm of Grinnel and Minturn bought it from the intended owner while it was still on the stocks, by offering double the original price. But when it was launched, the *Flying Cloud* was also the largest merchant ship afloat. As one newspaper reported with pride when the clipper departed New York on its maiden voyage on June 2, 1851, "The *Flying Cloud* is just the kind of a vehicle, or whatever it might be called, that a sensible man would choose for a ninety-day voyage."[3]

Currier and Ives liked to picture clippers that set new speed records, like *Clipper Ship "Dreadnought"* (1856) by Charles Parsons and Daniel McFarlane. The print notes that in December 1854 the *Dreadnought* made the trip from New York to Liverpool in only thirteen days and eleven hours. The *Flying Cloud* also set records, including an astonishing eighty-nine-day run from New York to San Francisco, a one-day sail of 374 miles (598 kilometers), and a four-day voyage of 1,256 miles (2,010 kilometers). But the firm also showed clipper ships in danger. The design that allowed them to break all speed records also made them peculiarly susceptible to high winds at sea. Images of clipper ships with broken masts, heeling at dangerous angles under gale-force winds, were common. Typical are the anonymously drawn *An American Clipper Ship off Sandy Hook Light in a Snow Storm* (undated); Charles Parson's *Clipper Ship "Comet" of New York* (1855), picturing that clipper in a hurricane off the coast of Bermuda; and *A Squall off Cape Horn*, undated and with no artist listed.[4]

Built largely to satisfy the urge for speed without regard to cargo capacity, the clipper ship had a glorious but short-lived career. It enthralled America for only a few years, catching every nuance of a youthful nation flexing its muscles. And then, just as quickly, the ship that represented the ultimate in America's skill, exuberant courage, and adventurous spirit vanished. Yachts lived on, but steam replaced wind as the most effective and efficient means of powering commercial transportation on water and land, and Currier and Ives caught the new wave of America's fascination with the nation's steamboats and steam locomotives.[5]

New Yorker Robert Fulton may not have invented the steamboat—that honor goes to the less well known John Fitch, a frustrated genius

whose life ended in suicide—but Fulton certainly popularized it. Fulton's *Clermont*, launched in 1807, did not venture beyond the inland waterways of New York, but by the time of the Civil War, vessels built on essentially the same technology conquered the world's oceans. In the years immediately following the Civil War, Currier and Ives produced approximately two hundred prints of American steamers, some at sea but even more in various harbors and on the nation's major rivers—the Hudson and especially the Mississippi. In fact the great majority of Currier and Ives's many Mississippi River prints included at least one steamboat, sometimes more.

If Americans hailed clipper ships for their beauty, grace, and speed, they boasted of their steamers' size and strength. Currier and Ives's *"Great Eastern"* (1859), by Charles Parsons, of which there were at least five separate lithographs, is representative. In addition to picturing the magnificent six-masted, steam-sailing ship, equipped with sails and paddle wheels, the print included all of the data in which Americans were so interested: its dimensions (far larger than the clipper ships), tonnage, and horsepower. Appropriate to the industrial age into which the nation had entered, the emphasis was on power, and when constructed in 1857–1858, the *Great Eastern* was the largest steamboat afloat. It was almost 700 feet (213 meters) long and was designed to carry four thousand passengers.[6]

Currier and Ives published at least two hundred prints of some of the most luxurious steamboats of the period, like Frances Palmer's *"St. John"* (1864), which pictured one of the most fashionable passenger vessels that plied the Hudson River.[7] They also pictured racing steamboats, as in *The Great Race on the Mississippi* (1870), in which the steamers *Robert E. Lee* and *Natchez* challenged one another en route from New Orleans to St. Louis. More than $1 million was waged on the contest, in which the *Lee* won. Palmer also did the original work for *A Midnight Race on the Mississippi* (1860), based on H. D. Manning's sketch of a race between the *Natchez* and the *Eclipse*. In *Life on the Mississippi* (1883), Mark Twain described one such race:

In the "flush times" of steamboating, a race between two notoriously fleet steamers was an event of vast importance. The date was set for it, several weeks in advance, and from that time forward the whole Mississippi was in a state of consummating excitement. . . . The chosen date being come, and all things in readiness, the two great steamers back into the stream, and lie there jockeying a moment, apparently watching each other, like sentient creatures; flags drooping, the pent steam

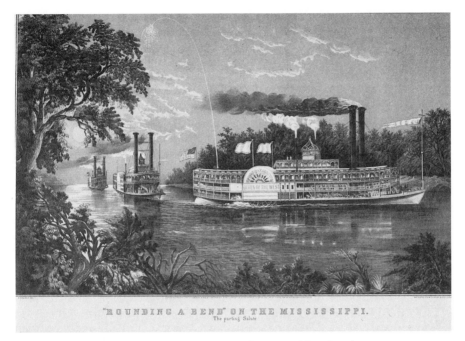

"ROUNDING A BEND" ON THE MISSISSIPPI.
The parting Salute

FIGURE 53. *"Rounding a Bend" on the Mississippi.* Currier and Ives (1866).

shrieking through safety-valves, black smoke rolling and tumbling from the chimneys and darkening all the air.[8]

A Cincinnati newspaper editor proclaimed the steamboat the most colorful, dynamic, and vital fact of life in mid-America: "Rushing down the Mississippi, as on the wings of the wind . . . walking against the mighty current bearing speculators, merchants, dandies, [and] fine ladies . . . with pianos and stacks of novels and cards and dice . . . flirting and love-making and drinking champagne . . . a steamboat . . . brings to . . . the very doors of the cabins, a little bit of Paris, a section of Broadway, or a slice of Philadelphia, to ferment in the minds of our young people, the innate propensity for fashions and finery."[9] Currier and Ives pictured one of the best-known of these luxurious steamboats, the *Queen of the West,* in *"Rounding a Bend" on the Mississippi* (1866, Fig. 53), a picture Frances Palmer made romantic by including two other steamers, all racing up the river in the moonlight. American flags fly from two of the vessels. A single aerial pyrotechnic has been launched from the *Queen of the West;* thus the subtitle *"The Parting Salute."* She captured the spirit of the times in *The*

Champions of the Mississippi: "A Race for the Buckhorns" (1866), wherein four steamers race side by side down the river in the full moonlight, while a group of men gathers on the bank around a bonfire to cheer them on.

No doubt in part because of the steamboats' power and might, Currier and Ives produced more than fifty steamboat disaster prints, as well. It was one such lithograph, *The Awful Conflagration of the Steamboat "Lexington" in Long Island Sound* (1840), that made Currier and Ives famous (see pages 11–13). Other steamboat disaster prints include *Awful Wreck of the Magnificent Steamer "Atlantic"* (1846), an accident that resulted in the deaths of forty passengers; *Burning of the Palace Steamer "Robert E. Lee"* (1882); *Burning of the Splendid Steamer "Erie"* (1841); *Terrible Collision between the Steamboats "Stonington" and "Narragansett"* (1880); and *Terrific Collision between the Steamboats "Dean Richmond" and "C. Vanderbilt"* (1867), all by unknown artists.

Besides the seagoing vessels, a new and fascinating form of transportation was developing on land—the railroad. Currier and Ives produced nearly fifty lithographs of America's highly advanced steam locomotives. Trains had their beginning in England, but they appeared in the United States in the 1820s. By 1840 every seaboard state had them; by 1860 approximately 30,000 miles (48,000 kilometers) of track had been laid, and by 1869 rails spanned the continent. They provided the transportation network that supported America's industrial revolution, but they also provided one of the major means by which the nation conquered the West.[10]

Despite the railroad's rapid rise to prominence, and a great deal of publicity for it, artists were slow to bring it to the front and center of their paintings. Works done in the 1840s by Thomas Cole, Thomas Doughty, and others pictured trains nestled within the Catskills or the New England landscape. Even George Inness, when commissioned in 1855 by the Lackawanna Railroad to paint the roundhouse of the Delaware, Lackawanna, and Western Railroad at Scranton, Pennsylvania, distanced the train from the viewer. There are, for example, Thomas Cole's *River in the Catskills* (1843), Thomas Doughty's *A View of Swampscott, Massachusetts* (1847), and George Inness's *The Lackawanna Valley* (1856–1857).[11]

All that changed in the mid-1850s, and Currier and Ives led the charge to celebrate the railroad and its contribution to westward expansion. In contrast to the resistance to technology described in works such as Leo Marx's *Machine in the Garden,* the evidence suggests that Currier and Ives's America embraced it.[12] Although retaining a nos-

talgic image of a preindustrial rural world of "home sweet home,"
Currier and Ives developed a parallel collective vision of prosperity at-
tained through technology, welcoming machines into their pastoral
gardens. Any conflict between the two images apparently made little
difference.

In reviewing Currier and Ives's many railroad prints, two things be-
come clear. First, with all their parts pictured with meticulous accu-
racy, trains proved to be very attractive to the firm's clientele. Second,
Currier and Ives's public apparently did not find it difficult to recon-
cile this symbol of industrialization with nature. Not only are the
trains frequently surrounded by an abundance of scenery, but appar-
ently no incongruity was felt when they were thrown in as an inci-
dental portion of an otherwise pristine landscape.

Currier and Ives celebrated American trains in about thirty prints,
including two series by Frances Palmer titled The "Lightning Express"
Trains (1863–1871) and The American Express Train (1853–1864), drawn
in collaboration with Charles Parsons. In the first series, Palmer por-
trays locomotives as powerful symbols of progress, whose headlights
and smoke-belching engines seem to vie with the moon to light the
night. In the 1855 printing of the second series, a train emerges from
a station in full view of an admiring crowd of people. A man holds
and calms horses hitched to a buggy, the animals spooked by the "iron
horse." In the 1864 printing, thick black smoke billows from the train's
smokestack as it passes two sailboats and a riverboat on a river. In both
of these series one or more trains dominate the scene; little else in the
picture distracts the viewer's gaze or detracts from the train's majesty.
An even more dramatic representation of this mighty power of the
rails is An American Railway Scene (1863), in which Charles Parsons
and Lyman Atwater picture several trains side by side in the Erie Rail-
way yards at Hornellsville, New York.

Currier and Ives's prints in which trains are the featured subject
amidst considerable landscape are American Railroad Scene (1874), The
Route to California (1871), and Through to the Pacific (1870). Prints in
which the scenery is dominant and the railroad incidental include Ice-
Boat Race on the Hudson (undated), The Great West (1870), Lookout
Mountain, Tennessee and the Chattanooga Railroad (1866), Pennsylva-
nia Railroad Scenery (undated), and View of Harper's Ferry (undated).
Currier and Ives celebrated the magnificent railroad bridges of
America in pictures like The Rail Road Suspension Bridge (1856), sited
near Niagara Falls and designed by John A. Roebling (famous for his
work on the Brooklyn Bridge). And they pointed to the role of the

bands of steel in spanning the West in *Across the Continent: Westward the Course of Empire Takes Its Way* (1868; see pages 121–122).

If prints picturing the power and might of steamboats were countered by several disaster prints, majestic railroad scenes were balanced by similarly threatening scenes only occasionally. There are no train wrecks. The possibility is suggested in *The Danger Signal* (1884), which shows two trains on the same track approaching one another head-on, but this print was produced as part of an advertisement for an insurance company.[13] One of Currier and Ives's most highly regarded prints, *American Railroad Scene: Snow Bound* (1871), pictures a train stalled in the countryside, a small army of men working frantically to shovel snow from the tracks. Legend has it that James J. Hill is pictured among the men, leaning on a shovel.[14] *Prairie Fires of the Great West* (1871) pictures a passenger train heading West, threatened by one of the prairie fires common to that region, from which a herd of bison flees as well.

Upon occasion Currier and Ives pictured trains, especially rail travel, among its comics. In one representative comic print, *A "Limited Express"* (1884), subtitled *Five Seconds for Refreshments,* Thomas Worth pictures a large group of male passengers leaping from a train at one of its stops, stampeding over one another to purchase refreshments from a vendor on the platform. A sign on the doorway reads "Lunch on the American Plan."

Most comic prints featuring railroads involve collisions between trains and animals and even humans—which may provide some sense of conflict between human and machine, nature and technology, but in a humorous vein. Examples of the former, matching trains against animals, are *Blood Will Tell* (1879), *Crossed by a Milk Train* (1885), *More Plucky Than Prudent* (1885), and *Wrecked by a Cow Catcher* (1885). In *The Accommodation Train* (1875), *A Nightmare in the Sleeping Car* (1875), *A Short Stop at a Way Station* (1875), *A Wild Cat Train* (1884), and *Waking Up the Wrong Passenger* (1875), humans find themselves wrapped around the engine of an oncoming train; rushing from a station dining room, napkin still in hand, to board a departing train; or falling victim to various sleeping-car embarrassments. Such cartoons give evidence of some level of misgiving about the new mode of life that the railroad represented, but it does not dominate the overall positive image of its place in Currier and Ives's America.[15]

Progress met resistance, of course, and more than a few voices protested the impact of the railroad on American life and landscape. But such voices did not find expression in the prints of Currier and

Ives, which express no consciousness of conflict between trains, as symbols of industry, and nature. Instead, they picture both as at peace, if not in harmony, with one another. At the same time they translate the building of the nation's railroads into progress, prosperity, and continental or even world dominion. California poet Joaquin Miller spoke for many Americans, and expressed a sentiment similar to that found in Currier and Ives, when he wrote, "There is more poetry in the rush of a single railroad train across the continent than in all the gory story of burning Troy."[16]

Fire was the dread enemy of cities, including American cities. Built quickly and in a comparatively haphazard manner with little attention to safety, highly flammable buildings were often crowded together like so many tinderboxes creating an invitation to disaster. New York City, the most rapidly growing urban area in nineteenth-century America, faced the constant threat of immolation. It was also the venue of one of the most significant fire-related measures of the century: organized amateur, and then professional, firefighting. The urban volunteer fireman became the object of considerable American pride; not surprisingly he also became the subject of one of Currier and Ives's most popular lines of prints.[17]

As has been noted, Currier and Ives first caught the nation's attention by picturing urban fires. *Ruins of the Merchant's Exchange, N.Y.* (1835) was key to the rise of the company, and the burning of New York's Crystal Palace became the subject of two of Currier and Ives's prints (undated). Other notable fire-disaster prints that Currier and Ives produced in lurid detail and rushed to an eager market included the anonymous drawing *Burning of the City Hall, New York* (undated), a fire believed to have been ignited by fireworks exhibited in commemoration of the laying of the Atlantic telegraph cable in 1858; *View of the Great Conflagration* (1836), by John Bufford, in which people remaining in a burning building can be seen in windows and on the roof; and *View of the Great Conflagration at New York* (1845) by an unknown artist, featuring the valiant efforts of firefighters to subdue the flames.

Currier and Ives published prints of catastrophic fires in other cities as well, the most notable being *The Burning of Chicago* (1871). Chicago's famous conflagration of 1871 consumed a major portion of its commercial district, cost upward of five hundred lives, rendered one hundred thousand people homeless, and totaled an estimated $200 million in property damage. Other prints featured major fires in Pittsburgh (1845), Boston (1872), St. Louis (1849), and New Orleans

(undated).[18] Over the years, firefighters became increasingly prominent in Currier and Ives's disaster prints until finally they became a line onto themselves.

By 1840 New York City had sixty-four volunteer fire companies with a force of sixteen hundred men on call. Nathaniel Currier was among them, as he and other members of socially prominent companies voluntarily bore the burden and faced the dangers of fire fighting. Currier belonged to the Excelsior Company No. 2.[19] When an alarm sounded, volunteers grabbed their uniforms, rushed to their firehouses, dressed for the event, hauled equipment to the site of the blaze, and fought the fire.

Volunteers often organized along ethnic lines. They received no pay, but they were proud of the role they played in protecting the city. They frequently paraded in full-dress uniforms. They built elaborate firehouses—some with drawing rooms, libraries, and dining rooms— and at least those who could afford it staged banquets and balls that were fashionable events in the city's social life. Their brightly painted engines bore identifying emblems or decorations. "The Americans" was decorated with a tiger's head, and when the captain of America's Fire Engine Company of No. 6 Henry Street, William Marcy "Boss" Tweed, became a political leader, the symbol of his fire company became the trademark of Tammany Hall.[20]

Currier and Ives issued at least twenty-five separate fire-fighting prints. Some offered views of the latest fire-fighting equipment, like *Fire Engine No. —* and *Fire Engine "Pacific" Brooklyn N.Y.*, both undated. The firm paid homage to fallen firefighters in *New York Fireman's Monument* (1855), picturing a public monument in Greenwood Cemetery. Built behind an iron gate, a four-sided column stands topped by the figure of a fireman holding a child in one arm and a trumpet in the other. By far the best-known firefighter prints were the two series, *The Life of a Fireman* (1854–1866) and *The American Fireman* (1858), scenes from which are still commonly reproduced for insurance company literature, flyers, and other promotional pieces. From the start Currier and Ives hawked them to insurance companies, as well as to firemen and "all interested in the fire department."[21]

The Life of a Fireman consists of six fire-fighting scenes highlighting the men, their equipment, and their heroic efforts. Louis Maurer created four of these scenes, all published in 1854. In *The Night Alarm—"Start Her Lively Boys,"* Maurer pictures a crew of firemen pulling a pumper wagon from a firehouse in response to an alarm. The clock inside the firehouse reads 1:22 (A.M.). In *The Race—"Jump Her*

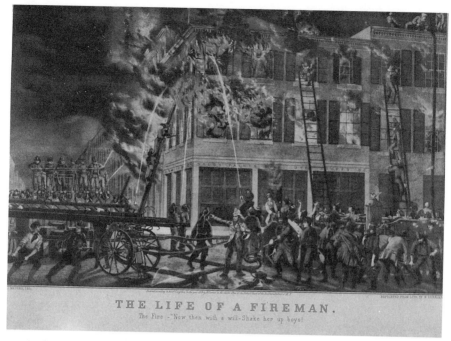

THE LIFE OF A FIREMAN.
The Fire.—"Now then with a will—Shake her up boys!"

FIGURE 54. *The Fire—"Now Then with a Will— Shake Her Up Boys!"* Nathaniel Currier (1854).

Boys, Jump Her!" the clock on the cupola of New York's city hall reads 1:32. Teams of firemen rush toward a fire, pulling a water tank and pumper on high-wheeled carriages. They fight the fire in *The Fire— "Now Then with a Will—Shake Her Up Boys!"* (Fig. 54), a print that shows firefighters scaling ladders to rescue tenants from a burning building. In a classic touch, a fireman climbs out a third-story window with a baby, and a woman on the ground raises her arm in relief. The aftermath of the conflagration and the departure of the heroes is presented in *The Ruins—"Take Up"—Man Your Rope.*

Currier and Ives claimed that its fire-fighting prints were made from the artist's firsthand observations of New York City's many conflagrations.[22] Maurer certainly emphasized accuracy in the many details he included. In *The Night Alarm*, for example, he pictures Excelsior Company No. 2, of 21 Henry Street, leaving the fire station in response to an alarm. At the left, Nathaniel Currier runs to join his comrades. *The Fire* may have been the first print in this series to be used as an advertisement by an insurance company, the American Insurance Company of Newark, New Jersey.[23]

Charles Parsons and John Cameron provided the remaining two scenes in *The Life of a Fireman* series. Parsons's *The New Era. Steam and Muscle* (1861) highlighted new steam-powered pumper wagons being used to fight a fire burning in a five-story building. The new pumpers were first used in the city in 1841, but they were only gradually accepted as a replacement for the hand pumps.[24] In 1865 New York City disbanded its volunteer system and established the Metropolitan Fire Department. The era of the modern professional firefighter had begun, a development duly noted in Cameron's *The Metropolitan System* (1866). Cameron shows two horse-drawn fire wagons, a steam-powered pumper and hose wagon, and a hook-and-ladder wagon rushing to the scene of a fire.[25] It was the last of Currier and Ives's fire-fighting prints.

Organization of a professional fire department may have had as much to do with the social problems created by the volunteer organizations as it did with efficiency and effectiveness. As neighborhood and ethnic companies sprang up around the city, rivalries developed and cooperation diminished. Companies raced each other to the scenes of fires. In *The Life of a Fireman: The Race*, for example, Engine Company No. 21 passes Hose Company No. 60. Feuds developed. Rival companies hindered one another's efforts and engaged in brawls, encouraging companies to recruit men more for their ability to fist fight than fire fight. When in 1865 the New York State legislature created New York City's Metropolitan Fire Department, volunteers threatened to hold their firehouses against all comers, but in the end they capitulated.[26]

Maurer repeated his dramatic rendering four years later in *The American Fireman Series* (1858), which is even more heroic. In *Rushing to the Conflict* a fireman holding a horn in his left hand points down the street with his right. In *Always Ready* a fireman (said to be a portrait of Nathaniel Currier) pulls a hose carriage into a fire-fighting scene.[27] In *Facing the Enemy* a fireman, holding a hose, stands posed in action at the edge of burning rubble, and in *Prompt to the Rescue* a fireman carries an unconscious girl in a white nightgown away from the flames.

What Currier and Ives chose to exclude from their prints is often as interesting as what they included. In contrast to the firm's many prints on firemen, absent are any significant references to policemen. It is not tenable to suggest that Nathaniel Currier's devotion to his fire company alone accounted for the company's many fine fire prints. The principals' business acumen precluded that; they gauged popu-

lar taste and created and sold prints accordingly.[28] Simply put, dramatic and colorful fire prints sold, so why not police prints?

In all the Currier and Ives scenes of raging fires, only a few policemen are pictured, and they are very much in the background. Moreover there are not many more policemen in the entirety of the Currier and Ives inventory. In the political cartoon, *"The Impending Crisis"* or *Caught in the Act* (1860), a policeman armed with a club labeled *New York Daily Times* arrests Horace Greeley. And in the romantic vignette *Thou Hast Learned to Love Another* (1875), a policeman kisses a governess in the park. But that is about all. Neither print is negative, but the firm was not interested, it seems, in portraying the heroism of police as they did the firemen's.

The comparative absence of interest in policemen is even more curious considering that the same nineteenth-century conditions that accounted for so many major fires in the cities also contributed to an alarming rise in crime. The growing numbers of poor and unassimilated immigrants in crowded and inadequate housing made the work of the police just as hectic as that of the firemen.[29] Unlike the firemen, however, they did not establish an enviable reputation for themselves. This was certainly true of the New York City police, with whom Currier and Ives were familiar and most likely to portray. In 1840 the *New York Commercial Advertiser* wrote, "It is notorious that the New York police is wretchedly inadequate to the arrest of offenders and the punishment of crime; as to prevention of crime, we might as well be without the name police, as we are all but without the substance." Four years later, a committee of the board of aldermen reported, "Witness the lawless hands of ruffians that stroll about our city, the gamblers, pickpockets, burglars, incendiaries, assassins, and a numerous host of their abettors in crime, that go unwhipt of justice, and we find indeed that it is true that something should be done to give more efficiency to our laws and protection to our unoffending citizens."[30]

New York City disbanded its centuries-old watch system in 1845 and replaced it with a police force modeled on London's new system. Although the new system was an improvement over the old, it faced formidable problems. Besides the pickpockets, incendiaries, and assassins about which the board of aldermen complained, there were more than ten thousand prostitutes and a prodigious number of licensed drinking establishments, which the more established, mainly Protestant citizens demanded be monitored. A decade after the new system of policing was instituted, the board of aldermen still complained, "The Police Department . . . is entirely inefficient, either for

the protection of property or the preservation of the public peace." They were also suspected of influencing municipal elections in favor of Mayor Fernando Wood, both by their contributions and their "policing" of the polls.[31]

In 1857 the Republican state legislature took control of the police department from the mayor and gave it to a board of commissioners, of which five were to be appointed by the governor, one by the mayor of New York, and one by the mayor of Brooklyn. Until the courts upheld the measure, however, New York City had two police forces, one loyal to the board of commissioners and one loyal to the mayor. Sometimes a person was arrested by one force and freed by the other, and at one point the two police forces clashed with one another and the Seventh Regiment had to separate them.[32]

As a result of Democratic victories at the state level, Boss Tweed was able in 1870 to return to a system of four commissioners appointed by the mayor of New York and subject to the Democratic machine. Officers had to pay to get appointed and promoted and they, in turn, exacted tribute from prostitutes, liquor dealers, and gamblers. They also developed a reputation for brutality. Even a New York City police superintendent was forced to admit, "To such an extent is the public demoralized that they no longer consider the policeman in his true light, that of a preserver of the peace; but actually, and with some degree of justice, deem him a public enemy."[33] Such enemies would not be appropriate for Currier and Ives.

This is not to suggest that the firemen were above politics or even politically nefarious deeds. We have already noted that volunteer fire departments could resort to violence, and not only among themselves. In one instance the members of Niagara Company No. 10 left their apparatus at the scene of a fire and proceeded to pummel an alderman they disliked. In 1836 a thousand people became enmeshed in a fight in Chatham Square that started between fire crews. An engine belonging to a defeated company was upended in the gutter and hosed down until its decorations came off. Such violence got worse until 1865, and the establishment of the professional Metropolitan Fire Department in that year did little to solve the problem. Once again, in 1870, Boss Tweed managed to get the New York State legislature to change the system in order to give the mayor of New York City, not the state governor, the power to appoint fire commissioners.[34]

Why, then, did Currier and Ives give such prominence to the fire department, as opposed to the police department? Perhaps because, as volunteers, and often recruited from the upper classes, the fire-

fighters were seen as noble and romantic. The corrupt acts of police-
men might seem venal, but any untoward acts of firemen were often
excused as little more than "manly good fun." Even if the police had
not been so corrupt, inefficient, and brutal, they would not have been
portrayed by Currier and Ives, for another reason: "No matter how
scrupulous the police might have been, they still dealt with the lower
classes and the underworld. Those whose work associated them with
brothels, saloons, and the poor inevitably were tainted. Nice people
would want nothing to do with them."[35]

Currier and Ives's America at Play

Leisure-time activity in nineteenth-century America combined the
previously noted pride in things American with an obsession with
speed and strength and a love of sports that became prominent in the
United States in that century. The creation of leisure time, the devel-
opment of sporting activities, and the rise of an urban industrial na-
tion were all linked. As people gathered in cities in increasingly large
numbers and had their work hours regulated, they had the time, in-
terest, and even disposable income to encourage entrepreneurs to use
all three to their advantage. This happened only gradually, and then
at first only in the middle and upper classes. But in the period after
the Civil War such changes were evident, and they coincided with the
equally gradual demise of any lingering Calvinist heritage that
equated even the most innocent of earthly pleasures with sin.[36]

That is not to say that people living in rural areas did not have their
own amusements. Life was different there, and so were their leisure
time activities. Some pastimes did appeal to both populations; for ex-
ample, hunting and fishing were popular among country and city folk
alike, but such activities were more of a sport for urbanites than for
their rural counterparts. In the country, people found entertainment
in nonurban activities like quilting bees, house raisings, maple sugaring-
off parties, and county fairs.[37]

Many urban residents continued activities that had been part of
rural life for generations, like ice skating, as we saw earlier in the Cur-
rier and Ives print of Central Park. When the red ball was hung from
a tower near the park's reservoir to indicate that the ice was safe, resi-
dents rushed to the pond to skate. Skating was particularly popular
among urban women, for whom there were few other permitted ath-
letic outlets—provided they did not overdo it. One source notes that
when a young woman reported that she was sweating, her mother re-

sponded, "Only animals sweat. Men sometimes perspire. Girls glow, my dear."[38] But urban areas soon evolved their own pastimes, often adapting rural sports to their urban environment. One such sport was horse racing.

Horse racing became wildly popular in the nineteenth century. And although anyone with a horse could participate at some level, and many did, the comparative absence of horses in urban areas, and the money invested in breeding and keeping thoroughbreds, ensured that horse racing quickly became for many a spectator sport. Nathaniel Currier was fond of trotters, but James Ives earned a reputation as one of the most knowledgeable men of his time on the animal.[39] Perhaps for that reason, as well as in response to the horse-racing craze of the nineteenth century, Currier and Ives produced more than 750 related prints. Horse racing may have been on its way to becoming "the sport of kings," but it attracted a large following among those of more modest means. As the great American poet of the time, Walt Whitman, then living in Brooklyn, exclaimed, "Never was such horseflesh as in those days on Long Island or in the City."[40]

Thoroughbred racing probably had its start in colonial Maryland and Virginia, but even before American independence a track was constructed in Suffolk County, New York. Named after the famous Newmarket track in England, it was fashionable from the start but limited in its popularity to the comparatively wealthy. In 1821 the Union Course was erected on Long Island, and it attracted larger crowds. On May 27, 1823, sixty thousand people visited the track to watch five Virginia and Kentucky thoroughbreds challenge Eclipse, a descendant of the English thoroughbreds Messenger and Diomed.[41]

Trotting races came into vogue in the early decades of the nineteenth century. By the 1830s a trotting course was established just outside New York City near Jamaica, and within a few years trotting races drew larger crowds than thoroughbred racing. At least at the start, some horses of quite modest origins became heroes. Top Gallant, for example, one of the first trotters to achieve popularity and to win large sums of money, once pulled a New York hackney, or cab. Dutchman, another hero of the day, began life trampling clay in a Philadelphia brickyard. Moreover, because so many middle- and upper-class urban men owned potential trotters—horses used for the more practical purpose of transportation but that might be raced through city streets—amateur racing was soon in vogue. As one commentator said, "By mid-century, harness trotting had developed into the average citizen's most frequent impromptu sport." To another, it was "a great equalizer."[42]

PEYTONA AND FASHION

FIGURE 55. *Peytona and Fashion.* Nathaniel Currier (undated).

It was the golden age of trotting, and the trotting craze developed into an amazing fever. New York's Third Avenue presented a fine, clear sweep from Harlem to the Bowery and became a favorite spot for amateur racing. Some pushed the contest to dangerous, even disastrous, ends. One New York observer described the scene on certain New York streets as places where "fast old men and fast young men . . . stock speculators, millionaires, railroad kings [and] bankers . . . the bloods of the city" turned out to race their trotters and rigs. "All is exhilaration," he wrote, "the road is full of dust; teams crowd the thoroughfare . . . [where they] frequently interlock and smash up, while the tearing teams hold on their course."[43]

Thoroughbred racing staged a comeback after the Civil War. Gambling on horse racing became the rage, and speed—not only of the horses but of the races themselves—became paramount. Inexpensive legal wagers made it attractive for people of more modest means to bet, and racing's new audience, of a decidedly less leisured class, did not care to wait for the customary four heats over longer courses taken by trotters. Thoroughbreds could decide wagers in one short sprint.[44] A sizable portion of Currier and Ives's collection pictured thoroughbred racing. Among the best known of this genre was *Pey-*

tona and Fashion (Fig. 55) by Charles Severin. Undated, but likely done soon after the race, it celebrated "their Great Match for $20,000 over the Union Course, L[ong] I[sland]. May 13th, 1845." Severin showed Peytona, the victor, and Fashion, with jockeys in the saddle, racing past a bend in the track. Crowds of people, estimated at 76,000 to 100,000, line the track, many on horseback and in horse-drawn carriages. The print includes all the vital information concerning the horses, the jockeys, the race, and the public wagers.[45]

Many of the most famous thoroughbred races of the antebellum period were intersectional, pitting Northern horses against Southern favorites. The race between Peytona and Fashion was one such rivalry. It was dubbed "the Race of a Century." Peytona was bred in Alabama, Fashion in New Jersey. The South, the "land of cavaliers, kings, and ladies fair," long had taken pride in its fine mounts, but in the nineteenth century the North fielded several serious, and often victorious, challengers. In May 1845, however, the South retained its dominance in this particular sport. One source has claimed that thoroughbred horse racing was the only intersectional sports rivalry in antebellum America. "The code of the southern gentry seemed to rule out individual competition" in other sports. "The breeding of fine horseflesh was a concern of the gentry, North and South, a pursuit in the English tradition."[46]

Currier and Ives provided portraits of the great thoroughbreds of the day, standing alone, posing for the artist, and not in the process of racing. Such prints usually listed the horses' owners and reference to their greatest victories. Representative of these thoroughbred prints are *Lexington: The Great Monarch of the Turf and Sire of Racers* (undated), showing probably the most famous thoroughbred of the nineteenth century, and *Imported Messenger: The Great Fountain Head—in America—of "the Messenger Blood"* (1880). In his 1905 book, *The American Thoroughbred*, Charles Trevathan wrote, "Lexington belonged not alone to the turfmen. He was the heritage of the nation. He was Lexington in the minds of the people, and after him there was merely other horses."[47] Louis Maurer drew the portrait of Lexington; John Cameron pictured Imported Messenger. Messenger, imported from England, sired some of the nation's top racehorses.[48]

Currier and Ives pictured racing trotters, as well, in both formal and informal racing venues, on the track and off. The first group included nationally prominent trotters. Louis Maurer's *Stella and Alice Grey/Lantern and Whalebone* (1855) pictures a group of well-known trotters "passing the stand" in a race at Union Course in 1855. John

Cameron presents another scene from a harness race at Hartford, Connecticut, in 1878 in *Sweetser—Sleepy George and Lucy* (1878). But an even greater number of prominent trotters are offered individually, much like the many thoroughbred portraits Currier and Ives offered for sale. A representative sampling includes *The Trotting Horse George Palmer Driven by C. Champlin* (1870), *The Trotting Mare "American Girl" Driven by M. Roden* (1871), and *The Trotting Mare Goldsmith Maid Driven by Budd Doble* (1870), all drawn by John Cameron. Whereas thoroughbreds posed without rider or even saddle, trotters appeared fully harnessed, with driver, in action. Each also includes the usual list of vital statistics. If Cameron or any of the other artists consciously strayed from an exact rendering of the horse being pictured, it was only in elongating slightly the bodies of the animals, the attenuation giving a greater effect of speed.[49]

In 1869 Thomas Worth drew two companion prints that show several men in their horse-drawn carriages racing through a city street to a race track. *Going to the Trot: A Good Day and Good Track* pictures them en route; *Coming from the Trot: Sports on the Home Stretch* pictures their return. New York's Harlem Lane, nicknamed the "Speedway," was the scene of many informal contests, including no less a personage than Commodore Vanderbilt as shown by John Cameron in *Fast Trotters on Harlem Lane, NY* (1870). Cameron pictured several horses and carriages racing along this tree- and mansion-lined lane, which sported a building labeled "Club House" with a separate "Ladies Entrance" well removed from the main entrance. In *"Trotting Cracks" on the Snow* (1858) Louis Maurer pictured several one- and two-horse sleighs pulled by famous trotters—Pocahontas, Lancet, Prince, Grey Eddy, General Darcy, Flora Temple, Lantern, Lady Woodruff, Brown Dick, Alice Grey, and Stella—racing along a snowy road, a black dog in pursuit.

Hunting and fishing became very fashionable among urbanites in the 1830s and 1840s, and Currier and Ives produced dozens of prints on those subjects. Foxhunting was particularly popular among the upper classes, who aped the manners of British aristocrats. According to one chronicler of the time, in the second-half of the nineteenth century foxhunting became "more widespread and more significant" in the United States than in England, where it originated. It "had an amazing effect on the social development of the country . . . politics and business," and Manhattan in particular became a "foxhunting paradise."[50]

Currier and Ives pictured the foxhunt in two popular series: the four-part *Fox Chase* (1846) and the four-part *Fox-Hunting* (undated).

Both series take the viewer from the gathering of hunters, horses, and hounds through the pursuit, the killing, and the triumphant return of the hunters. The first series is subtitled *Throwing Off, Gone Away, In Full Cry,* and *The Death.* The second is similarly segmented into *The Meet, The Find, Full Cry,* and *The Death.*

Much more numerous among Currier and Ives's hunting prints are the more than one hundred lithographs that focused on the hunting of the middle class. They followed the lead of nineteenth-century popular magazines that explained in detail the "love" of the hunt, picturing it in quite urban, well-mannered, highly fashionable—and masculine—terms. Most Americans in the seventeenth and eighteenth centuries got nearly all their meat from domesticated animals. Hunting was an inessential luxury. Even in the first decades of the nineteenth century, when the nation was still overwhelmingly rural, hunting was held up to ridicule as a waste of time and money and mocked as "the play of insufficiently grown-up boys." In the popular press, it was portrayed as "both exotic and foolish. Hunters themselves were often portrayed as little more than tedious bores looking for any opportunity to tell the same tired story of the glorious hunt."[51]

By midcentury the American attitude toward hunting had changed, especially among the urban. The cities of America had grown rapidly, changing the lives of those who moved there just as quickly and often disconcertingly. As the pseudonymous Frank Forester wrote, "Never was it more needful for the advantage, moral and physical, of all classes, that some comprehensive plan of rational diversion and relaxation from incessant labor and anxiety, should be devised and recommended." Forester's real name was Henry William Herbert. He became America's first author of sporting books and was a good friend of Arthur Fitzwilliam Tait, Currier and Ives's best source of hunting and fishing pictures.[52] Forester and Tait, like poet William Cullen Bryant and painters Thomas Cole and Asher B. Durand, advocated close communion with nature as a way of healing the ills of "civilization." However, as Bryant pointed out in "Thanatopsis": "To him who in love of nature holds / Communion with her visible forms, she speaks / A various language."[53]

There seemed to be at least two different "languages" with which nature spoke to nineteenth-century Americans. One approach was epitomized in the words of Henry David Thoreau: "In wildness is the preservation of the world." Alfred M. Mayer echoed this sentiment in his book *Sport with Gun and Rod in American Woods and Waters* (1883):

An impulse, often irresistible it seems, leads man away from civilization, from its artificial pleasures and its mechanical life, to the forests, the fields, and the waters, where he may have that freedom and peace which civilization denies him."[54]

Another approach was taken by nature-lovers such as C. W. Webber, author of *The Hunter-Naturalist, Romance of Sporting; or Wild Scenes and Wild Hunters* (1851), who found in nature a more atavistic communion:

All the impulsion of our national character—all of the hardy, stern, resolute and generous that may be nature, we take through the noble blood of our hunter ancestors.[55]

Some thirty years later, D. W. Cross embellished on the idea in *Fifty Years with the Gun and Rod* (1880):

From Nimrod, "the mighty hunter before the Lord," down to the time of David Crockett, Daniel Boone and their compeers of today, the fame of the hunter, his cunning, skill and prowess, run parallel with the glory and honors of the most renowned warriors. It was a great honor to be a "mighty hunter before the Lord," and today the skilled hunter has an admiring and enthusiastic following.[56]

The growing popularity of hunting was given impetus by American arms manufacturing, which reached new heights of productivity during the 1850s and sought to create a market other than that of the federal government. Colt, Sharps, Remington, Robbins and Lawrence, Smith and Wesson, and Winchester all promoted the sport and advertised their products in the leading popular magazines of the day.[57] The rise of hunting as a sport was also connected with troubling aspects of masculinity, or at least the challenges posed to traditional definitions of masculinity by the switch from a rural to an urban America, where the same gendered divisions of life no longer existed. In 1832 Oliver Wendell Holmes sadly characterized the college students of his acquaintance as "soft muscled, pasty complexioned youth," to which, a few years later, Frank Forester added, "It will scarcely, I think, be questioned or disputed, that never was there more need that some measure of manliness should be infused into the amusements of the youth of the so-styled upper classes—the jeunesse dorée—of the Atlantic cities, some touch of manhood inoculated into the ingenuous youths themselves."[58]

To assist the cities' youth in improving their manliness, Forester published *The Complete Manual for Young Sportsmen* (1864). As early as 1827, however, there had been hunting books such as *The American Shooter's Manual*. It was advertised as "comprising such plain and simple rules, as are necessary to introduce the inexperienced into a full knowledge of all that relates to the dog, and the correct use of the gun," as well as "a description of the game of this country, by a gentleman of Philadelphia County."[59] D. W. Cross made the case for hunting and fishing as the best way to train youth in manliness: "Most boys as naturally take to the rod and gun as young ducks to the water. Encourage them in this if you would instill into their minds self-respect, self-confidence, and an ardent love of nature; and develop in their young muscles such vigor and endurance as will enable them to defend themselves and their country in battle; and in peace, to drive the hungry wolf from their doors."[60]

Largely through Forester's and Cross's efforts—as well as John Stuart Skinner's *American Turf Register*, which began publication in 1829, and William T. Porter's *Spirit of the Times*, first published in 1831—hunting became an appropriate enterprise for would-be gentlemen. "It is extremely difficult to find an article published in either of those journals or a gun advertisement in any newspaper that did not use the word 'gentleman' in describing a hunter."[61] The result was a man's bonding with and deep, romantic affection for his favorite gun. The increasingly widespread belief was that real men hunt, while "the effeminate young man may die at home, or languish in a dead calm for the want of some external impulse to give circulation to the blood."[62]

Nineteenth-century American men's love affair with hunting paralleled their fascination with trappers and hunters of the West, and even involved artists of the West, such as Arthur Tait. A dedicated outdoorsman, Tait soon came to know the woods of northern New York State, where he spent a substantial part of every year hunting, fishing, and sketching. The same longing to escape the confines of civilization and to test one's mettle against the forces of nature fueled the appeal of Tait's hunting and fishing prints as well as his pictures of the frontier trapper.

As one popular writer of 1857 told his restless male readers, quite likely touching a responsive chord among many, he often woke up in his city home with a sense of suffocation: "I wanted to be free and comfortable for a month; to lay around loose in a promiscuous way among the hills, where beautiful lakes lay sleeping." His watchful wife detected the signs and packed his valise without remonstrance, and

he was off to the land of boyhood memories.[63] He did not leave without proper attire, modeled after British aristocratic sportsmen, and an ample supply of the creature comforts he had came to appreciate in the city. Henry William Herbert, a writer and outdoorsman who sometimes collaborated with Currier and Ives, described the ritual for the anointed as they left New York for the wilds: "The fine guns were packed—Mantons and Joe Spurlings and double-rifles; the best diamond gunpowder from the fashionable sports shop of Brough; a fifty-pound round of spiced beef from Fulton Market; a gallon of "Old Ferintosh" whiskey from the Octagon; a plump cheshire cheese; Manila cigars and a case of port or claret."[64]

In 1869 it was estimated that a gentleman-camper from New York could enjoy a month in the wilderness for $125. His guide would cost him $2.50 per day and board per man $2 a week. But as the authority W. H. H. Murray told his readers, a man would get more from such a trip than from all the "Sabbath-school festivals and pastoral tea-parties": "I know of no other excursion in which such a small sum of money will return such per cent in health, pleasure and profit." And, beyond health and pleasure, the take was not inconsiderable. One group hunting in the Adirondacks in 1859 reported that they had bagged twenty-one quail, nineteen woodcock, four grouse, and a rabbit. In the afternoon they added fifty-two woodcock, twenty-four quail, five grouse, and a rabbit.[65]

Arthur Tait produced a series of prints for Currier and Ives that documented the transformation of hunting into the sport of gentlemen, complete with previously unknown luxurious trappings. Two of his finest are *Camping in the Woods: "A Good Time Coming"* (1863) and *Camping in the Woods: "Laying Off"* (1863, Fig. 56). In the first scene four fashionably dressed "gentlemen woodsmen," with bountiful and elaborate supplies, set out to enjoy the delights of nature, hunting, and fishing. In the second scene, they have returned and are gathered around a campfire to enjoy a well-prepared meal, combining the day's catch of fish and fowl with the "necessities" of civilization.

Two prints quite similar in their representation of the gentlemen hunters are Tait's companion prints *American Hunting Scenes* (1860): *"An Early Start"* and *"A Good Chance."* In the first print two sportsmen are about to board a canoe. One holds a rifle; a dead deer hangs from a nearby tree at the end of the forest. Another canoe has already been launched carrying two other hunters. *"A Good Chance"* shows two of those hunters in a canoe, one paddling while the other fires his rifle at a moose on shore. Both scenes are set in the Adirondacks.

CAMPING IN THE WOODS

FIGURE 56. *Camping in the Woods: "Laying Off."* Currier and Ives (1863).

To the modern eye Tait's more dramatic scenes, like *The Life of a Hunter: A Tight Fix* (1861) and *The Life of a Hunter: Catching a Tartar (1861)*, look implausible and over-dramatized, with their fearless if disheveled huntsmen grappling in hand-to-claw or hand-to-horn combat with enraged wild beasts. Yet there is at least some evidence to confirm Tait's tales. In 1848 Henry William Herbert, a leading authority on hunting in those days, said in *Frank Forester's Field Sports* that Western bear hunters with bowie knives had "no hesitation whatever in going in hand to hand with the brute when at bay, in order to preserve their hounds . . . nor is it once in a hundred times that their temerity is punished by a wound."[66]

Louis Maurer later recalled that he had been in Tait's studio when he was working on the original painting for *A Tight Fix*, and that Tait had mentioned that a guide from Long Lake in the Adirondacks had witnessed and told him the story upon which the picture was based. Two hunters suddenly came upon a large black bear. The angered animal attacked one, wounding him in the shoulder, but when the bear then hesitated, the second hunter had the opportunity to draw a bead and shoot it.[67]

In 1809 Elisha Risdon, a northern New York State farmer who left a remarkable diary, had a personal struggle with a wounded deer that was so like Tait's *Catching a Tartar* that one wonders if Tait had heard the tale somewhere in the Adirondacks. Mostly, however, both prints allayed urban male fears that it was no longer possible to be men, and the demand for them encouraged Currier and Ives to issue an estimated seven thousand copies.[68]

Frances Palmer was well represented in this line of lithographs, as well. Her husband was something of a hunter, and she seems to have accompanied him on some hunts, no doubt much tamer than those just noted. Palmer sketched what she witnessed, including her husband and his dogs. In 1852 she produced a series of such prints titled *Woodcock Shooting, Partridges Shooting, Wild Duck Shooting,* and *Rail Shooting on the Delaware.* She, Tait, and others also produced dozens of prints of various game birds, fish, and hunting dogs.

Though not as obviously masculine as hunting, the sport of fishing became popular at about the same time. D. W. Cross described "the devotees of this art (for angling is an art)" as "widespread and cosmopolitan. The rich and poor, the wise and simple, the statesman and the humble laborer, have each and all, from time immemorial, 'cast their lines in pleasant places,' for pleasure, for profit, for pastime and food." He went on to say that "a fool and knave could never become a professional angler. The contact of the angler with nature and with nature's God would be too much for him."[69]

Arthur Tait's pictures of the gentlemen sportsmen in *American Hunting Scenes* (1860) were noted earlier. Two quite similar prints titled *Life in the Woods* appeared in the same year. They have been attributed to Louis Maurer, but the similarities are striking. In *"Starting Out,"* four gentlemen prepare to embark from camp. One man, with a gun across his knees, and a dog are seated in a canoe, which a second man pushes away from the shore. A third man carries a fly rod and a net and steps into a rowboat, while the fourth emerges from the woods carrying oars and a gun. Another dog swims toward the canoe. In the second print they have all returned to camp, a pile of fish lying on the bank of the lake.

Much like Currier and Ives's hunters, their fishermen are gentlemen with leisure at their disposal. Some belonged to private clubs. Many dressed in conventional coats and neckties and used more sportsmanlike, as opposed to more efficient, methods to fish—like fly-fishing versus bait. As John J. Brown wrote in 1845 in *The American Angler's Guide,* "Of all the various modes adopted and contrived by the

ingenuity of man for pulling out the "cunning trout," this [fly-fishing] at once recommends itself as the perfection of the art . . . it is the most gentlemanly, the most elegant."[70]

Obviously Currier and Ives's fishing prints, much like their hunting scenes, were idealized, but in their many attempts at reflecting the reality of particular elements, they also "reminded" male viewers of similar experiences they had known and enjoyed. In the case of *Trolling for Blue Fish* (1866), for example, Frances Palmer—who, it is reported, was an avid blue fisherwoman—did the background for the print (and signed it), but Thomas Worth drew the boat. It was based on the vessel from which he often fished. It was also nearly identical to the boat used for the same purpose included in a marginal vignette on the table of contents of Brown's *American Angler's Guide.*[71]

The print shows the then-popular method of fishing for bluefish: trolling, or "squidding," with squid-baited hooks dragged along the surface at a leisurely pace. Small sailboats, like that pictured, known as the Cape Cod catboat, were ideally suited for trolling; it was highly maneuverable, but also broad-beamed, stable, and safe. The one pictured once belonged to Capt. Hank Hoff, a legendary Long Island sailor-skipper in international cup competitions. The setting is just off Staten Island, which was in those days a fisherman's paradise.[72]

Freshwater fishermen flocked to the Catskills and Adirondacks, and Arthur Tait caught several of those outdoor expeditions in his paintings, the printing rights to which he sold to Currier and Ives. Otto Knirsch used one of Tait's pictures to produce *Catching a Trout: "We Hab You Now, Sar"* (1854). Frank Forester is pictured as one of the two fisherman (on the right). The stiff bearing and formal dress of the fishermen suggest that trout fishing was a sport for gentlemen.

Tait pictured ice fishing in *American Winter Sports: Trout Fishing "On Chateaugay Lake" (Franklin Co. N.Y.)* (1856). Tait had a camp on Chateaugay Lake, and the man he pictured fishing through a hole in the ice was a friend, Thomas Barbour. In the company's 1860 catalog, Currier and Ives described the fisherman as an enthusiastic disciple of Izaak Walton, the well-known English sportsman and author of *The Compleat Angler* (1653).[73] Tait also provided Currier and Ives with a representative stream fishing scene in *Brook Trout Fishing: "An Anxious Moment"* (1862). A bearded, fashionably dressed sportsman stands in a stream reeling in a trout to add to the two good-sized fish lying on the bank next to him. He appears to be struggling to keep his balance, grasping a slender tree next to him with one hand, while holding his pole in the other.

Frances Palmer's fishing prints were generally less "action packed" and more idyllic, although drawn from first-hand observation like Tait's. One such print is *The Trout Stream* (1852). One man, perhaps her husband, stands fly-fishing on the bank of a river, a wicker creel over his shoulder. A companion watches, seated on a mossy rock and holding a net. The fisherman's line disappears into a pool at the base of the rapids that pour down a boulder-strewn incline beside a rocky outcropping.

Before 1860 the only purely professional sports were boxing, horse racing, and cockfighting. Of the amateur sports only rowing and baseball had been organized, and it was not until after the Civil War that sports were taken up by the colleges. In 1865 the nation's oldest intercollegiate competition was initiated when Harvard and Yale began to row an annual four-mile (6.4-kilometer) race. College track events got under way in 1874, and the Intercollegiate Association of Amateur Athletics was formed in 1876. English lawn tennis reached America about 1875, but American football, golf, and basketball did not take hold until the 1880s and 1890s and are, therefore, absent from the Currier and Ives collection. Except for the horse-racing pictures, and a few foxhunting prints copied from English prints, virtually all of the seven hundred or so Currier and Ives sporting prints were done after the Civil War.

The company made fifteen or so boxing prints, several of which were discussed earlier in the context of Irish Americans, among whom prizefighting was quite popular. As noted, it was one way the nearly destitute could earn a decent wage. The first recorded boxing match in the United States took place in 1816. Then, and for most of the rest of the century, prizefighting was done bare knuckle, and a match continued until one of the fighters could not continue to fight. Many a fight went beyond a hundred rounds and lasted more than two hours.[74]

The most popular prizefights were between national champions. One such fight covered by Currier and Ives, pitting the Irish American John Heenan and the English champion Tom Sayers in 1860, was described on page 251. Portraits of boxers, including the boxers' physical measurements and accomplishments, were more common. They included *Arthur Chambers: Lightweight Champion* (undated), by John Cameron; *Nat Langham: Champion of the Middleweights* (undated), by an unknown artist; *Paddy Ryan: "The Trojan Giant"* (undated), by an unknown artist; *Tom Paddock* (undated), by an unknown artist; and a series of six portraits of the aforementioned English champion, Tom

Sayers, all based on a design by Louis Maurer in 1860, the year he fought "The Benicia Boy."

Currier and Ives pictured cockfighting in much the same way, offering prints of the contest and of the participants, birds trained and "dressed" to fight to the death. In *A Main of Cocks—the First Battle* (undated), by an unknown artist, two gamecocks, their beaks almost touching with spurs attached to their feet, square off for a fight. The ring in which they are to fight is pictured behind them. Another unknown artist pictured the gamecock El Gallo de Pelea in two prints so titled in 1848 and 1849, the latter subtitled *In Full Feather*.

No one is certain just how baseball first came into being. Most leading authorities no longer believe that Abner Doubleday invented it in 1839 at Cooperstown, New York, but some still hold out that he helped organize the sport. During the early decades of the nineteenth century, there were several informal games that used bats, balls, and bases. The game likely originated in the old English game of rounders. The New England variant was called "town ball," and Oliver Wendell Holmes recalled playing it at Harvard College in the 1820s. However, in these early ball games there was no set number of players, and the batter stood in the middle of one side of a square playing field. Outs were recorded by "plunking" base runners with a thrown ball, and one out retired the side. A fixed number of runs, usually one hundred, won the game.[75]

The first genuine baseball team in the United States was the Knickerbocker Base Ball Club, organized in New York City in 1845 by a number of gentlemen sportsmen. Their home field was in Hoboken, New Jersey, where they played by more modern rules provided by Alexander Cartwright. They had nine-man teams and flat bases placed 90 feet (27.4 meters) apart, and they developed what was known as the "knickerbocker" or "New York" style of baseball. For several years baseball was played almost exclusively in the environs of New York City, by young gentlemen in cricket flannels, straw hats, and cleated boots. The first game on record between two teams did not take place until 1846, but in the remaining years before the Civil War baseball clubs were formed in many large cities of the Northeast. By 1860 there were more than fifty member teams in the National Association of Baseball Players, organized three years earlier.[76] The reader will recall from the previous chapter that in 1860 baseball was well enough known nationally to be employed by Louis Maurer in the political cartoon, *The National Game: Three "Outs" and One "Run"/*

THE AMERICAN NATIONAL GAME OF BASE BALL

FIGURE 57. *The American National Game of Base Ball.* Currier and Ives (1866).

Abraham Winning the Ball, a commentary on the presidential election of that year (see page 274).

During the long years of the Civil War, American soldiers on both sides found themselves with idle hours to spend at games and sports. One of the most popular of the new games among them was baseball, which the men took home to all parts of the country when the fighting ceased. One of the earliest baseball lithographs shows captured soldiers playing the game. *Union Prisoners at Salisbury, N.C.* was drawn by Act. Maj. Otto Boetticher and published in 1863 by Major and Knapp, one of Currier and Ives's competitors. By 1866 there were more than two hundred member clubs in the National Association, and in that year Currier and Ives published *The American National Game of Base Ball* (Fig. 57).[77]

The American National Game of Base Ball, by an unknown artist, pictures "the grand match for the championship at the Elysian Fields, Hoboken, N.J." None of the players is wearing a glove—it was not invented until 1875 and then was resisted for several years as an "effemi-

nate" innovation. The pitcher throws the ball underhand, and the umpire stands far to the right on the first-base line. Only if the batter persistently declined to swing at pitches did the umpire call a strike. A foul ball, if caught on its first bounce, was an out, but the ball was made of India rubber and, it was said, "often bounced a housetop high." Fashionably dressed male and female spectators, and their carriages, line the outfield; others crowd the infield. Nevertheless, the scene looks familiar. It is the best of the early baseball lithographs.[78]

For reasons that are still hotly contested, baseball quickly became the national game. In 1866 one commentator called it "a game which is peculiarly suited to the American temperament and disposition." Twenty years later Mark Twain referred to baseball as "the very symbol, the outward and visible expression of the drive and push and rush and struggle of the raging, tearing, booming nineteenth century."[79] More contemporary students of the game have predicated its success on its marking "the transition from individual to corporate values"; its expressing "the American notion of individualism . . . independence, self-reliance and equality"; and its articulating the "American commitment to equal opportunity as each batter is afforded the same number of at-bats regardless of success."[80] All of these themes are present in Currier and Ives's prints. Interestingly, however, Currier and Ives did not produce any more "straight" baseball prints, no doubt because there was no market for them yet. In the 1870s and later they issued four baseball comics as part of their *Darktown* series, but that was all.

America's love of yachting was closely tied to its earlier fascination with clipper ships. Currier and Ives published at least seventy lithographs dealing with yachting. Twenty or so are devoted to the vessels that took part in the America's Cup races, up to and including the 1893 challenge of the defender *Vigilant* by the unsuccessful *Valkyrie II* in *"Vigilant" and "Valkyrie" in a "Thrash to Windward"* (1893). The print pronounces *Vigilant* the winner of the race that took place on October 7, 9, and 13 and shows the *Vigilant* in the lead, racing through a calm sea ahead of her opponent.

Before the Civil War, there had been only one yacht club in America—the New York Yacht Club, which had been organized in 1844. First headquartered in Hoboken, New Jersey, after about twenty years it was moved to Staten Island, the locale of the 1869 Currier and Ives print, *The New York Yacht Club Regatta: The New Club House.* Drawn by Charles R. Parsons and Lyman W. Atwater, it focuses on a large group of fashionably attired ladies and gentlemen gathered at

the club to watch the race. A line of fully rigged yachts stretches to the horizon, ready to begin the race.[81]

After 1850 certain members of the New York Yacht Club, having raced among themselves for years, wondered how their fast schooners might stack up against their British counterparts. They issued a challenge to the Royal Yacht Squadron. The British replied with only a polite and tentative acknowledgment, but that was enough to spur the club into hiring George Steers to design and build a new yacht, the *America*. In 1851 John Stevens sailed her to England to issue a challenge to all comers to race for a substantial purse.[82]

On the morning of its arrival in the English Channel, *America* was met and challenged by a new British yacht named *Laverock*. Although the American vessel was heavily laden with all of the baggage and gear for a transatlantic crossing, it so easily defeated the English yacht that no other skippers stepped forward individually to challenge it. Stevens entered *America* in a Royal Yacht Squadron race around the Isle of Wight, the stakes for which were a large silver cup and a hundred guineas. On August 22, 1851, *America* outsailed seventeen of the Royal Yacht Squadron's best vessels and claimed the urn that thereafter would be known as the America's Cup.[83] Currier and Ives rushed out *The Clipper Yacht "America" of New York* (undated) to mark the victory.

The yacht also appears in the firm's cartoon *Great Exhibition of 1851* (undated), which boastfully compares American achievements with those of the British on display at the Crystal Palace exhibition. A poem on the print reads:

Yankee Doodle had a craft,
A rather tidy clipper,
And he challenged, while they laughed,
The British to whip her.
Their whole yacht squadron she outsped,
And that on their own waters;
Of all the lot she went ahead,
And they came nowhere arter.

The last line echoes the legendary response to Queen Victoria's inquiry about which boat came in second: "There is no second, Your Majesty," the observer reported.[84] In *Great Exhibition* an unknown artist pictures an American in an early version of the still-evolving Uncle Sam, John Bull as a fat Englishman, two paddle wheelers, and the yacht *America*. A group of Englishmen nearby grumble over the

ingenuity of an American agricultural implement in the background.

Other representative Currier and Ives yacht prints are *The Yacht "Henrietta" of N.Y.* (undated) and *The Yacht "Madeline," N.Y. Yacht Club* (undated), typically listing information on the yachts' accomplishments, measurements, owners, and skippers. The company's racing prints include *The Great International Yacht Race* (1876) and *The Race for the Queen's Cup* (undated), more properly titled *The Race for the America's Cup*. The first noted race took place in 1870 off Staten Island and involved seventeen American yachts and one English craft, the American vessel *Magic* winning the day. The second race featured the contest between the American yacht *Sappho* and the English yacht *Livonia*, in New York harbor in 1871, which was won by the American vessel as well. Most Currier and Ives prints pictured American victors, which were plentiful in the decades immediately following the Civil War.

In 1865 rowing became the nation's first intercollegiate competition, when Harvard and Yale began an annual race. As this would suggest, it was a very popular sport in the mid–nineteenth century, but by then it had been in America for more than a hundred years. The first recorded race was in New York harbor in 1756. A race in 1811 between Long Island and New York crews is often cited as the first American match, apparently because the winning boat was later displayed in P.T. Barnum's museum. There was a regatta at Poughkeepsie on the Hudson in 1837. In 1834 the Castle Garden Amateur Rowing Association, a group of amateur rowing clubs, was formed, with a boathouse at Castle Garden and a racing course to Bedloe's Island and back.[85]

Two rowing heroes at midcentury, James Hamill and Walter Brown, held the public's attention for years with their feats in single shells propelled by short oars, known as sculls. In 1867 Hamill and Brown competed in a five-mile (eight-kilometer) rowing match on Newburg Bay in the Hudson River for a four-thousand-dollar prize and the privilege of being called the American champion. Currier and Ives captured the moment in the anonymously drawn *James Hammill and Walter Brown in Their Great Five Mile Rowing Match* (1867). The print shows the two men in single sculls, Hamill holding a slight lead. Rowing teams, sailing vessels, and paddle wheelers are all around them, and spectators dot the river banks. The caption explains that Hamill won, "on a claim of 'foul' allowed by the referee Stephen Roberts, Esq." in forty-one minutes and fifty-six seconds. It also provides the vital statistics on the boats, including their builders and measurements.

Another popular sport of the time was long-distance walking. In the United States it started with Edward Payson Weston, who, having lost a bet on the 1860 presidential election, was required to walk 478 miles (717 kilometers) between Boston and Washington to attend the inauguration of Abraham Lincoln. Weston attracted a good bit of attention for his exploit, and soon he was making a living from long-distance walking for wagers. In October and November of 1867 he walked the 1,237 miles (1,979 kilometers) from Portland, Maine, to Chicago for a ten-thousand-dollar stake.[86]

By the 1870s the sport of long-distance walking moved to indoor tracks, organized into set competitions, and began awarding championship belts. In 1879 Currier and Ives issued *Charles Rowell, The Celebrated Pedestrian* upon Rowell's winning the Astley Belt, representing the long-distance championship of the world. The contest took place at Gilmore's Garden, New York, March 10–15, 1879. The print, by an unknown artist, is a portrait of the great walker, complete with the statistics on his measurements and accomplishments. Currier and Ives made light of the event and the fate of its participants in *The Great Walk. "Go as You Please." The Start* (1879) and *The Great Walk. "Come in as You Can." The Finish* (1879), both of which involved Irishman John Ennis and England's Charles Rowell.

Sporting Humor

Americans took sports seriously, whether participatory or spectator. But they could also find humor in them. We have already seen a few of these comics as they relate to the Irish; many more appeared in the *Darktown* series, wherein Thomas Worth pictured the ineptitude of blacks to engage in any "white" sports, despite their desire to do so and their best efforts. The remaining sports comics were many and varied.

The largest number of sports comics deal with horse racing, not surprisingly, given the frequency of the subject among all sports prints. Many involve sulkeys. Some are simple renderings of not uncommon mishaps. In *"A Balk" on a Sweepstake* (1881), for example, Thomas Worth pictures two jockeys being flipped out of their carriages over the heads of their horses, when the horses balk at the approach of another team that is dragging tree branches to smooth the track. In his two-part comic *Delaying a Start: "Come Quit Fooling and Bring up That Horse"* (1881) and *A Feather Weight Mounting a Scalper: "It's Only a Little Playful He Is"* (1881), Worth pictures a diminutive jockey losing con-

trol of his mount. The horse kicks its hind legs high in the air, bucking the jockey into the arms of its trainer. In the second print the horse has the jockey's cap and some of his hair in its teeth.

Other prints find humor in the pretense of the inelegant to thoroughbred status, as in the anonymously drawn *The Boss of the Track* (1881). The horse, whose rider wears pants patched on the backside, lopes around the track, legs askew, while three judges, a stableboy, and a spectator cheer them on, highly amused. In the ironically titled *The Horse for the Money: Dexter in Danger* (1869), John Cameron shows a young boy in tattered clothes, presenting a bony, dispirited nag to a newspaper editor who, nearby signs indicate, had recently offered a hundred thousand dollars for any horse that might equal the champion, Dexter.

A number of prints satirize questionable practices at the track in attempts to influence the outcome of races. One rule of organized thoroughbred racing allowed judges to provide substitute riders in the case of the last-minute withdrawal of the original jockey, provided the substitute is "competent and reliable"—therefore, in theory, not changing the odds for victory. In *A Change of Drivers under the Rule: The Man Who Drives to Win. The Man Who "Pulls" His Horse* (1876), Worth pictures an obese driver being paid fifty dollars to be a substitute rider for the horse, Hercules, while another man, perhaps his owner, expresses outrage.

Currier and Ives published prints that found humor in the mishaps in training or caring for racehorses. In the two-part vignette, *A Crack Trotter—"A Little Off"* and *A Crack Trotter—"Coming Around,"* both issued in 1880, Thomas Worth shows a racehorse in a checkered blanket first standing in a tub of water while the groom sponges him down, then bucking high and sending the groom, the tub, and various bottles flying, and biting another groom on the seat of his pants. In an anonymously drawn print, *A "Crack Trotter" between the Heats* (1875), while four grooms attend a trotter and the driver looks on, one of the grooms pours whiskey down the horse's throat. The humor of this print must have appealed to some because it was soon reissued as a trade card (a common form of advertisement of the time) with gin substituted for the whiskey. Worth reversed the situation in the two-part comic vignette *Getting a Boost* (1882) and *On the Homestretch* (1882). He pictures three black men preparing an entry for a harness race by boosting an inebriated white driver into a rig. In the next scene, the driver has been thrown on his backside, part way through the rig's folded convertible top, both legs sticking up in the air, much

to the amusement of the black grooms who slap their knees and dance with laughter.

Given the popularity of impromptu street racing among horse-drawn carriages, it is not surprising that Currier and Ives issued so many prints satirizing that common occurrence. In 1855, for example, Thomas Worth poked fun at the pride taken by the wellborn in their rigs by picturing one such debonair older gentleman being nearly run off the street by a wagon driven by two young boys. The young driver shouts, "Hi! Hi! G-long old hoss. I'm one of the Woodruffs," while the other thumbs his nose at the older man, shouting: "Say, old feller, 'ain't we some?" The print was titled *A Brush on the Road: Mile Heats, Best Two in Three* (1855). John Cameron offered a similar print under essentially the same title, *A Brush on the Road: Best Two in Three* (1872), nearly twenty years later. Worth pictured the reverse, and more common occurrence, in *The Bully Team! Scaldine and Early Nose* (1882), wherein a caricature of "Comm. W. H. Vanderbilt," wearing a top hat and sunglasses, with huge side-whiskers, passes under an arch labeled "Charter Hoax Park" and challenges the more commonly attired driver of a rather puny horse to a race.

In 1873 Worth and Cameron teamed up to picture another humorous street racing scene in *Trotting on the Road: Swill against Swell.* In this print two rigs, each drawn by a single horse, race neck and neck along the road. One vehicle is driven by a well-dressed gentleman, the other by a toothless, disheveled, and ragged fellow, who stands on his wagon grinning at the gentleman. The poorer man's wagon is loaded with a huge keg of liquor from which spirits splash in response to the rough ride.

In contrast to their many prints celebrating victory, Currier and Ives also saw humor in the "agony of defeat." In *Dusted—and Disgusted* (1878), for example, Thomas Worth showed one particularly disgusted, well-dressed driver of a four-wheeled carriage trying to reign in his horse, which is rearing up in an attempt to avoid great clouds of dust left behind by the much faster rig that pulls ahead in the street contest. In *The Horse That Died on the Man's Hands* (1878) the anonymous artist shows a driver with enormous hands and a look of horror on his face, holding a trotter upside down in his arms as it expires. The moral of the story is suggested in the subtitle *"Don't' Hold Your Trotter Too High."*

Hunting and fishing comics were popular as well, picturing the mishaps of gentlemen testing their mettle against the forces of nature. Particularly popular were reversals of fortune, as in Thomas Worth's

A Bare Chance (1879). A terrified hunter, waist deep in a river, finds himself on the wrong side of his own rifle, now in the paws of an angry bear standing on the shore. The hunter's clothes hang from a tree limb, beneath which his dog lies asleep. In 1881 Worth continued the theme in a print set farther west, *"Got the Drop on Him."* A mountain lion gets the drop on a hunter, having chased him up a tree and out on a branch. As the hunter hangs on desperately to the end of the branch, an Indian in a canoe aims his rifle at the lion. The story has an unexpected ending, however. In the companion print, *"Tumbled to It"* (1881) the branch has broken, tumbling the hunter and lion onto the canoe, capsizing it. The heads of all three characters then pop through the bottom of the capsized canoe.

In *On a Strong Scent!* (1880) an unknown artist shows a rotund hunter holding his nose as he walks through cattails and tall grass to where his hunting dog has discovered a dead cow being devoured by birds. In *A Very Warm Corner* (1883) Thomas Worth presents an elderly hunter and his dog falling victim to a number of snares: metal traps that have clamped onto the man's feet and one of the dog's paws; a gun barrel firing from a bush, hitting the man in his backside; and the dog suspended by the neck on the pole of a snare. A sign on the tree that branches overhead reads, "Beware of spring guns and man traps."

Another comic theme is the hunter caught unaware or dozing. In *A Brace of Meadow Larks* (1879) an anonymous artist shows two hunters dozing beneath a haystack in a field near a lake. While they sleep, the area has flooded. The water covers them up to their waists, ducks swim by, and flies or bees swarm about their snoring, open mouths. In *Caught Napping* (1879) Thomas Worth pictures an overweight hunter lying asleep against a tree, his dog napping between his legs, while a fox stealthily approaches a pile of game birds lying behind him.

And, of course, Currier and Ives found humor in scenes still common today, like the overcrowded hunt on the first day of hunting season. In *The First Bird of the Season* (1879, Fig. 58), Thomas Worth put on paper a scene of ten hunters converged in a field, all firing their shotguns simultaneously at a bird, which explodes into a flurry of feathers and body parts. Four other hunters rush in from the background, while a dog sits nearby, quietly observing the scene.

Fishing comics followed the comic lines—reversals, mishaps, unawareness, and tangled lines. In *Barefaced Cheek* (1881) Thomas Worth pictures a fisherman trapped on a tree trunk that has fallen across a

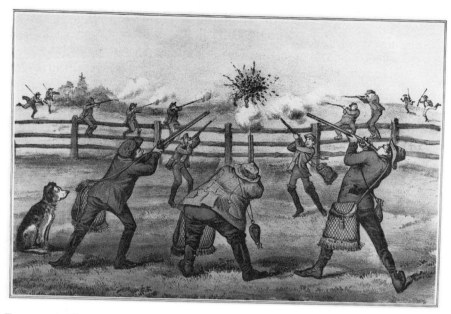

FIGURE 58. *The First Bird of the Season.* Currier and Ives (1879).

river. One bear eats the man's catch of the day; another drinks from his flask. A fisherman is bitten on the backside by a fish his companion has hooked and pulled from the water in Worth's *Biting Lively* (1882). This causes him to swing the fish on his own line into the face of the second sportsman, knocking him from their boat.

In Worth's *Caught on the Fly* (1879) two men fishing from a stream bank hook each other, while a dog eats their fish out of a wicker basket. A grinning boy in a straw hat, fishing nearby, lands another catch to add to the string of fish he has hung from a tree. In a companion print, *Landing a Trout,* a fisherman and his dog fall off a log into a stream. A fish he has hooked flies into the air, and he loses his day's catch into the water. In a play on the favorite kind of sports fishing, *Fly Fishing* (1879), by an unsigned artist, shows a fisherman in a stream, besieged by insects, having yanked his catch into a tangle in the branch of a tree. In a uniquely humorous print, *Waiting for a Bite* (undated), J. Schutz drew a man surrounded by fishing gear, but sitting in a robe and cap in an armchair by his fireplace at home, fishing in a tub of water placed only a few feet away.

Currier and Ives's boxing comics poke fun at men knocked senseless in ridiculous poses. In *The Champion Slugger: "Knocking 'Em Out"* (1883) Edward Kemble caricatures a victorious fighter, dressed in

knickers, holding his oversized fists over his head and straddling his two fallen opponents. Similarly in *Slugged Out: "Better Luck Next Time"* Thomas Worth drew a brutally beaten boxer, his face grotesquely disfigured. A man wearing a derby, the boxer's manager or trainer, stands behind him holding a liquor bottle and tossing a sponge (instead of a towel, but to the same end) into the air.

In the companion prints *Coming Up Smiling* (1884) and *A Little Groggy* (1884), Worth pictures a black boxer struck with a bottle thrown by a small white man. In the second print the black boxer raises his fists in triumph, but his face is swollen and he is unsteady on his feet. White spectators behind a rope look angrily at two black spectators, who are fearful of the boxer's groggy condition. *Yankee Doodle on His Muscle* (undated), picturing the mayhem surrounding the Heenan-Sayer fight, has been discussed in the context of Irish American prizefighters (see page 251).

Currier and Ives included nearly all nineteenth-century American sports in their comics, but none of the remaining activities received nearly as much attention as horse racing, hunting, fishing, and boxing. Skating comics tended to focus on the mishaps of show-offs, especially well-dressed gentlemen. In 1862, for example, when skating in Central Park was becoming popular, Ben Day produced *A Big Thing on Ice*. A fashionable gentleman is surprised to find himself on his backside on the ice, his legs sprawled before him. His hat flies off and the ice cracks beneath him, much to the amusement of the equally fashionable onlookers. *In the Skating Carnival* (undated) the unknown artist adds a black man among the crowd of skaters who pass by one of their fallen ranks.

In 1876 Thomas Worth offered *Amateur Muscle in the Shell*, a rowing comic, in which he caricatured a rower by distorting the size of his head, arms, and shoulders to larger-than-life proportions. He reaches the finish line in a single crew shell, wearing a striped cap, sweat pouring from his face. In another boat the rower falls backward when his oars break. Two floats are included, one holding the prize in the shape of a big teapot, the other the two race officials, one holding a notepad, the other a large pocket watch.

Worth offered three other rowing cartoons in 1876. In *Caved In: The Busted Sculler* he pictured an exhausted sculler being held up, limp and drooping, by a small man wearing a straw boater, who applies a sponge to the sculler's head. An obese doctor in spectacles, top hat, suit, and waistcoat, disdainfully takes the sculler's pulse. In *Champion Rowist—the Pride of the Club* (1876) Worth once again exaggerates the

size of the heads of the rowers, in marked contrast to their tiny legs. In this vignette, the victorious oarsman, dressed in white, is carried chair-fashion by two cheering men in business suits, who tip their boaters. The oarsman holds the prize "teakettle." In *A Modern College Scull: Graduating with All the Honors* (1876) Worth employed the same exaggerated physical features to caricature a college rowing contest. The contestant rows a scull beneath a bridge labeled "Pons Asinorum" ("bridge of asses," roughly translated). His scull is loaded with numerous "honors," or trophies, showing victories for each of four years, 1873 through 1876.

Epilogue: Declining Fortunes, Demise, and Revival

Business began to fail for Currier and Ives in the 1870s. In 1872 the firm gave up its retail shop of thirty-four years for smaller quarters at 125 Nassau Street; two years later it moved to 123 Nassau and again in 1877 to 115 Nassau, where it remained for the next seventeen years. From 1877 to 1894 the company continued to publish its *Celebrated Mammoth Catalogue*, offering 1,412 of "the Best, the Cheapest, and the Most Popular Pictures in the World," and there were times when events revived interest in those prints. But overall demand for those prints, and consequently the production of new prints, began to slide.[1]

Elections continued to bring in business, as did the deaths of major public figures. One temporary resurgence occurred in the fall of 1881, following Charles Guiteau's assassination of President James Garfield. The firm already had a portrait of the president in stock, but upon his unexpected death on September 19 they added notice of his death to the print and offered it for sale. In a letter to his father dated September 21, Ned Currier reported that the demand for the print was "perfectly overwhelming," and that "it surpasses everything." They could not print them fast enough to keep up with demand and closed the day without a single copy in stock—and that after having raised the price! Currier added that he expected not only another day of brisk sales but also an increased demand for prints of the previously assassinated Abraham Lincoln.[2]

Ned's prediction concerning Garfield print sales proved to be an underestimation. Four days later, on September 25, he wrote that the firm had taken in thirty-five hundred dollars over the past five days, so much that they had to devote all their spare time to getting the money into the bank: "Silver, greenbacks, and nickels have flowed in like a mountain torrent." At times the store had been so packed with buyers that they had to build a barricade to keep the crowd in the front part of the store. Their shouting for pictures actually scared the neighbors, "who put their heads out of the windows to see what the matter was."[3]

During the 1880s and 1890s the firm offered "Grand Illuminated Posters,"or advertising posters, which it vowed to produce "for any and all sporting occasions" and businesses, like the American Tobacco Company. The firm even offered frames with its pictures. But this venture was short-lived; as Harry Peters put it, "It was the last flowering of the old firm."[4] On August 28, 1882, Ned Currier wrote to his father: "Business is so stale, flat, and unprofitable, that I do not think that it will be of much interest to hear about it." They had little work except for a few odd jobs. On October 2, 1882, he commented that the only subjects selling were comics, Catholics, and horses.[5]

Upon the death of Ulysses Grant in 1885, the firm expected to reap the same benefits that had accrued from the assassination of President Garfield four years earlier. "The grand old General has passed away," Ned wrote to his father, "and New York will give him an imposing funeral. I do not know as yet whether we will have a 'boom' in prints or not. The date of the funeral is so far advanced that patriots do not enthuse as yet." The following week, however, he wrote: "The Grant

boom is exceedingly quiet. There has been an over production of everything in that line."[6]

Nathaniel Currier retired from the firm in 1880; he died eight years later. His son Ned, who was trained as a lawyer but who had also worked as a salesman in the store, succeeded him. James Ives remained active until shortly before his death in 1895. He too was succeeded by his son, Chauncey. In 1894 the firm moved its retail shop to 108 Fulton, and in 1896 it closed altogether; the main office moved into the factory building at 33 Spruce Street. The last-known dated prints with the Currier and Ives imprint were issued in 1898, covering events of the Spanish-American War.[7]

By 1902 the firm consolidated its activities on one floor of the factory building. In the same year Ned sold out to Chauncey Ives, who then gradually liquidated the business, finally selling out in 1907 to Daniel W. Logan, the former sales manager, and his son Edgar, who planned to continue the business. Daniel's ill health persuaded them to abandon the idea, and within a year they disposed of the remaining stock and equipment and sold the lithographic stones by the pound. The stones had all the lithographs removed except the *Darktown* comics. Still popular even at that late date, they were sold to another lithographic firm.[8]

The development of new processes of picture reproduction and the rise of new mediums through which the public could be reached more simply and directly had left the old firm behind. Those associated with the firm in its last years blamed the firm's decline on its failure to keep pace; Nathaniel Currier is cited in particular as resisting the newly developed steam presses.[9] The refinement of photography and the development of photoengraving forced the reshaping of printmaking, no longer feasible for commercial purposes, into an art. Photoengraving took over the lithograph's illustrative and reportorial functions, and the camera's ability to reflect reality assumed lithography's reproductive capabilities. As one chronicler noted, "Who needed to buy a lithograph of a fire when you could see the real thing in a photo?"[10] Newspapers and illustrated magazines like *Frank Leslie's Illustrated Newspaper* and *Harper's* took over the job of providing the public with pictures. Chromolithographs replaced lithographs on the walls of American homes, and the stereoscope, which paired photographs to appear in three dimensions when viewed through its eyepiece, became the rage.[11]

One particularly insightful story illustrating the decline of the company was told to collector Harry Peters by Chauncey Ives. One day in

the 1860s, Nathaniel Currier's old friend P. T. Barnum strode into the store at 152 Nassau Street with midget Tom Thumb on his shoulder. Barnum, who had taken his business to Currier and Ives for some time, was there to discuss a new lithographed portrait of Thumb to use for promotional purposes. In the middle of the conversation, Thumb interrupted: "Barnum, I have a better idea. Let's go uptown to Sarony, and I'll pose for a photo. He does all the big boys, and these old lithos are out of date."[12]

Technological advances alone, however, did not account for the decline in sales for Currier and Ives. The early years of chromolithography's popularity, for example, coincided with Currier and Ives's most productive years, suggesting that the two media could and did coexist. Chromolithographs, though far less expensive than original fine art, were more expensive than Currier and Ives's prints and seldom offered the same content. They focused on facsimiles of fine art, something Currier and Ives did not emphasize, but such prints did become more popular among middle-class Americans in the second half of the nineteenth century. Unlike Currier and Ives, Louis Prang, its leading practitioner, used chromolithography to advance the cause of art in the United States by educating the public in fine art.[13]

As reportage, photography possessed authenticity and detail beyond the scope of manual printmaking, thereby posing a threat to the firm's earliest line of reportage prints. But it did not possess the flexibility and the avenues for creativity that helped mold the line of prints issued beginning in the 1850s. In 1860 there were approximately sixty lithographic firms in America, employing eight hundred people with a capital investment of about $445,250. By 1890 the number had grown to seven hundred establishments employing eight thousand people with a yearly production valued at twenty million dollars.[14]

The demise of Currier and Ives's line of lithography must be attributed to the changing tastes of Americans during the final decades of the century. "What brought about the end of Currier and Ives may have been more fundamental than [chromolithography and photography]. During the 1870s profound changes occurred in the middle class's taste in decorative arts—changes that shook loose the firm grasp Currier and Ives had on the middle-class print market."[15] During the early Victorian years (from the 1830s), homes were usually adorned with an eclectic mix of a few paintings and, because they were far less expensive, several framed prints. Beginning about 1880, however, greater emphasis was placed on decorating unity. Homeowners sought to harmonize their decorative and architectural schemes

through the use of friezes, murals, decorative tiles, wall hangings, and large-scale paintings or chromolithographs. Moreover, heavily carved woodwork and woven and painted tapestries consumed more and more of the available wall space in homes.[16]

Middle-class America's taste in art changed as well. At midcentury, middle-class women constituted a large audience for lithographs, especially those appropriately refined and didactic for hanging in their parlors in full view of family and friends. Their shopping list would include sentimental prints and genre scenes, loaded with moralistic do's and don'ts, mottoes, religious scenes, edifying landscapes, pictures of children and famous people, game birds and fish, and still lifes of flowers and/or fruit. Sentiment, nostalgia, and even romance were key, but such prints also promoted a domestic and social bond that was an essential ingredient in the chemistry of Victorian life.[17]

Before the Civil War, popular culture was patriotic, aggressive, religious, and sentimental. The American flag and portraits of George Washington abounded, as did scenes reflecting American materialism, optimism, and restlessness. The Bible reigned supreme, as did gestures and expressions of piety and moralism, and sentiment—especially between husbands and wives, parents and children—ruled the day.[18] After the war, yachting, foxhunts, and other high-society activities gained popularity, and their specialized clubs needed prints of those interests to decorate the walls, but there was less room for these prints in the home's more lavishly adorned parlor.

Currier and Ives did not pretend, or intend, to produce great art. As one critic wrote, they hired "many a hack artist" and other artists "so obscure they never signed their names to their paintings" to produce "pictures to order." But as even that critic allowed, it did result, if not in great art, in a uniform art, which is exactly what the public wanted. Genre pictures, en bloc, sold. Given their less-sophisticated consumers, however, Currier and Ives's inexpensive, mass-produced lithographs had to be more literal, more sentimental, and, if intended to be comical, more exaggerated in their humor, compared with Mount's gentleness and Bingham's sharpness, for example. It was "art for the people" in a very special period in American history.[19]

By the 1890s the tenor of the times had changed, however. Such older, hackneyed sentiments became outmoded and fell to ridicule; the unsophisticated charms of Currier and Ives no longer proved attractive. A culture that had not recognized class distinctions began to divide into "highbrow" and "lowbrow." Middle-class Americans began to define "art" as something removed from everyday life.[20]

Stimulated at least in part by displays at the 1876 Centennial Exhibi-
tion in Philadelphia, popular interest in the homely, picturesque, and
generally rural images upon which Currier and Ives depended turned
toward European art and even exotic Japanese prints and Oriental and
Near Eastern furnishings. Further influenced by the late-nineteenth-
century Aesthetic movement, consumers became more concerned
with the quality and uniformity of prints, characteristics that were in-
compatible with the mass-production methods of firms like Currier
and Ives.[21]

In time Americans would resurrect and pay homage to those prints
and the window they believed the prints provided on nineteenth-
century America, thereby completing the commonplace sequence of
popular culture wherein reality becomes myth, which then becomes
reality. Susan Parker, a girl perhaps six to eight years old, had been
given a Currier and Ives print in 1941; as she wrote to Harry Peters,
the print spoke to her soul: "I often wish I had lived around 1870 or
1880. People seem to have been dressed so lovely."[22]

But for a brief time, as the nineteenth century drew to a close,
Americans sought expression of their worldview elsewhere, in other
forms, and they took down and discarded Currier and Ives's prints
much like yesterday's newspapers—which was not entirely inconsis-
tent with what Nathaniel Currier had intended more than a half cen-
tury earlier. The once-popular prints quickly disappeared from the na-
tion's walls and, for a time, they were all but forgotten. The Grolier
Club's exhibit of early lithographs in 1896 helped attract antiquarian
attention in nineteenth-century lithography, and the historical re-
search of Frank Weitenkampf, the first curator of prints at the New
York Public Library, prompted some academic work on the subject.
But popular interest in Currier and Ives did not revive until after
World War I.

As Bernard Reilly tells it, in 1914 Willard D. Straight commis-
sioned an art dealer named Max Williams to decorate India House,
a prominent men's luncheon club in New York City. Williams em-
ployed a maritime theme and furnished the club's interior with ship
models, marine prints, and nautical artifacts. The decorative scheme
created a sensation, he reports, and sparked an avid interest in the ship
portraits and naval scenes for which Currier and Ives were well
known.[23] After the war Williams and a partner, Fred J. Peters, initi-
ated a famous series of Thursday-night auctions, at which prosperous
businessmen bid on the large horse folios, views, and ship prints that
alert dealers were beginning to salvage from old houses in Massa-

chusetts and Connecticut. As the stock market soared during the 1920s, so too did competition for Currier and Ives's prints and some of the finest and largest collections were created, including that of Harry T. Peters (no relation to Fred J. Peters).[24]

In 1929 Harry Peters published *Currier and Ives: Printmakers to the American People,* still one of the most influential books on the subject. More than any other writer since, Peters is responsible for the mystique surrounding Currier and Ives. He saw the prints as illustrations of a romantic era in American history—of graceful sailing ships and prosperous farms, of tranquility at home and westward expansion, of optimism and simple values. And he reproduced the prints that supported that perspective in this and his later books.

The first crack in the wall Harry Peters built around Currier and Ives appeared in the Museum of the City of New York's exhibit that opened in 1995, titled *Currier and Ives, Printmakers to the American People.* As guest curator, Bonnie Yochelson explained to viewers that the purpose of the exhibit was "to loosen the moorings" set by Peters in the 1920s for a generation in search of "a shared American heritage." Yochelson chose to view the prints, drawn largely from the Peters Collection, not as evidence of a romantic, heroic era but as an opportunity to understand how nineteenth-century Americans wished to see themselves in their swiftly modernizing society marked by dramatic industrial and urban growth, geographic expansion, civil war, and massive European immigration.[25]

What Yochelson suggested in that small exhibit, I have more fully developed and expanded upon in this book. Nevertheless, given the immense size of the Currier and Ives's inventory (more than seven thousand prints), this book cannot exhaust all avenues such a revisionist approach to Currier and Ives opens. Although mentioned briefly in chapters on the Irish and the family, more could be done with the company's religious prints. Similarly Currier and Ives's social (nonpolitical) cartoons merit more extensive examination, to cite just two examples. This book points the way to further study of this fascinating subject.

ᎶᏁ N O T E S ᏞᏩ

Introduction

1. Donald H. Karshan, "American Printmaking, 1670-1968," *Art in America* 56 (July 1968): 31; Bernard F. Reilly Jr., compiler, *Currier and Ives: A Catalogue Raisonné* (Detroit: Gale Research, 1984), 1:xxxviii–xlii.

2. Judith Goldman, *American Prints: Process and Proofs* (New York: Harper and Row for Whitney Museum of American Art, 1981), 31.

3. As quoted in Peter C. Marzio, *The Democratic Art, Chromolithography 1840–1900: Pictures for a Nineteenth-Century America* (Boston: David R. Godine for Amon Carter Museum of Western Art, 1979), 1-2.

4. Karal Ann Marling, in her study of Depression-era post-office murals, *Wall to Wall America: A Cultural History of Post Office Murals in the Great Depression* (Minneapolis: University of Minnesota Press, 1982), 14. See also Francis V. O'Connor, *WPA: Art for the Millions* (Boston: New York Graphic Society, 1973), 18.

5. Goldman, 23; Peter Marzio, "Illustrated News in Early American Prints," in *American Printmaking before 1876: Fact, Fiction, and Fantasy* (Washington, D.C.: Library of Congress, 1975), 53-54; William M. Ivins Jr., *Prints and Visual Communication* (New York: Da Capo Press, 1969), 1-3.

6. As quoted in Harry T. Peters, *Currier and Ives: Printmakers to the American People* (1929; New York: Doubleday, 1942), 7.

7. See Bryan Le Beau, "'Colored Engravings for the People': The World According to Currier and Ives," *American Studies* 35 (fall 1994): 140-141.

8. See Marling, for example.

9. Russel Nye, *Unembarrassed Muse: The Popular Arts in America* (New York: Dial Press, 1979), 1, 4.

10. Karshan, 2; see also James Thomas Flexner, *That Wilder Image: The Painting of America's Native School from Thomas Cole to Winslow Homer* (Boston: Little, Brown, 1962), 254.

11. Holland Cotter, "Currier and Ives as Telling as Ozzie and Harriet," *New York Times*, July 14, 1996, sec. 2, p. 33.

12. Cotter, 33.

13. Cotter, 33; Russel Crouse, *Mr. Currier and Mr. Ives: A Note on Their Lives and Times* (Garden City, N.Y.: Garden City Publishing, 1936), 3.

14. Cotter, 33.

15. Cotter, 33.

16. Marticia Sawin, "The Backgrounds of American Printmaking," *Arts Magazine* (September 1956): 37; John Lowell Pratt, ed., *Currier and Ives: Chronicles of America* (Maplewood, N.J.: Hammond, 1968), 7.

17. Nancy R. Davidson, "The Grand Triumphal Quick Step; or, Street Music Covers in America," in *Prints in and of America to 1850,* ed. John D. Morse (Charlottesville: University Press of Virginia, 1970), 215.

18. Marzio, *Democratic Art,* xi.

19. Harry Holcomb; clipping dated December 29, 1929, in Harry T. Peters Collection, box 5, "Correspondence," Museum of the City of New York Collection on Currier and Ives.

20. Elizabeth Johns, *American Genre Painting: The Politics of Everyday Life* (New Haven: Yale University Press, 1991), 205, n. 1. See also George Ehrlich, "Reinterpreting Antebellum Art," *American Studies* 34 (fall 1993): 101–106.

21. Hermann Warner Williams Jr., *Mirror to the American Past: A Survey of American Genre Painting: 1750–1900* (Greenwich, Conn.: New York Graphic Society, 1973), 12–17; Karshan, 22; Johns, *American Genre Painting,* xi–xiii.

22. Bernard Reilly Jr., "The Prints of Life in the West, 1840–1860," in *American Frontier Life: Early Western Painting and Prints,* ed. Ronnie C. Tyler et al. (New York: Abbeville Press for the Amon Carter Museum, 1987), 167.

23. Lawrence W. Levine, "The Folklore of Industrial Society: Popular Culture and Its Audiences," *American Historical Review* 97 (December 1992): 1381. Levine described popular culture "not as the imposition of texts on passive people who constitute a tabula rasa but as a process of interaction between texts that harbor more than monolithic meanings and audiences who embody more than monolithic assemblies of compliant people."

24. See the flyer for an exhibit of Currier and Ives, undated but giving evidence of the mid-1930s, in Peters Collection, box 5, "Correspondence"; Merle Curti, *The Growth of American Thought,* 2d ed. (New York: Harper and Brothers, 1951), 277.

25. Albert K. Baragwanath, *Currier and Ives* (New York: Abbeville Press, 1986), 13; Marzio, *Democratic Art,* 109; Marzio, "Illustrated News in Early American Prints," 54; Jonathan L. Fairbanks, "Introduction," in Morse, *Prints in and of America,* xv.

26. Johns, *American Genre Painting,* xiii.

27. See Louise L. Stevenson, *The Victorian Homefront: American Thought and Culture 1860–1880* (New York: Twayne Publishers, 1991), xviii, xx–xxiii, 5.

28. Harriet Endicott Waite, "Data on Currier and Ives Lithographers (undated)," Harriet Endicott Waite Papers, Archives of American Art, Smithsonian Institution, Washington, D.C., microfilm, roll 681, frame 80.

Chapter 1

1. Walton Rawls, *The Great Book of Currier and Ives' America* (New York: Abbeville Press, 1979), 23–25.

2. Walton Rawls writes that the first copies of *Lexington* hit the streets "in a day or so." Rawls, 23, 25.

3. Peters, *Currier and Ives*, 1.

4. Peters, *Currier and Ives*, 1, 14.

5. The reasons for not continuing the partnership are unknown, but Benjamin Day Jr.—the editor's son—later worked as a lithographer in Currier's shop. Ironically, the younger Day advanced the idea of the illustrated newspaper begun by his father and Currier, and the demise of lithography in that capacity, by inventing a type of screened dot pattern now called "Benday." It permits photographs to be printed in a newspaper or magazine without the previously necessary step of redoing the picture as a lithograph or engraving. Rawls, 25.

6. Peters, *Currier and Ives*, 2; Stephen Hess and Milton Kaplan, *The Ungentlemanly Art: A History of American Political Cartoons* (New York: Macmillan, 1968), 73; Rawls, 22.

7. Peters, *Currier and Ives*, 4; Rawls, 26; Louis Prang, *Catalogue of an Exhibition Illustrative of a Centenary of Artistic Lithography, 1795–1896* (New York: Grolier Club, 1896), 4–5; Wilhelm Weber, *A History of Lithography* (London: Thames and Hudson, 1966), 16; Felix H. Man, *Artists' Lithographs: A World History from Senefelder to the Present Day* (London: Studio Vista, 1970), 7.

8. Rawls, 26–27; Prang, 4–5.

9. Rawls, 27; Prang, 6–7; Weber, 11. For a discussion of changes in the process through the nineteenth century, see Marzio, *Democratic Art*, 64–93, and Davidson.

10. Bernard Reilly Jr., *Catalogue Raisonné*, 1:xxii; Rawls, 27, 30; Peters, *Currier and Ives*, 4; Prang, 8; Cleveland Museum of Art, *Catalogue of an Exhibition of the Art of Lithography (Commemorating the Sesquicentennial of its Invention, 1798–1948)* (Cleveland, Ohio: Cleveland Museum of Art, 1948), np; Man, 8.

11. Marzio, *Democratic Art*, 6; Man, 20–21, 26–28, 34–37, 39–41; Claude Roger-Marx, *Graphic Art of the Nineteenth Century* (London: Thames and Hudson, 1962), 44–59; Weber, 11.

12. Rawls, 30–31; Elizabeth Broun, "The Art of Lithography," in *Images on Stone: Two Centuries of Artist's Lithographs*, ed. Peter C. Marzio (Houston, Tex.: University of Houston, 1987), 10; Man, 16, 23.

13. Prang, 8; Rawls, 31; Sawin, 37; Man, 47–48; Janet Flint, "The American Painter-Lithographer," in *Art and Commerce: American Prints of the Nineteenth Century* (Charlottesville: University Press of Virginia, 1978), 150; Frank Weitenkampf, *American Graphic Art* (New York: Henry Holt, 1912), 180.

14. Goldman, 11.

15. Karshan, 22; Weitenkampf, 181.

16. Sawin, 37; Goldman, 11–25; Richard B. Holman, "Seventeenth-Century Ameri-

can Prints," in Morse, *Prints in and of America*, 23–52; Marzio, "Illustrated News in Early American Prints," 54–55, 59–60.

17. George W. Bethune, "The Prospects of Art in the United States," *Crayon* (July 1857): 59; Joan Dometsch, "Prints in Colonial America: Supply and Demand in the Mid-Eighteenth Century," in Morse, *Prints in and of America*, 54–55, 66.

18. See Carl Bode, *The Anatomy of American Popular Culture, 1840–1861* (Westport, Conn.: Greenwood Press, 1983), x.

19. Sawin, 37; Goldman, 23. Also see Isabelle Lehuu, *Carnival on the Page: Popular Print Media in Antebellum America* (Chapel Hill: University of North Carolina Press, 2000).

20. Rawls, 31; John Carbonell, "Anthony Imbert: New York's Pioneer Lithographer," in *Prints and Printmakers of New York State, 1825–1940*, ed. David Tatham (Syracuse, N.Y.: Syracuse University Press, 1986), 13; Man, 47–48.

21. Peters, *Currier and Ives,* 5; Rawls, 25, 31; Man, 49; Bernard Reilly Jr., *Catalogue Raisonné*, 1:xxii–xxiii.

22. Peters, *Currier and Ives,* 5. A portrait, *William O. Dewees. MD.*, dated 1834, bears the imprint "N. Currier." The date is a year earlier than Nathaniel Currier was set up in business with his own imprint. Dewees was a professor of obstetrics at the University of Pennsylvania, leading critics to conclude that Currier created the lithograph while in Philadelphia and that it was executed by E. D. Brown as a "letter of recommendation" for Currier's future New York employer. Rawls, 32.

23. Crouse, 4; Peters, *Currier and Ives,* 10; Rawls, 32; Davidson, 274; Man, 48.

24. Marzio, *Democratic Art,* 4, 43, 64; Carbonell, 12, 23.

25. Johns, *American Genre Painting,* 22–23.

26. Peters, *Currier and Ives,* 5, 10; Davidson, 268; Rawls, 32–34.

27. Crouse, 4–5.

28. Rawls, 21; Bernard Reilly Jr., *Catalogue Raisonné*, 1:xxiii. At midcentury, city directories described the firm variously as "publishers," "print publishers," "publishers of prints and engravings," and "lithographers," reflecting the wide range of work in which Currier engaged. Peters, *Currier and Ives,* 6.

29. Waite Papers, "Data on Currier and Ives Lithographers (undated)," microfilm, roll 681, frames 83 and 88; Peters, *Currier and Ives,* 7.

30. Peters, *Currier and Ives,* 7; Rawls, 38.

31. Peters, *Currier and Ives,* 7.

32. Waite Papers, "Data on Currier and Ives Lithographers (undated)," microfilm, roll 681, frame 96; "Captain James Merritt Ives," *Port Chester Journal*, January 10, 1895, 1.

33. Peters, *Currier and Ives,* 8–9; Rawls, 39.

34. Peters, *Currier and Ives,* 8; Rawls, 39; Bernard Reilly Jr., *Catalogue Raisonné*, 1:xxx; Tatham, *Prints and Printmakers,* 2.

35. Peters, *Currier and Ives,* 12; Rawls, 48; Waite Papers, "History of Currier and Ives (undated)," microfilm, roll 681, frames 74 and 78.

36. Flexner, 251.

37. Georgia Brady Bumgardner, "George and William Endicott: Commercial

Lithography in New York, 1831–51," in Tatham, *Prints and Printmakers,* 49; Peters, *Currier and Ives,* 15–16; Flexner, 251; A. Hyatt Mayor, *Prints and People: A Social History of Printed Pictures* (New York: Metropolitan Museum of Art, 1971), description with print no. 651.

38. Peters, *Currier and Ives,* 15–16.

39. Rawls, 51.

40. Peters, *Currier and Ives,* 32; Karshan, 31.

41. Crouse, 8; Marzio, *Democratic Art,* 59.

42. Rawls, 51.

43. Tatham, *Prints and Printmakers,* 5. Harriet Endicott Waite gathered considerable personal information on those artists associated with Currier and Ives; see Waite Papers, "Data on Currier and Ives Lithographers (undated)," microfilm, roll 681, frames 79–111.

44. Peters, *Currier and Ives,* 12–13, 26–29; Rawls, 49; Charlotte Streifer Rubinstein, "The Early Career of Frances Flora Bond Palmer (1812–1876)," *American Art Journal* 17 (autumn 1985): 71–88; Mary Bartlette Cowdrey, "Fanny Palmer" and "Palmer, Frances Flora Bond," in *Notable American Women: 1607–1950* (Cambridge, Mass.: Harvard University Press, 1971), 10–11.

45. Peters, *Currier and Ives,* 27.

46. Waite Papers, "History of Currier and Ives (undated)," microfilm, roll 681, frame 68; Joni Louise Kinsey, "Artists' Biographies," in *The West as America: Reinterpreting Images of the Frontier, 1820–1920,* ed. William H. Truettner (Washington, D.C.: Smithsonian Institution Press, 1991), 363. Rubinstein, 71–88; Cowdrey, 10–11.

47. Rawls, 49; Peters, *Currier and Ives,* 21; Williams, *Mirror to the American Past,* 217–218.

48. Rawls, 49–50; Peters, *Currier and Ives,* 23–26, 29–31.

49. Marzio, *Democratic Art,* 152; Bumgardner, 49.

50. Peters, *Currier and Ives,* 12–13; Rawls, 52–53.

51. Peters, *Currier and Ives,* 13–14; Marzio, *Democratic Art,* 49–50.

52. Peters, *Currier and Ives,* 13–14; Rawls, 49; Marzio, *Democratic Art,* 49–50.

53. Peters, *Currier and Ives,* 14; Rawls, 56–57; Bernard Reilly Jr., *Catalogue Raisonné,* 1:xv; Marzio, *Democratic Art,* 59–63; A. Hyatt Mayor, description with print no. 651.

54. Peters, *Currier and Ives,* 14–15; Rawls, 54–55; Waite Papers, "History of Currier and Ives (undated)," microfilm, roll 681, frame 70.

55. Peters, *Currier and Ives,* 14–15; Rawls, 54–55.

56. Rawls, 38; Peters, *Currier and Ives,* 11; Harriet Endicott Waite to Harry Peters, January 7, 1926, "Waite-Peters Correspondence," Waite Papers, microfilm, roll 681, frames 22–26.

57. Peters, *Currier and Ives,* 10–11; W. S. Hall, *The Spirit of America: Currier and Ives Prints* (New York: William Edwin Rudge, 1930), 5; Marzio, *Democratic Art,* 59; Waite to Peters, January 7, 1926, Waite Papers, microfilm, roll 681, frames 22–26; Bonnie Yochelson, *Currier and Ives, Printmakers to the American People: Highlights from the Collection of the Museum of the City of New York* (New York: Museum of the City of New York, 1995), 2.

58. Goldman, 26.

59. Currier and Ives to unnamed person, May 29, 1873, Peters Collection; Currier and Ives to unnamed person, undated (written between 1877 and 1894), Peters Collection; Peters, *Currier and Ives*, 11; Rawls, 37–38, 50; Waite to Peters, January 7, 1926, Waite Papers, microfilm, roll 681, frames 22–26; Peters collection, front cover of catalog (undated, ca. 1862).

60. Peters, *Currier and Ives*, 11–12.

61. Bernard Reilly Jr., *Catalogue Raisonné*, 1:xxv.

62. Bernard Reilly Jr., *Catalogue Raisonné*, 1:xxi.

63. Rawls, 60; Tatham, 1.

64. Rawls, 60; Tatham, 4.

Chapter 2

1. Henry Steele Commager, "The Search for a Usable Past, *American Heritage* 16 (February 1965): 4. Commanger took the phrase "usable past" from an essay by Van Wyck Brooks, "On Creating a Usable Past," *Dial*, April 11, 1918, 337, 341.

2. Commager, 4–5.

3. Commager, 6.

4. Commager, 6.

5. Michael Kammen, *Mystic Chords of Memory: The Transformation of Tradition in American Culture* (New York: Alfred A. Knopf, 1991), 7, 19; Alexis de Tocqueville, *Democracy in America*, ed. Phillips Bradley (New York: Vintage Books, 1945), 80.

6. Commager, 155, 7.

7. Commager, 7–8. See also R. W. B. Lewis, *The American Adam: Innocence, Tragedy, and Tradition in the Nineteenth Century* (Chicago, Ill.: University of Chicago Press, 1955).

8. Commager, 8.

9. Commager, 9.

10. Commager, 9.

11. Mike Wallace, *Mickey Mouse History and Other Essays on American Memory* (Philadelphia: Temple University Press, 1996), x; Kammen, *Mystic Chords of Memory*, 27; Commager, 90.

12. Kammen, *Mystic Chords of Memory*, 4, 17, 33.

13. Kammen, *Mystic Chords of Memory*, 17; John Bodnar, *Remaking America: Public Memory, Commemoration, and Patriotism in the Twentieth Century* (Princeton, N.J.: Princeton University Press, 1992), 17; Claude Lévi-Strauss, *Structural Anthropology* (New York: Basic Books, 1976), 2:268.

14. Bodnar, *Remaking America*, 14–15; Kammen, *Mystic Chords of Memory*, 3.

15. Wallace, viii; Bodnar, *Remaking America*, 21.

16. Kammen, *Mystic Chords of Memory*, 4–5; Bodnar, *Remaking America*, 14.

17. Kammen, *Mystic Chords of Memory*, 28.

18. Kammen, *Mystic Chords of Memory*, 19.

19. Frederic A. Conningham, *Currier and Ives Prints: An Illustrated Check List*

(New York: Crown Publishers, 1983), xii; Glenn C. Altschuler and Stuart M. Blumin, "'Where Is the Real America?': Politics and Popular Consciousness the Antebellum Era," *American Quarterly* 49 (June 1997): 246.

20. Roy King and Burke Davis, *The World of Currier and Ives* (New York: Bonanza Books, 1968), np.

21. King and Davis, np.

22. Baragwanath, 90.

23. John Lowell Pratt, 23.

24. Rawls, 66.

25. Rawls, 66. See also Mason L. Weems, *The Life of Washington*, ed. Marcus Cunliffe (Cambridge, Mass.: Harvard University Press, 1962).

26. Barry Schwartz, *George Washington: The Making of an American Symbol* (New York: Free Press, 1987), 1.

27. Barry Schwartz, 1–2.

28. Barry Schwartz, 2–3, 8; Washington Irving, *Life of George Washington* (New York: G. P. Putnam, 1856–1859); Mark Edward Thistlethwaite, *The Image of George Washington: Studies in Mid-Nineteenth-Century American History Painting* (New York: Garland Publishing, 1979). See also Jared Sparks, *The Life of George Washington* (Boston: Tappan and Dennet, 1837) and other popular biographies of the time.

29. See Michael Kammen, *A Season of Youth: The American Revolution and the Historical Imagination* (New York: Alfred A. Knopf, 1978).

30. John Lowell Pratt, 28.

31. Roger B. Stein, "Gilded Age Pilgrims," in *Picturing Old New England: Image and Memory*, eds. William R. Truettner and Roger B. Stein (New Haven, Conn.: Yale University Press for the National Museum of American Art, 1999), 43.

32. Stein, 43.

33. Stein, 43–45.

34. Rawls, 65.

35. John Lowell Pratt, 23.

36. Rawls, 665.

37. John Lowell Pratt, 23.

38. Claudia L. Bushman, *America Discovers Columbus: How an Italian Explorer Became an American Hero* (Hanover, N.H.: University Press of New England, 1992), xii, 41–59, 107–126, 158–190.

39. Kammen, *Mystic Chords of Memory*, 64; Robert D. Arner, "Plymouth Rock Revisited: The Landing of the Pilgrim Fathers," in *Journal of American Culture* 6 (winter 1983): 25–35.

40. Arner, 25–35; Mark L. Sargent, "The Conservative Covenant: The Rise of the Mayflower Compact in American Myth," *New England Quarterly* 6 (1988): 233–243; John D. Seelye, *Memory's Nation—The Place of Plymouth Rock* (Chapel Hill: University of North Carolina Press, 1998), 6–59; John Lowell Pratt, 23.

41. Roy Harvey Pearce, *Savagism and Civilization: A Study of the Indian and the American Mind* (Baltimore, Md.: Johns Hopkins University Press, 1967), 35–41; John Lowell Pratt, 23.

42. Donald E. Pease, *Visionary Compacts: American Renaissance Writings in Cultural Context* (Madison: University of Wisconsin Press, 1987), 51-55, 68-76.

43. William Fletcher Thompson Jr., *The Image of War: The Pictorial Reporting of the American Civil War* (New York: Thomas Yoseloff, 1960), 16-17; Kammen, *Mystic Chords of Memory*, 65.

44. Bodnar, *Remaking America*, 22; Michael Kammen, *A Machine That Would Go of Itself: The Constitution in American Culture* (New York: Alfred A. Knopf, 1986), 75-77; John Lowell Pratt, 28.

45. Bodnar, *Remaking America*, 24-25.

46. John Lowell Pratt, 28; Rawls, 67; Conningham, xii.

47. Baragwanath, 98.

48. Howard H. Peckham, *The War for Independence: A Military History* (Chicago, Ill.: University of Chicago Press, 1979), 20.

49. Crouse, 138.

50. Peckham, 180.

51. John Lowell Pratt, 28; Baragwanath, 96.

52. Harry M. Ward, *The American Revolution: Nationhood Achieved, 1763-1788* (New York: St. Martin's Press, 1995), 112.

53. Yochelson, 36.

54. John Lowell Pratt, 41

55. Baragwanath, 92.

56. John Carbonell, "Prints of the Battle of New Orleans," in *Prints of the American West: Papers Presented at the Ninth Annual North American Print Conference*, ed. Ronnie C. Tyler, (Fort Worth, Tex.: Amon Carter Museum of Western Art, 1983), 2.

57. Kammen, *Mystic Chords of Memory*, 19; John William Ward, *Andrew Jackson: Symbol for an Age* (New York: Oxford University Press, 1962), 1.

58. Carbonell, "Prints of the Battle of New Orleans," 6-12; See also Robin Reilly, *The British at the Gates: The New Orleans Campaign in the War of 1812* (New York: G. P. Putnam, 1974).

59. Larry Freeman, ed., *Currier and Ives Pictorial History of American Battle Scenes* (Watkins Glen, N.Y.: Century House, 1961), 15.

60. Carbonell, "Prints of the Battle of New Orleans," 2.

61. Rawls, 67.

62. Freeman, 6.

63. Ronnie C. Tyler, "Prints of the Mexican War as Historical 'Sources,'" in *American Printmaking before 1876*, 61-62, 69. For comparison see George Wilkins Kendall, *The War between the United States and Mexico Illustrated, Embracing Pictorial Drawings of All the Principal Conflicts* (New York: D. Appleton, 1851).

64. Freeman, 18-19; John Lowell Pratt, 47; Tyler, "Prints of the Mexican War as Historical 'Sources,'" 61.

65. Thompson, *The Image of War*, 17; Tyler, "Prints of the Mexican War as Historical 'Sources,'" 63.

66. John Lowell Pratt, 47.

67. Tyler, "Prints of the Mexican War as Historical 'Sources,'" 64.

68. Tyler, "Prints of the Mexican War as Historical 'Sources,'" 66.

69. Kammen, *Mystic Chords of Memory*, 134–135; Paul A. Carter, *The Spiritual Crisis of the Gilded Age* (DeKalb: Northern Illinois University Press, 1971), 164–175; Henry Nash Smith, ed., *Popular Culture and Industrialism, 1865–1890* (New York: New York University Press, 1967), 3–18.

70. Charles B. Hosmer Jr., *Presence of the Past: A History of the Preservation Movement in the United States before Williamsburg* (New York: Putnam, 1965), 10; Kammen, *Mystic Chords of Memory*, 135–136; Stevenson, 185.

71. Kammen, *Mystic Chords of Memory*, 202.

72. See Robert Taft, *Artists and Illustrators of the Old West, 1850–1900* (New York: Scribner, 1953), 129–134.

Chapter 3

1. James M. Banner Jr., in John Lowell Pratt, 143.

2. Arthur G. Neal, *National Trauma and Collective Memory: Major Events in the American Century* (Armonk, N.Y.: M. E. Sharpe, 1998), 3–4; see also Kai Erikson, *A New Species of Trouble: The Human Experience of Modern Disasters* (New York: W. W. Norton, 1994); Ronnie Janoff-Bulman, *Shattered Assumptions: Toward a New Psychology of Trauma* (New York: Free Press, 1992). See Ernest Becker, *The Structure of Evil: An Essay on the Unification of the Science of Man* (New York: George Braziller, 1968); Richard O. Curry and Thomas M. Brown, eds., *Conspiracy: Fear of Subversion in American History* (New York: Holt, Rinehart, and Winston, 1972); John Mirowsky and Catherine E. Ross, *Social Causes of Psychological Distress* (New York: Aldine de Gruyter, 1989).

3. Neal, 7, 288; Hermann Warner Williams Jr., *The Civil War: The Artists' Record* (Washington, D.C.: Corcoran Gallery of Art, 1961), 27.

4. Jim Cullen, *The Civil War in Popular Culture: A Re-Usable Past* (Washington: Smithsonian Institution Press, 1995), 15–16. See also Arthur M. Schlesinger Jr., *The Age of Jackson* (New York: Little, Brown, 1945); Sean Wilentz, *Chants Democrat: New York City and the Rise of the American Working Class* (New York: Oxford University Press, 1984).

5. Cullen, 16; see Eric Foner, *Free Soil, Free Labor, Free Men: The Ideology of the Republican Party before the Civil War* (New York: Oxford University Press, 1980).

6. Cullen, 16; see George M. Fredrickson, *The Inner Civil War: Northern Intellectuals and the Crisis of the Union* (New York: Harper and Row, 1965).

7. Cullen, 17.

8. Cullen, 17.

9. *The Civil War: A Centennial Exhibition of Eyewitness Drawings* (Washington, D.C.: National Gallery of Art, 1961), 5–6; Kristen M. Smith, *The Lines Are Drawn: Political Cartoons of the Civil War* (Athens, Ga.: Hill Street Press, 1999), xi.

10. *Civil War: Centennial Exhibition*, 9–13; Kristen M. Smith, xv. See Fletcher Pratt, *Civil War in Pictures* (Garden City, N.Y.: Garden City Books, 1955); Mark E.

Neely Jr. and Harold Holzer, *The Union Image: Popular Prints of the Civil War North* (Chapel Hill: University of North Carolina Press, 2000), 199–200; Thompson, *Image of War*, 20–24; William Fletcher Thompson Jr., "Pictorial Propaganda and the Civil War," *Wisconsin Magazine of History* 46 (autumn 1962): 21; William Fletcher Thompson Jr., "Illustrating the Civil War," *Wisconsin Magazine of History* 45 (autumn 1961): 12; Mott, 453, 469, 562.

11. Cotter, 33.

12. Thompson, *Image of War*, 37; Neely and Holzer, 199.

13. "Captain James Merritt Ives," 1, 8.

14. Pearce, 7; *Civil War: Centennial Exhibition*, 25, 88; Williams, *Civil War*, 16–23; Rawls, 289.

15. Thompson, "Pictorial Propaganda," 22; Thompson, "Illustrating the Civil War," 11, 13–14; Marcus Cunliffe, *Soldiers and Civilians: The Martial Spirit in America, 1775–1865* (Boston, Mass.: Little, Brown, 1968), 4, 388.

16. Thompson, *Image of War*, 46.

17. Thompson, "Pictorial Propaganda," 26–28; Thompson, "Illustrating the Civil War," 14.

18. Thompson, "Pictorial Propaganda," 23; "Nathaniel Currier," *New York Times*, November 22, 1888, 2.

19. Thompson, *Image of War*, 86.

20. Neely and Holzer, 1, 3.

21. Neely and Holzer, 6.

22. Neely and Holzer, 6.

23. Neely and Holzer, 15.

24. Neely and Holzer, 28–31.

25. James M. McPherson, *Ordeal By Fire: The Civil War and Reconstruction*, 2d ed. (New York: McGraw-Hill, 1992),181–182.

26. Neely and Holzer, 117; McPherson, *Ordeal by Fire*, 182.

27. See, for example, Neely and Holzer, 115.

28. McPherson, *Ordeal by Fire*, 209–213, 256–258.

29. McPherson, *Ordeal by Fire*, 280–287.

30. Mertil D. Peterson, *Lincoln in American Memory* (New York: Oxford University Press, 1994), 114–115.

31. Neely and Holzer, 110.

32. Neely and Holzer, 110.

33. Kristen M. Smith, 143; Peterson, 485.

34. Kammen, *Mystic Chords of Memory*, 125; Frank E. Vandiver, "Jefferson Davis—Leader without Legend," *Journal of Southern History* (February 1977): 3–18; Roy F. Nichols, "United States versus Jefferson Davis. 1865–1869," *American Historical Review* 31 (February 1926): 266–284.

35. Thompson, "Pictorial Propaganda," 25.

36. Neely and Holzer, 25–26.

37. Rufus Rockwell Wilson, *Lincoln in Caricature* (New York: Horizon Press, 1953), 178.

38. See Weitenkampf, *American Graphic Art*, 259.

39. Weitenkampf, *American Graphic Art*, 259; Rufus Rockwell Wilson, 136.

40. Rufus Rockwell Wilson, 136.

41. Kevin O'Rourke, *Currier and Ives: The Irish and America* (New York: Henry N. Abrams, 1995), 87.

42. Allan Nevins and Frank Weitenkampf, *A Century of Political Cartoons: Caricature in the United States from 1800 to 1900* (New York: Scribner, 1944), 108.

43. Neely and Holzer, 151.

44. Thompson, "Pictorial Propaganda," 25; Thompson, *Image of War*, 47-48.

45. Neely and Holzer, 141; Stephen W. Sears, *George B. McClellan: The Young Napolean* (New York: Ticknor and Fields, 1988), 220-221.

46. Cunliffe, *Soldiers and Civilians*, 215; Thompson, "Pictorial Propaganda," 23. For a brief discussion of why men enlisted, see Susan-Mary Grant, "For God and Country: Why Men Joined up for the U.S. Civil War," *History Today* 50 (July 2000): 21-27.

47. Thompson, "Pictorial Propaganda," 23.

48. Thompson, "Pictorial Propaganda," 23-24.

49. Weitenkampf, *American Graphic Art*, 259; Smith, 34.

50. Thompson, *Image of War*, 86-98.

51. Kristen M. Smith, 107.

52. McPherson, *Ordeal by Fire*, 440.

53. Neely and Holzer, 142.

54. Rufus Rockwell Wilson, 268.

55. Thompson, "Pictorial Propaganda," 28.

56. Thompson, "Illustrating the Civil War," 17; Neely and Holzer, 57.

57. Williams, *Civil War*, 108-111; McPherson, *Ordeal by Fire*, 251, 293, 353-358; Cunliffe, *Soldiers and Civilians*, 215, 233.

58. Thompson, *Image of War*, 15.

59. See, for example, the *Anderson Prison* prints of John Bums Walker, Co. (1864); Williams, *Civil War*, 193-197, 201-209; Thompson, *Image of War*, 133.

60. Between 1861 and 1865, 90,215 nineteen-year-olds joined the Union army, along with 133,475 eighteen-year-olds, 6,425 seventeen-year-olds, 2,758 sixteen-year-olds, 773 fifteen-year-olds, 330 fourteen-year-olds, and 127 who were only thirteen; Neely and Holzer, 91..

61. Neely and Holzer, 91, 93.

62. Neely and Holzer, 86.

63. Neely and Holzer, 85-87.

64. Williams, *Civil War*, 35, 221-226; Catherine Clinton and Nina Silber, eds., *Divided Houses: Gender and the Civil War* (New York: Oxford University Press, 1992), 243; Fredrickson, *Inner Civil War*, chap. 7; Thompson, "Pictorial Propaganda," 24; Thompson, *Image of War*, 104-105.

65. Mary M. Roberts, *American Nursing: History and Interpretation* (New York: Macmillan, 1954), 9-11; Stephen B. Oates, *A Woman of Valor: Clara Barton and the Civil War* (New York: Free Press, 1995), 234; Kristie Ross, "Arranging a Doll's House:

Refined Women as Union Nurses," in Clinton and Silber, 99, 110; Thompson, *Image of War*, 104; Thompson, "Pictorial Propaganda," 24.

66. Neely and Holzer, 93.

67. Peterson, 3.

68. Peters, *Currier and Ives*, 147; Harold Holzer, Gabor S. Boritt, and Mark E. Neely Jr., *The Lincoln Image: Abraham Lincoln and the Popular Print* (New York: Charles Scribner's Sons, 1984), 27; Rufus Rockwell Wilson, vii–viii; Peterson, 3–4; Dorothy M. Kunhardt and Phillip B. Kunhardt Jr., *Twenty Days* (New York: Harper and Row, 1965), 80–81.

69. Roy Prentice Basler, *The Lincoln Legend: A Study in Changing Conceptions* (New York: Houghton Mifflin, 1983), 164; Neely and Holzer, 27.

70. Lloyd Lewis, *Myths after Lincoln* (New York: Harcourt Brace, 1929), 109–115; Thomas Reed Turner, *Beware the People Weeping: Public Opinion and the Assassination of Abraham Lincoln* (Baton Rouge: Louisiana State University Press, 1982), 87–88.

71. Neely and Holzer, 162.

72. Neely and Holzer, 166–167.

73. Peterson, 7; Neely and Holzer, 153–154.

74. Peterson, 27.

75. Neely and Holzer, 192–205; Peterson, 28.

Chapter 4

1. William H. Truettner, "Ideology and Image: Justifying Westward Expansion," in *West as America*, 40; Richard Slotkin, "Myth and the Production of History," in *Ideology and Classic American Literature*, Sacvan Bercovitch and Myra Jeklen, eds. (New York: Cambridge University Press, 1987), 70; Peter H. Hassrick, *The American West: Out of Myth, into Reality* (Washington, D.C.: Trust for Museum Exhibitions for the Mississippi Museum of Art, 2000), 15.

2. Tyler, *Prints of the American West*, vii; Patricia Hills, *The American Frontier: Images and Myths* (New York: Whitney Museum of American Art, 1973), 5.

3. Williams, *Mirror to the American Past*, 59; William H. Goetzmann and William N. Goetzmann, *The West of the Imagination* (New York: W. W. Norton, 1986), xi.

4. Hassrick, 24, 27.

5. Edward Buscombe, ed., *The British Film Institute's Companion to the Western* (London: Da Capo Press, 1988), 181; Hubert Cohen, "'Men Have Tears in Them': The Other Cowboy Hero," *Journal of American Culture: Studies of a Civilization* 21 (winter 1998): 57.

6. Henry Nash Smith, "The Mountain Man as Western Hero: Kit Carson," in *The American Man*, Elizabeth H. Pleck and Joseph H. Pleck, eds. (Englewood Cliffs, N.J.: Prentice Hall, 1980), 159–172.

7. Hassrick, 27.

8. Henry Nash Smith, "Mountain Man," 159–172.

9. Phillip Drennon Thomas, "The West of Currier and Ives: Nineteenth-Century

Lithographs Capture the Frontier Adventure," *American West* 19 (January–February 1982), 18; Conningham, xii.

10. "Too Politically Correct," review of the Museum of the City of New York's Exhibit of Currier and Ives Prints, curated by Bonnie Yochelson; *New York Times*, May 19, 1996, section 13, 6.

11. Kevin Starr, *Americans and the California Dream, 1850–1915* (New York: Oxford University Press, 1973), 79; Howard P. Lamar, "An Overview of Westward Expansion," in Truettner, *West as America*, 15; Harry T. Peters, *California on Stone* (Garden City, N.Y.: Doubleday, Doran, 1935), 4; Goetzmann and Goetzmann, 124–125.

12. Peters, *California on Stone*, 4.

13. Hills, *American Frontier*, 11–12.

14. Peters, *California on Stone*, 8.

15. Hills, *American Frontier*, 12.

16. Hills, *American Frontier*, 12; Claire Perry, *Pacific Arcadia: Images of California, 1600–1915* (New York: Oxford University Press, 1999), 33; see Peters, *California on Stone*.

17. Hills, *American Frontier*, 12.

18. Elizabeth Johns, "Settlement and Development: Claiming the West," in Truettner, *West as America*, 222.

19. Johns, "Settlement and Development," 226; Johns, *American Genre Painting*, 90–91; Starr; Jeanne Van Nostrand, *The First Hundred Years of Painting in California, 1775–1875* (San Francisco: Johns Howell, 1980); Rawls, 205.

20. Perry, 32.

21. Johns, "Settlement and Development," 218.

22. Goetzmann and Goetzmann, 130.

23. Collin Simkin, *Currier and Ives' America* (New York: Crown Publishers, 1952), np.

24. Williams, *Mirror to the American Past*, 60.

25. Hassrick, 74; see also Goetzmann and Goetzmann, 91.

26. Goetzmann and Goetzmann, 194.

27. Patricia Hills, "Picturing Progress in the Era of Westward Expansion," in Truettner and Stein, *Picturing New England*, 117, 119; Hills, *American Frontier*, 5, 10; Goetzmann and Goetzmann, 114.

28. Hills, "Picturing Progress," 130; Thomas, 25.

29. Johns, *American Genre Painting*, 60; Richard Slotkin, *The Fatal Environment: The Myth of the Frontier in the Age of Industrialization, 1800–1890* (Middletown, Conn.: Wesleyan University Press, 1985), 41, 45; see also: Henry Nash Smith, *Virgin Land: The American West as Symbol and Myth* (Cambridge, Mass.: Harvard University Press, 1950); Richard Slotkin, *Regeneration through Violence: The Mythology of the American Frontier, 1600–1860* (Middletown, Conn.: Wesleyan University Press, 1973); Patricia Nelson Limerick, *The Legacy of Conquest: The Unbroken Past of the American West* (New York: W. W. Norton, 1987); Richard Wade, *The Urban Frontier: Pioneer Life in Early Pittsburgh, Cincinnati, Lexington, Louisville, and St. Louis* (Chicago, Ill.: University of Chicago Press, 1964); Slotkin, *Fatal Environment*, 41, 45.

30. Truettner, "Ideology and Image," 30.

31. Hills, *American Frontier*, 5. See also Hills, "Picturing Progress," 100.

32. See Perry Miller, "Errand into the Wilderness," *William and Mary Quarterly*, 3d ser., 10 (January 1953): 3-19.

33. Johns, *American Genre Painting*, 60. See Hugh Honour, *The New Golden Land: European Images of America from the Discoveries to the Present Time* (New York: Pantheon, 1975); Ray Allen Billington, *Land of Savagery, Land of Promise: The European Image of the American Frontier in the Nineteenth Century* (Norman: University of Oklahoma Press, 1981); King and Davis, 91; Bodnar, *Remaking America*, 26.

34. Johns, *American Genre Painting*, 61; Henry David Thoreau, *Journal* (New York: Dover, 1962), 2:171.

35. Johns, *American Genre Painting*, 61; James Hall, *Sketches of History, Life, and Manners in the West* (Philadelphia, Pa.: Harrison Hall, 1835), 21.

36. Truettner, "Ideology and Image," 41-42; Henry Nash Smith, *Virgin Land*, 133-144; Rawls, 205-206.

37. Daniel Boorstin makes this point in Bodnar, *Remaking America*, 26; Bernard Reilly Jr., "The Prints of Life in the West, 1840-1860," in Tyler, *American Frontier Life*, 169; Johns, *American Genre Painting*, 62.

38. Johns, *American Genre Painting*, 63; Linda Ayres, "William Ranney," in Tyler, *American Frontier Life*, 82. See also the influence of Washington Irving, Sir Walter Scott, and Francis Parkman; Johns, *American Genre Painting*, 69, 73; Henry Nash Smith, *Virgin Land*, 87-89; Jules Zanger, "The Frontiersman in Popular Fiction, 1820-1860," in *The Frontier Re-Examined*, John F. McDermott, ed. (Urbana: University of Illinois Press, 1967); David Leverenz, *Manhood and the American Renaissance* (Ithaca, N.Y.: Cornell University Press, 1989), 217-226; Pearce, 203.

39. Hills, *American Frontier*, 7; Frederick Jackson Turner, "The Significance of the Frontier in American History," in *Frontier and Section: Selected Essays of Frederick Jackson Turner* (Edgewood Cliffs, N.J.: Prentice Hall, 1961), 38; Johns, *American Genre Painting*, 62; Albert K. Weinberg, *Manifest Destiny: A Study of Nationalist Expansion in American History* (Chicago: Quadrangle, 1963); Frederick Merk, *Manifest Destiny and Mission in American History: A Reinterpretation* (New York: Vintage Books, 1966); Leverenz; Rawls, 204-205.

40. John Lowell Pratt, 190.

41. Johns, *American Genre Painting*, 83; Leland D. Baldwin, *The Keelboat Age on Western Waters* (Pittsburgh, Pa.: University of Pittsburgh Press, 1941); Goetzmann and Goetzmann, 75.

42. Morton Cronin, "Currier and Ives: A Content Analysis," *American Quarterly* 4 (winter 1952), 321.

43. Johns, *American Genre Painting*, 87.

44. Harry T. Peters, *America on Stone* (New York: Doubleday, Doran, 1931), 31, 36; Hills, *American Frontier*, 8; Johns, "Settlement and Development," 203-240.

45. Johns, "Settlement and Development," 192-193.

46. Johns, *American Genre Painting*, 91-92; Johns, "Settlement and Development," 193.

47. Johns, *American Genre Painting*, 92–94; Peters, *America on Stone*, 38; Johns, "Settlement and Development," 196; Goetzmann and Goetzmann, 78–79.

48. Peters, *America on Stone*, 40; Altschuler and Blumin, 243–244.

49. See Henry Nash Smith, *Virgin Land*, chaps. xii and xxi.

50. Thomas, 18; see also Cronin, 323.

51. Johns, *American Genre Painting*, 67; see also LeRoy R. Hafen, ed., *Mountain Men and the Fur Traders of the Far West* (Lincoln: University of Nebraska Press, 1982); Billington, *Land of Savagery, Land of Promise*, 41–68; William H. Goetzmann, *Exploration and Empire: The Explorer and the Scientist in the Winning of the American West* (New York: Alfred A. Knopf, 1966).

52. Johns, *American Genre Painting*, 68, 73; see also Truettner, "Ideology and Image," 42; Henry Nash Smith, *Virgin Land*, 84–85.

53. Ayres, 81; see also Carol Clark, "Charles Deas," in Tyler, *American Frontier Life*, 59.

54. Clark, 60.

55. The hackneyed symbolism of light and dark, good and evil, is clear, but neither will survive. Disaster awaits each side of Indian–white strife. What relieves the tragic message is that the trapper had become expendable—indeed perhaps he had to become expendable because of his character traits that could not be reconciled with civilization. His demise is an inevitable consequence of the end of the frontier and the establishment of a more permanent white settlement. Julie Schimmel, "Inventing 'the Indian,'" in Truettner, *West as America*, 165, 187 n. 29.

56. Dawn Glanz, *How the West Was Drawn: American Art and the Settling of the Frontier* (Ann Arbor, Mich.: UMI Research Press, 1982), 27; Ayres, 90.

57. Ayres, 109, 112; Johns, *American Genre Painting*, 80, 99, 224 n. 32; Williams, *Mirror to the American Past*, 111; Peters, *America on Stone*, 19; Johns, "Settlement and Development," 364–365, 368. See Warder H. Cadbury and Henry F. Marsh, *Arthur Fitzwilliam Tait, Artist in the Adirondacks: An Account of His Career . . . [and] a Checklist of His Works* (Newark: University of Delaware Press, 1986).

58. Johns, *American Genre Painting*, 80, 225 n. 33; Warder H. Cadbury, "Arthur F. Tait," in Tyler, *American Frontier Life*, 114–117. For a contrasting interpretation that sees the outcome in doubt, see Schimmel, 165.

59. Johns, *American Genre Painting*, 81; *New York Herald*, February 17, 1852, quoted in Cadbury, "Arthur F. Tait," 114.

60. Bernard De Voto, *Across the Wide Missouri* (Boston: Houghton Mifflin, 1987), 397; Harold McCracken, *Portrait of the Old West* (New York: McGraw Hill, 1952), 128.

61. Johns, *American Genre Painting*, 99; Cadbury, 110; Thomas, 22.

62. Johns, *American Genre Painting*, 81–82; Cadbury, 110.

63. Cadbury, 119.

64. Cadbury, 110.

65. Johns, *American Genre Painting*, 81.

66. Glanz, 52.

67. Thomas, 19.

68. Another version of this print was titled *Trappers on the Prairie—Peace or War?* (1866); John Lowell Pratt, 94.

69. De Voto, *Across the Wide Missouri*, 36.

70. Thomas, 23; King and Davis, np.

71. King and Davis, np.

72. King and Davis, np.

73. Truettner, "Ideology and Image," 44; Limerick, 190.

74. Schimmel, 151, 159.

75. Schimmel, 151.

76. Schimmel, 151; Robert F. Berkhofer Jr., *The White Man's Indian: Images of the American-Indian from Columbus to the Present* (New York: Knopf, 1978), 72–80.

77. Quoted in Goetzmann and Goetzmann, 16–17.

78. John Lowell Pratt, 86; William H. Truettner, "For European Audiences: George Catlin's *North American Indian Portfolio*," in *West as America*, 26; Yochelson, 51.

79. Pearce, v, 3–4, 53; also, Schimmel, 162, 174; Peters, *America on Stone*, 10; Francis Jennings, *Invasion of America: Indians, Colonialism, and the Cant of Conquest* (New York: Norton, 1975), 146.

80. Pearce, 58–59; Schimmel, 168; Hassrick, 85.

81. Rawls, 197, 205; Hills, *American Frontier*, 7; Schimmel, 44.

82. Goetzmann and Goetzmann, *West of Imagination*, 26; Rawls, 201; Hills, *American Frontier*, 6–7.

83. Bernard Reilly Jr., "Prints of Life in the West," 174–175.

84. Truettner, "For European Audiences," 25–26; Hills, *American Frontier*, 7.

85. Pearce, 82–83; Truettner, "For European Audiences," 29; Herman J. Viola, "The American Indian Genre Paintings of Catlin, Stanley, Wimar, Eastman, and Miller," in Tyler, *American Frontier Life*, 133–134; Goetzmann and Goetzmann, 27.

86. Truettner, "For European Audiences," 31; Bernard Reilly Jr., "Prints of Life in the West," 176.

87. John Lowell Pratt, 86; Rawls, 201; Baragwanath, 60.

88. Yochelson, 37.

89. Kammen, *Mystic Chords of Memory*, 85.

90. Schimmel, 150.

Chapter 5

1. Johns, *American Genre Painting*, 176; Edward K. Spann, *The New Metropolis: New York City, 1840–1857* (New York: Columbia University Press, 1981), 23–26; Philip M. Hosay, *The Challenge of Urban Poverty* (New York: Arno Press, 1980), 11–12; Paul Boyer, *Urban Masses and Moral Order in America, 1820–1920* (Cambridge, Mass.: Harvard University Press, 1978), 67–68.

2. Hills, *American Frontier*, 9.

3. Williams, *Mirror to the American Past*, 139, 141–142.

4. Johns, *American Genre Painting*, 177; Thomas Bender, *Toward an Urban Vision: Ideas and Institutions in Nineteenth-Century America* (Lexington: University Press of

Kentucky, 1975). See also Stuart M. Blumin, *The Emergence of the Middle Class: Social Experience in the American City, 1760–1900* (New York: Cambridge University Press, 1989).

5. Johns, *American Genre Painting*, 177; Boyer, 73; Spann; Carrol Smith-Rosenberg, *Religion and the Rise of the American City: The New York City Mission Movement, 1812–1870* (Ithaca, N.Y.: Cornell University Press, 1997).

6. Johns, *American Genre Painting*, 177–178.

7. Hosay, 12; Spann, 23; Johns, *American Genre Painting*, 182; see also Robert Ernst, *Immigrant Life in New York City, 1825–1863* (New York: King's Crown Press, 1949); David Ward, *Cities and Immigrants: A Geography of Change in Nineteenth-Century America* (New York: Oxford University Press, 1971); John Bodnar, *The Transplanted: A History of Immigrants in Urban America* (Bloomington: Indiana University Press, 1985).

8. Johns, *American Genre Painting*, 182–183.

9. Johns, *American Genre Painting*, 183–185.

10. Johns, *American Genre Painting*, 192.

11. Cronin, 326; Altschuler and Blumin, 243.

12. Cronin, 327.

13. Rawls, 110; Cleveland Museum, *Catalogue*, 108.

14. Baragwanath, 38.

15. Rawls, 110.

16. Mayor, description with print no. 108.

17. Rawls, 110; King and Davis, np.

18. Rawls, 111.

19. Rawls, 111.

20. Rawls, 112; Baragwanath, 22.

21. Stephanie Munsing, *Made in America: Printmaking 1760–1860: An Exhibition of the Original Prints from the Collections of the Library Company of Philadelphia and the Historical Society of Pennsylvania, April–June, 1973* (Philadelphia, Pa.: Library Company of Philadelphia, 1973), 39.

22. Munsing, 39.

23. Rawls, 112.

24. Rawls, 113–114.

25. Kevin Baker, "The Riot That Remade a City," *American Heritage* (November 1999): 22; Kammen, *Mystic Chords of Memory*, 19.

26. Baker, 22.

27. Baragwanath, 112.

28. Rawls, 114.

29. Holzer, Boritt, and Neely, *Lincoln Image*, 114.

30. *American Historical Prints: Early Views of American Cities, Etc.* (New York: New York Public Library, 1933), ix; John W. Reps, "Upstate Cities on Paper and Stone: Urban Lithographs of Nineteenth-Century New York," in Tatham, *Prints and Printmakers*, 119.

31. Reps, "Upstate Cities on Paper and Stone," 111; see also John W. Reps, *Views and Viewmakers of Urban America: Lithographs of Towns an Cities in the United States*

and Canada, Notes on the Artists and Publishers, and a Union Catalog of Their Work, 1825–1925 (Columbia: University of Missouri Press, 1984).

32. Karshan, 22–25.

33. Rawls, 241.

34. Quoted in Rawls, 242.

35. Bodnar, *Remaking America*, 67–69.

36. Johns, *American Genre Painting*, 24–25.

37. Johns, *American Genre Painting*, 25.

38. Johns, *American Genre Painting*, 26.

39. Williams, *Mirror to the American Past*, 70, 72.

40. Rawls, 242.

41. Truettner and Stein, xi.

42. Truettner and Stein, xii.

43. Dona Brown and Stephen Nissenbaum, "Changing New England: 1865–1945," in Truettner and Stein, 2–3.

44. Brown and Nissenbaum, 4–5.

45. Roger B. Stein, "After the War: Constructing a Rural Past," in Truettner and Stein, *Picturing Old New England*, 19.

46. Cronin, 318–319.

47. Cronin, 319–320.

48. Cronin, 320–321.

49. Peters Collection, front cover of catalog (undated, ca. 1862).

50. Baragwanath, 77.

51. Yochelson, 40.

52. Baragwanath, 24.

53. Baragwanath, 16.

54. Williams, *Mirror to the American Past*, 149.

55. Rawls, 246.

56. Bode, 88–89.

57. King and Davis, np.

58. Baragwanath, 20.

59. Stevenson, xxv.

60. Yochelson, 39.

61. Peters Collection, front cover of catalog (undated, ca. 1862).

62. Peters Collection, front cover of catalog (undated, ca. 1862).

63. King and Davis, np.

64. Peters Collection, front cover of catalog (undated, ca. 1862).

Chapter 6

1. Stevenson, xxiii.

2. E. McSherry Fowble, "Currier and Ives and the American Parlor," *Imprint* 15 (autumn 1990): 15, 19 n. 1.

3. Catherine E. Beecher and Harriet Beecher Stowe, *The American Woman's Home* (New York: J. B. Ford, 1869).

4. Marzio, *Democratic Art*, 116; Harriet Bridgeman and Elizabeth Drury, eds., *The Encyclopedia of Victoriana* (New York: Macmillan, 1975), 65–70.

5. Catherine E. Beecher and Harriet Beecher Stowe, *The New Housekeeper's Manual* (New York: J. B. Ford, 1873), 19; Stevenson, xxiv; Marzio, *Democratic Art*, 116–117.

6. Marzio, *Democratic Art*, 7; Beecher and Beecher Stowe, *New Housekeeper's Manual*, 19.

7. Quoted in Rawls, 244.

8. Quoted in Rawls, 244.

9. Charles A. Beard and Mary R. Beard, *The Rise of American Civilization* (New York: Macmillan, 1937), 1:757; Beecher and Beecher Stowe, *New Housekeeper's Manual*, 24–25; Marzio, *Democratic Art*, 117; Katherine C. Grier, *Culture and Comfort: Parlor Making and Middle-Class Identity, 1850–1930* (Washington, D.C.: Smithsonian Institution Press, 1997), 6; Mayor, 3.

10. Stevenson, 1; Rawls, 245.

11. Stevenson, 1–2; Grier, 2, 7.

12. Quoted in Grier, 8.

13. Beecher and Beecher Stowe, *American Woman's Home*, 18–19, 24; Prang, 5.

14. Conningham, xii; see for example Elizabeth Gilmore Holt, "Revivalist Theme in American Prints and Folk Songs, 1830–1850," in *American Printmaking before 1876*, 34–46; Peters, *Currier and Ives*, 36; Rawls, 453–455.

15. Yochelson, 43.

16. James P. Gifford, "The Celebrated World of Currier and Ives: In Which Heroic Fire Laddies Raced to Battle Conflagrations while the Police Disappeared in the Most Amazing Way," *New York Historical Society Quarterly* 59 (October 1975): 363.

17. Marzio, *Democratic Art*, 117, 120, 123; see also Lehuu, 123–124.

18. Marzio, *Democratic Art*, 123.

19. Rawls, 241–242.

20. Baragwanath, 110.

21. Yochelson, 28.

22. Yochelson, 28–29; Baragwanath, 28.

23. Yochelson, 29.

24. Fowble, 14–19.

25. Fowble, 19.

26. Marzio, *Democratic Art*, 125; see Ann Douglas, *The Feminization of American Culture* (New York: Anchor Press, 1988).

27. Quoted in Fred Lewis Pattee, *The Feminine Fifties* (New York: D. Appleton, 1940), 92; Marzio, *Democratic Art*, 125.

28. Marzio, *Democratic Art*, 125; Bethune, 213.

29. Marzio, *Democratic Art*, 125; Bethune, 213; Lehuu, chap. 5.

30. Quoted in Fowble, 17.

31. Marzio, *Democratic Art*, 127.

32. For a similar approach to gender in New Deal public art, see Barbara Melosh, *Engendering Culture: Manhood and Womanhood in New Deal Public Art and Theater* (Washington, D.C.: Smithsonian Institution Press, 1991).

33. Linda K. Kerber, *Women of the Republic: Intellect and Ideology in Revolutionary America* (Chapel Hill: University of North Carolina Press, 1980), 7; Michael Kimmel, *Manhood in America: A Cultural History* (New York: Free Press, 1996), 16–17, 26.

34. Kimmel, 53, 55; Barbara Welter, "The Cult of True Womanhood, 1820–1860," in *American Quarterly* 18 (summer 1966): 151; Lehuu, 11.

35. Ronald G. Walters, *American Reformers, 1815–1860* (New York: Hill and Wang, 1978), 102–103; Welter, "Cult of True Womanhood," 151–174. For a general discussion of maternalism in the United States see Molly Ladd-Taylor, "Toward Defining Maternalism in U.S. History," *Journal of Women's History* 5 (fall 1993): 110–113.

36. Kimmel, 17; Linda K. Kerber, "The Republican Mother," in *Women's America: Refocusing the Past*, ed. Linda Kerber and Jane De Hart (New York: Oxford University Press, 1991), 88.

37. Stevenson, 121–122.

38. Kimmel, 57.

39. Stevenson, 122; see also Mabel Newcomer, *A Century of Higher Education for American Women* (New York: Harper, 1959), 26.

40. Rawls, 450.

41. Kerber, *Women of the Republic*, 10; Robert H. Abzug, *Cosmos Crumbling: American Reform and the Religious Imagination* (New York: Oxford University Press, 1994), 183–203; Ronald G. Walters, 103.

42. Rawls, 449.

43. Rawls, 449.

44. Kerber, *Women of the Republic*, 111; Glenda Riley, *Inventing the American Woman: A Perspective on Women's History* (Arlington Heights, Ill.: Harlan Davidson, 1987), 74, 75–76, 96–98; Mott, 46; Rawls, 449.

45. Rawls, 449.

46. Crouse, 24; King and Davis, np.

47. Conningham, xii.

48. Rawls, 244.

49. Quoted in King and Davis, np.

50. Lori D. Ginzberg, "'Moral Suasion Is Moral Balderdash': Women, Politics, and Social Activism in the 1850s," *Journal of American History* 73 (December 1986): 601–622.

51. Rawls, 451; Walters, 106–107.

52. Walters, 107.

53. Walters, 107–108; Abzug, 184–185.

54. Stevenson, 153; Crouse, 17; see also Blanche Glassman Hersh, "'A Partnership of Equals': Feminist Marriage in Nineteenth-Century America," in Pleck and Pleck, *American Man*, 183–215.

55. Stevenson, 153–154; Judith Papachristou, *Women Together: A History in Documents of the Women's Movement in the United States* (New York: Knopf, 1976), 75–76;

Amanda Frisken, "Sex in Politics: Victoria Woodhull as an American Public Woman, 1870–1876," *Journal of Women's History* 12 (spring 2000): 89.

56. Johns, *American Genre Painting*, 137–138.

57. Johns, *American Genre Painting*, 142; see also Carl N. Degler, *At Odds: Women and the Family in America from the Revolution to the Present* (New York: Oxford University Press, 1980); Griselda Pollock and Rozsika Parker, *Old Mistresses: Women, Art, and Ideology* (New York: Pantheon, 1981); Griselda Pollock, *Vision and Difference: Femininity, Feminism and Histories of Art* (London: Routledge, 1988); Linda Nochlia, *Women, Art, and Power and Other Essays* (New York: Harper and Row, 1988).

58. Stevenson, 6–7.

59. Rawls, 453; Lehuu, 107–114.

60. Rawls, 453.

61. Mott, 50–51.

62. Rawls, 453; Crouse, 63–64.

63. Crouse, 73.

64. Carl N. Degler, "What Ought to Be and What Was: Women's Sexuality in the Nineteenth Century," *American Historical Review* 79 (December 1974): 1479–1490; Crouse, 74.

65. Gifford, 362.

66. Bernard Reilly Jr., *Catalogue Raisonné*, 1:xxv. On the French influence on American culture, see Beatrice Farwell, *The Cult of Images: Baudelaire and the Nineteenth-Century Media Explosion* (Santa Barbara: University of California at Santa Barbara Art Museum, 1977).

67. Hess and Kaplan, 67.

68. Bernard Reilly Jr., *Catalogue Raisonné*, 1:viii; James Brust, "Prints of Questionable Taste That Nathaniel Currier Would Not Sign," *Imprint* 20 (spring 1995): 7.

69. Johns, *American Genre Painting*, 144.

70. Johns, *American Genre Painting*, 144; see also Sarah Burns, "Yankee Romance: The Comic Courtship Scene in Nineteenth-Century American Art," *American Art Journal* 18 (October 1986): 51–75.

71. Kimmel, 35–36, 43–44.

72. Kimmel, 52–55, 59–63.

73. Brust, 10–11.

74. Crouse, 81.

75. Stevenson, xxv.

76. Stevenson, 77.

77. In Harry Peters's collection of Currier and Ives material is a letter from a woman requesting a copy of the original print because it included the snake. She had purchased the third edition, from which it had been omitted, probably because of the responses of other patrons. Peters, *Currier and Ives*, 37; Baragwanath, 108.

78. Flexner, 230.

79. Kimmel, 58; Johns, *American Genre Painting*, 151. See also Sarah Burns, "Barefoot Boys and Other Country Children: Sentiment and Ideology in Nineteenth-Century American Art," *American Art Journal* 20 (January 1998): 25–50; Sarah Burns, *Pas-*

toral Inventions: Rural Life in Nineteenth-Century American Art and Culture (Philadelphia, Pa.: Temple University Press, 1989); Bernard Wishy, *The Child and the Republic: The Dawn of Modern American Child Nurture* (Philadelphia: University of Pennsylvania Press, 1968); Michael Gordon, ed., *The American Family in Social Historical Perspective* (New York: St. Martin's Press, 1978); Joseph Kett, *Rites of Passage: Adolescence in America, 1790 to the Present* (New York: Basic Books, 1977); Marylynn Stevens Heininger et al., *A Century of Childhood, 1820–1920* (Rochester, N.Y.: Margaret Woodbury Strong Museum, 1984).

80. Flexner, 230.
81. Johns, *American Genre Painting*, 152.
82. Quoted in Johns, *American Genre Painting*, 152.
83. Johns, *American Genre Painting*, 153.
84. Rawls, 162.
85. Rawls, 162–163, 405.
86. Rawls, 162–163.

Chapter 7

1. Mary Douglas, *Purity and Danger: An Analysis of the Concepts of Pollution and Taboo* (London and New York: Ark, 1966), 54.

2. Stevenson, xxi.

3. Johns, *American Genre Painting*, 100–101; see Hugh Honour, *The Image of the Black in Western Art*, vol. 4, *From the American Revolution to World War I* (Cambridge, Mass.: Harvard University Press, 1989); James Walvin, *Black and White: The Negro and English Society, 1555–1945* (London: Penguin Press, 1973); George M. Fredrickson, *The Black Image in the White Mind: The Debate on Afro-American Character and Destiny, 1817–1914* (Middletown, Conn.: Wesleyan University Press, 1971); Albert Boime, *The Art of Exclusion: Representing Blacks in the Nineteenth Century* (Washington, D.C.: Smithsonian Institution Press, 1990); Sidney Kaplan, *Portrayal of the Negro in American Art* (Brunswick, Maine: Bowdoin College, 1967); Ellwood Parry, *The Image of the Indian and the Black Man in American Art, 1590–1900* (New York: George Braziller, 1974); Guy C. McElroy, Henry Louis Gates, and Christopher C. French, *Facing History: The Black Image in American Art, 1710–1940* (San Francisco, Ca.: Bedford Arts for the Corcoran Gallery of Art, 1990).

4. Dennis Clark, quoted in L. Perry Curtis Jr., *Apes and Angels; The Irishman in Victorian Caricature*, rev. ed. (Washington, D.C.: Smithsonian Institution Press, 1997), x. See also Ruth Thibodeau, "From Racism to Tokenism: The Changing Face of Blacks in *New Yorker* Cartoons," *Public Opinion Quarterly* 53 (winter 1989): 482; J. H. Burma, "Humor as Technique in Race Conflict," *American Sociological Review* 2 (December 1946): 710–715; W. H. Martineau, "A Model of the Social Functions of Humour," in *The Psychology of Humour: Theoretical Perspectives and Empirical Issues*, ed. J. H. Goldstein and P. E. McGhee (New York: Academic Press, 1972).

5. Curtis, x.

6. William Fletcher Thompson Jr., "Pictorial Images of the Negro during the Civil War," *Wisconsin Magazine of History* (summer 1965): 283. See also Drew Gilpin Faust, *The Ideology of Slavery: Proslavery Thought in the Antebellum South, 1830–1860* (Baton Rouge: Louisiana University Press, 1981), 3; John R. McKivigan, *The War against Proslavery Religion: Abolitionism and the Northern Churches, 1830–1865* (Ithaca, N.Y.: Cornell University Press, 1984), 22; Richard J. Carwardine, *Evangelicals and Politics in Antebellum America* (New Haven: Yale University Press, 1973), 153–154; Philip Shaw Paludan, "Religion and the American Civil War," in *Religion and the American Civil War*, ed. Randall M. Miller, Harry S. Stout, and Charles Reagan Wilson (New York: Oxford University Press, 1998), 23.

7. Thompson, "Pictorial Images of the Negro," 283. See also Leon Litwack, *North of Slavery, The Negro in the Free States, 1790–1860* (Chicago, Ill.: University of Chicago Press, 1961), 99, 103; see Honour, *Image of the Black*; Fredrickson, *Black Image*; Boime.

8. Williams, *Civil War*, 28.

9. See Cronin, 327–328.

10. Cullen, 14; Benjamin Quarles, *Lincoln and the Negro* (New York: Oxford University Press, 1962), 134. See Moira Davison Reynolds, *Uncle Tom's Cabin and Mid-Nineteenth Century United States: Pen and Conscience* (Jefferson, N.C.: McFarland, 1985); Thomas F. Gossett, *Uncle Tom's Cabin and American Culture* (Dallas, Tex.: Southern Methodist University Press, 1985).

11. Yochelson, 44.

12. Peters Collections, front cover of catalog (undated, ca. 1862).

13. Thompson, "Pictorial Propaganda," 30.

14. Quarles, 67–68, and chap. 7.

15. James M. McPherson, *The Struggle for Equality: Abolitionists and the Negro in the Civil War and Reconstruction* (Princeton: Princeton University Press, 1964), 211.

16. Attributed to Maurer in Weitenkampf, *American Graphic Art*, 258; Rufus Rockwell Wilson, 32.

17. Rufus Rockwell Wilson, 50.

18. Thompson, "Pictorial Images of the Negro," 293; McPherson, *Ordeal by Fire*, 440.

19. Kristen M. Smith, 122; Thompson, *Image of War*, 168. See Quarles, 214–215.

20. McPherson, *Ordeal by Fire*, 545–546.

21. Waite Papers, "History of Currier and Ives (undated)," microfilm, roll 681, frame 74; Baragwanath, 104; Thompson, "Pictorial Images of the Negro," 285.

22. Yochelson, 20.

23. Flexner, 234.

24. The "cakewalk," a dance contest from African harvest festivals, reached white audiences during this period as a strutting dance step in blackface minstrel shows; Yochelson, 31.

25. See Philip F. Gura and James F. Bollman, *America's Instrument: The Banjo in the Nineteenth Century* (Chapel Hill: University of North Carolina Press, 1999).

26. See, for example, William Loren Katz, *The Black West*, 3d ed. (Seattle, Wash.:

Open Hand Publishing, 1987); Quintard Taylor, *In Search of the Racial Frontier: African Americans in the American West, 1528–1990* (New York: W. W. Norton, 1998); Monroe Lee Billington and Roger D. Hardaway, eds., *African Americans on the Western Frontier* (Niwot: University Press of Colorado, 1998); William Sherman Savage, *Blacks in the West* (Westpoint, Conn.: Greenwood Press, 1976).

27. W. Eugene Hollon, *Frontier Violence: Another Look* (New York: Oxford University Press, 1974), 81, 95.

28. Quoted in Hollon, 80.

29. Hollon, 81, 93–95.

30. O'Rourke, 129.

31. O'Rourke, 98.

32. O'Rourke, 48. See James Hennesey, *American Catholics: A History of the Roman Catholic Community in the United States* (New York: Oxford University Press, 1981), chapter 10; Ray Allan Billington, *The Protestant Crusade, 1800–1860* (Chicago, Ill.: University of Chicago Press, 1938); Carleton Beals, *Brass Knuckle Crusade: The Great Know-Nothing Conspiracy, 1820–1860* (New York: Hastings House, 1960).

33. O'Rouke, 11.

34. O'Rouke, 13.

35. O'Rourke, 31.

36. O'Rourke, 62.

37. O'Rourke, 64–66.

38. O'Rourke, 73–74, 76, 81–83.

39. O'Rourke, 77.

40. O'Rourke, 87.

41. O'Rourke, 72.

42. O'Rourke, 94.

43. O'Rourke, 96.

44. John Lowell Pratt, 178.

45. O'Rourke, 108; Crouse, 85–88.

46. Curtis, x–xiii, xx. See Robert MacDougall, "Red, Brown and Yellow Prints: Images of the American Enemy in 1940s and 1950s," *Journal of Popular Culture* 32 (spring 1999): 62.

47. Neely and Holzer, 144; Iver Bernstein, *The New York City Draft Riots: Their Significance for American Society and Politics in the Age of the Civil War* (New York: Oxford University Press, 1990), 5, 33, 38–39.

48. Cunliffe, *Soldiers and Civilians*, 229, 235.

49. Bernstein, chaps. 1 and 2; Thompson, *Image of War*, 108; James G. Randall, *The Civil War and Reconstruction* (Boston: D. C. Heath, 1937), 410–416; Thompson, "Pictorial Propaganda," 24.

50. See, for example, Bernstein, chaps. 3–5.

51. Thompson, *Image of War*, 109; Thompson, "Pictorial Propaganda," 24; Bernstein, chap. 6. Seymour was the Democratic candidate for president. In the companion print, *The Man of Deeds* (1868), his Republican opponent, Ulysses Grant, is shown having slain the serpent "Rebellion" and accepting Robert E. Lee's sword in surrender.

52. Baker, 20; O'Rourke, 100; Rawls, 116–117.

53. O'Rourke, 58.

54. O'Rourke, 54.

Chapter 8

1. William Murrell, *A History of Graphic Humor, 1865–1938* (New York: Macmillan, 1938), 2:3.

2. Altschuler and Blumin, 246; Kristen M. Smith, xv.

3. Nevins and Weitenkampf, 9; Kristen M. Smith, xv–xvi; Conningham, xii.

4. MacNelly is quoted in John Darby, *Dressed to Kill: Cartoonists and the Northern Ireland Conflict* (Belfast: Appletree Press, 1983), 16.

5. Nye, 216.

6. Murrell, 1:4, 9; Hess and Kaplan, 16.

7. Bernard Reilly Jr., "Comic Drawing in New York in the 1850s," in Tatham, *Prints and Printmakers,* 147.

8. Hess and Kaplan, 13.

9. Murrell, 1:5.

10. Murrell, 1:10–11; Hess and Kaplan, 16.

11. Nevins and Weitenkampf, 9.

12. Murrell, 1:10–42; Weitenkampf, *American Graphic Art,* 240; Sawin, 37; Hess and Kaplan, 52.

13. Hess and Kaplan, 55.

14. Weitenkampf, *American Graphic Art,* 241–242.

15. Weitenkampf, *American Graphic Art,* 242–243.

16. Hess and Kaplan, 61.

17. Murrell, 1:42–43; Weitenkampf, *American Graphic Art,* 246. See also Sawin, 38.

18. Hess and Kaplan, 61.

19. Hess and Kaplan, 63–64; Murrell, vol. 1, chap. 6.

20. Hess and Kaplan, 35, 39–41, 68, 70–71; Nevins and Weitenkampf, 9–11; Thoreau, 20–24.

21. Judy Fayard, "A Busy Day at the Grand Palais," *Wall Street Journal Europe,* November 12–13, 1999, 15; Weber, 67; Broun, 11–12; Man, 42–43.

22. Michael Gibson, "Daumier Immortal: A Master of Attitude," *International Herald Tribune,* November 13–14, 1999, 7.

23. Bernard Reilly Jr., "Comic Drawing," 148; Bernard Reilly Jr., *Catalogue Raisonné,* 1:xxvii; Nancy R. Davison, "E. W. Clay and the American Political Caricature Business," in Tatham, *Prints and Printmakers,* 43–65.

24. Murrell, 1:115–116; Hess and Kaplan, 73.

25. Nevins and Weitenkampf, 11–12; Hess and Kaplan, 73; Baragwanath, 104.

26. Mott, 103; Bernard Reilly Jr., "Comic Drawing," 151.

27. Bernard Reilly Jr., "Comic Drawing," 151; Weitenkampf, *American Graphic Art,* 255; Thompson, *Image of War,* 166; Waite Papers, "History of Currier and Ives (undated)," microfilm, roll 681, frame 74.

28. Murrell, 1:184–185; Hess and Kaplan, 74.

29. Johns, *American Genre Painting*, 85, 132–139; David Tatham, "D. C. Johnston's Satiric Views of Art in Boston, 1825–1850," in Flint, *Art and Commerce*, 9–24.

30. Nevins and Weitenkampf, 16; "Nathaniel Currier," obituary, *New York Times*, November 22, 1888, 2; "Capt. James Merritt Ives," 1.

31. Peters, *Currier and Ives*, 33–34; Bernard Reilly Jr., *Catalogue Raisonné*, 1:xvi; Weitenkampf, *American Graphic Art*, 255; Brust, 7; Hess and Kaplan, 73, 75.

32. Hess and Kaplan, 75; Neely and Holzer, 137.

33. Murrell, 1:185.

34. Murrell, 1:185.

35. Nevins and Weitenkampf, 72.

36. Hess and Kaplan, 77; *The Great American Buck Hunt of 1856* is attributed to Maurer in Weitenkampf, *American Graphic Art*, 258.

37. Murrell, 1:221–222.

38. Murrell, 1:221–222; Hess and Kaplan, 75.

39. Attributed to Maurer in Weitenkampf, *American Graphic Art*, 258.

40. Attributed to Maurer in Weitenkampf, *American Graphic Art*, 258.

41. Quoted in Rufus Rockwell Wilson, 30.

42. Attributed to Maurer in Weitenkampf, *American Graphic Art*, 258.

43. Rufus Rockwell Wilson, 34.

44. Jules Tygiel, *Past Time: Baseball as History* (New York: Oxford University Press, 2000), chap. 1.

45. Rufus Rockwell Wilson, 6.

46. Nevins and Weitenkampf, 84.

47. Weitenkampf, *American Graphic Art*, 258.

48. Rufus Rockwell Wilson, 10.

49. Rufus Rockwell Wilson, 8.

50. Neely and Holzer, 140, 152–158.

51. Neely and Holzer, 130–132.

52. Neely and Holzer, 140; Arthur M. Schlesinger Jr. and Fred L. Israel, *History of American Presidential Elections, 1789–1968* (New York: Chelsea House, 1971), 4:1179; Stephen W. Sears, ed., *The Civil War Papers of George B. McClellan: Selected Correspondence, 1860–1865* (New York: Ticknor and Fields, 1989), 596; Thompson, *Image of War*, 175–176.

53. Stanley Kaplan, "The Miscegenation Issue in the Campaign of 1864," *Journal of Negro History* 34 (July 1949): 317.

54. Wilson, x.

55. Neely and Holzer, 134.

56. Rufus Rockwell Wilson, 272.

57. Neely and Holzer, 137.

58. See Bernard Reilly Jr., *Catalogue Raisonné*, 2:667–668.

59. Neely and Holzer, 144.

60. Rufus Rockwell Wilson, 290; Hess and Kaplan, 131.

61. Nevins and Weitenkampf, 112.

62. Kenneth M. Stampp, *The Era of Reconstruction, 1865–1877* (New York: Alfred A. Knopf, 1966), 148–154; McPherson, *Ordeal by Fire*, 526–529.

63. Nevins and Weitenkampf, 116.

64. McPherson, *Ordeal by Fire*, 543–545.

65. Rawls, 291.

Chapter 9

1. Crouse, 53; King and Davis, np; Crouse, 51–58.

2. Rawls, 61–71.

3. King and Davis, np.

4. King and Davis, np; Perry, 34–35.

5. John Lowell Pratt, 54.

6. Rawls, 75; John Lowell Pratt, 77.

7. Conningham, xii.

8. Baragwanath, 88.

9. King and Davis, np.

10. Rawls, 207.

11. Hills, "Picturing Progress," 127.

12. Leo Marx, *The Machine in the Garden: Technology and the Pastoral Ideal in America* (New York: Oxford University Press, 1964), especially chap. 4.

13. Cronin, 324.

14. Baragwanath, 48.

15. Cronin, 325.

16. King and Davis, np. See also John Lowell Pratt, 133.

17. King and Davis, np.

18. Baragwanath, 44; Crouse, 29–32.

19. Gifford, 354; King and Davis, np.

20. King and Davis, np; Crouse, 69; Rawls, 123; John Lowell Pratt, 122; Gifford, 354; Lowell M. Limpus, *History of the New York Fire Department* (New York: Dutton, 1940), 202. See also Amy S. Greenburg, *Cause for Alarm: The Volunteer Fire Department in the Nineteenth-Century City* (Princeton, N.J.: Princeton University Press, 1998).

21. Peters Collection, advertisement for Currier and Ives's Fireman Pictures (ca. 1884).

22. Peters Collection, advertisement for Currier and Ives's Fireman Pictures (ca. 1884).

23. Yochelson, 18; Bernard Reilly Jr., *Catalogue Raisonné*, 1:403; Gifford, 350–352.

24. Rawls, 123.

25. Baragwanath, 40; Gifford, 351–352.

26. Crouse, 70; Rawls, 123; John Lowell Pratt, 122.

27. Rawls, 123.

28. Gifford, 355.

29. Gifford, 356.

30. James F. Richardson, *The New York Police, Colonial Times to 1901* (New York: Oxford University Press, 1970), 26; Isaac Newton Phelps Stokes, *The Iconography of Manhattan Island, 1498–1909* (New York: Robert H. Dodd, 1928), 3:642.

31. Gifford, 356–357; Richardson, 89, 95–96; Thompson, "Pictorial Image of the Negro," 203.

32. Richardson, 96, 104, 105.

33. Richardson, 120, 163, 180, 191; Gifford, 358.

34. Limpus, 166 , 172, 186, 188, 225, 259; Gifford, 361; Stokes, 3:660, 756.

35. Gifford, 361–363.

36. Rawls, 405; Yochelson, 44.

37. Rawls, 405.

38. Crouse, 14.

39. "Captain James Merrit Ives," 8.

40. Rawls, 404.

41. Crouse, 45–46; Rawls, 406.

42. Crouse, 43–44; Rawls, 407–408; Yochelson, 9.

43. Crouse, 44; King and Davis, np.

44. Crouse, 47; Rawls, 406.

45. Rawls, 406; John Lowell Pratt, 182.

46. King and Davis, np.

47. Quoted in Baragwanath, 78. See also Rawls, 79.

48. Baragwanath, 78; King and Davis, np.

49. Mumsing, 48.

50. Conningham, xii. Book advertisement for John Blan van Urk, *The Story of American Foxhunting: From Challenge to Full Cry* (New York: Derrydale Press, 1940), in Peters Collection, "Correspondence."

51. Michael A. Bellesiles, "The Origins of Gun Culture in the United States, 1760–1865," in *Whose Right to Bear Arms Did the Second Amendment Protect?* ed. Saul Cornell (New York: Bedford/St. Martin's, 2000), 158.

52. Rawls, 325. Tait included Forester in his *Catching a Trout* (1854).

53. Rawls, 325.

54. Quoted in Rawls, 325.

55. Quoted in Rawls, 326.

56. Quoted in Rawls, 326.

57. Bellesiles, 164; "Guns in America: Arms and the Man," *Economist*, July 3, 1999, 19; Rawls, 329.

58. Quoted in Rawls, 327.

59. Quoted in Rawls, 328.

60. Quoted in Rawls, 328.

61. Bellesiles, 165.

62. *American Turf Register and Sporting Magazine* 1 (1829–1830): 79, 338–339; quoted in Bellesiles, 165.

63. King and Davis, np.

64. King and Davis, np; see also Bellesiles, 165.

65. King and Davis, np.

66. John Lowell Pratt, 202.

67. Baragwanath, 70.

68. Baragwanath, 70; John Lowell Pratt, 202.

69. Quoted in Rawls, 328–329.

70. Quoted in John Lowell Pratt, 216.

71. King and Davis, np; John Lowell Pratt, 216; Baragwanath, 66.

72. King and Davis, np; Baragwanath, 66.

73. Baragwanath, 64.

74. Rawls, 409.

75. Rawls, 411; King and Davis, np; Crouse, 130; Tygiel, 5.

76. Tygiel, 56; Rawls, 411; King and Davis, np; Crouse, 131.

77. Rawls, 408, 412; Crouse, 132; Tygiel, 13–14.

78. Frederic D. Schwartz, "Glove Story," *American Heritage* (July–August 2000): 60–63; King and Davis, np.

79. Quoted in Tygiel, 8–9.

80. Tygiel, 10.

81. Rawls, 414; John Lowell Pratt, 70.

82. Rawls, 414–415; John Lowell Pratt, 70.

83. John Lowell Pratt, 70.

84. Rawls, 415.

85. King and Davis, np.

86. Rawls, 411.

Epilogue

1. Rawls, 62.

2. Ned Currier to Nathaniel Currier, September 21, 1881, "Letters from 'Ned' Currier to His Father or Mother, 1881–1889," microfilm, roll 2323, frames 809–810, Nathaniel Currier Papers, Archives of American Art, Smithsonian Institution, Washington D.C.

3. Ned Currier to Nathaniel Currier, September 25, 1881, Nathaniel Currier Papers, microfilm, roll 2323, frames 811–813.

4. Waite Papers, "History of Currier and Ives (undated)," microfilm, roll 681, frame 71; Ned Currier to Nathaniel Currier, October 2, 1882, Nathaniel Currier Papers, microfilm, roll 2323, frames 847–858; Peters, 16–17.

5. Ned Currier to Nathaniel Currier, August 28, 1882, Nathaniel Currier Papers, microfilm, roll 2323, frames 840–842; Ned Currier to Nathaniel Currier, October 2, 1882, Nathaniel Currier Papers, microfilm, roll 2323, frames 857–858.

6. Ned Currier to Nathaniel Currier, July 27, 1885, Nathaniel Currier Papers, microfilm, roll 2323, frames 926–927; Ned Currier to Nathaniel Currier, August 3, 1885, Nathaniel Currier Papers, microfilm, roll 2323, frames 928–929; Ned Currier to Nathaniel Currier, August 10, 1885, Nathaniel Currier Papers, microfilm, roll 2323, frames 930–931.

7. Peters, *Currier and Ives,* 17; Rawls, 60, 63; John Lowell Pratt, 15.

8. Peters, *Currier and Ives,* 17; Rawls, 60-63; Waite Papers, "History of Currier (undated)," microfilm, roll 681, frames 69-70.

9. Waite Papers, "History of Currier and Ives (undated)," microfilm, roll 681, frame 68.

10. Goldman, 31; see also Josephine Cobb, "Prints, the Camera, and Historical Accuracy," in *American Printmaking before 1876,* 1-10; Sawin, 37.

11. Peters, *Currier and Ives,* 17; Rawls, 62.

12. Rawls, 62; see trade cards in Peters Collection, box 12, "Miscellaneous."

13. Marzio, *Democratic Art,* 94-106, 176; Peter Marzio, "The Democratic Art of Chromolithography in America: An Overview," in *Art and Commerce,* 77-78; Sinclair H. Hitchings, "Fine Art Lithography in Boston: Craftsmanship in Color, 1840 1900," in *Art and Commerce,* 103-125.

14. Jay Cantor, "Prints and the American Art-Union" in Morse, *Prints in and of America,* 322; Bernard Reilly Jr., *Catalogue Raisonné,* 1:xxx-xxxi; Marzio, *Democratic Art, 3.*

15. Bernard Reilly Jr., *Catalogue Raisonné,* 1:xxx-xxxi.

16. Bernard Reilly Jr., *Catalogue Raisonné,* 1:xxxii; Stevenson, 4.

17. Marzio, *Democratic Art,* 116-123, 127; Stevenson, 6.

18. Bode, xii-xiv; Curti, 408.

19. Bode, 89; Frank Luther Mott, *A History of American Magazines, 1865-1885* (Cambridge, Mass.: Harvard University Press, 1939), 182.

20. Lawrence W. Levine, *Highbrow, Lowbrow: The Emergence of Cultural Hierarchy in America* (Cambridge, Mass: Harvard University Press, 1990).

21. Bernard Reilly Jr., *Catalogue Raisonné,* 1:xxxii-xxiv; Cantor, 322; Stevenson, 26-27, 60-61.

22. Susan Parker to Harry T. Peters, May 29, 1941, Peters Collection, box 10, "Correspondence."

23. Bernard Reilly Jr., *A Catalogue Raisonné,* 1:xxxiv.

24. Bernard Reilly Jr., *A Catalogue Raisonné,* 1:xxxiv.

25. Peters Collection, exhibit materials for *Currier and Ives, Printmakers to the American People.*

INDEX

Abraham Lincoln: The Martyr President (print), 105

Abraham Lincoln: The Nation's Martyr (print), 105

Abraham's Dream (cartoon), 283

Accepted, The (print), 209

Accommodation Train, The (print), 300

Across the Continent: Westward the Course of Empire Takes Its Way (print), 121–122, 124, 148, 300

Adam and Eve Driven Out of Paradise (print), 204

Adam and Eve in the Garden of Eden (print), 204

Adam Naming the Creatures (print), 211

Aesthetic Craze, The: What's de Matter wid de Nigga? Why Oscar You's Gone Wild (print), 237–238

Affair of Honor, An (print): *Critical Moment, The: Now Den Brace Em Up—One! Two!!; Stray Shot, A: "Whar yer Givine to Nigga? You Done Shot Old Sawbones,"* 238

African Americans, 6, 9, 10, 22, 24, 216–244

Age of Brass, The—or the Triumphs of Women's Rights (print), 199, 200 (fig.)

Age of Iron, The: Man as He Expects to Be (print), 199

agrarian ideal, 9, 24, 25, 127–131, 171–172, 177

All in Tune: "Thumb It Darkies, Thumb It— O How Loose I Feel!" (print), 241

All on Their Mettle: "Git Dere Fast if You's Bust You Trousers!" (print), 239

Amateur Muscle in the Shell (print), 330

American Autumn Fruits (print), 185

American Clipper Ship off Sandy Hook Light in a Snow Storm (print), 295

American Country Life series (prints), 178–179, 220; *Pleasures of Winter,* 179, 220

American Express Train, The (print), 299

American Farm Scenes series (prints), 22, 178

American Farm Yard—Evening (print), 178

American Farm Yard—Morning (print), 178

American Fireman, The (print), 302

American Forest Scene: Maple Sugaring (print), 173–174

American Frontier Life (print), 135

American Homestead , The series (prints), 178

American Hunting Scenes (prints), 315

American National Game of Base Ball, The (print), 321–322

American Patriot's Dream/The Night Before the Battle (print), 99–100

American Railroad Scene (prints), 299, 300

American Railway Scene, An (print), 299

American Revolution, 9, 16, 41–42, 46, 53–59, 259–260

American Speckled Brook Trout (print), 25

American Winter Sports: Trout Fishing "On Chateaugay Lake" (Franklin Co. N.Y.) (print), 318

Among the Pines: A First Settlement (print), 126

Angels of the Battlefield, The (print), 102, 103 (fig.)

Apostle of Ireland, The—Saint Patrick (print), 247–248
Arguing the Point (print), 130
Arkansas Traveler, The: Scene in the Back Woods of Arkansas (print), 129
Arthur Chambers: Lightweight Champion (print), 319
Art of Making Money Plenty, The (print), 38 (fig.), 39
Assassination of President Lincoln, The: At Ford's Theatre, Washington, D.C., April 14, 1865 (print), 105
Attack on the Deadhead Coach (print), 241–242
Attack on the Widow McCormack's House on Boulagh Common, July 27, 1848 (print), 250
"Auld Times" of Donnybrook Fair (print), 255
Autumn in New England: Cider Making (print), 177
Awful Conflagration of the Steam Boat Lexington (print), 12 (fig.), 298
Awful Wreck of the Magnificent Steamer "Atlantic" (print), 298

Bad Husband, The: The Fruits of Intemperance and Idleness (print),154
"Balk" on a Sweepstake (print), 325
Baptism of Pocahontas, The (print), 53
Bare Chance, A (print), 328
Barefaced Cheek (print), 328–329
Barsqualdi's Statue Liberty Frighten the World: BedLam's Island, N.Y. Harbor (print), 242, 244
Battle at Bunker's Hill (print), 55
Battle of Antietam, The (print), 77, 78
Battle of Booneville, The, or the Grand Missouri "Lyon" Hunt (print), 85
Battle of Bull Run (print), 78
Battle of Cerro Gordo April 18th 1847 (print), 65
Battle of Sharpsburg, The (print), 78–79
Benjamin Franklin. The Stateman and Philosopher (print), 37
Bewildered Hunter, The (print), 211
Bible and Temperance series (prints), 153–154
Big Thing on Ice, A (print), 330
Biting Lively (print), 329
Black Squall, A (print), 240–241
Blockade on the "Connecticut Plan," The (print), 87

Blood Will Tell! (cartoon), 286, 300
Bloomer Costume, The (print), 202
Body of the Martyr President, The: Lying in State at the City Hall, N.Y. April 24th and 25th 1865 (print), 107
Bombardment of Fort Sumter, Charleston Harbor (print), 74
Bombardment of Fort Sumter, Charleston Harbor: From Fort Moultrie (print), 74
Boss of the Road (print), 234
Boss of the Track (print), 326
Bound to Shine/Bound to Smash (prints), 234
"Boy of the Period" Stirring Up the Animals, Black Friday, September 1869 (cartoon), 287
Brace of Meadow Larks, A (print), 328
Branding Slaves: On the Coast of Africa Previous to Embarkation (print), 218, 219 (fig.)
Brave Wife, The (print), 100
"Breaking In": A Black Imposition (print), 242
Breaking Out: A Lively Scrimmage (print), 242
Breaking That Bone (cartoon), 85, 86 (fig.)
Brer Thuldy's Statue/Liberty Frightenin de World: To Be Stuck up on BedLam's Is;and/ Jersey Flats, Opposite de United States (print), 243 (fig.), 244
Brian Boru—Monarch of Ireland and Hero of Clontarf (print), 248
Brigadier General Michael Corcoran at the Head of His Gallant Irish Brigade (print), 249
Brilliant Charge of Capt. May, The (print), 65
Brook Trout Fishing: "An Anxious Moment" (print), 318
Brush on the Road, A: Best Two in Three (print), 327
Brush on the Road, A: Mile Heats, Best Two in Three (print), 327
Buffalo Bull Chasing Back (print), 145
Buffalo Chase (print), 144
Buffalo Chase, The (print), 242
Buffalo Dance, The (print), 144
Buffalo Hunt, The (print), 138
Buffalo Hunt, The: "Surrounding the Herd" (print), 144
Buffalo Hunt under the White Wolf Skin: An Indian Strategem on the Level Prairies (print), 144
Bully Team, The! Scaldine and Early Nose (print), 327

Burning of Chicago, The (print), 301
Burning of the City Hall, New York (print), 301
Burning of the Palace Steamer "Robert E. Lee"
 (print), 298
Burning of the Splendid Steamer "Erie"
 (print), 298

California gold rush, 9, 111–119
Camping in the Woods: "A Good Time Coming"
 (print), 315
Camping in the Woods: "Laying Off" (print),
 315, 316 (fig.)
Capitulation of Vera Cruz (print), 65
*Capture of an Unprotected Female, The, or the
 Close of the Rebellion* (print), 82, 83 (fig.)
Capturing a Wild Horse (print), 143
cartoons, 10, 16, 84–95, 216–222; political, 10,
 68, 95–103, 223–228, 252–254, 259–290, 305
Catching a Trout (print), 220
Catching a Trout: "We Hab You Now, Sar"
 (print), 318
Cause and Effect (prints), 242
Caught Napping (print), 328
Caught on the Fly (print), 329
*Cavalry Tactics, by the Darktown Horse
 Guards* (print), 238
Caved In: The Busted Sculler (print), 330
Caving In, or a Rebel "Deeply Humiliated"
 (print), 86–87
Central Park, the Lake (print), 163
Central Park, Winter: The Skating Pond
 (print), 24, 163
Champion of Catholic Emancipation (print), 248
Champion of Freedom (print), 248
Champion Rowist—The Pride of the Club
 (print), 330–331
Champion Slugger, The: "Knocking 'Em Out"
 (print), 329–330
*Champions of the Mississippi, The: "A Race for
 the Buckhorns"* (print), 297–298
*Change of Base, A: I Just Done Got a Call to
 Anodder Congregation* (print), 239
*Change of Drivers under the Rule, A: The Man
 Who Drives to Win. The Man Who "Pulls"
 His Horse* (print), 326
*Chappaqua Farm, Westchester County, N.Y.:
 The Residence of the Hon. Horace Greeley*
 (print), 166

Charles Rowell, The Celebrated Pedestrian
 (print), 325
Check, A: "Keep Your Distance" (print), 135
*Chicago Platform and Candidate: A War
 Candidate on the Peace Platform* (cartoon),
 252, 280–281
Chinese, 113, 118–119, 244–245
City Hall and Vicinity, New York City (print),
 158, 159 (fig.)
City Hall, New York (print), 158
Civil War, 2, 9, 20, 46, 47, 68, 69–103, 249;
 cartoons, 84–90; and Reconstruction, 10,
 67; *see also* Lincoln, Abraham
"Clearing, A"; On the American Frontier
 (print), 127
Clipper Ship "Comet" of New York (print), 295
Clipper Ship "Dreadnought" (print), 295
Clipper Ship "Flying Cloud" (print), 294
Clipper Ship "Great Republic" (print), 294
Clipper Yacht "America" of New York, The
 (print), 323
*Col. Michael Corcoran at the Battle of Bull
 Run* (print), 77, 78
*Col. Theodore Roosevelt, U.S.V. Commander of
 the Famous Rough Riders* (print), 68
colonial period, 9, 47–48, 50–51
Colored Beauty, The (print), 231
Columbus, Christopher, 48, 49–50, 51–52, 68
*Coming from the Trot: Sports on the Home
 Stretch* (print), 311
Coming Up Smiling (print), 330
Compromise Doctors (cartoon), 275
Constitution and Guerriere, The (print), 60
Corinthian Race, A: A High Tones Start
 (print), 232 (fig.), 233
Corinthian Race, A: A Low Toned Finish
 (print), 233
Cotton Plantation on the Mississippi, A
 (print), 25, 221
Crack Trotter, A—"A Little Off" (print), 326
"Crack Trotter" between the Heats, A (print),
 326
Crack Trotter, A—"Coming Around" (print),
 326
Crossed by a Milk Train (print), 300
Crow Quadrilles, The (music sheet cover), 18
Currier, Charles, 20, 263
Currier, Edward (Ned) W., 8, 19, 333

Currier, Nathaniel (1813–1888), 17, 19–20; brother (*see* Currier, Charles); publishing business, 4, 8, 11, 13, 16, 17–19, 308, 334; son (*see* Currier, Edward W.); *see also* Currier and Ives lithographs

Currier and Ives lithographs: as advertisements, 22; art criticism of, 1–2, 4, 72; artists, 19, 21, 22–24, 54, 108; catalogs, 27–28; collections, 2, 338; color, 25–26; composites and changes, 20, 22–23, 39–40, 56, 104, 105, 145; detail, 6, 135; demise, 335–336; genre prints, 5–6, 8, 166; labels, 9; of nineteenth century America, 2, 3, 4, 5, 9, 21, 29; publications about, 5; sales, 1, 13, 26–27, 335; society typing, 6; staff, 22–25, 26; subjects (*see* African Americans; agrarian ideal; American Revolution; California gold rush; Civil War; colonial period; disaster prints; family and home life; immigration; leisure time; Mexican War; minorities; Native Americans; railroads; rural America; ships; sports; urban life; War of 1812; westward movement; women); success, 1, 3, 6, 26, 28–29, 332–334

Currier and Stodart lithographs, 17, 158

Custer's Last Charge (print), 67

Custom House and Main Floor Plan: Designed by Ithiel Town and Alexander Jackson Davis, Architects (print), 158

Danger Signal, The (print), 300

Darktown Banjo Class, The (print), 241

Darktown Donation Party, A series (prints), 240

Darktown Elopement, The (print), 240

Darktown Fire Brigade (print), 239

Darktown Hook and Ladder Corps, The (prints), 239

Darktown Hunt, The (print), 235–236

Darktown Lawn Party, A: A Bully Time (print), 235, 237 (fig.)

Darktown Lawn Party, A: Music in the Air (print), 235, 236 (fig.)

Darktown Opera (prints), 237

Darktown Race, A—Won by a Neck (print), 234

Darktown Riding Class (prints), 233

Darktown series (prints), 22, 24, 229, 231–242, 322

Darktown Sociables series (prints), 236

Darktown Sports—A Grand Sport (print), 234

Darktown Sports—Winning Easy (print), 234

Darktown Trotter Ready for the Word, A (print), 234

Darktown Wedding, A (prints), 240

Darktown Yacht Club—Hard Up for a Breeze: The Cup in Danger (print), 235

Darktown Yacht Club—On the Winning Track: The Cup Secure (print), 235

Davis, Jefferson, 82–83, 84, 85, 86–87, 90, 92, 94, 95, 227–228, 230, 278, 282

Day before Marriage, The (print), 209

Death Bed of the Martyr President Abraham Lincoln, The (print, 105–106

Death of Col. Ellsworth (print), 76

Death of General Robert E. Lee (print), 84

Death of Minnehaha, The (print), 145

Death of President Lincoln...The Nation's Martyr (print), 106–107

Death of Tecumseh, Battle of the Thames, October 18, 1813 (print), 62, 63 (fig.)

Death of Warren at the Battle of Bunker Hill (print), 55

Death of Washington (print), 45–46, 218, 220

De Cake Walk: For Beauty, Grace and Style; de Winner Takes de Cake (print), 234–235

Declaration , The (print), 209

Declaration Committee, The (print), 58

Declaration of Independence (print), 58

Decoration of the Casket of General Lee, The (print), 84

Delaying a Start: "Come Quit Fooling and Bring Up That Horse" (cartoon), 325–326

Democracy in Search of a Candidate, The (cartoon), 285

Democratic Platform, The (cartoon), 96, 224

Destruction of Tea at Boston Harbor (print), 57

disaster prints, 8, 11–13, 19, 298, 301–307

Disloyal British Subject, A (print), 249, 250

Dis-United States or the Southern Confederacy, The (cartoon), 92

"Dodge" That Won't Work, A (print), 230

Domestic Blockade, The (print), 103

Drunkard's Progress, The—From the First Glass to the Grave (print), 195

Dude Belle (print), 235

Dude Swell (print), 235
Dusted and Disgusted (print), 327

1876–On Guard: "Unceasing Vigilence Is the Price of Liberty" (print), 67
Elephant and His Keepers, The (cartoon), 289
End of Long Branch, The (cartoon), 288–289

Fall from Grace, A (print), 242
family and home life, 9–10, 171, 181–191; *see also* Victorian Americans
Fancied Security, or the Rats on a Bender (cartoon), 267–268
Farmer's Home series (prints), 176
Fast Trotters on Harlem Lane, NY (print), 311
Fate of the Radical Party (cartoon), 96, 230
Father's Pride (print), 213
Feather Weight Mounting a Scalper, A: "It's Only a Little Playful He Is" (cartoon), 325–326
Fire Engine No.— (print), 302
Fire Engine "Pacific" Brooklyn N.Y. (print), 302
First Bird of the Season, The (print), 328, 329 (fig.)
First Landing of Columbus on the Shores of the New World (print), 51–52
First Martyr of Ireland in Her Revolution of 1848, The (print), 249
First Meeting of Washington and Lafayette, The (print), 46
Flag of Our Union, The (print), 75
Flight of the Mexican Army (print), 66
Fly Fishing (print), 329
Folly of Secession, The (cartoon), 91
Four Seasons of Life, The (prints), 187, 188, 189–190
Fox Chase (print), 311
Fox-Hunting series (prints), 312
Fox without a Tail, The (cartoon), 92
Franklin, Benjamin, 16, 34, 37, 38 (fig.), 39, 54, 57
Franklin's Experiment, June 1752 (print), 39–40
Frederick Douglass: The Colored Champion of Freedom (print), 222
frontier. *See* westward movement
Frontier Lake, The (print), 127
Fruits of Intemperance, The (print), 154
Fruits of Temperance, The (print), 154, 195–196

Funeral of President Lincoln, The (print), 107
Futurity Race, The, Sheepshead Bay (print), 25

Gallant Charge of the Fifty-Fourth Massachusetts (Colored) Regiment, The (print), 222
Gallant Charge of the Kentuckians at the Battle of Buena Vista, The (print), 66
Gallop, The (print), 233–234
Game of the Arrow: Archery of the Mandan Indians (print), 143
Gap of Dunloe, The (print), 247
General Andrew Jackson: The Hero of New Orleans (print), 61
General Francis Marion of South Carolina (print), 220
General Meagher at the Battle of Fair Oaks, Va., June 1, 1862 (print), 249
General Scott's Victorious Entry into the City of Mexico, Sept. 14th 1847 (print), 66
General Taylor at the Battle of Palo Alto (print), 66
"General Taylor Never Surrenders" (print), 66
General William H. Harrison at the Battle of Tippecanoe (print), 62
George Washington: First President of the United States (print), 45
Getting a Boost (print), 326
"Give Me Liberty or Give Me Death" (print), 57
God Bless Our Home (print), 186
Going to the Trot: A Good Day and Good Track (print), 311
Gold Mining in California (print), 114
Good Times on the Old Plantation (print), 222
"Got the Drop on Him" (print), 328
Grand Patent India-Rubber Air Line Railway (print), 118
Grand Centennial Smoke: History in Vapor (cartoon), 68
Grand Centennial Wedding: Of Uncle Sam and Liberty (print), 68
Grand Display of Fireworks and Illuminations at the Opening of Brooklyn Bridge, The (print), 155, 156 (fig.)
Grand Drive, Central Park NY (print), 164
Grant, Ulysses S., 80, 81–82, 86, 90, 94, 105, 230, 285, 286, 287

Great American Buck Hunt of 1856, The
(cartoon), 270
Great American Tanner, The (cartoon), 286
*Great Bartholdi Statue, Libert Enlightening
the World, The* (print), 160, 161 (fig.), 244
"*Great Eastern*" (print), 296
Great East River Suspension Bridge (print), 155
Great Exhibition of 1851 (cartoon), 325–326
Great Exhibition of 1860 (print), 224, 270
*Great Fight between the "Merrimac" and
"Monitor," The, March 9th, 1862: The First
Battle between Iron-Clad Ships of War*
(print), 76–77
Great Fight for the Championship, The
(print), 251
Great International Yacht Race, The (print), 324
Great Match at Baltimore, The (cartoon),
252, 275
*Great Oyster Eating Match between the Dark-
town Cormorant and the Blackville Buster*
(print), 241
Great Race on the Mississippi (print), 296
Great Republican Reform Party, The (car-
toon), 96, 267, 270
*Great Republican Reform Party, The: Calling
on Their Candidate* print), 223-224
*Great Riot at the Astor Place Opera House,
New York* (print), 254
*Great Walk, The. "Come in as You Can." The
Finish* (print), 325
Great Walk, The. "Go as You Please." The Start
(print), 325
Great West, The (print), 122, 299
Grecian Bend, The/Fifth Avenue Style
(print), 201
Guardian Angel, The (print), 213
Gunboat Candidate, The (cartoon), 90
*Gunboat Candidate at the Battle of Malvern
Hill, The* (cartoon), 89–90, 280
Gymnasium, Political, The (cartoon), 273

Halls of Justice (print), 157
Haying Time: The First Load (print), 176
Haying Time: The Last Load (print), 176
Headwaters of the Missouri (print), 143
"*Heathen Chinee, The*" (print), 119, 244, 245
*Heir to the Throne, The, or the Next Republi-
can Candidate* (print), 226, 227 (fig.), 272

Heroes of "76," Marching to the Fight (print), 58
Hiawatha's Departure (print), 145, 147–148
Hiawatha's Wedding (print), 145, 147
Hiawatha's Wooing (print), 145, 147
*High Old Smoke: "Go in Fellers, Dese am de
Best in de Market!"* (print), 242
"*High Water" in the Mississippi* (print), 221
His Mother-in-Law (print), 208–209
Holy Well, The (print), 248
Home from War/The Soldier's Return
(print), 101
Home in the Wilderness, A (print), 128
Home on the Mississippi, A (print), 22, 23
(fig.), 176–177, 220–221
Home Sweet Home (print), 167, 168 (fig.),
185–186
Home to Thanksgiving (print), 167–168, 169
(fig.), 185, 195, 196
Homeward Bound—New York (print), 246
Honest Abe Taking Them on the Half Shell
(cartoon), 276–277
*Hook and Ladder Gymnastics: Brace Her up
Dar! And Cotch Her on de Fly!* (print), 230
Horse for the Money, The: Dexter in Danger
(print), 326
Horse That Died on the Man's Hands, The
(print), 327
Howling Swell, A—On the War Path
(print), 129
Howling Swell, A—With His Scalp in Danger
(print), 129
Hunter's Strategem, The (print), 135
Huntress of the Mississippi, The (print), 142
*Hurry Mr. Jonsing, Dars Dat Chile Lopin wif
de Coachman* (print), 240
Husking (print), 173, 175

Ice-Boat Race on the Hudson (print), 299
immigration, 4, 10, 113, 118–119, 150, 151–152
*Impeachment of Dame Butler, Fessenden, But-
ler, and Ben Wade* (cartoon), 285
Impending Catastrophe, An (cartoon), 286
"*Impending Crisis, The*" or *Caught in the Act*
(cartoon), 305
*Imported Messenger, The: The Great Fountain
Head—in America—of "The Messenger
Blood"* (print), 310
Inauguration of Washington, The (print), 45

Independent Gold Hunter on His Way to California, The (print), 116 (fig.), 117, 118
Indian Ball Players (print), 142
Indian Bear Dance, The (print), 144, 145
Indian Buffalo Hunt: "Close Quarters" (print), 144
Indian Buffalo Hunt: On the "Prairie Bluffs" (print), 144
Indian Family, The (print), 142–143, 204
Indian Hunter, The (print), 142
Indians Attacking the Grizzly Bear (print), 143–144, 145
Indian Warrior, The (print), 142
industry, 4, 67, 70
Initiation Ceremonies of the Darktown Lodge (print), 238
In the Skating Carnival (print), 330
Irish Americans, 7, 10, 93, 245–256
"Irrepressible Conflict," or the Republican Barge in Danger (print), 225–226
"Irrepressible Conflict," The, or the Republican Party in Danger (cartoon), 96, 264, 271
Ives, Chauncey, 334
Ives, James Merritt (1824–1895), 8, 20–21, 72, 208, 334; *see also* Currier and Ives lithographs

James Hammill and Walter Brown in Their Great Five Mile Rowing Match (print), 324
Jay Eye Sore—De Great World Beater (print), 234
Jeff D.—Hung on a "Sour Apple Tree," or Treason Made Odious (cartoon), 92
Jeff Davis On His Own Platform or The Last "Act of Secession" (cartoon), 92
Jefferson, Thomas, 9, 34, 40, 57
Jeff's Last Shift (print), 82–83
John Adams; Second President of the United States (print), 40
John Brown: Meeting the Slave Mother and Her Child on the Steps of Charleston Jail on His Way to Execution (print), 222

Kiss Me Quick (print), 205, 206 (fig.)

Lackawanna Valley, The (print), 298
Lafayette at the Tomb of Washington (print), 46
Landing a Trout (print), 329

Landing of Columbus, The (print), 68
Landing of the Pilgrims at Plymouth (print), 50, 51 (fig.)
"Last Ditch" of the Democratic Party, The (cartoon), 290
Last Shot, The (print), 136
Last War-Whoop, The (print), 136, 137 (fig.)
Lawn Tennis at Darktown—A Scientific Player (print), 235
Lee, Robert E., 77, 79, 81–82, 83–84, 90, 94
leisure time, 10, 24, 25, 172, 173, 178–179, 184, 220, 307–320
Letting the Cat Out of the Bag!! (cartoon), 271–272
Levee, The—New Orleans (print), 220
Lexington: The Great Monarch of the Turf and Sire of Racers (print), 310
Lieutenant General Ulysses S. Grant at the Siege of Vicksburg (print), 80
Life in New York: That's So (print), 154–155
Life in New York: The Breadth of Fashion: Fifth Avenue (print), 154, 202
Life in the Camp: "Preparing for Supper" (print), 98
Life in the Country–Evening (print), 180
Life in the Country: The Morning Ride (print), 173
Life in the Woods (print), 317
Life of a Fireman series (prints), 24, 3-2–304
Life of A Hunter, The: A Tight Fix (print), 316
Life of a Hunter, The: Catching a Tartar (print), 316, 317
Light Artillery (print), 102–103
"Lightning Express" Trains, The (print), 299
"Limited Express" A (print), 300
Lincoln, Abraham, 37, 47, 67, 226, 227 (fig.), 272, 276–277, 282–283; assassination and death, 104–108; and Civil War, 70, 75, 77, 79, 85, 86–87, 88 (fig.), 89, 90, 95, 224–225, 226, 227 (fig.), 228–229
Lismore Castle—County Waterford (print), 247
Literary Debate in the Darktown Club, A (prints), 237
lithographs, 1, 2, 4, 5, 15, 25; *see also* Currier and Ives lithographs
lithography, 4, 11, 13–16, 17, 18, 21–22, 25, 262–263

Little Game of Bagatelle, A, between Old Abe the Rail Splitter and Little Mac the Gunboat General (cartoon), 279

Little Groggy, A (print), 330

Little Recruit, The (print), 102

Lookout Mountain, Tennessee and the Chattanooga Railroad (print), 299

Lost Cause, The (print), 231

Love, Marriage, and Separation (print), 208

Lovely Calm, A (print), 240

Lovers Leap, The: Whar Yer Givine to, Dis Ain't in de Book (print), 237

Lovers' Quarrel, The (print), 209

Lovers' Reconciliation, The (print), 209, 211

Low Water in the Mississippi (print), 127, 221

McClellan, George B., 47, 78, 79, 85, 89–90, 95, 102, 226–227, 228, 278, 271–281, 282

Magic Cure (print), 241

Main of Cocks, A—The First Battle (print), 320

Managing a Candidate (cartoon), 266

Man of Words, The, The Man of Deeds. Which Do You Think the Country Needs? (cartoon), 253, 285–286

Man That Gave Barnum His "Turn," The (print), 255 (fig.), 256

Marriage Vow, The (print), 209

Married (print), 209

May Morning (print), 179

Merchant's Exchange, New York: Wall Street (print), 159

Mexican War (1846–1848), 9, 64–66

middle class, 4, 6, 7, 29, 125, 126, 150, 182, 192, 335, 336

Midnight Race on the Mississippi, A (print), 296

minorities, 7, 113, 114; *see also* African Americans; Chinese; Irish Americans; Native Americans

"Minute-Men" of the Revolution, The (print), 58

Mississippi in Time of Peace, The (print), 80

Mississippi in Time of War, The (print), 80, 81

Modern College Scull, A: Graduating with All the Honors (print), 331

More Plucky Than Prudent (print), 300

Mountaineer's Home, The (print), 128

Mountain Spring, The (print), 171

Murder of Miss Jane McCrea A.D. 1777 (print), 59

music sheets, 8, 17, 18

"Mustang" Team, The (cartoon), 266–267, 269–270

National Game, The: Three 'Outs and One Run'/Abraham Winning the Ball (cartoon), 274, 320–321

Native Americans: images, 140–141, 142–148; and white man, 52–53, 58–59, 62, 63 (fig.), 67, 111, 121–122, 129, 132, 135, 136–138, 145, 146 (fig.)

Nat Langham: Champion of the Middleweights (print), 319

New "Confederate Cruiser," The (cartoon), 289–290

New England Coast Scene (print), 171

New England Scenery (print), 171

New York Firemen's Monument (print), 302

New York from Weehawken (print), 154

New York Light Guards Quickstep, The (print), 17

New York Yacht Club Regatta, The: The New Club House (print), 322–323

Nice Family Party, A (cartoon), 288

"Nigger" in the Woodpile, The (print), 224–225, 272

Nightmare in the Sleeping Car, A (print), 300

Noah's Ark (print), 211

North American Indians (print), 145

October Afternoon (print), 179

"O Dat Watermillion!" (print), 241

Off for the War: The Soldiers Adieu (prints), 100–101

Offspring of Chiago Miscegenation, The (cartoon), 281

Off the Key: "If Yous Can't Play de Music, Jes Leff de Banjo Go!" (print), 241

Of Plimoth Plantation (print), 48

Old Barn Floor, The (print), 168, 221

Old Bull Dog on the Right Track (cartoon), 90, 280

Old Farm Gate, The (print), 168–169

Old Flag Again Waves over Sumter, The (print), 76

Old General Ready for a "Movement," The (print), 84–85

Old Oaken Bucket, The (print), 187

Old Plantation Home, The (print), 221

Old Swiss Mill, The (print), 211

Old Windmill, The (print), 168

On a Strong Scent! (print), 328

On de Haf Shell! (print), 241

Only Treaty That Never Was Broken, The (print), 53

On the Homestretch (print), 326–327

On the St. Lawrence (print), 143

On the War-Path (print), 135

"Ostend Doctrine, The" (cartoon), 269

Our Victorious Fleets in Cuban Waters (print), 68

Outward Bound—Dublin (print), 246

Paddy and the Pigs (print), 254

Paddy Ryan: "The Trojan Giant" (print), 319

Pap, Soup, and Chowder (cartoon), 266

Parley, A (print), 137

Partridges Shooting (print), 317

Patriot of 1776 Defending His Homestead, A (print), 58, 59 (fig.)

Pattern in Connemara, A (print), 254

Penitant Mule, A—The Parson on Deck: "Nebber Mind de Sermon Parson, We Seen de Pint (print), 240

Pennsylvania Railroad Scenery (print), 299

Perry's Victory on Lake Erie (print), 60

Peytona and Fashion (print), 309–310

Philosophy in Ecstacy, A (cartoon), 288

Pioneer's Home: On the Western Frontier (print), 128, 131

Pocahontas Saving the Life of Captain John Smith (print), 53

Political "Blondins" Crossing Salt River (cartoon), 273–274

Political Debate in the Darktown Club, A (prints), 238, 239

Political "Siamese" Twins, The (cartoon), 281

Popping the Question (print), 209

Prairie Fires of the Great West (print), 300

Prairie Hunter, The–One Rubbed Out (print), 133, 134 (fig.)

Preparing for Market (print), 172, 173 (fig.)

Presenting the Brush: "You Done Better

Keep It Kurnel to Polish You Check (print), 236

Presidential Fishing Party of 1848, The (cartoon), 265

Prince of Wales at the Tomb of Washington, The: Oct. 1860 (print), 46

Progressive Democracy—Prospect of a Smash Up (cartoon), 276, 287

Progress of Intemperance, The series (prints), 195, 196

Progress of the Century, The (print), 67, 292–293

Pursuit, The (print), 136

Put Up Job, A (print), 242

Puzzled Fox, The (print), 211

Puzzle for a Winter's Evening, A (print), 212

Queen of the Amazons Attacked by a Lion (print), 203

Race for the Queen's Cup, The (print), 324

Radical Party on a Heavy Grade, The (cartoon), 286

Rail Candidate, The (print), 226, 272

railroads, 10, 23, 113, 121, 122, 298–301

Rail Road Suspension Bridge, The (print), 299

Rail Shooting on the Delaware (print), 317

"Rail Splitter" at Work Repairing the Union, The (cartoon), 283

Red Hot Republicans on the Democratic Gridiron: "The San Domingo War Dance" (print), 230–231

Rejected, The (print), 209

Republican Party Going to the Right House, The (cartoon), 210

Right Man for the Right Place, The (cartoon), 268

River in the Catskills (print), 298

Road, The—Winter (print), 19, 22

Robinson Crusoe and His Pets (print), 211

Rocky Mountains, The: Emigrants Crossing the Plains (print), 121, 122

"Rounding a Bend" on the Mississippi (print), 297

Route to California, The (print), 113, 299

Ruins of the Merchants' Exchange N.Y. after the Destructive Conflagration of Decbr. 16 & 17, 1835 (print), 19, 301

Ruins of the Planters Hotel, New Orleans (print), 19
Running the Machine (cartoon), 88–89
rural America, 9, 22, 23, 165–180; *see also* agrarian ideal
Rural Lake, The (print), 171

"St. John" (print), 296
Scene in Old Ireland, A (print), 247
"Secession Movement," The (cartoon), 91
Second Battle of Bull Run, The (print), 77, 78
Selling Out Cheap! (cartoon), 288
Serenade, The: "Come Lub Come de Moon Am in de Sky" (print), 236–237
Serviceable Government, A, or the Reverie of a Bachelor (cartoon), 269
Seven Stages of Matrimony, The (print), 208
Shade and Tomb of Napoleon, The (print), 212
Shade and Tomb of Washington, The (print), 212
ships, 60, 68, 76–77, 221; clipper, 10, 24, 27, 293–295; steam, 8, 10, 11–13, 23, 80, 81 (fig.), 87, 295–298
Short Stop at a Way Station, A (print), 300
Siege and Capture of Vicksburg (print), 80
Siege of Limerick, The (print), 248
Siege of Vera Cruz (print), 65
Signal Fire on Slievenamon Mountain (print), 249
Single (print), 209, 210 (fig.)
Skip Softly Lub, Don't Sturb de Ole Man an Old Bull Pup! (print), 240
Sleigh Rave, The (print), 22
Slightly Demoralized: "I Know We'd Make Em Take Water" (print), 239
Slugged Out: "Better Luck Next Time (print), 330
Smelling Committee, The (cartoon), 284
Snow-Shoe Dance, The (print), 144
Snow-Shoe Dance to Thank the Great Spirit for the First Appearance of Snow (print), 145
Soldier Boy, The: "Off Duty" (print), 98
Soldier Boy, The: "On Duty" (print), 98
Soldier's Dream of Home, The (print), 98
Soldier's Grave, The (print), 103–104
Soldier's Home, The, The Vision (print), 98–99
Soldier's Memorial, The (print), 104
South Carolina's "Ultimatum" (print), 92

Southern "Volunteers" (cartoon), 94
Spirit of 61/God, Our Country and Liberty, The (print), 75
Spirit of the Union, The (print), 46–47, 67, 291
Splitting the Party (cartoon), 288–289
"Spoons" as Falstaff Mustering the Impeachment Managers (cartoon), 284
sports, 10, 142, 143, 233, 251, 270, 320–331
Squall off Cape Horn (print), 295
Star of the North (print), 28, 204
Star of the South (print), 28, 204
Staten Island and the Narrows (print), 157
Stella and Alice Grey/Lantern and Whalebone (print), 310–311
Stephen Finding "His Mother" (cartoon), 275
Storming of the Heights at Monterey (print), 66
Storming the Castle "Old Abe" on Guard (cartoon), 276
Story of the Fight, The (print), 101–102
Story of the Revolution, The (print), 59
Suburban Retreat, A (print), 180
Summer's Evening (print), 179
Surprise, The (print), 137
Surrender of Cornwallis (print), 55–56
Surrender of Cornwallis: At Yorktown VA (print), 44
Surrender of General Burgoyne at Saratoga (print), 55
Surrender of General Lee at Appomattox C. H. (print), 82
Surrender of Lord Cornwallis (print), 56
Sweetser—Sleepy George and Lucy (print), 311
Swell Smoker, A—Getting the Short End (print), 242
Swell Smoker, A–Giving Long Odds (print), 242
Swell Sport on a Buffalo Hunt, A (print), 139
Swell Sport Stampeded, A (print), 139

Taking the Back Track: A Dangerous Neighborhood (print), 137
"Taking the Stump," or Stephen in Search of His Mother (cartoon), 275
Terrible Collision between the Steamboats "Stonington" and "Narragansett" (print), 298
Terric Collision between the Steamboats "Dean Richmond" and "C. Vanderbilt" (print), 298

Terrific Combat between the "Monitor" 2 Guns and "Merrimac" 10 Guns: The Fist Fight between Iron Clad Ships of War (print), 77

Thatched Cottage, The (print), 167

Thomas Jefferson: Third President of the United States (print), 40

Thou Hast Learned to Love Another (print), 305

Three Graces, The (print), 204

Thrilling Incident during Voting, A—18th Ward, Philadelphia, Oct. 11 (cartoon), 282

Through to the Pacific (print), 122–123, 299

Tom Paddock (print), 319

Trappers Camp Fire, The (prints), 137–138

Trial of the Irish Patriots at Clonmel (print), 249

Trolling fro Blue Fish (print), 318

Trot, The (print), 233

"Trotting Cracks" on the Snow (print), 311

Trotting Horse George Palmer Driven by C. Champlin, The (print), 311

Trotting Mare "American Girl" Driven by M. Roden, The (print), 311

Trotting Mare Goldsmith Maid Driven by Budd Doble, The (print), 311

Trotting on the Road: Swill against Swell (print), 327

Trout Stream, The (print), 319

True Issue, The, or "That's What's the Matter" (cartoon), 95, 278

True Peace Commissioners, The (cartoon), 94–95

"Tumbled to It" (print), 328

Turn of the Tune, The: Traveler Playing the "Arkansas Traveler" (print), 129

"Uncle Sam" Making New Arrangements (cartoon), 277

Uncle Tom's Cabin (print from book), 218

Undecided Prize Fight, The (cartoon), 272

Under Full Steam: Now Den Squirt, for All She's Wuff (print), 239

Union Volunteer, The (print), 75

Union Volunteer, The/Home from the War (print), 101

U.S. Battleship Maine, The (print), 68

urban life, 4, 6, 7, 9, 13–24, 149–165, 301–307

Very Warm Corner, A (print), 328

Victorian Americans, 7, 9, 191–214

Victory on Lake Champlain (print), 60

View of Alton, Illinois (print), 164

View of Baltimore (print), 165

View of Boston (print), 165

View of Harper's Ferry (print), 299

View of New York: From Brooklyn Heights (print), 156

View of New York: From Weehawken (print), 156

View of San Francisco...from Telegraph Hill (print), 165

View of Swampscott, Massachusetts, A (print), 298

View of the Distributive Reservoir: On Murrays Hill—City of New York (print), 155

View of the Great Conflagration (print), 301

View of the Great Conflagration at New York (print), 301

View on the Harlem River (print), 157

"Vigilant" and "Valkyrie" on a "Thrash to Windward" (print), 322

Village Blacksmith, The (print), 187

Voluntary Manner in Which Some of the Southern Volunteers Enlist, The (cartoon), 94

Waiting for a Bite (print), 329

Waking Up the Wrong Passenger (print)

War of 1812, 9, 60–62, 63 (fig.)

Washington, George, 37, 67, 105, 218, 220, 291; as general, 22, 41–42, 44–45, 55–56, 57, 68; as president, 43 (fig.), 45–47, 107–108

Washington: Cincinnatus of the West (print), 45

Washington: First in Valor, Wisdom and Virtue (print), 45

Washington: First in War, First in Peace, and First in the Hearts of His Countrymen (print), 45

Washington, Appointed Commander in Chief (print), 42

Washington, Crossing the Delaware (print), 44

Washington, McClellan, and Scott (print), 47

Washington and Lincoln: The Father and the Saviour of Our Country (print), 47, 107–108

Washington at Mount Vernon 1797 (print), 218

Washington at Prayer (print), 42

Washington at Princeton (print), 44–45

Washington at Valley Forge (print), 45

Washington's Dream (print), 42, 43 (fig.)

Washington's Farewell to the Officers of His Army (print), 22, 42, 44 (fig.)

Washington's Reception by the Ladies (print), 41

Washington Taking Leave of the Officers of His Army (print), 22

Way They Came from California, The (print), 114

Way They Cross the Isthmus, The (print), 114, 115

Way They Get Married in California, The (print), 114, 117–118

Way They Go to California, The (print), 114–115, 118

Way They Raise a California Outfit, The (print), 114, 117

Way They Wait for "The Steamer" at Panama, The (print), 114, 115, 117

Wedding Morning, The (print), 204

Wedding Night, The (print), 204–205

Western Farmer's Home, The (print), 127–128

westward movement, 9, 24, 109–148, 241

Why Don't You Take It (cartoon), 86, 264

Wi-jun-jon—The Pigeons Egg Head: Going to Washington/Returning to His Home (print), 145, 146 (fig.)

Wild Cat Train, A (print), 300

Wild Duck Shooting (print), 317

Wild West in Darktown (prints), 241–242

William Penn's Treaty with the Indians (print), 52, 53

Winter in the Country: Getting Ice (print), 176

Winter in the Country: The Old Grist Mill (print), 177

Winter Morning in the Country (print) 22

Woman's Holy War: Grand Charge on the Enemy's Works (print), 196–197

women, 6, 7, 9, 28, 234–235, 242–244; and Civil war, 100, 101–102; image of, 200–211; social causes, 194–200, 202; status of, 192–194, 201, 211

Woodcock Shooting (print), 317

"Wooding Up" on the Mississippi (print), 220

Wrecked by a Cow Catcher (print), 300

Yacht "Henrietta" of N.Y., The (print), 324

Yacht "Madeline" N.Y. Yacht Club, The (print), 324

Yankee Doodle on His Muscle, or The Way the Bernicia Boy Astonished the English Men (print), 251, 230

Year after Marriage, A (print), 209

Yosemite Valley—California: "The Bridal Veil" Fall (print), 113

Young African, The (print), 231

Your Plan and Mine (cartoon), 282

**EAST BATON ROUGE PARISH
LIBRARY**
BATON ROUGE, LOUISIANA

MAIN